PRINCIPLES OF
ART
APPRECIATION

STEPHEN C. PEPPER

Professor of Philosophy and Aesthetics,

Chairman of the Department of Art,

University of California, Berkeley

GREENWOOD PRESS, PUBLISHERS
WESTPORT, CONNECTICUT

The Library of Congress cataloged this book as follows:

Pepper, Stephen Coburn, 1891–
 Principles of art appreciation ₍by₎ Stephen C. Pepper.
Westport, Conn., Greenwood Press ₍1970, ᶜ1949₎
 vii, 326 p. illus., 20 plates. 23 cm.

 1. Art appreciation. ɪ. Title.

N7477.P44 1970 701.18 70–98238
ISBN 0–8371–3690–3 MARC

Library of Congress 70 ₍4₎

Copyright 1949 by Harcourt, Brace & World, Inc.,
New York

Reprinted with the permission of Harcourt, Brace & World, Inc.

Reprinted by Greenwood Press, Inc.

First Greenwood reprinting 1970
Second Greenwood reprinting 1977

Library of Congress catalog card number 70-98238

ISBN 0-8371-3690-3

Printed in the United States of America

PREFACE

I CONFESS that my strongest personal motive in writing this book has been a desire to share all this material with others. When anyone is riding along in a car and sees a field of flowers or a waterfall, he spontaneously calls everybody else's attention to it. That is the way I feel about these things in the arts. I should like everybody to see them and have the delight out of them that I have had.

But I·have also discovered that mere pointing is not enough. A great deal of intelligent persuasion and explanation is needed just to induce people to become alert and discriminating. Besides, there is a fascination in discovering the reasons for things, which extends to the grounds of our likes and dislikes. So, this material has taken shape in an organization of statements and hypotheses which are as nearly true and verifiable as my present knowledge can make them.

The material of this book is the result of much close contact with the arts and with artists, much reading on the subject, some experimenting, and much teaching. It is put together primarily as a help to other teachers, who may profit from my experience as I have profited from the experience of previous writers.

A word should be said about the point of view from which the subject is here approached. I have deliberately taken the naturalistic point of view which stresses the value of pleasure in art. It is the easiest approach for our times, the least controversial. But my choice in this instance does not mean that I have abandoned my high opinion of other points of view from which I have written other studies on the subject in the past. The various ways of approach complement one another, in my judgment, but with much overlapping. To have tried to combine them all here would only have confused the reader.

An attempt to name all the persons to whom I am indebted for material and assistance in bringing this book to completion would be out of the question, for it would lead far back into the forgotten past. But I

should like to express a special gratitude to members of the publisher's staff, the outside advisers they engaged to read and criticize the manuscript, and to my friends and colleagues in Berkeley interested in the arts who have read all or portions of the manuscript and given me the benefit of their judgment.

S.C.P.

Berkeley, California
January 10, 1949

The plates in this book are printed with the following permissions:

PLATE I: National Gallery of Art, Washington, D.C. PLATE II: Metropolitan Museum, New York, reproduction from E. S. Herrmann, Inc., New York. PLATE III: The Metropolitan Museum, New York. PLATE IV: George Rowley, from *Principles of Chinese Painting*. PLATE V: National Gallery of Art, Washington, D.C. PLATE VI: National Gallery of Art, Washington, D.C. PLATE VII: Piperdrucke, Munich. PLATE VIII: Erle Loran, from *Cézanne's Composition*. PLATE IXA: Collection of The Museum of Modern Art, New York. PLATE IXB: Roland Penrose, owner, reproduction courtesy of The Museum of Modern Art, New York. PLATE X: D. Anderson, Rome. PLATE XI: Collection of The Museum of Modern Art, New York. PLATE XII: The Metropolitan Museum, New York. PLATES XIIIA and XIIIB: Pegot Waring, Beverly Hills, California. PLATE XIIIC: Richard O'Hanlon, owner, Lew Tyrrell, photographer. PLATE XIV: Collection of The Museum of Modern Art, New York. PLATE XV: Buchholz Gallery, reproduction courtesy of The Museum of Modern Art, New York. PLATE XVI: Alinari, Florence. PLATE XVII: Joseph Coburn Smith, photographer. PLATE XVIII: Frederick Langhorst, architect. PLATE XIX: Munchner Verlag, Berlin and Syndicat de la Propriété Artistique, Paris. PLATE XX: Albert Skira, Geneva.

CONTENTS

Part One

THE PSYCHOLOGY
OF ART APPRECIATION

THE APPRECIATION
OF A WORK OF ART

The Appreciative Attitude

THIS BOOK has a double purpose — to enlarge our understanding of the arts and thereby to increase our appreciation of them. The two aims actually go together and cannot be separated. For art cannot be understood without appreciation, and appreciation depends upon understanding.

What is appreciation? In the broadest sense it is the liking of things for themselves. It is having vivid pleasant experiences. How do we get these experiences? What sorts of attitudes in us tend to produce such experiences? And what sorts of materials and forms in objects tend to produce the favorable attitudes? These are the questions we shall try to answer.

Roughly speaking, the appreciative attitude is opposed to both the practical and the analytical. We shall need to modify this statement later. But at the start it makes things clearer if we sharply distinguish these three attitudes one from another.

When a man is being intensely practical, he is not thinking about the delights of the present or the sensuous quality of the thing before him. He is thinking about some future goal and the means of attaining it, and sees in objects about him only the relations they have to his goal. He sees things as instruments. He values things not for themselves, but only as means to ends. So a farmer sees a cloud, and sees it merely as a carrier of rain which is good for his beets or bad for his hay. Only if he stops being a practical man for a moment does he see the cloud as a mass of moving shapes fascinating to the eye.

Similarly, if a man is being purely analytical he does not enjoy the thing for itself. The thing is then something to be classified, related to other things by cause and effect, or broken down into elements which can be correlated and formulated into laws. A meteorologist looking at the cloud immediately begins to classify it, sees it as "cumulous" in type, and from this classification and other relations observed, he draws inferences and perhaps predicts an electrical storm. In his attitude as scientist he is interested in these relations and predictions, and does not appreciate the cloud for itself any more than the farmer.

To appreciate an object, then, we must get away from thinking about what

uses it can have for us, or what relations can be analyzed out of it. To appreciate it is to find delight in it for just the thing it is in our perception.

Actually, if we can keep the practical and analytical attitudes off to one side, and keep our perceptions and emotional responses keen, almost inevitably what we see before us will be appreciated. It will be either liked or disliked for itself. If it is liked, it is just what we mean by an object of appreciation. It is the sort of thing that is often called a " thing of beauty."

To some extent, then, it is within our power to find things beautiful or not at will. If we bring an appreciative attitude to the world about us, we immediately find much to appreciate. The cloud is out there ready to be appreciated by anybody in the appreciative attitude. But if we are absorbed in practical matters, it is very difficult for the beauty of the cloud to break through; that is, for the cloud to get perceived as an object of immediate enjoyment. There are, to be sure, a few things so obviously and intensely enjoyable that it surprises us if people do not enjoy them — such things as bright sunsets. Yet even a sunset does not always make itself felt. There is always some need of co-operation on the spectator's part. At least he must bring some readiness to be appreciative.

However, there are some objects so designed as particularly to stimulate the appreciative attitude, and to hold it steadily once it is attained. These are works of art. And it is these, as we said, that we propose particularly to study. For if we can understand these objects and the ways in which they give us enjoyment and the ways we can get enjoyment out of them, then we shall be able to understand objects of appreciation generally. If we understand the pleasures of works of art, this should help us to understand other pleasures too.

Can Matters of Pleasure Be Understood?

At this point the question is sure to arise: How can matters of pleasure be understood? An old maxim says there is no disputing about tastes. Like most maxims it states a half truth, and we rather confidently look around for another popular maxim that states the other half of the truth. Keats's famous line gives it: " A thing of beauty is a joy forever." He goes on and says, " Its loveliness increases," which is also worth remembering.

Put these two maxims together and we have the setting of our problem. For there is no question that people do differ in their tastes and that mere talking about it has never changed a man's likings. If talking about it leads a man to do something about his tastes, that is another matter. But you cannot argue a man out of his likes or dislikes as you can argue him out of a false conclusion by showing that the conclusion does not follow from his premises. There is something ultimate about our likes and dislikes. At least while we have them we simply do have them, and that is that.

But at the same time, there is no question that in all ages a large body of opinion has held that some likings are better than others, and that there is such a thing as good or bad taste. The notion persists that there is some more or less stable criterion by which likings and dislikings may be properly judged for their worth. It is not thought absurd to consider certain objects as great works of art which ought to be liked even if they are not.

The issue between these two points of view produces the controversy between what are known as subjectivists or relativists in theories about values *versus* objectivists or absolutists. The issue, however, is not quite so black and white as these names suggest. There are degrees of relativity and objectivity. Since it will make for clarity if the reader knows at once where this book stands on this issue, let us distinguish four degrees in the scale from extreme subjectivism to extreme absolutism.

1. INDIVIDUAL RELATIVITY or the view that one's likes and dislikes are a purely individual affair is the extreme subjectivistic position. If you like one artist and I like another, that is a psychologically interesting difference between us, and that is all that can be legitimately said about it. I may judge your taste on the basis of mine and disapprove of your likes and dislikes, but all that that indicates is that your likes and mine do not agree. I may seek to persuade you to my ways of feeling. But even if I succeed, all it means is that our likings now agree where previously they disagreed. Even if a majority of people agreed in their likings, that would not mean anything more than the fact that a majority did agree. The majority might put pressures on the minority and make it disagreeable for them to confess their unpopular likings. But the unpopularity of one's likings does not affect them as likings. In short, likings and dislikings are entirely relative to the individual, and it is meaningless to say that one individual *ought* to like what another one happens to.

2. CULTURAL RELATIVITY is a considerably modified view, which calls attention to the existence of cultural institutions and the role these play in shaping men's ideals and approvals and ultimately their most intimate likings and dislikings. It would deny that individuals are as independent in their tastes as the extreme subjectivists seem to think. On the contrary, men's tastes are determined by their culture. Children are not born into a vacuum. They are born into a culture, they pick up the traditions and customs of that culture, and their approvals and enjoyments come to conform to the cultural pattern. The culture consequently standardizes their approvals and enjoyments. It does so very quietly. Most individuals do not realize how much their taste is controlled. But the pattern of the control can be brought out by methods such as anthropologists have developed.

In the application to art, these cultural patterns are known as *styles*. Some works of art represent these styles more fully than others. Since men's approvals

within a culture tend, on this view, to follow the styles, these styles can be easily regarded as relatively objective criteria of good and bad taste for the culture concerned. When a cultural pattern in the form of a style of art is taken as a standard for the significance of a work of art, we have an illustration of cultural relativity. The value of the work is determined by the cultural pattern, and is as enduring as the life of the culture. To that extent it is objective. But there is nothing eternal or absolute about the value, since it is relative to the life of the culture.

3. BIOLOGICAL RELATIVITY is a still more modified view. It observes that basic patterns of likes and dislikes among animals vary from species to species. It calls attention to the large amount of similarity among men, and consequently the considerable amount of predictability in human actions. Human likes and dislikes are relative to human nature. And human nature is considered fairly stable. We do not expect men to act like dogs and cats, which shows how much we expect men to act like human beings. This view holds that apart from a small quantity of hereditary differences, most of the variations in men's likes and dislikes can be accounted for in accordance with psychological laws. Some of these laws are well understood. Others are becoming so. It follows that our likes and dislikes are controllable. We know, on this view, a number of fairly reliable principles by which a man's likes and dislikes may be changed. If his repertoire of enjoyments (that is, his taste) is small and shallow, and he has many dislikes, then ways can be shown by which he can enlarge and deepen his enjoyments and lessen the range of his dislikes. And if one of the fairly reliable principles of human psychology is that men prefer enjoyments to pains, irritations, and boredom, it follows that in this sense, at least, a large repertoire of rich enjoyments is better than a small repertoire of shallow enjoyments.

That is to say, if one is satisfied with the evidence for a large degree of constancy and predictability in human behavior, he has grounds for saying that a certain kind of taste is better than another kind. The better kind is that which tends to give the greater amount of predictable satisfaction. On much the same grounds, it is argued that one work of art is better than another if, relying on the constancy of human nature, one work can be shown to be predictably richer than the other, once a person has learned to like it.

The constancy of human nature here referred to does not, of course, mean a belief that all men's likings are just the same. That would be obviously absurd, since men's likings are so obviously different. It means that the psychological laws governing human likings and dislikings are the same for all men. It means that his likes and dislikes can to a considerable degree be predicted and that consequently a man has some control over his taste and can develop it so that his life may have fuller satisfactions than before.

4. ABSOLUTISM is the view that the beauty of an object is independent of

men's responses to it. The view appears in many forms. There is an ancient form which holds that there exists an abstract ideal of beauty independent of all objects that we see, and that perceived objects are beautiful or not in proportion as they approach that ideal. This abstract ideal is sometimes conceived as existing in the mind of God. Beauty may also be identified with simple relations such as those for harmonious musical intervals, or for regular geometrical figures; and objects having these relations are considered beautiful whether anyone sees them or not. These are extreme forms of the view, and probably will not appear even plausible to most people today. But it would not be wise to reject out of hand the possibility of some form of absolute values.

In this book we shall take the point of view of biological relativism. We shall hold that the appreciation of a great work of art is something more than a matter of personal likes and dislikes, something more than its conformity to art styles of social cultures. A great work of art, in our view, is the potentiality of a vivid and satisfying human experience. The possibility of that experience lies in the structure of the physical object to which we respond. The conditions for our having the experience lie in ourselves. Have we developed our powers of appreciation so that we can respond to the object appropriately? If not, we naturally cannot expect to enjoy it any more than we can expect to see an object if we keep our eyes shut.

The elaborate discipline an artist goes through to "learn" how to compose the design and pattern of his work is based on solid data concerning what human beings find pleasing and otherwise in a work of art. These facts about what does and does not please apply to the spectator's responses exactly as they do to the artist's successful creation. Just as we can predict that under suitable lighting conditions, anyone with a normal eye will see a red rose as red, so we shall take the view in this book that if a spectator has met the conditions for the appreciation of a great work of art, he may expect to have the vivid satisfying experience that awaits him there. These conditions, of course, are much more complicated than just opening one's eyes. It is the task of this book to describe some of these conditions, so far as we know them. For we believe the more these principles of art appreciation are understood, the more persons will be able to have these experiences which are among the most satisfying that life provides.

The difficulty with cultural relativism, in our view, is that it seems to deny the importance of universal human traits which run through all art. Basic principles of design and pattern are grounded on basic psychological principles to which every man's responses are subject. All men have the same instincts, the same mechanisms of learning, the same emotional mechanisms for meeting conflicts and frustrations. All these basic principles enter into the organization of works of art. Cultural traits ride on top of these.

There are many works of art in which the local cultural traits are entirely incidental to appreciation. Then, of course, there are others in which a sympathetic understanding of the aims of a style and the cultural interests out of which it grew are essential. But for the latter a sympathetic understanding can be gained by suitable methods of study. That is to say, we can predict the psychological conditions under which a man can come to appreciate Egyptian, Persian, or Chinese painting. In fact, a large part of an education in the appreciation of the art of other peoples consists in breaking down the rigidity of a man's own local cultural ideals — turning him from a sort of provincial robot into a human being. He becomes a man, and is able to appreciate what is human in all art. And because he now sees how human it is to develop one or another ideal to its perfection, he becomes able to sympathize easily with many ideals. He sees his own cultural ideal in the human perspective, and possibly then appreciates even his own cultural ideals more fully.

The difficulty with individual relativism is of the same sort as that with cultural relativism, but more aggravated. In every person's response there are some purely private characteristics. But to exaggerate these to the point of saying that there is no significant uniformity in men's appreciation of a work of art appears to be contrary to a large amount of evidence.

However, there are today many cultural and individual relativists. This book, which takes a more objective position, need not be entirely uninteresting to them. The cultural relativist may find in it a fair illustration of a school of aesthetic thinking in the middle of the twentieth century. And an individual relativist may find it amusing to compare his own responses to the various works of art referred to in the coming pages with mine. He is free to discard my implications of a potential objective human experience of the work which it would profit us both to attain. He may, if he likes, regard the descriptions I give of my experiences with these works as purely personal responses of mine. Sometimes perhaps he will agree with me about some things he had not noticed — as I am sure I should often agree with him about things in the work I had not noticed. We could have a good time together just comparing notes. If that is as far as he wants to go, I should be agreeable. But I do believe we could go further, and that there is sufficient evidence in this very book to show that a well-organized work of art implies a standard human experience of it, which it would well repay us to learn to understand and appreciate.

The Work of Art

What is this standard human experience of a work of art to which I have been referring? It is the complete system of relevant perceptions for that work. This conception will need some explanation. Let us take an illustration. Sup-

pose we are trying to get the full aesthetic experience of Renoir's picture, *Mme. Charpentier and Her Children* (reproduced in PLATE II). The original of this picture hangs in the Metropolitan Museum of New York. What hangs on the wall there, however, is only a physical object, a piece of canvas with some pigments spread over it. This physical object is clearly not literally the object of our appreciation. It is simply the source of stimulation for an appreciative experience. It is, nevertheless, a very important object, for without it we could never obtain the experiences which we do appreciate. We shall call it the *physical work of art*.

The physical work of art becomes a source of appreciation only when a spectator comes before it under suitable conditions of illumination and gets a perception of it. The first perception a spectator gets is the beginning of his appreciation of the picture. The object appreciated by the spectator in this perception is very different from the physical picture, which we have just called the physical work of art. For the object of the spectator's perception is an organization of colors, lines, shapes, and representations of a woman and two children and a dog, and a number of other things in the volume of a room. What the spectator perceives is not canvas and pigments but colors and shapes and a highly composed representation of a woman and her two children. The latter is the object of his perception. This object, which is the actual object of his contemplation, and which he wishes to understand and appreciate fully, we shall call the *aesthetic work of art*.

The aesthetic work of art is, as we have said, the direct object of his perception. The physical work of art is not literally the object of his perception. But it is very important for his perceptions, because it is what guides the spectator in determining what is relevant or irrelevant to his perceptions. For instance, the spectator may be aware of somebody passing in front of him, or coughing behind him. He excludes these as irrelevant because he knows they are not stimulated by the physical picture. If he does not like the frame, he will exclude that (possibly with some difficulty) because he knows that does not belong to the picture. A thought of an engagement to meet a friend may cross his mind, and he will exclude that for the same reason. The rug on the floor in the picture might for a moment make him think of a neighbor of his, who owns such a rug. He will exclude that too as an irrelevant association. What makes him exclude all these is their irrelevancy to the source of stimulation in the physical work of art. And what is most revealing, such thoughts as these just do not enter the spectator's theater of perception if he gets thoroughly absorbed in the picture. You do not notice anybody coughing or passing in front of you if the picture interests you intensely; also highly irrelevant thoughts just do not occur to you.

These illustrations of irrelevancy are clear enough. But just how do you know

where to draw the line between relevancy and irrelevancy? Really, this whole book is on that subject. It attempts to show to the best of our present knowledge the sorts of things that are relevant to the perceptions of a picture or a statue or a piece of architecture, and the psychological grounds for that relevancy.

Relevancy turns out to be one of the most important concepts in the appreciation of art. It is another way of saying what is *in* the work of art. Any detail has a place *in* an aesthetic work of art if it can be shown to be relevant to the perception of a physical work of art.

In general there are two ways of establishing relevancy, One is to show that a detail in the perception is a sensation *directly stimulated* by the physical work of art, The blue of the little girls' dresses would be such a sensation, as well as all the other colors throughout the picture. Also the lines outlining all the shapes, and the rhythms of repeated shapes like those on the rug and chairback. But there are very few works of art that rely wholly on direct stimulation. Perhaps a Persian tile with a purely abstract design could be said to do so. That is to say, there are very few works of art that are purely sensuous in their appeal.

The second way of establishing relevancy is to show that the details refer to one another throughout the object of perception, and all tie in to the directly stimulated details. In one word, the second way is by *organization*. How do you know, for instance, that the black and white shapes in the middle of the picture represent a woman? It is because you have in your mind an idea of a typical woman which is already an organization of certain traits in certain relations to one another. You see in the middle of the picture a shape that looks like a woman's hand. Your guess is confirmed when you see it is connected with an arm and shoulders and head and bosom, as your idea of a typical woman would lead you to expect. The perception of a woman's shape, then, is relevant to the picture. You see the woman as if she were at some depth back in the volume of a room. That there is depth and volume in the picture is confirmed by every other object perceived, for every object takes its place in an organized perspective. And so from detail to detail we can work through the picture to find all that is relevant to it. The more highly organized a picture the more definitely we can confirm by this sort of internal verification what is in it, what constitutes its objective structure as an aesthetic work of art.

These details are very obvious ones, which no one would miss. But the reason we accept them as belonging to the picture, and not as irrelevant fancies woven about a few scattered shapes and colors stimulated from some pigments spread over a canvas — that reason is not so obvious. But once the principle of relevance is grasped, it will permit us to proceed to the hundreds of subtler details relevant to the picture, which it takes much more discrimination to perceive. From these details the picture gets its richness of delight, and these are what we

are seeking in this and other works of art in all the subsequent chapters of this book.

Perhaps now the reader has a clearer conception of that " complete system of relevant perception " which we suggested as the standard human experience of a work of art. It is not something that can be attained in the first glance at a work of art, unless the work is very simple indeed, or unless it is one very similar to others with which the spectator is very familiar. It takes many successive perceptions to approach the full perception of the work. At the first glance a spectator sees only a few of the details relevant to the work. He may be trying to ascribe to it details that do not belong to it. He may be trying to judge this impressionistic picture of Renoir's by the realistic standards of Ingres. He may not like it, because he is trying to see in it details that are not there. If he wishes to appreciate the picture he has to get rid of these irrelevancies. But barring irrelevancies, a spectator in his first perception can hardly see more than a few of the traits that belong to the picture. Seeing it frequently, however, he begins to understand little by little the full richness of the picture. He remembers what he has seen in it before and adds this to what he finds in it afresh, so that each successive perception gets richer and richer. This process of fusing one's memories of former perceptions into the present one is called *funding*. Past appreciations are added to the present one as in a savings bank fund. The goal of this funding process is the sort of perception we aim at for the full understanding and appreciation of an aesthetic work of art. Such a final funding of all the relevant details in a single perception or system of perceptions (necessarily a system, if the work is a statue, for instance, that has to be seen from all sides) is the standard aesthetic work of art. It is the final and ideal stage of the perceptions of an aesthetic work of art. A spectator may never quite attain it. But it can be described and verified, since relevancy is always open to verification. If a spectator clears his perceptions of irrelevances, he is always in contact with some part of the structure of the aesthetic work of art.

It is to help us attain or, at least, approximate such full appreciation that we are entering into this coming study. Actually, every time we learn to appreciate one work of art richly, it helps us to appreciate another one more quickly. For wherever aesthetic works of art have traits in common, relevant funding may go on from one work to another.

A simile may help, by way of summary, to make this conception of an objectively verifiable aesthetic work of art clearer. The complete aesthetic work of art is an object of very much the same sort as a magnetic field in physics. Both are describable, verifiable, highly structured, and both exist generally in the status of potential objects. The pole of the magnet is to the magnetic field as the physical work of art is to the field of relevant details which constitutes the aesthetic work of art. Without the magnetic pole there would be no magnetic

field. Similarly, without the physical work of art there would be no structure of relevant perceptual details for an aesthetic work of art. The lines of force in the magnetic field are observable only when a sensitive needle is brought within the field, and it is the behavior of the needle relative to the magnetic pole that determines the structure of the magnetic field. Similarly, the details of the aesthetic work of art are observable only when a normally sensitive man enters into the perceptual field of the physical work of art, and the structure of the aesthetic work of art is known only through the relevant perceptions of detail stimulated by the physical work of art.

If the magnetic field is an objective structure so is the aesthetic work of art.

The only important difference is that a needle is never aware of the magnetic field as a whole. A sensitive needle cannot remember its behavior in one part of the field when it is carried to another. But a sensitive man in the perceptual field of a physical work of art can remember his previous perceptions and can fund them into a present one focused on some other detail of the field, and can actually sometimes obtain a funded intuition of the total structure of the field. That is, the total aesthetic work of art may sometimes cease to be a potential object and actually become an object of immediate present perception in a fully funded experience.

There is much more, of course, that could now be said about the aesthetic work of art, but since this is the object of our study, we shall let it reveal itself as we go along.

About Beauty and This Book

COMMON BEAUTY AND EXCELLENT BEAUTY. Our main attention will be on works of art. But these comprise only a small group of all things liked for themselves. We should, accordingly, regard this narrower area made up of works of art simply as a supremely representative sample of the whole field of beauty. For we do not want to foster the idea that beauty can be found only in museums and concert halls. It appears all about us. So, as our principal guide to the field of our own study, we should select a definition of the field of beauty that is broad enough. The one we have mentioned several times is a good first approximation, that of *things liked for themselves*. We may wish to modify this definition somewhat later. But it is a good over-all working definition to show the general area of our present interest.

We shall call a thing beautiful in the broadest aesthetic sense if it is simply something liked for itself. Ripples on the sand are beautiful, the odor of pine needles, the texture of an Indian shawl, the taste of a juicy pear. All these are beautiful if they are things you like for themselves. Such simple likes we shall call *common beauty*. The organization of such elements of common beauty into

works of art in the manner described in the preceding pages we shall call *excellent beauty*.

Simple immediate dislikes we shall call " common ugliness." But a physical object which gathers together and incorporates immediate dislikes into a structure that is intensely disagreeable in itself, may be called an object of " supreme ugliness."

Many simple immediate dislikes, however, may be converted into immediate likes. And sometimes objects are felt as supremely ugly which on further experience the spectator accepts as excellent beauty. Changes in the opposite direction also occur.

Such changes of immediate likings and dislikings are extremely important. As matters of pure intellectual curiosity in the understanding of art appreciation, they are important — but still more so in their bearing on the way we may plan our lives. For clearly if we can plan our lives so as to increase the probable quantity of our likings and decrease periods of dullness and irritation, our lives will be the better for it. And so we may do. By understanding the way changes occur in our valuing of things we can enlarge our capacities of interest and enjoyment. This process is often called the cultivation of taste. It is an important and relatively neglected part of a man's education. Much thought and time is put today upon the cultivation of intellect and the learning of skills, but much too little time is put upon the cultivation of our likings. These have been pretty much left to take care of themselves, and they have suffered a good deal from neglect.

CHAPTER ORGANIZATION. Our first concern in this book will be to try to understand how some of these changes of taste come about. We know much too little concerning them. Nevertheless, we know sufficient to make up the chapter which immediately follows. Much of this knowledge is very tentative, but that is no reason to slight it. Rather it is reason to give it all the more attention.

There are a large number of psychological mechanisms which bring about changes in our likings for things in themselves. It seems to be possible, however, to bring them together in three groups, which we shall treat as so many distinct kinds of value changes. The names we shall give to these kinds are rather arbitrary, but they have proved convenient. The generally recognized technical name for a value change is *value mutation*. Accordingly we shall call the first of these groups of value changes the conditioning mutations, the second the habituation mutations, and the third the fatigue mutations. These value mutations will be taken up in sequence in the following chapter which, together with the present one on the general subject of the appreciation of a work of art, makes up Part I.

In Part II we shall examine the principles of artistic organization. Many things are disliked for want of understanding how the aesthetic materials of which they are composed are organized. Therefore, one step in the direction of appreciating them is learning to recognize various modes of organization in art or nature.

There are four chief modes of organization: design, pattern (which includes rhythm), type, and emotion. The first three principles taken together comprise what is commonly called " form " in art, though, as we shall see, they are based on quite different psychological mechanisms and perform quite different psychological functions. Most discussions of " form " have not, in my judgment, sufficiently considered the psychological differences underlying these principles. We intend doing so, however, and therefore shall rarely use the word " form "; we shall instead use the terms " design," " pattern," or " type " as the situation requires. The fourth, emotion (that is, the spectator's emotion), fuses into one enveloping feeling the various sensations received while viewing an object or work of art. It is therefore an organizing principle and will be so considered.

The remainder of this volume will be concerned with an application of these principles to the visual arts. In Part III we shall describe the aesthetic materials that enter into the visual arts. We shall then be ready for the study in Part IV of the major visual arts themselves: painting, sculpture, and architecture.

OUR PROVINCE IN THE WORLD OF ART. If the world of the fine arts is viewed from a sufficient distance to get a perspective of it, it will be found divided into four great continents — the visual arts, music, literature, and theater. Each of these has its inner subdivisions, but there is a distinctive treatment of aesthetic materials in these four great divisions which sets apart each from the other in a striking manner. The first three are markedly distinguishable by their aesthetic materials. The visual arts develop out of color, line, mass, and volume; music out of sounds; literature out of words. Theater is peculiar in having no special aesthetic material of its own. Its distinction is that it uses the materials of all the other arts in various proportions and combines them through the medium of the stage or of the screen. It is for that reason sometimes aptly called " the synthetic art."

The visual arts are the only ones in the four groups that are purely spatial. Architecture, sculpture, painting; and the host of minor visual arts (e.g., ceramics, textiles, metal work, leather work) do not make use of motion or change of materials within their organizations. They do count on shifts of attention in the spectator or even motion on his part to walk about and take in one aspect of the work after another. But the work itself is static. When movement is brought into visual material, as in the moving picture, the art is promptly considered a new variety of theater art. And properly it belongs there because it immediately receives the synthetic treatment characteristic of theater. Actors and written words were at once incorporated into the moving picture, and presently music and the spoken word also. A motion picture is therefore a highly synthetic art. So it comes about that the visual arts are the purely spatial arts and the only ones that are. Music and literature are by the necessity of their materials tem-

poral, and theater likewise is temporal through the synthesis of visual materials with those of music and literature.

It is evident, then, that the visual arts are different from the other three in that they are purely spatial and involve neither sound nor motion. They constitute a natural province in the world of art. Our general aesthetic principles are well represented through them. We shall accordingly confine our attention to them in this book.

We turn now to the basic question of the formation of our likes and dislikes.

C H A P T E R 2

THE FORMATION OF OUR
LIKES AND DISLIKES

Changes of Likes and Dislikes by Conditioning

GENERAL EFFECTS OF CONDITIONING. Anyone who has ever been interested in experiments in animal behavior will have heard of Pavlov's dog. For Pavlov's experiments are the classic ones on the " conditioned response." The term " conditioning" itself comes from him, and has practically supplanted the older term " association of ideas." But very few people seem to have noticed that Pavlov's experiments on dogs have an important bearing on aesthetics.

For the result of his experiments was to show that objects which were at first quite neutral in an organism's environment became through the process of " conditioning" objects of intense value. Moreover, these objects first valued because they were signs, or means, for suggesting or for leading to objects which the animals liked for themselves, came after a while to be themselves liked for themselves.

In his experiments Pavlov operated on dogs in such a way that the secretion of the salivary glands flowed into an external container where it could be measured. Pavlov discovered that the amount of the secretion was a good measure of the appetite of a dog for food presented. It was, in other words, a measure of the amount of liking a dog had for his food at the time. Since food is a thing obviously liked for itself, it is, of course, a typical instance of common beauty. Among other matters, Pavlov was actually studying canine aesthetics.

Now, Pavlov began ringing a bell whenever he fed the dogs. Such a sound under ordinary circumstances has no effect on a dog's salivary glands. But after ringing the bell a number of times with the feeding, Pavlov discovered that then the sound of the bell even without food would stimulate the secretion of the salivary glands. The glandular response to the food had become also attached to the bell, so that the dog was reacting to the bell just as he would react to the food. The dog, in other words, now liked the bell for itself just as he had liked the food for itself.

Here our own reaction to this experiment, as readers of it, may well be, " Why, of course, what else would Pavlov have expected? Don't we all when hungry like

the smell of a cooking dinner, knowing what it means? Don't we enjoy such odors for themselves even when we are passing under a neighbor's kitchen window? Don't we even enjoy hearing people talk about delicious food when we are hungry? Don't we even spontaneously imagine tasty things, and if we are poets make appetizing descriptions of them as did Keats in ' The Eve of Saint Agnes '? [1] Don't our mouths water at the thought? "

Of course, and this is all evidence in support of Pavlov's finding. But have we fully taken in the significance of these facts? They mean that through this conditioning mechanism we can add new likings to the original field of our instinctive likings. Things first valued simply as signs or means for other things come to be valued for themselves. We may call it the means-to-end mutation.

In the case of Pavlov's dogs this mutation was apparently never permanent. If, after a considerable length of time, the dogs were not fed when the bell rang, eventually the dogs ceased to salivate at the sound of the bell. It ceased to be a sign of food and apparently ceased to be a source of enjoyment for them. The sound of the bell as something liked in itself never became for the dogs entirely independent of the food which it was a sign of. The means-to-end mutation was never for the dogs, in other words, complete. Many means-to-end mutations among men are of this partial sort. Some change of value has unquestionably occurred but it is not a complete or permanent mutation, not a " fixation " as a complete means-to-end mutation is sometimes called. These partial means-to-end mutations need to be reinforced from time to time in order to be maintained.

This fact is of importance to the artist, for it gives him a clue as to which ones of these mutations — these acquired likings — he can count on when he uses them as materials in a work of art. He can count, of course, on any of our instinctive likings (except in those instances where they have been culturally inhibited, in which instances he can of course count on the inhibitions), and he can count on the acquired likings which are reinforced sufficiently from time to time either by the physical or cultural conditions which surround them.

A novelist, for instance, can count on his readers' liking the image of the odor of cooking meat, or the image of the sound of its sizzling over the fire because he knows that these acquired likings will be frequently reinforced by the eating of meat in a man's usual physical environment. Most men eat cooked meat, and

[1] For any readers who are concerned with the mingling of several kinds of signs in these illustrations, let me say this is intentional and that I am well aware of the many important distinctions among signs. For instance, the odor of onions being a sign of food is a " natural sign " since the association is due to cause-and-effect relation in the physical environment. But the word " onions " being an arbitrary sound conventionally attached to the vegetable is a " conventional sign " since it is established by cultural agencies. Both are learned by conditioning, however. We are dealing with " meaning " in the present section only in the most general sense.

physically the cooking of meat is frequently accompanied by odors and sizzling. If a man has camped in the wilds, the campfire that cooked the meat and also the smell of the wood smoke and the look of the smoke twisting in a thin blue ribbon up into the treetops will be things liked for themselves. So will the utensils, the frying pan and the axe and the fishing rod and perhaps the canoe and the paddle. A painter can now depict the scene and count on a man's finding delight merely in the subject matter. For all these things have come into the field of common beauty.

Moreover, an object once brought into the field of beauty and fixated or adequately reinforced from time to time becomes itself a center of conditioning for other objects. A fishing rod is presently liked for itself because of its connection with the fish which are fun to catch and eat. But the very feel of the rod becomes also a delight. A man will put his rod together and begin casting on land, not merely for practice, but because he enjoys the feeling of it. Men come to love their instruments. A well-balanced paddle is a delight to handle, and so is an axe, and a rifle. A man will enjoy a pipe with no tobacco in it.

These values may spread also by a process of diffusion. If there is an impulse to enjoy some sort of object and the object is absent, the enjoyment may be projected upon some other object similar to it. That object may then come to be liked for itself. This process is called "transfer," and was partly covered by the old term "association by similarity." The amount of common beauty due to diffusion of impulse through transfer is probably very great and most of it performed so easily and imperceptibly that we are entirely unconscious of it. Santayana believes that most of our love of nature as well as our devotion to many other things is due to a diffusion of the sex impulse.

"Sex is not the only object of sexual passion," he writes. "When love lacks its specific object, when it does not yet understand itself, or has been sacrificed to some other interest, we see the stifled fire bursting out in various directions. One is religious devotion, another is zealous philanthropy, a third is the fondling of pet animals, but not the least fortunate is the love of nature and of art; for nature is often a second mistress that consoles us for the loss of a first. Passion then overflows and visibly floods those neighboring regions which it has always secretly watered. For the nervous organization which sex involves, with its necessarily wide branchings and associations in the brain, must be partially stimulated by other objects than its specific or ultimate one; especially in man, who, unlike some of the lower animals, has not his instincts clearly distinct and intermittent, but always partially active, and never active in isolation. We may say, then, that for man all nature is a secondary object of sexual passion, and that to this fact the beauty of nature is largely due." [1]

EXTENSION OF VALUES BY THE MEANS-TO-END MUTATION. Through condition-

[1] George Santayana, *The Sense of Beauty*, Scribner, 1896, pp. 61–62.

ing, then, when the conditioned object gains complete or virtual independence of the originally liked object, resulting in what we are calling the means-to-end mutation, our field of things liked for themselves is in general vastly enlarged. The point of departure for this mutation is our original repertoire of instinctive likings. These are to the best of our knowledge practically identical in all men — all who are not congenitally abnormal or deficient in some respect such as deafness or color blindness. From this common base new likings are added through the means-to-end mutations according to the influences of the physical and social environment. In so far as we can count on a common physical environment and a common culture, we can count on a large range of common acquired likings in a group of men. Where there are differences in these respects, we have to anticipate differences of likings.

There results a sort of stratification of likings. Objects which stimulate our original instinctive likings,[1] and those basic conditionings which occur in any human environment, can be counted on in any normal man. Works of art which appeal in great degree to this basic stratum of likings are universal. No matter in what culture they have been produced, they will find a response in men of other cultures thousands of miles or thousands of years away. For even if some culture manages to inhibit temporarily some types of instinctive likings by taboo, still these likings are sure to crop out again in other cultures. For the instinctive forces of human life can only be extinguished by the extinction of the human species.

Above this base of universal likings is a stratum of mores or deep-lying very extensive cultural traits such as the common heritage of Occidental civilization from the Greeks to the present time. In the next stratum comes what we might call custom, consisting of regional and national traits and the traits of periods like the Elizabethan and the Victorian. Above this come the levels of provincial peculiarities, the idiosyncrasies of a social set or class or party or sect or club or even of a single family, and, in the time dimension, the fugitive fashions of the day. Finally we reach the peculiarities of a single individual which are his own private acquisition in the way of likings and dislikings and which nobody else but him can understand sympathetically and for which he is regarded by other people as just queer.

Discrepancies of taste increase as we ascend this scale of acquired likings. These strata, consequently, have their effects on the permanence or the popularity, the depth or the shallowness, the untimeliness or the timeliness of works of art. Some works of art make their appeal largely to the superficial strata and for that reason have a very limited appeal — though it may well be a strong one. Other works of art appeal largely to the lower strata. Unless these are very sim-

[1] There will be a discussion of our instincts and a suggested list of them in Chapter 6 on emotions.

ple, however, they are bound to draw upon the upper strata as well. A picture expressing love or death, which are universal themes based directly on human instincts and the inescapable physical effects of any environment, could hardly depict its characters without representing them in some dress in some setting of city or of cultivated or wild country with some instruments of the period in evidence, and all these would be traits of the more superficial levels.

In fact, a work of universal appeal generally gains in richness and effectiveness by drawing on the traits of the upper levels, as much as to say: "These human instincts and emotions are with us at all times and exhibit themselves through whatever may be the peculiar dress or furniture or manners of any time or place. Here is just how love and death appeared in Egypt or Persia or Chartres or Venice, to the very way the hair was brushed and the feet were shod, and so these same moving events carry us along today together with our haircuts, hairdos, shoes, and slippers."

Just for the reason that our instincts are the source of all other likings, no matter how distantly derived through the channels of the means-to-end mutations, it can scarcely be otherwise than that the greatest art will be art with a universal appeal. It is not simply or mainly because such art has permanence or survival value in the sense that it will move men again and again in cultures far different from its own. It is fundamentally because such art has insight into the interconnections of our likings and can develop greater massiveness of organization of our likings, and has altogether more spread and depth of human significance.

The extension of the range of our likings by the means-to-end mutation is a good deal like that of a column of smoke rising from a campfire in the plains. The column is all derived from the burning coals, and when the fire of our instincts goes out, the smoke vanishes completely. As the smoke rises, it spreads, and grows thinner and thinner as it spreads. The area it spreads into depends on the direction of breeze. Now it blows east and now it blows west. If the fire burns long and the wind changes through all the points of the compass the smoke will at one time or another fill the atmosphere in every visible direction, but it never fills all the atmosphere all the time, and so is variable. Yet all the time, however the wind is blowing, the fire burns constantly and the smoke is always thickest and warmest near the flames.

So, by the means-to-end mutation there is almost nothing we can think of that might not become an object of liking and thus fall within the aesthetic field. But in general our likings remain strongest when they are not too distantly derived from their instinctive sources. This fact is what gives stability to the extraordinary potential range of the aesthetic field, and gives it also a definite constancy in spite of its wide variability. All our derived likings are an-

chored to our instinctive and basic likings, however widely the former may swing with the winds and tides of culture.

A NARROWING EFFECT OF CONDITIONING. Up to this point we have been showing how conditioning through the means-to-end mutation extends the aesthetic field. Now, we must point out how in an indirect way it sometimes narrows the field and causes men to lose the capacity of likings they once had. This loss comes about through the drying up of common interests by disuse and by their energy being drained away to some overabsorbing narrow interest. It is a frequent effect of overspecialization.

A businessman, a lawyer, a scientist, a mathematician, an historian may become so absorbed through a long period of his life in a narrow set of activities that he loses his capacity to enjoy things which most men come to like just in the natural course of living. His specialty has become his sole aesthetic field. The means-to-end mutation has served him there too well.

Think of a certain type of businessman. The trip to the office, the desk, opening the mail, conferences with clients, dictating to the stenographer, looking over the plant, purchasing and selling — these, as we often say, have become the man's life. Every detail of his business routine he has come to like for itself. This is his aesthetic field. Perhaps he enjoys a game of golf on Saturdays. No doubt he still enjoys his meals. He may get a kick out of a good variety show. But possibly even these seem frivolous to him and his thoughts keep returning to his business, whatever it is he may be doing. There is nothing else he can talk about with genuine interest.

In middle life when he has acquired a great or a moderate fortune, his wife finally persuades him to take a vacation. What will they do? Where will they go? To Mexico perhaps, to London or Paris. When they get there, what will they do? Pictures, music, the life of a city, the parks, the buildings, these have no interest for him. The scenery of the country bores him. Perhaps he meets a similar businessman on a similar trip, and for the first time a spark is lit. They can talk business together. Perhaps that gives him the idea of looking up the agents of his business in the locality. After that he finds a way of keeping out of boredom. He frequents the hotel bars and lobbies for the chance of meeting other fellow businessmen and he looks up his business connections wherever he goes. It is a great relief at last to get back to the old office and routine again. He tells his friends that the greatest advantage of going on a vacation is to find how good it is to get back to work again. When finally he has to retire, he has nothing to fall back on. Perhaps he keeps a desk in the old office just so as to have contact with life — for here in his office was practically all his field of common beauty, all that he lived for.

Sinclair Lewis drew a picture of such a man in his novel *Dodsworth*. If one

has any doubt of what I am referring to, he should read this novel. Dodsworth, the automobile manufacturer, still had enough gleams of interest alight outside his absorbing drive for success in his business to be able to remake himself partially before it was too late. The novel is the story of this regeneration. Subordinately, there is also the story of Dodsworth's wife who suffered from the same disease of dried-up interests but in a subtler and even more insidious form. Sinclair Lewis pictures her as beyond redemption. She was a social climber and it turned out that all her protestations of admiration for the arts and for culture were just sham. Her life proved empty as a shell.

This drying up of interest can happen to others besides businessmen. Darwin reports that after his intensive biological studies, which went on for many years, he lost the power of enjoying a novel. Intensive specialization can apparently drain off the enjoyment from even some of our basic strata of interest.

What happens in these instances is in general clear enough, though the precise psychological mechanisms which dry up whole areas of a man's usual interests may be rather intricate. The means-to-end mutation operates on the details of a man's specialty and brings them into his aesthetic field and probably fixates them there. They become the centers of all his enjoyments. Circumstances, or his own deliberate ordering of his life, lead him to indulge in practically no other enjoyments. Even these may become dulled by routine. No other means-to-end mutations are formed, and those formerly acquired become from lack of reinforcement extinct. Even his other instinctive likings get diverted and transferred as completely as possible from their natural objects to the details of his specialty. He gets wrapped up in his specialty, and becomes literally and completely a specialist.

Society at times has a need for such abandoned specialists. But, on the whole, they are great moral risks, for their sense of values is necessarily entirely distorted from the normal full growth of a man. Such specialists can have no sympathetic awareness of the interests of other men and women outside their specialty, or judgment about the adjustment and integration of such interests in social policies and ideals. But whatever the social hazard, the aesthetic loss is obviously enormous. Not only is the delight and the insight derivable from the fine arts shut off, but most of the common beauties of nature.

There is no reason, of course, why a man may not be at once a specialist and a man with breadth of taste and judgment. There are many examples of such men in fiction and history and probably within the sphere of anyone's acquaintance. There is a proper balance between concentration in a life purpose and a spread of interest as a setting for that purpose.

We have been criticizing the overspecialized man. While we are making these ethical comments, we may also call attention to the underspecialized man, the man who has no purpose in life. He may be a man of very wide and refined

taste. But not to have a purpose in life, not to have some function in society, is as abnormal as to become utterly absorbed in a single narrow specialty. Such a functionless man is likely to be shallow for all his width of appreciation and connoisseurship. He is the sort of man who is sometimes disparagingly called " a mere amateur."

In sum, though the means-to-end mutation tends to enlarge the field of things we like for themselves, it sometimes acts in the opposite way. Some degree of control over its action is therefore worth keeping in mind in the building of one's life. A wide spread of enjoyable interests among which is some central group of purposeful interests in a business occupation, research, creative achievement, or the bringing up of a family produces that balance of emotional breadth and purposiveness which for most conditions gives the most of both ethical and aesthetic value.

The ways in which this means-to-end mutation affects the fine arts will be seen in detail in the chapters on type and emotion.

THE MECHANIZED HABIT MUTATION. There is another mutation of values besides the means-to-end bearing on the aesthetic field and produced by conditioning. It is often called habit but is better called mechanized habit. Things or acts which regularly come together or follow one another in sequence with little variability tend to drop into unconsciousness. When we are first learning to run an automobile, every act of gear shifting, accelerating, braking, steering is vividly before our consciousness. Little by little as we acquire the habit, the acts get to work of themselves and we cease to be aware that we are performing them. We drive and talk to someone beside us, and only once in a while when a red light flashes, or a car unexpectedly appears from a side street, do we notice our handling of the wheel or the gears. The habit has become mechanized. The mutation can be diagrammatically represented like this:

PLEASURE	NEUTRALITY	PAIN
+	0	−

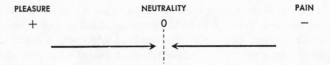

From the line of neutrality in the middle, let distances to the left represent degrees of pleasure or liking and distances to the right degrees of pain or disliking. The arrows represent the effect of mechanization in carrying things previously liked or disliked towards neutrality, or, as in this instance, unconscious response. The mechanized response is often, though not always, completely unconscious. When it is unconscious, there is, of course, no feeling of liking or disliking. Consequently, this mutation is antagonistic to aesthetic values. Through this mutation things liked or disliked for themselves cease to be

so, or are much reduced in their value intensity. This is a long-term mutation. That is, it takes hours, weeks, or months to establish it, and once established it lasts a long time.

Our various senses are differently affected by this mutation. It is most obvious in the muscle-joint sensations (the kinesthetic sensations as they are called), which give us the awareness of actions like automobile driving, bicycle riding, typing, swimming, walking, etc. But all other sensations are susceptible to it. We rarely notice how much we take familiar faces for granted. At a glance we recognize a friend or a member of the family almost without noticing distinctive features of his face.

Can you remember accurately which of your cousins wears glasses or has a mustache? We also pay little attention to familiar objects in our daily lives. We enter a room while talking to someone, and take a chair without seeing it.

We are all familiar with such mechanized actions. They are essential to the practical operations of living. When we want to do any routine act we set a mechanized habit going and our minds are free for other things. All techniques depend on mechanization. Violin and piano playing, musical and literary composition, painting, etc., all would be impossible if a man had to be conscious of every detail of action. A reader could never enjoy a poem, if he had to be conscious of the spelling of every word and all its grammatical connections. As with driving an automobile, he only notices these when something goes wrong. His attention is released thereby for the images and meanings of the phrases. But, of course, if he is unconscious of spelling and grammar he gets no pleasure out of it either. In these instances, he is not supposed to, and art is helped by the fact.

But often mechanized habit begins to work on objects which were intended to please, and then it becomes a thing to be guarded against. We are constantly in danger of allowing our environment to get mechanized about us. This is very likely to happen in one's living room. The way to avoid it is to provide for a change of objects in the room to break up our visual habits. The Japanese understand the principle. In their living rooms is an alcove with a *kakemono* (a long picture with a roller at the bottom) hanging behind a stand on which is a flower decoration. The *kakemono* and the flower decoration are changed every few days. Since these are the central feature of the room, one's perceptions are kept always expectant and vivid. Moreover, it allows one to have and enjoy many more pictures and other changeable objects than are on view at any one time. We Occidentals tend to arrange our rooms in an attractive way, and never touch them again unless something cataclysmic happens. Our rooms thus gradually become mechanized habits with all that is in them. We may do well to consider whether we might not do better with fewer things visible and these more advantageously disposed and more frequently changed.

Mechanized habit also plays tricks on people from the opposite, or the disagreeable side. We get so that we do not see things we dislike. This might seem a blessing, and no doubt it often is when some disagreeable things in our environment are unavoidable. But we forget that every fresh eye or ear that comes into our environment will perceive these things even if we do not.

I know a man who had gradually gathered a pile of rubbish in his front yard. He intended to take it away, but procrastinated until he finally forgot about it. It stayed there all spring. Returning from a several weeks' trip in the summer, he walked up to his door, and the ugliness of the rubbish heap was immediately apparent. Of course, every visitor who had walked up to his door that spring had had the same vivid perception.

We can take this example to heart and apply it to much bigger things. What about the telegraph poles, spans of wires, and billboards that screen our city views? What about the depressed housing areas? In commuting back and forth we get used to these things. But every visitor with a fresh eye is irritated by them.

Moreover, we ourselves do not get completely used to most of them. They do not quite sink out of all consciousness. Our perceptions have merely become very much dulled to them. They take a slow grinding toll on our nerves. And vice versa, a beautiful city, even if we do get rather used to it (though it may be composed with such constant variety of vista and planting and architecture that we never cease to enjoy it vividly) still caresses our nerves and soothes us with its scarcely perceived delights.

The mutation of mechanized habit is, therefore, something which in aesthetic matters needs to be carefully watched. It is practically helpful in all manner of techniques when we want complicated serviceable actions to carry themselves on and leave our attention free for richer values. But it is practically and aesthetically harmful when it begins to attack the richer values themselves. The more vivid we can keep our perceptions, the more alive we are to the world about us and to ourselves. Our own capacities of enjoyment are increased, as are our abilities to see what can be done with our environment to make it a constant source of delight and contentment.

SOME VALUES IN FORGETTING. Conditioning is a process of learning. It is pertinent in this connection to point out that there are some aesthetic values in forgetting. In speaking just now of the aesthetic dangers of mechanization, we were practically saying not to let learning go too far in areas of experience where we do not want it to go. A mechanized habit is a particular kind of complete learning. It is a good thing where we want a skill. But it is not a good thing where we want vivid awareness. If by chance our perceptions of the things about us which we wish to enjoy begin to get mechanized, then we want to break up these habits. One way to break up a habit is to give it a shock. Let something unusual cross its path. If we have got too used to a room, or to a certain arrange-

ment of flowers in a garden, change things around, and the room and garden will become alive again.

Another way is to put the habit out of use for a while. This is what happened to the man who went off for a few weeks and returned to be aware of his trash heap. He forgot somewhat the features of his front yard from not seeing it for some time, so that when he returned he saw it freshly. Forgetting is thus the reverse mutation of the habit mutation. It would be diagrammed thus:

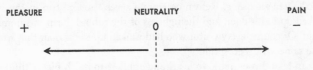

Its aesthetic value is obvious from the diagram. It brings things from neutrality back to liking and, of course, also to disliking. The disliking, to be sure, is negative, but notice that there is no chance for any aesthetic values if they are all at neutrality. But if things get out of neutrality to be liked or disliked, then we can take measures to seek the things liked and avoid the things disliked. But if things are all mechanized at neutrality, there are no aesthetic values at all. So, forgetting is often aesthetically a very good thing.

It is forgetting that makes it possible to hear a piece of music over and over again with fresh enjoyment each time if we take only a little care not to hear it too often in close repetition. Similarly with rereading a novel or a poem.

The virtues of forgetting can operate even within the details of a poem or a piece of music. Imagine someone who learned so quickly and had so retentive a memory that he never forgot in reading a poem just how often a rhyme was used, or a word repeated, or a certain rhythmical combination employed. These repetitions would then come to his attention exactly as if they were repeated side by side. They would be as tiresome as a metronome. Poets and composers count on our forgetting lots of things, so that details can be used frequently in a composition without loss of freshness. An artist in the temporal arts must be a subtle psychologist, who creates some habits in his listener, but not too deep for mechanization, and carefully avoids creating other habits, counting on time and forgetting to maintain a continuance of freshness in the stream of delight.

SYMBOLIC MEANING AND TYPE. Besides the means-to-end and the mechanized habit mutations, the process of conditioning produces two other effects of great importance in aesthetics. One is *symbolic meaning* and the other is what, following Santayana, we shall call *type* (which, as earlier stated, is one of the principal modes of aesthetic organization).

In the broadest sense, meaning is any reference of one thing to another thing through human or animal response. The bell meant food to Pavlov's dog, and as long as that association stood in the animal's mind, that meaning was there. The

smell of cooking means dinner to anyone who associates the two. And so on. In the broadest sense whenever an organism learns to associate a couple of things, there is meaning, and each term means the other.

Symbolic meaning, however, is a special form of meaning in which one term in the meaning reference is taken by convention to stand for the other. A symbol is, in short, a conventional sign. Thus a flag means a nation by convention. We say the flag stands for the nation, is the symbol of it. This sort of reference is very different from that of cat to dog. In the minds of most people, dog and cat are associated, and for them the one means the other. But neither would be considered a symbol for the other. Just what constitutes symbolic meaning is a complex question and need not concern us seriously in this volume since it does not affect the visual arts in any great degree. But it is very important for literature. For words are the outstanding manifestation of symbolic meaning, and literature is the art of words.

Type is another form of meaning. It is the form in which a number of terms are associated into a *system* of meanings. Our ordinary idea of a cat, for instance, would be a type. It is an association of a certain set of traits in certain relationships, so that these traits make up a meaningful system. Most of us would expect a cat to be a four-legged animal with round eyes, round head, pointed ears, whiskers, padded feet, claws, etc. This system of traits would constitute our idea of a cat, and that would be a good example of a type.

A type differs from symbolic meaning in that no term in the system can be said to stand for, or conventionally symbolize, the others, but it is far from an instance of simple association like cat referring to dog. A type is an associated system of terms.

There are many varieties of types, and these are so important in all the arts that they will require a chapter of their own.

The law of conditioning, then, yields four important principles bearing on aesthetics: (1) the means-to-end mutation, (2) the mechanized habit mutation, (3) symbolic meaning, and (4) type. The effects of the first two principles have been shown in this chapter. Type will be discussed in a separate chapter later, when we have finished examining the various value mutations affecting art. Symbolic meaning requires no further amplification, since, as we have seen, it is a special concern in the study of literature.

Habituation

EVIDENCES FOR ANOTHER KIND OF LONG-TERM MUTATION. A second sort of long-term mutation which has far-reaching consequences in the appreciation of art is what we shall call *habituation*. In writings on the arts it is often confused with simple aesthetic fatigue, to be taken up in the last section of this chapter. It is,

however, quite a distinct phenomenon in itself, as we shall see, and the term should not be confused with the mechanized habit mutation, or with the means-to-end mutation already discussed.

Habituation is our name for the process whereby sensations originally disliked come to be much liked, apparently as a result only of experience with them. The range of our likings can thus be expanded over a period of time. There are evidences of it among all of our sensory qualities and simple combinations of sensory qualities. Our concern with the mutation in this volume bears particularly on its effects upon colors and color combinations, linear proportions, shapes, patterns, and other aesthetic materials entering into the visual arts. But in order to emphasize the peculiarities of habituation changes it will pay us to notice their effects on certain other materials not involved in the visual arts. An accumulation of a wide range of examples makes it easier to see the effects of the mutation on the materials of our narrower field of study.

Let us begin with common everyday examples of the sense of taste. Consider the old adage about olives: If you do not like them, just eat a dozen and you will. This old adage is being constantly verified. It sounds superficially like habit, and people speak of " getting used to olives," but actually the effects are totally different. For the result is not that you tolerate olives when before you disliked them, but that as a result of the repeated stimulation you come to like olives very much indeed. It is a mutation from intense dislike to intense liking.

But another example from the gustatory field will show that the mechanism of the mutation involves still greater complexities. There are many people who have to " learn " to like cheeses. Enquiry shows a remarkable uniformity in the sequence of cheeses liked, running usually from " mild " to " strong." At the beginning, a person can generally be persuaded to try some mild cream cheese. From that he may be led to a mild American cheese, thence to something like Edam. Most of the medium cheeses will now open up to his enjoyment. Presently, however, he will discover a special delight even in Camembert, the mushier the better. And then in a while will come the turn of a still stronger cheese, Roquefort, after which there will probably be no variety of cheeses that he cannot enjoy.

Such a series of potential likings I am going to call an " affective sequence." And I am going to suggest that most of our sense qualities and simple combinations of qualities are bound together in such sequences. At one end of such a sequence are elements potentially easy to appreciate, at the other end elements potentially hard to appreciate, and habituation migrates normally from the easy to the hard end as a result simply of adequate stimulation or exposure to the elements of the sequence.

Moreover, I suggest that the change of taste is set in motion by *any* of the elements of the sequence provided they are not too disagreeable to be endured.

In other words, experience with any element of a sequence changes in some degree the potential liking of every other element. When a person acquires a new appreciation of Edam cheese, it affects his potential appreciation of every other variety of cheese. Camembert is then not so potentially disagreeable as it was before, American cheese is possibly just a little tame, and cream cheese definitely tamer.

Another peculiarity of the habituation mutation is that the new element just brought over from dislike to liking rapidly becomes the most liked of all elements in the affective sequence. It leaps up to the place of maximum pleasure. The elements behind it trail along below the line of neutrality in successive degrees of potential dislike. The elements previously liked now trail along in successive degrees of tameness (that is, of mild liking) on the positive side of the line of neutrality. To illustrate, the likings went this way:

	STRONG LIKING	NEUTRALITY	STRONG DISLIKE
	+	0	−
before:	(cream cheese)	(Amer.) (Edam) (Camembert) (Roquefort)	
later:	(Edam) (Amer.) (cream cheese)	(Camembert) (Roquefort)	

The freshly liked element has leaped ahead of all the others. Presently, of course, as a result of more experience with this affective sequence, the next element of potential liking will supplant the last one as the most liked, and push the former one back as now a little tame. The formerly tame elements become yet a little tamer. These changes, needless to say, cover days, weeks, and even years.

Now let me call attention to a mutation of this kind that has caught the attention of scholars in one of the major arts — I refer to the changes in the appreciation of musical intervals. A musical interval is the distance between two pitches. In our scale of seven tones, an interval is named by the number of intervening tones in the scale. Thus a second means the interval between the first and second tones in the scale, or any similar interval. A third means the interval between the first and third tones, or any similar interval. And so on.

Historically these intervals have not always been liked. Those liked used to be called consonant intervals, those disliked dissonant. But the appreciation of these intervals has gone through successive changes, as can be shown from the manner in which musicians treated them as consonant or dissonant. The Greeks apparently regarded only the octave as consonant. In the fourth century A.D. fourths and fifths were accepted and used profusely. Much later thirds and sixths were accepted. Only lately have sevenths and seconds been accepted. Today a cultivated ear is supposed to find enjoyment in any interval whatever. If seconds and sevenths still bother anybody, much modern music will sound

noisy and disagreeable to him. But if he wants to, he can " learn " to enjoy modern music by listening to it from time to time. If he is open to it (not blocked by some inhibiting attitude) habituation will gradually do its work, and one day he will find himself getting a tang of enjoyment out of it.

In fact, a psychologist, H. T. Moore, some years ago when the average ear was still resistant to sevenths, induced changes of appreciation for these intervals under controlled conditions by means of repeated stimulation.

The changes described in these two illustrations of the liking for cheeses and for musical intervals are such as occur in what I shall call the *continuous phase* of habituation. This consists in a continuous bringing over of potentially disliked elements in an affective sequence to potential liking. When all the disliked elements have been brought over to a condition of liking, then we have attained what I shall call complete habituation. This is clearly an advantageous condition for the individual, since the range of his likings is increased and of his dislikings decreased. His environment spreads out as a more expansive field of potential enjoyment.

But sometimes the continuous phase of habituation does not immediately lead to a general liking of the elements successively brought over from disliking. When the potentially most difficult elements are at last appreciated, it sometimes happens that the potentially easiest elements to appreciate have become so tame that they seem dull or even unbearable — that is, the other end of the affective sequence now gets disliked.

When this occurs, a reverse process can often be observed. The likings begin to swing towards the opposite pole, and then begins what may be called the *cyclic phase* of habituation. A familiar instance of this cyclic process can be seen in dress styles in the movement from wide skirts and frills and ribbons to close skirts and simplicity. But the history of the arts is full of these cycles. For some writers they acquire an almost cosmic significance. I would suggest that most of them are simply manifestations of the cyclic phase of habituation. Such would seem to be most of the so-called " classic " to " romantic " cycles. Such quite clearly are the cycles of " simple " to " ornate " and back again in architecture. Just now we are passing through a movement of functional simplicity which is in reaction to Victorian ornateness, and perhaps already our taste is showing signs of interest in a counterreaction. The cycles, I believe, operate particularly where the materials involved as elements of the affective sequence are intricate or very numerous, so that it is difficult for the organism to make a comprehensive adjustment to the whole sequence at once.

For the simpler elements, however, such as for single colors and color combinations, for lines and linear proportions, for visual rhythms and patterns of various sorts, complete habituation without cycles is attainable and often attained by men of cultivated taste.

We shall call attention to the presence of affective sequences wherever we encounter them in the chapters to come. Here I shall merely expand on the subject of color combinations. Some experimental work has been done on this subject, enough to support the probability that there are no intrinsically "best" color combinations, nor any intrinsically "bad" color combinations. Within certain contexts of pattern and design and emotional effect, certain color combinations are appropriate and others inappropriate and ugly. But there is no color combination that would be ugly in every context for every spectator.

Evidence indicated that the less experience with colors a person had, the greater the number of color combinations he disliked. Persons of much experience with colors would have very few combinations they disliked or none. If a combination was disliked irrespective of context by experienced persons, the reason could often be traced to unhappy emotional situations in which these colors had a part. Such colors were, in short, not open to habituation because they were too heavily conditioned with emotional significance. Incidentally, the more experienced with colors people are, the less they apparently tend to associate colors with situations. Experienced people have noticed colors under so many circumstances that all associations have neutralized one another.

The most difficult color combinations to appreciate are those consisting of rather close intervals of warm colors, such as orange and lilac. But these are the very ones most stimulating and delightful to many habituated tastes. The Persians, who are renowned for their color appreciation, particularly delighted in these difficult combinations. Matisse favored them. One reason for selecting the *Odalisque* (PLATE XX) is to show how beautiful such colors can be. This picture revels in difficult color combinations. It is a fine contrast to the Fra Angelico Madonna (PLATE I) which uses mainly the very easily appreciated combinations of yellow and blue with a little red and black. For some spectators, fresh enthusiasts of Matisse's spicy colors, Fra Angelico's simple complementaries may seem utterly dull. If so, that is unfortunate. For Fra Angelico is also admired as a great colorist. Both extremes are open to appreciation, and the human organism is big enough to adjust to both extremes at once in a fully habituated taste for colors. There is no reason why we should not enjoy the acid tang of the Matisse and also the simple dignity of the Fra Angelico. To be restricted in one's appreciation to either one or the other is a loss of much enjoyment. Herein lies the advantage of attaining the breadth of complete habituation.

A DESCRIPTION OF THE HABITUATION PROCESS. By way of summarizing the materials of this section, I shall now briefly sketch an hypothesis of the nature of the habituation mutation. The mutation appears to imply that our potential likings are not sporadic and disconnected preferences, but are normally bound together in sequences, which we have called affective sequences. These sequences have as their elements simple sense qualities of a sensory scheme such as tastes,

smells, colors, or combinations of these such as color combinations, linear proportions, rhythms, and musical intervals. In general, the elements at the end of the sequence easiest to appreciate are the simpler ones such as regular metrical rhythms, symmetrical balance, octaves and fifths in music; those at the difficult end are the more complex ones like free rhythms, asymmetry, and the sevenths and seconds among musical intervals.

Previous to experience with the elements of these sequences, only a few elements, the simpler ones, seem to be available for enjoyment. Most of the elements are likely to be potentially disliked. There is some evidence that this is not the condition in a very young child. Very young children seem to be extremely open in their range of enjoyments. If advantage is taken of this condition, what amounts to complete habituation may be attained and held from infancy. Children who have tasted adult cheeses and wines, heard " modern " music all about them, seen " modern " paintings in their homes, often never have to be habituated to these delights. But when this early habituation has not taken place, most of the elements of affective sequences have to be acquired by the slow process of habituation over many years, and in some areas complete habituation is in many adults never attained. In an adult who has not been habituated in infancy, the usual state of his potential likings in an affective sequence is for just a few elements at the easy end. Most of the elements are potentially disliked. He enjoys only a few color combinations, wants things symmetrically arranged, wants to feel a strong metrical repetition in rhythmical patterns.

From such a state of an affective sequence habituation first operates through a continuous phase. The peculiarity of the changes of appreciation in this stage is that when a new element is brought over from dislike to liking it migrates very rapidly to a state of intense liking above all other elements in the affective sequence. The newly acquired enjoyment in an affective sequence is the most appreciated enjoyment. The stimulus for this change of taste is simply exposure to the elements of the sequence — simply experience with those aesthetic materials. Experience with any element in the sequence seems to promote the habituation changes for all the other elements. Excessive stimulation of the duller elements makes them still duller and prepares for a welcoming of the tang of the slightly disliked elements. Exposure to the disliked elements, if it can be endured, tends to make them more endurable with corresponding changes throughout the whole affective sequence. But the most promising element to work upon, if rapid habituation is desired, is the element just below the line of neutrality in an affective sequence, the element just a little disliked.

When all the elements in an affective sequence have been brought over from dislike to liking, then the *continuous* phase of habituation is finished. If, as sometimes happens, the elements are all well liked, complete habituation has been attained. But sometimes, especially in sequences of complex elements, it

will be found at the termination of the continuous phase that the elements on the easy end of the sequence are now regarded as so dull and simple as to be actually disliked. If this happens, there follows, as a result of still further exposure to the materials, a gradual reversal of likings back to those on the easy end again. This constitutes the *cyclic* phase of habituation, which works as a simple pendulum swing from extreme to extreme. Here it is noticeable that elements between the extremes (those means which are neither very simple nor very complex) come up to a stage of maximum liking twice to every once that the extremes come up to that stage. This is why critics sometimes extoll means above extremes. An artist whose works develop materials that are neither extremely simple nor extremely difficult, elaborate, or free, will in the periodic cyclic swings come up twice for intense appreciation (supposing he has the merit to survive his generation) where an extremist will come up but once. When an extremist is wanted, however, in an habituation cycle, he is wanted very much, and moderate artists then seem tame.

It appears to me probable, too, on some of the evidence, that if these cycles operate within the lifetime of a single perceptive individual, the length of the pendulum swings diminishes with each swing towards a state of complete habituation in which the spectator can enjoy both extremes and the means about equally, depending on his moods and attitudes of the day. Complete habituation seems rather obviously a desirable state of appreciation for a critic or a spectator who wishes to get the most out of art and life. It is not, of course, a state of neutral intellectual tolerance that accepts most anything and gets excited over nothing. Quite the contrary, it is a state of readiness to find as many available delights as the human organism is capable of receiving. To shut oneself off from any of these delights — not to be able to enjoy Fra Angelico, for instance, because one enjoys Matisse, or vice versa — seems stupid.

Such, I suggest, is the habituation mutation. It is a field that needs much more study. Just now the important thing is to become aware of it, so as to make intelligent use of it in the development of our own appreciation of enjoyable experiences, and also so as not to confuse it with the mutations we have previously described.

HABITUATION COMPARED WITH OTHER MUTATIONS. The foregoing description of the habituation mutation makes it easy to see that it does not appear to follow the form of any of the mutations we have studied before. It is not habit, though these are both long-term mutations, for habit reduces everything to neutrality and unconsciousness, whereas habituation raises disliked objects to a state of intense liking.

Also, habituation is not the means-to-end mutation (at least, not obviously) for the change does not seem to depend upon an end for which the object that comes to be liked is a means. Moreover, the connections among elements in

an affective sequence are distinctive features not involved in the means-to-end mutation. In fact, the means-to-end mutation often appears to interrupt an affective sequence and to pull an object out of the sequence, so that an opposition between habituation and a means-to-end mutation can sometimes be clearly observed. In an experiment with color combinations, for instance, there was a certain combination that one subject associated with his college fraternity, where the associative value so overshadowed the habituative value of the combination that he did not know how much he liked the combination apart from its association. For another person, there was a certain light blue which was the color of the paper of a letter he once received containing upsetting news, so that in any combination where this color occurred, he was unable to say how much he liked the combination because this color had such a strong emotional association. It looks, therefore, as if the means-to-end mutation acted independently of the habituation mutation, and had often a disturbing influence upon it. Moreover, unless the associations had very deep emotional significance, they seemed to cancel out and neutralize one another in the end for the experienced subjects, so that the process of habituation ultimately gained primary control over most of the sensuous material.

It seems, then, as if conditioning is not the mechanism that explains the action of habituation. For orthodox psychology, however, in which all long-term changes are accounted for in terms of conditioning, this is so radical a conclusion that an attempt perhaps should be made to construct an hypothesis in terms of conditioning to account for the habituation changes.

Here is one suggested hypothesis. First, primitive connections among dispositions in an "affective sequence" are questioned. Then the change of liking in the continuous phase which moves an object from unpleasantness to pleasantness is accounted for on the supposition that there is a pleasant setting in which unpleasant objects are experienced. For unpleasant olives to become liked, the hypothesis says, they must be tasted at picnics and dinners where surroundings are pleasant, so the pleasant associations become attached to the taste and the former unpleasant feelings for the taste disappear. The appearance of a sequence of dispositions to like or dislike a certain cheese is, says the hypothesis, somewhat illusory. For obviously it will require a greater number of pleasant associations and feelings if the disliked object is extremely unpleasant than if it is only mildly so. Consequently, the hypothesis holds, it takes longer to develop a means-to-end mutation for Roquefort than for Edam cheese. That alone is what gives the cheeses the appearance of a sequence.

The decline in liking for cream cheese and, in general, for the earlier liked objects of our affective sequence is accounted for by habit.

It is just possible that in some such way conditioning will explain the habituation mutation. For the present, however, the evidence for primitive connections

among the dispositions of an affective sequence seems too strong to permit one to be satisfied with the foregoing type of explanation. Conditioning will not at present explain how one's great repugnance for Roquefort and other strong cheeses is reduced by eating Edam and Camembert and hardly ever touching Roquefort. It looks as if one were prepared for enjoying Roquefort by experiencing something quite different. Nor does habit seem an adequate explanation for the decline in one's liking for Edam at the very moment that Camembert acquired the ascendancy before held by Edam. There is an orderliness in the succession of habituation changes which conditioning seems ill prepared to account for.

It appears to me wiser to consider habituation as a distinct kind of change of taste — leaving it to future study and experiment to determine what are the precise mechanisms that produce it.

CERTAIN APPLICATIONS OF HABITUATION. The bearing of habituation upon a large number of aesthetic questions is fairly obvious. But I do wish to bring out two important applications. One is the explanation it gives of why artists are so seldom appreciated in their day. The other is the application of habituation to the development of one's taste.

The law of habituation makes it clear why the artist is so often ahead of the taste of his public. As a man who lives in his art, the artist inevitably has much more experience with the materials of his art than his public has. Accordingly, the changes of habituation take place in him much faster than in his public. He begins to find stale the things his public still greatly delights in, and he gets intense delight from objects his public finds irritating and disagreeable. As a sincere artist following his aesthetic conscience he cannot, however, do other than create according to his taste. If he did otherwise he would be a caterer rather than an artist and his works would never go very deep, since he would not be following his emotions but would be checking up all the time on what other people liked. Yet in following his own feelings he is soon likely to outstrip his public so far that they can no longer understand him.

This situation is inevitable whenever a sharp change is due in art. A gap then cannot be avoided. It can, however, be mitigated by an understanding on the part of both the artist and the public of what is taking place. If artists were more informed about the habituation process they might possibly have a little more patience with their public and anticipate the lag. And if the public were more informed they might have more respect for what they cannot understand in contemporary artists, and might seek more actively to increase their experience so as to catch up with the advanced taste of their day. For actually any public has more in common with its own artists than with those of other generations, provided only they can understand them.

This leads to the bearing of habituation on the aesthetic education of the

public. Most people think of education as a matter of conditioning, as a matter of setting up associations among things so that on being asked a question one can give the right answer, or on getting into an automobile one knows what to do with the gearshift. There is a good deal of aesthetic education of this order. If we have learned something about an artist's technique, or the forms of a composition, we can get a special delight from observing their perfection. This kind of delight we shall call the enjoyment of " types " (Chap. 5). Types have to be learned like spelling or arithmetic.

But habituation involves a totally different sort of learning. It is not a learning to relate things, but a learning to like things. By sheer will power you could sit down to learn about the life of, say, Matisse so as to pass an examination upon it a week hence — whether you like his life or not. But not in that way can you develop an understanding and a liking for his pictures.

If you have a strong dislike for one of Matisse's pictures, how do you go about learning to like it? It is apparently something well worth liking, for those who do like it say it is quite as exciting as a Fra Angelico. One way to do is to hang a Matisse on your wall and let it work upon you day by day. There are some harsh color combinations to get habituated to, some shapes that do not easily please, and a rather complex set of relations in his composition. If you do not dislike a Matisse too intensely, you might put one up where you can look at it often, and in time it will probably do its work upon you and you will find some day that you really like it and would miss it if it were taken away.

But if you dislike it very much, so that you cannot endure the sight of it, you can do something else. You might look back over Matisse's predecessors, to Gauguin, to Lautrec, to Degas, to Daumier. Which ones of these do you like? Daumier, perhaps. You declare that of course you admire him. He is so human, so easy to understand, and draws with such knowledge of character and with such a sure and vigorous line. And Degas — you perhaps have a real affection for Degas. He is so observant of life and has such luscious colors, and is besides such an excellent draughtsman. Sometimes his compositions seem to slide from corner to corner of his pictures. You may prefer those of his pictures that do not do that, but you do like Degas, and you are always happy to see his work. But Lautrec — that man is vulgar. He always does something bizarre and shocking, even in the way he places his figures on paper. Of course, he is entirely understandable. You know whenever he draws a human arm or face that it is a human arm and face. He does not make those awful distortions which the moderns make — at least, not very much. And when he does, you can see just why he does it, to make the figure more grotesque. But why does he have to paint such subjects and in such a crude way?

Well, now we see where you are in this sequence of painters. Clearly you enjoy Daumier and Degas. You would not, perhaps, want to say which was the

greater artist, but evidently you find Degas the more exciting of the two just at present. But there you stop. Lautrec is below the line of neutrality and annoys you. Very well, then, if you are eager to find what attracts people to Matisse, see a lot of Lautrec's paintings, see a lot of Degas' too. Pretty soon, for all of Degas' charm and faithfulness to fact, you may begin to find him a little too soft and too literal. Lautrec's bite and irony and readiness to exaggerate a feature to make it tell may now fill you with excitement. Yes, of course Lautrec is vulgar, but now you relish it. He is so rakishly vulgar!

By now, too, you will find you are ready for deliberate distortions, not only for caricature's sake but for design's sake. You are ready for the lines and shapes of a human figure to enter into the shapes of a landscape or of a balcony railing or the back of a chair. And you are perhaps ready for colors bold enough to forget that they are the colors of anything. You may even be ready to relish crude and vulgar combinations. From seeing and enjoying Degas and Lautrec you will discover yourself at length delighted with Gauguin and Matisse.

The moral of this is that the cultivation of taste for areas of delight that are still beyond you is most quickly and pleasantly done by getting lots of enjoyment out of the areas you like most, and by sympathetically exposing yourself to the objects just beyond your line of liking. The most rapid progress toward complete habituation comes from having lots of experience with the things you like, interspersing them with exposure to things which you almost like. The almost-liked things will then soon become much liked, and so you move on toward complete habituation.

Why should you desire complete habituation? So that in your living you will have so many more things to enjoy, so much less to annoy you. Moreover, whatever depths there are in art — and great art reaches far down into human emotions — generally have to be reached through things difficult to appreciate. If you are bothered by the dissonances, the colors, the shapes and patterns, or other sensuous complexities of a work of art, so that you cannot joyfully follow the leadings of the work, you may be missing a great artist's intimate message to you, and certainly you are missing a vivid experience in life that is open to you.

But does not habituation make all things equally good, so that nothing any longer is bad in art? If habituation could perform that miracle, how wonderful it would be! But no one need have fears of that possibility, for there is plenty of pain and ugliness in the world that is beyond the effects of habituation. Besides the unchangeable pains of injury and disease, there are the dulling effects of habit and monotony which need always to be combatted, and the irritations of confusion, the inappropriateness of details to the whole, weaknesses of technique, insincerity, shallowness, and, in general, failure to make the most out of one's aesthetic materials. Out of these things and much else grows ugliness.

Habituation reduces the extent of our pains, and increases the range of our

sources of happiness. It does not, however, make ugly works of art beautiful. When a work of art is truly judged to be beautiful, we assume that it is the judgment of a competent critic. But no person would be a competent critic of a work who had not reached the state of habituation required to appreciate it. If a person does not like a Matisse which many competent critics have judged beautiful, his judgment does not affect the aesthetic value of the Matisse. His judgment merely indicates how far he, himself has progressed on the road to final habituation.

The Fatigue Mutations

Conditioning and habituation produce, as we have seen, long-term mutations — changes of liking that take days and years to produce, and once produced last as dispositions within us for months and perhaps for a lifetime. We now come to a group of short-term mutations, so short that they are often made and unmade several times within the duration of a single work of art. We shall call them the "fatigue mutations."

Habituation has often been carelessly confused with fatigue. But since one is a long-term and the other a short-term mutation, they obviously have nothing to do with each other. When people speak of "getting tired" of the old styles of architecture, or furniture, or music, or painting, they should not think that what has happened is like what happens when the ticking of a clock becomes monotonous and drops out of attention. The dulling of our delight in such things as styles of architecture is a long-term affair, and so is the cycle which returns them to pleasure again. Habituation has nothing to do with aesthetic fatigue. Fatigue operates entirely above habituation and has no effect at all upon our underlying preferences. I can through sensory fatigue become temporarily satiated with Camembert cheese, but that will still be the cheese I have the disposition to like best, provided such is my existing stage of habituation.

Two quite different physiological processes produce most short-term changes, but the form of the mutation and its aesthetic effect is almost exactly the same for the two processes. So, we shall call them both by the same name of "aesthetic fatigue."

One of these processes affects the sense organs and is referred to by psychologists as "sensory adaptation," the other affects our attention and goes on in the brain. We shall call the first process *sensory fatigue* and the second *attentive fatigue*.

SENSORY FATIGUE. With most of our senses, the first stimulations are the most vivid — the first taste of a pear or of maple syrup, the first odor of the sea, or of a flower, the first touch of a texture or pressure on the skin. After a period of continuous or closely repeated stimulation, the senses do not respond as strongly

as they did at first, and the result is sensory fatigue. Put on a pair of blue glasses. At first everything is very blue, but in a few minutes this color change is less noticeable. The world is still blue but not nearly so intensely blue as at first. The cones of the eye, which are the organs that respond to hues, have lost some of their energy of response through continuous stimulation.

The general form of this mutation, as the example just given indicates, is exactly like that of the habit mutation described on page 23. The same diagram can symbolize it, namely:

PLEASURE NEUTRALITY PAIN
 + 0 —

After a little continuous stimulation a pleasant odor becomes less and less vivid and generally in consequence less and less pleasant. Similarly, an unpleasant odor becomes less and less unpleasant. After working with an unpleasant fertilizer for a few minutes one scarcely smells it. And so it is with the other senses susceptible to sensory fatigue. The color effect of a stage set is strongest when the lights first come on.

The similarity of form between the fatigue mutation and mechanized habit frequently leads to the mistaken idea that they are the same thing. But their aesthetic effects are completely different. For the fatigue mutation requires only a few moments to develop and, equally, only a short time for recovery with a complete readiness for fresh stimulation. It is, as we said, a short-term mutation, and therefore can be utilized over and over again in a single work of art. But mechanized habit is a long-term mutation and once developed sticks and takes a very long time to undo. For instance, a musical theme can be repeated a few times till you begin to tire of it, and then after an interval be repeated again and heard with relish in the same piece of music. But when a popular tune has been heard so much that it is "stale," and has become a mechanized auditory habit, it takes a very long time for it to become fresh again.

The reverse of the fatigue mutation, or the return to full capacity of vivid sensation in a sense organ, has the same form as that of forgetting in conditioning, namely:

 + 0 —

But, of course, it is not a case of forgetting, which is a long-term affair requiring days, months, or years. The reverse fatigue mutation is simply a case of resting. Give the overstimulated sense organs a rest (that is, absence of stimulation),

and they recover their energy in a few moments, and are ready to give vivid sensations with the corresponding intensity of pleasure or pain that goes with the intensity of the sensation. You soon get dull to the odor of acacia or almond, but leave for a few minutes and return to the trees and the odor is strong again.

There is, however, another way of producing the counterfatigue mutation, which is probably more rapid than mere absence of stimulation. There is no adequate experimental evidence on the matter, but there is plenty of evidence in the practice of artists indicating that the stimulation of the sensation opposite or contrasting to the one fatigued produces a quicker recovery than simple rest. Moreover, the fatiguing of one sensation apparently increases the capacity of vividness for its opposite. This effect is called *sensory contrast*.

Most sensations have physiological opposites. This is notably the case with colors, and can be physiologically demonstrated. If the eye is stimulated for a while with a strong blue area, and then shifted to a white wall, a patch called an " after image " will appear on the wall just the shape of the blue area, but yellow. This is known as *successive contrast*, and shows that yellow is the physiological opposite of blue. Similarly, stimulation of yellow gives an after image of blue. Such colors are known as *complementary colors*. Red and a bluish green are such another pair of colors, and so are black and white. Every color has its complement.

This physiological contrast effect appears even while one is looking at a color. If you look at a strong blue patch on a gray ground and turn your attention to the gray area around the blue, you will find that it is tinged yellow, and, similarly, the area around a strong yellow patch will be tinged blue. This is known as *simultaneous contrast*. It follows that if a yellow patch is placed upon a blue ground the yellow will be increased in intensity (or, to use the more technical term, in " saturation "). This occurs because the color of the yellow patch is rendered more intense by the yellow sensation resulting from the simultaneous contrast of yellow and blue. In the Fra Angelico Madonna (PLATE I), notice the yellow in the lower folds of the Madonna's gown. See how intense it is compared with the same yellow about the face of the Madonna. In the original picture the difference of intensity is so great that at first one doubts if the two sets of folds are painted with the same pigment. Fra Angelico unquestionably intended these differences of contrast. The strong yellow and blue on the gown about the Madonna's feet enrich the texture of the gown framing the divinity of the Mother of God. But so intense a contrast about the Madonna's head would detract from the beauty of her face. Notice also that the blue about her face is lightened almost to white to hold down the contrast. At the same time, of course, this whiteness suggests a light shining on her head from the halo behind, so that the artist is producing several effects at once by the handling of his colors — as great artists always do.

Returning to the effects of simultaneous contrast, we may now notice that the whole blue gown enveloping the Madonna is laid upon a gold ground, which is a species of intense yellow. The consequence is that by simultaneous contrast the whole gown is intensified by the gold, and the gold by the gown. The total picture is thus endowed with an effect of supernatural brilliance, as if a light radiated from the colors themselves. The reproduction, of course, only partially carries over the brilliance of the original picture. The gold in the original is real gold leaf.

This illustration gives some idea of the aesthetic force of sensory contrast. It develops out of sensory fatigue and would not be felt but for the aesthetic fatigue mutation and its countermutation.

Sensory contrast is most vividly experienced with complementary sensations. But other sensations can also give a strong contrast effect provided they are distantly related to each other in the " natural order " (as some writers call it) of sensations. By the " natural order " of sense qualities is meant the array the qualities make when they are spread out in series of imperceptible gradations. Thus blues grade into greens, which grade into yellows, which grade into reds, thence into purples and violets, and finally back to blues again. This circle of hues grading into each other is their natural order, or, as I shall henceforth call it, their *sensory scheme*.

There are sensory schemes for all sensations. We shall develop those for color, line, mass, and volume when we come to these topics later. It is the position of sense qualities in such schemes that determines whether they are closely or distantly related to each other. The further apart two qualities are from each other in a scheme (that is, the larger the number of barely perceptible steps of gradation from one quality to the other) the greater the contrast. There is not much contrast between red and orange, because they so quickly grade into each other. But between red and yellow there develops a moderate contrast, and between red and green a very strong contrast. Complementary sense qualities are always far apart in a sensory scheme. Where they exist, they are properly placed at opposite poles of a scheme, if it is constructed to represent the maximum contrast as it is actually felt and physiologically reported. Consequently a sensory scheme of color hues which follows the natural order of contrasting colors will place the physiological complementaries opposite each other — a bluish-green opposite red, and yellow opposite blue. For these are the hues which the physiological effects of simultaneous and successive contrast indicate are the most vividly contrasting ones. However, as we have said, any hues with a wide gap between them in a sensory scheme will have a strong contrast effect.

One further point in this connection. Aesthetic contrasts hold only for qualities contained within a sensory scheme. Blue and yellow are strong contrasts since they are opposites in the scheme of colors. And rough and smooth are strong

aesthetic contrasts, both being within the scheme of sensations of texture. But smooth does not contrast with blue. These sense qualities are simply different. Aesthetic contrast thus signifies a definite relation of qualities holding within a qualitative scheme such as the sensory scheme of colors. The qualities of one sensory scheme are not in a contrast relation with those of another sensory scheme. A color may contrast with another color, but not with a line, or a shape, or a texture, or a sound, or an odor. The relief of contrast can be obtained only from qualities within the sensory scheme in which lies the sense quality suffering from the fatigue mutation. The stimulus of a new color will relieve the sensory fatigue to a color too long before the eye, but the fresh stimulus of a shape or a texture has no effect upon a color at all.

This is not to say that there are not subtle aesthetic relationships between certain colors and other sense qualities. We speak of delicate lines and delicate colors, strong lines and strong colors. A pattern of delicate lines might conceivably be contrasted with some strong colors. But here it is not the lines and colors that are in contrast but the moods of delicacy and strength which certain lines and colors are able to stimulate. For there is a natural order or scheme for moods. The scheme defines a gradation of moods from strength to delicacy and shows a strong contrast between the extremes. Apparent exceptions, therefore, simply prove further our principle that aesthetic contrasts hold only within qualitative schemes, and that a quality of one scheme cannot be contrasted with a quality of a different scheme.

We have been speaking so far only of sensory fatigue. Not all sensations are susceptible to sensory fatigue. Smell, taste, touch, and color are highly susceptible to it, but there are two types of sensations that are conspicuously free from it, namely, sound and kinesthetic (or muscle-joint) sensation. Consequently these are the sensations particularly useful for studying the effects of attentive fatigue, since whatever changes of liking or disliking appear with these sense qualities must be due to something different from a tiring of the sense organs.

ATTENTIVE FATIGUE. If you enter a room where a clock is ticking loudly, you are at first extremely conscious of the sound. But in a short time you find that you do not notice it any more. Yet if later somebody calls your attention to it, you hear it again as loud as ever. Notice that this sort of thing cannot happen with the blue from blue glasses. If you have been wearing blue glasses a while and have ceased to notice them, and then somebody reminds you of the glasses, you cannot recover, try as you will, the intense sensation of the blueness of things you felt when you first put the glasses on. Yet this is just the sort of thing you can always do with sensations of sound (unless the sound is deafening like a boiler factory or an artillery bombardment where actual injury is being done to the ears).

The gradual unconsciousness of sound that comes from repeated stimulation

like the ticking of a clock is not the result of a dulling of the sense organs, but of a loss of attention. The aesthetic result is about the same as that from sensory fatigue, but more complete. In sensory fatigue complete loss of sensation does not occur though the intensity of it is greatly reduced. But in attentive fatigue the stimulus is ultimately completely blotted out of consciousness. Thus attentive fatigue may work on top of sensory fatigue. In fact we just now had an instance of this fact in the reference to the blue glasses. When a person finds not only that the world is less blue than when he first put on the glasses, but that he has ceased to notice that it is blue at all, then attentive fatigue has worked on top of sensory fatigue.

But even though the mutation is more complete with attentive than with sensory fatigue, the aesthetic effect is more serious in sensory fatigue. For it takes more time for a sense organ to recover than it does to rearouse the attention. This is one reason, I believe, why the major arts, as they are called, favor the sense qualities that are not susceptible to sensory fatigue. There are no arts of taste, smell, and touch that have the degree of development found in music, literature, and the visual arts. It is noticeable that sound is free from sensory fatigue, and likewise the symbols of literature, and likewise all the qualities of the visual arts dependent on line (for line is not color sensation but probably a movement sensation).[1] I venture to say that if the art of painting depended solely on color and lacked linear form, it would never have developed further than the art of perfumery. But fortunately color could fuse with linear shapes and volumes and so greatly enhance the beauty of visual objects.

The general form of the fatigue mutation for attentive fatigue is the same as that for sensory fatigue. Accordingly the earlier diagrams apply equally to both forms of fatigue.

As with sensory fatigue, absence of stimulation automatically restores the capacity of awareness to the attention. It does so very quickly. Sometimes, as when a clock stops, the absence of the ticking is noticed even though the ticking just before was not. And as with sensory fatigue, a contrasting stimulus is the most effective way of restoring the original sensitivity. With attention, however, the effective contrast is not so much that of an opposition of sense qualities like yellow and blue, as that of quantity of stimulation. Contrasts of intensities like loud and soft, dark and light, or of extensities like large and small, long and short, wide and narrow, or of rhythms like quick and slow are the characteristic contrasts for rearousing attention. In short, qualitative contrasts are associated with sensory fatigue and quantitative contrasts with attentive fatigue.

An example of quantitative contrast may be seen in the rhythm developed by the folds of the mat beneath Fra Angelico's Madonna (PLATE 1). Each fold makes a group of *short* lines followed by a *long* line between the folds. This

[1] This will be considered in detail in Chapter 9.

rhythm is then repeated with a variation in the folds of the Madonna's blue gown. There is also a quantitative contrast between the *large* blue area of the Madonna and the *small* blue areas of the two little angels above. And similarly between the *large* red area at the Virgin's breast and the *smaller* red areas scattered about below.

Sometimes it is hard to decide whether to consider a contrast as quantitative or qualitative. Two sensations differ quantitatively if one is discriminated as more or less of the other in any way whatever. There is no question about the quantitative nature of the contrasts pointed out in the previous paragraph. A long line has more line than a short one, a large area more area than a small one. Also there is no question about the qualitative contrasts we pointed out in the previous section. There is no way in which blue can be considered more or less of yellow. These hues simply differ completely in their sensory qualities. Similarly with the contrast of red with blue or yellow. But suppose we think of black and gray, or of black, gray, and white. Black is definitely a darker gray, a *more* intensely dark gray. And white is a *more* intensely light gray. If a difference of intensity is felt in the contrasts of such colors, then the contrast must be considered quantitative, otherwise it should be considered qualitative. An artist can often make it clear which way such sensations should be interpreted, so that a spectator would not even think of taking them but one way. Notice the contrasting red and black squares on the mat under the Madonna. These will unquestionably be accepted as a qualitative contrast just like red and blue. Yet actually black can be regarded as the limit of a series of darker and darker reds. If some of the intermediate gradations of red to black were present in the design, this very combination of black and red might appear quantitatively opposed and contrasting. But Fra Angelico does not give us the least sign of a quantitative relation between red and black, and we accept them unquestioningly as a qualitative contrast.

The distinction between quantitative and qualitative relations among sensations is not particularly important in matters of aesthetic fatigue. But the distinction has important consequences in the development of certain kinds of patterns, as we shall see in Chapter 4. Note, however, that recovery from aesthetic fatigue (the counterfatigue mutation) may be induced by either qualitative or quantitative contrast, and that sensory fatigue tends to be associated with the former and attentive fatigue with the latter. Both kinds of contrast have about the same effect.

MONOTONY. Now it must have become abundantly clear from our examples that the fatigue mutation is subversive to art and something to be avoided for aesthetic appreciation, since it dulls sensation or puts it out of consciousness. When its effect becomes noticeable it is called *monotony*, and monotony is one of the cardinal sins of art. Aesthetic fatigue cannot, of course, be entirely

stopped. The mutation begins to work as soon as a stimulus is given. What an artist tries to do is to keep the mutation from going very far. He certainly wants to keep it well away from neutrality or unconsciousness.

The experience of generations has taught artists a number of methods for keeping the fatigue mutation at bay. These methods are aesthetically of very great importance, and no work of art is without them. They are known as the *principles of design* and will be the subject of the next chapter.

In this chapter we have studied the main principles relevant to the development of our immediate likes and dislikes. By way of summary, let us see how these fit together. Rather obviously, our basic dispositions to like and dislike are instinctive. These are probably much the same in all men, just as all men are much the same anatomically. On top of these instinctive dispositions ride the long-term mutations of conditioning and habituation. And on top of the latter ride the short-term mutations of fatigue.

Habituation seems to be a maturing process of our instinctive likings. Through experience a rather small original repertory of immediate sensory likings becomes enlarged so that nearly all sense qualities become enjoyable.

Conditioning is a process by which instinctive likes and dislikes become attached to objects which were originally of no interest, so that the range of objects immediately liked and disliked becomes greatly extended. In so far as the field of immediate likes is increased, this is to our aesthetic advantage.

The observed variations of taste among individuals are due largely to differences in the degree of habituation and to differences of conditioning. Since both of these are controllable, or, at least, understandable, there does not seem to be much justification for any very extreme skepticism about describing conditions of human appreciation. If a man does not appreciate a potentially beautiful object from lack of habituation, he can generally, if he desires, remedy this lack. Or if his lack of appreciation is a failure in acquiring some form of cultural conditioning, such as an understanding of the stylistic peculiarities of another period, these may be learned. In short, there is nothing about variations of taste to shut any man off from the appreciation of most objects of great beauty.

As to the short-term variations of likings due to fatigue, these are controlled by the artist himself through the principles of design which we are about to study.

Part Two

GENERAL AESTHETIC
PRINCIPLES

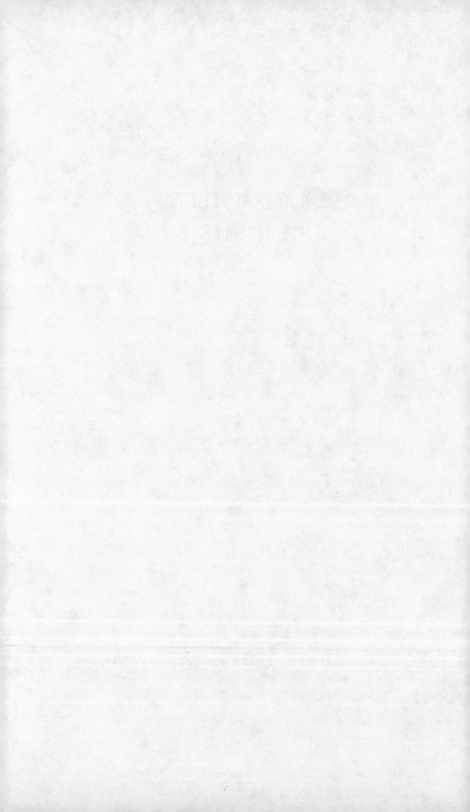

C H A P T E R 3

THE PRINCIPLES
OF DESIGN

On Organizing Principles in General

IN THE preceding two chapters, we have described the nature of aesthetic appreciation and the formation of our aesthetic likings. Likings are often gathered together into the objects which we call works of art. We are now ready to study the operation of the organizing principles which gather these likings together, and build them into works of art.

We have divided these principles on the basis of the underlying psychological processes which govern them. We find four such underlying processes, and accordingly present here a chapter for each of the four kinds. As earlier stated, this topic traditionally appears under the title of " form." But there is so little in common in the operation of these diverse principles, that we shall rarely employ the vague term " form " but rather refer to the specific principle at work.

The four general principles we shall call design, pattern, type, and emotion. The first grows out of the fatigue mutations, the second out of the limitations of attention and the psychological mechanisms for overcoming these limitations, the third grows out of the conditioning processes, and the fourth out of the emotional process of psychical fusion. Clearly these psychological processes have nothing in common except their power of gathering up loose likings and making works of art out of them.

We shall now proceed, and describe the operation of the first of these sorts of principles, those to which we are giving the name of Design.

The Four Principles of Design

As we saw in the preceding chapter, the fatigue mutations lead to monotony, which is something very much to be avoided in the arts. Principles of design are the artists' means of neutralizing the effect of aesthetic fatigue or monotony. Four such principles can be found in artists' practice, namely: (1) *contrast*, (2) *gradation*, (3) *theme and variation*, and (4) *restraint*. We shall take these up successively.

CONTRAST. Of these principles of design *contrast* is the simplest. It consists in holding off the fatigue mutation by throwing in those qualitative or quantitative contrasts of which we were speaking in the previous chapter. If an area of color begins to be monotonous, break it up into a number of contrasting areas of color. If a repetition of short vertical lines begins to get tiresome, put in some long lines, or a horizontal. Contrast is the most striking of the principles of design, and gives the quickest shock to the tendency for monotony. For it consists simply in the elementary principle of relieving sensory or attentive fatigue in the most immediately effective way.

The weakness of the method, however, is that it cannot be applied often by itself without leading to confusion. A succession of contrasting areas, or lines, or shapes without any unifying principle to give them order becomes a jumble, and we lose interest in them because a jumble is irritating. Four or five disconnected objects of contrast are the most that we would stand for.

An artist is thus caught between two aesthetically undesirable results — monotony and confusion. There is a certain amount of leeway between the two within which he can develop his object of beauty, but if he falls off on either side he drops into dullness or ugliness. The avoidance of monotony is often called variety, and the avoidance of confusion is often called unity. From this arises that age-old principle of unity in variety, which every work of art or thing of beauty must possess. But the idea of unity in variety is vague and not very rewarding until we can discover just what constitutes unity and what variety.

Aesthetic unity consists in fact in the avoidance of confusion, or, what amounts to the same thing, in the attainment of order, in what we shall soon study under the head of " pattern " (Chapter 4). Variety consists in the avoidance of monotony, that is, in keeping aesthetic fatigue at bay; and the means of doing this we are calling " design." What the ancient principle of " unity in variety " means, then, is that since variety carried to excess results in confusion, and unity carried to excess results in monotony, it is essential that design and pattern co-operate with one another if a work of art is to be successful and hold our interest steadily.

Now, there is no more direct way of stopping fatigue and monotony than by bringing in a contrasting quality, but after this has been done four or five times confusion threatens, the unity of the composition breaks down, and the spectator turns away in annoyance. For this reason artists have sought out other principles of design that have an element of order within themselves. Such are the principles of gradation and theme-and-variation, to which we turn in the next sections. These principles of design do not have as much force as contrast in breaking up monotony. They are not so much of a shock to aesthetic fatigue, but their lack of force is compensated by their much greater versatility

and capacity to hold the spectator's interest for much larger masses of aesthetic material.

GRADATION. We mentioned earlier the fact that sensory qualities can be organized in schemes. These schemes show which qualities are opposed to each other in strong contrast, and which ones are nearly related and close together. Now a gradation consists in following a sequence of nearly related qualities along a line in such a scheme.

Thus a sequence of grays from black to white would be a gradation, or a sequence of hues from red through orange to yellow. In fact, draw any line from one point to another in the color scheme, and you will have a sequence of color gradations. The same, of course, is possible with lengths and widths and degrees of curvature of lines, with sizes of areas and volumes, with shapes such as gradations from circles into narrower and narrower ellipses, or from squares into narrower and narrower rectangles. In sound there is a gradation of pitches from low to high, and of intensities from soft to loud. And so with all sense qualities.

The presentation of gradation sequences in a work of art is an excellent way of avoiding monotony. Any number of different sense qualities can be put together so long as they can be felt as following a line in a sensory scheme. The limitation of the principle of contrast to four or five elements only is thus overcome in the principle of gradation.

We tend to think of gradations as imperceptible transitions of qualities as in a rainbow or in the blue of the sky on a clear day which shades from light blue near the horizon to a deep ultramarine overhead. But a gradation can be felt also with wide gaps between the colors provided they are at regular intervals along a single line. Black, dark gray, light gray, and white will be felt as a gradation even though the gaps between the colors are very wide. And so it is with all sensations. A glissando on a violin where the finger slips up the string as the bow is drawn across it is a continuous gradation of rising pitch. But a rising pitch gradation is also felt in playing up a scale on the piano or running up a succession of octaves, where the gradation is discontinuous with large gaps between the pitches. So long as the line of gradation is clear in the sensory scheme, the feeling of gradation will be there and monotony will be avoided no matter how many different sense qualities are used, and no confusion will be felt either.

Moreover, some gradations have an added property — climax — that not only keeps monotony away but progressively increases interest. We shall call this *gradational climax* to distinguish it from another sort of climax, which comes out in the design principle of restraint. If, for any reason, one end of a sensory gradation is more interesting to us than the other, then the gradation from the

less to the more interesting end is a gradational climax. In general loud sounds are more arresting than soft ones, so that a transition from soft to loud is a typical gradational climax. Similarly long lines and large shapes tend to draw the attention more than short lines and small shapes, so that gradational climaxes naturally generate in transitions from small to large. Expressions or suggestions of movement are usually more striking than those of rest and quiet. Bright colors and black and white are generally more attractive to the attention than grays, so that gradation climaxes are often developed from less intense grayish colors to the intense saturated hues or to black or white. Also light is generally more attractive than darkness.

Several such gradation climaxes may be seen in the Fra Angelico Madonna. There is a suggestion of increased agitation as the eye (or, better, the visual attention) passes from the lap of the Madonna down toward the folds at her feet. It is a transition from large shapes with long lines to small shapes with short lines. Incidentally, notice that the movement of these forms is totally independent of any suggested movement by the Madonna herself, who is represented as momentarily motionless.

There is also a color gradation from dark to light with a gradational climax towards the light as the eye moves from the dark blues of her gown up to the light blue of her hood surrounding the light of her face. Here the interest in the light end of this gradation is augmented by the central interest in the Madonna's face. Even if light were not intrinsically more interesting than dark, this gradation of color would have been interpreted as a climax toward the light because of the interest set upon the light end of the gradation by the Madonna's face culminating at that end. A progressive gradation may thus be given a climax by placing something of great interest at one end of it.

Thus the design principle of gradation has unifying capacities lacked by contrast. It can bring together without confusion any number of qualities so long as they follow a simple gradational line. Its limitation is that these variations of quality must follow such a line.

It is superior to contrast. In fact we did not fully take in the limitations of contrast in the last section, because we overlooked the action of gradation in the Fra Angelico. But now imagine the Madonna's gown a flat blue without the gradations just noticed. How monotonous it would be! We shall see in the next section that theme-and-variation is as superior to gradation in holding off monotony without yielding to confusion as the latter is to contrast.

THEME-AND-VARIATION. Theme-and-variation consists in the selection of some easily recognizable pattern, such as a group of lines or a shape, which is then varied in any manner that the imagination suggests. A pattern so used is called a " theme " or " motive." The only requirement is that the theme should be recognizable through all its variations. For if the recognition fails, the connection

among the varied forms is lost, and so the order or sense of unity is lost, and confusion ensues. Strangely enough, the recognition does not always have to be fully conscious or explicit, so long as it is felt. Probably all richly developed designs contain many such subtle variations. The artist himself may not have been aware he was making them, but the composition seemed to him to call for a certain arrangement of lines in certain areas and this arrangement on analysis turns out to be a variation of one of the themes in the composition. All parts of the composition are thus pulled together by a sense of familiarity and family relationship.

In Fra Angelico's Madonna there is a pair of such themes that interweave and reappear all over the composition. We may pick them up from the curtain which the angels are holding up behind the Madonna. The pattern of this curtain consists of a row of circles alternated with a row of forms consisting of two pairs of straight lines set crosswise like a little grill. Take the circle and the grill as the two themes (noticing incidentally the strong linear contrast between them), and observe how they are echoed in variations all through the picture. The circle reappears varied in size in the halos, in the neck-lines, wristbands, and girdles of the angels and the Madonna, in the shapes of their heads. Arcs and elongations of the circles are taken up in the folds and edges of the Madonna's gown and the curtain and the mat, and in the ends of the cushion on which she is sitting. Circles will even be found in the centers of the contrasting grill theme.

Now follow the grill. It reappears on the mat in the form of alternate red and black squares. The alternation of red and black squares on the mat, incidentally, is a variation of the alternation of *red* circles and *black* grills on the curtain. The theme reappears in the half square formed by the angels' arms at right angles to each other, holding up the curtain. It comes out in a central position in the crossed arms of the Madonna. The child's arms form right angles, so does the Madonna's knee and some of the folds in her gown and in the drapery about her.

Are these analogies of forms far-fetched? Did Fra Angelico intend them? In the sense of deliberate, preconsidered intent, he probably did not. But in the sense of feeling his way through the creation of these forms toward a richly ordered composition, we may be quite sure he intended every one of them. He knew through his imagination how wrong any forms would be that did not interrelate with one another. In avoiding the jarring and confusion of unrelated forms, he inevitably created related forms that were variations of one another. Just imagine the squares of the mat turned into fleur-de-lys or violets, and you will see why Fra Aneglico made them squares. Go over the picture form by form and imagine some unrelated form in its place, and you will see why the artist was drawn to variation of a theme. He was avoiding confusion. And he was not making exact repetitions of his theme, because he was avoiding monot-

ony. Imagine the grills of the curtain repeated in the mat, or imagine little circles there. These would be passable but not nearly as interesting as the squares. Fra Angelico knew his squares felt right, whether he consciously knew they were variations of the grill pattern or not.

Why did I select the grill as the theme rather than the square? It makes no difference. Each is a variation of the other. As a matter of conjecture, I should venture that the crossed arms of the Madonna was the original source of the theme. This attitude has deep symbolic meaning partly instinctive, partly cultural. And perhaps the halo was the original source of the circle theme. The variation of these themes thus subtly carries the emotional tone of these symbols through the whole picture and helps to produce something of the mystical quality it has.

The power of theme-and-variation to keep away monotony is well illustrated in this example. There are practically no limits to the amount of material that can be kept interesting by this principle. The only limit lies in the selection of a theme which must be simple enough to be taken in quickly and recognized in its variations. But its variations may become as intricate as desired so long as a relationship to the theme is still felt. In fact, there is a very intricate development of the circular theme in the conventionalized plant form developed within the circles on the drapery behind the Madonna.

The versatility and flexibility of the principle of theme-and-variation in comparison with the principles of contrast and gradation comes out quite clearly in these examples.

RESTRAINT. We come now to the last of the four principles of design, that of restraint. This principle is on a different level from the others. It recognizes that interest itself grows tired. The other three principles assume that there is plenty of interest available in the spectator and that the only problem is how to keep that interest directed upon the aesthetic materials. But what if the store of interest is used up too quickly, and gives out, so that no more interest is available? The principle of restraint is the recognition of a need for economizing the expenditure of interest so that it will be adequately distributed over the whole duration and the whole extent of a work of art.

The principle is most clearly seen in a temporal work of art like a piece of music, a play, or a novel. One might naively think that in a play a dramatist would raise the interest to a maximum and hold it there or as nearly there as possible from the beginning to the end. But think of any actual play, and it is obvious that a playwright does not do that, and that if he did the effect would be satiating, strained, and unendurable for the two hours or so that a play is intended to last. The play opens with some scene of considerable interest to take hold of the attention. Then ordinarily the intensity of interest relaxes to give the spectator a view of the situation and the dramatic background out of

which the plot will evolve. There is then a gathering intensification of interest to what might be called the first incident. After this comes another relaxation which rises to another climax of interest, and so on, incident by incident, with alternations of tension and relaxation. In a well-formed play, the maximum of tension is usually held for an incident near the end of the play which is the climax of the performance, and then ordinarily there is a final relaxation of interest at the very end to relieve the spectator of extreme tension and release him from the play with a sense that there was still a great store of interest that might have been drawn upon. The spectator leaves the theater not totally drained, but still interested and perhaps wishing there were more of the play, or reflecting upon it and reliving it in imagination. This way of handling the spectator's store of interest, playing it out so that there is always more left, is what is meant by the principle of restraint.

Notice that it involves a new sense of climax. We shall call it "interest climax" to distinguish it from the "gradational climax" pointed out in an earlier section. Interest climax refers to a gathering increase of interest *developed through any sort of materials* selected by the artist, and leading up to a point of maximum interest in a work of art. Interest climax naturally utilizes gradational climaxes among other means of gathering interest. But a gradational climax is always restricted to a line of gradations within a sensory scheme. Interest climax has no such restriction.

The tensions and relaxations of interest, the alternating climaxes and recessions in the composition of a temporal work of art like a play can be imaginatively plotted as a succession of curves or waves, with the waves rising on the whole higher and higher, as the play progresses, up to the highest wave of all which is the climax of the entire play.

Now, the same sort of thing happens in a spatial work of art like a picture, or a statue, or a building. These also have their points of highest interest or interest climaxes and intervening areas of lesser interest. A picture equally interesting all over is likely to be disturbing, and to contain less total interest than one that makes more use of the principle of restraint. A picture very rich in aesthetic material would be unendurable without areas of relaxation.

Let us turn again to Fra Angelico's Madonna. The area of maximum interest, the climax of the whole picture, is obviously that enfolding the Madonna's face and the child, and the Madonna's face itself is the point of maximum interest in that area. The face acquires this interest not only from its emotional significance and from its being a deeply sympathetic representation of a type of human beauty, but from what are often called the formal aspects of painting. The face is the largest area of very light color in the picture. The hands of the Madonna and the child are painted in a darker slightly reddish tone which in this picture lowers the interest in these areas in comparison with the Madonna's

brighter face. A gradational climax of dark to light (already alluded to) leads up to the head. The head is framed in a large halo. It is at the apex of a triangle formed by her blue robe and seated posture and accented by converging lines in the folds of her garments, in the rug beneath her, and even in the drapery behind. Eliminate all emotional, symbolic, and representational elements and think of the picture as mere line, color, and shape, still the head of the Madonna would be the area of maximum interest, the climax of the picture.

But the child is a close rival of interest, a secondary climax, and after the child follow in interest the crossed hands of the Madonna, the two angels in the upper corners, the yellow folds at the hem of the Madonna's robe, and the folds at her feet. Interest gravitates to these areas from all other parts of the picture.

Between these areas of climax are, however, areas of rest. Consider the long blue surface between the child's head and the folds at the Madonna's feet, and all the other large areas of blue. The mat and even the rich drapery behind with the repetitive and so relatively monotonous patterns are relatively restful and relaxing in contrast to the attention due to the Madonna and child.

The picture thus develops an interest structure in space just as a play does in time. This too could be imaginatively plotted by thinking of the intensely interesting areas as heavily shaded, and the less interesting areas as more lightly shaded in proportion to the degree of interest present. This picture would then be very heavily shaded in the center and quite heavily shaded at the upper corners and around the hem of the Madonna's robe. The rest of the picture would be more lightly shaded. The quantity of lightly shaded areas is the sign of Fra Angelico's restraint.

Imagine an attempt to raise every surface of the picture to the intense interest of the Madonna's head. There would be too much competing interest and every area would lose in interest by the rivalry of all the other areas, and by the restlessness of it all. The net result would be a total picture of much less interest than this one — if, indeed, it did not become a total confusion and an object of aversion.

There is a maxim among some abstract painters of the present time that every area of a picture should hold up equally in interest with every other. Actually, in practice this ideal is never achieved. But there are approximations to it, especially among the less skillful abstractionists. Strictly adhered to, this practice would eliminate all climaxes within a picture as well as rest areas. The element of truth in the maxim is that every area of a picture should be interesting, but it by no means follows that every area should be *equally* interesting.

As may already have been noticed, there is a pattern of interest in any work of art well designed according to the principle of restraint. In the Fra Angelico the pattern is almost symmetrical — a large spot of major interest in the center,

two spots above on either side, and a semicircle of stressed interest around the base.

Thus, the principle of restraint not only acts negatively as a means of avoiding monotony, but also becomes a source of positive delight in the climactic suspense and balance of its pattern.

DESIGN PRINCIPLES MAY COMBINE. Contrast, gradation, theme-and-variation, and restraint are, then, the four principles of design. As our exemplification of all of them in the Fra Angelico shows, they are not mutually exclusive. On the contrary they are mutually co-operative, and any considerable work of art employs all of them together.

It happens that there is one combination of these principles so effective and so constantly used that it becomes practically a separate principle and deserves a separate name. We shall call it _segregation_. It consists of a combination of contrast and theme-and-variation. In music, for instance, a section of material is developed by theme-and-variation till monotony threatens, then contrasting material is introduced which in turn is developed by theme-and-variation, then a return to the original material is possible. A pattern thus develops of segregated areas of contrasted material within which theme-and-variation keeps off monotony. The Baluchistan rug (PLATE III) exhibits the principle. But the segregated areas also produce a pattern. Accordingly, for a clear understanding of the segregation principle we must first understand pattern, which is the topic of the next chapter.

C H A P T E R 4

PATTERN

Pattern and Attention

PATTERN is the principle of abstract unity in art, and is based on an understanding of the structure and limitations of human attention. To study pattern, then, is to study the way in which the psychology of attention is utilized by the artist in giving his work order, and in avoiding confusion. We should note here, however, that while pattern is the principle of abstract unity, there are other elements contributing to unity in a work of art, as we shall see in Chapters 5 and 6.

In common usage the terms " pattern " and " design " are often used interchangeably. We shall consider these two terms as quite distinct in meaning. By design, as pointed out in Chapter 3, we mean the principles which produce variety in a work of art and avoid the monotony resulting from the fatigue mutations. By *pattern we mean the principles which produce unity through the action of attention*, or, conversely, the principles which keep away the confusion that comes from neglecting limits of attention.

Pattern and design so defined are at once opposed and mutually co-operative modes of aesthetic organization. They are both abstract principles; that is, they have no connection with associative meanings or with emotions.[1] For this reason, they are properly linked closely together in an artist's thought and practice. But at the same time they are opposed in their action and each needs the check and compensation of the other, for when pattern overdoes the pursuit of abstract unity it quickly becomes monotonous, and when design overdoes the pursuit of variety it quickly becomes confused. The artist in his creative organization has to follow a rather narrow path between monotony on the one side and confusion on the other. This is the meaning of the ancient maxim that a good work of art must manifest " unity in variety." Today, more specifically, we can interpret the maxim to mean that a work of art must avoid fatigue and yet must keep within the limits of attention. Or, in short, it must have both design and pattern.

[1] This statement may require occasional qualification, as, for instance, in our treatment of symmetry and balance. But it is essentially correct.

How, then, does pattern develop out of the limits of attention?

If you place a number of spots at random on a piece of paper, you will find that up to a certain number you can take them all in at once without counting or putting them in groups. For instance, in Fig. 1 are five spots and you know there are five at a glance. But in Fig. 2 you can only feel that there are a lot of spots. How many you cannot tell. You can count them, of course. But that is a very different thing. Counting is a sort of instrument, a conceptional tool which we apply to a group of things when we cannot take them in intuitively with our attention at a glance. In fact, pattern may be defined as the number and arrangement of things that can be taken in intuitively by the attention.

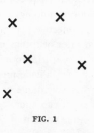

FIG. 1

Now, the attention can take in at a glance normally no more than seven or eight separate things. Most people find it difficult to take in more than five.

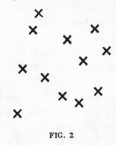

FIG. 2

You can experiment with yourself adding and subtracting dots on a piece of paper. You will soon find the limits of your attention.

It is true that as you experiment this way, you will discover that you can greatly increase the range of your intuitive grasp, if you are allowed to set the spots in groups. For instance, in Fig. 3 the spots are arranged in rows, so that they are inevitably taken in as three rows of four spots, or as four rows of three spots. By this deliberate grouping in rows, you can intuitively take in twelve spots with perfect ease. But notice that you can do this only because the number of rows is only three or four and the number of units in each row is only four or three, and these numbers of elements easily fall within the intuitive grasp of attention.

As it happens, there are also twelve spots in Fig. 2. But since these spots are not clearly grouped, they appear disordered and beyond a simple intuitive grasp of attention. However, it is possible that you had to restrain yourself from arbitrarily grouping the spots in Fig. 2. There is a strong impulse to try to put things in groups even if they are not in groups on the paper. Perhaps, in Fig. 2, you arbitrarily make a row out of

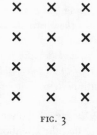

FIG. 3

the four spots on the left, and a square of the four spots upper right, and a drooping line of the remaining four spots. If so, you have in your mind arbitrarily made these twelve spots into three groups of four, which the attention can intuitively grasp. This sort of activity of the mind in making patterns where

they do not objectively exist is often called " subjective pattern." In Fig. 3 the mind does not have to make the groups. They are objectively given in the rows on the paper. Fig. 3 is accordingly called an " objective pattern." But there is no objective pattern in Fig. 2. If you make a pattern out of it by grouping, that is your own doing, and what you have is a " subjective pattern."

A subjective pattern is due to the impulse of attention to try to make great quantities of things intuitively comprehensible. The impulse is so strong that generally it tries to reduce numbers of things to groups of twos or threes. There is, in fact, a widespread opinion, especially among musicians, that all patterns are basically duple or triple. For what we have been showing above with spots on paper can equally well be shown with taps of sound. A group of taps is a rhythmic pattern. *Tum-tĕ* is a duple or two-unit rhythm; *Tum-tĕ-tĕ* a triple or three-unit rhythm; *Tum-tĕ-tĕ-tĕ* a four-unit rhythm, and so on. If the taps are fast enough, the attention can grasp up to seven or eight taps at a time just as with the spots on paper. But there is a very strong impulse of attention to break up longer rhythmic patterns with groups of twos or threes. If *Tum-tĕ-tĕ-tĕ* is tapped out slowly, it is almost impossible not to hear it as *Tum-tĕ-tá-tĕ*. This quadruple pattern is broken subjectively into two duples. And a quintuple pattern of taps, *Tum-tĕ-tĕ-tĕ-te*, turns into *Tum-tĕ-tá-tĕ-tĕ* or *Tum-tĕ-tĕ-tá-tĕ*, a duple and a triple. This impulse, as I said, is so strong that most musicians have come to accept the idea that there are only duple and triple rhythms. This is, of course, not true. What is true is that there is a strong tendency, whenever a strain is put upon the attention, to reduce a quantity of things to the simplest groupings possible, and ultimate simplicity is reached when things can be taken as groups of twos and threes.

If now you return to Fig. 1, you may find that you actually did take it in as a group of three and a group of two. If that is what you did do, see now that you did not need to, that your attention can perfectly well take it in at a glance as a single group of five.

Now *these two characteristics of attention:* (1) *the limitation of the range of attention to an intuitive grasp of one to five but not more than eight elements, and* (2) *the tendency of attention to reduce large numbers of elements to groups that fall within the range of attention — these two characteristics constitute pattern.* They constitute that which in common speech is often called " order."

What we call " disorder " is a condition where so many things are so jumbled about that the attention cannot take them in. What, for instance, makes a desk in disorder? A quantity of papers, letters, books, pamphlets, blotters, pens, pencils, cigarettes, an ash tray or two, a bottle of ink, a hat, a brief case, a foot rule, two or three pipes, tobacco cans, envelopes, pipe cleaners, clips, thumb tacks,

and matches are all jumbled together. All these things are too much for the attention. We say the desk is in disorder.

And what do we do to put it in order? We place the letters and papers in a folder, the books in a row, the pamphlets in a pile on the left of the desk. At the back we make a little group of pens, pencils, blotters, and foot rule beside the bottle of ink. We reduce the partly empty cigarette packages to one full package, and similarly reduce the tobacco cans, and make a group of these together with the pipes, matches, and ash tray, on the right of the desk. The clips and thumb tacks are gathered into a box and set beside the ink bottle. The hat is laid on the brief case, and the two set on the front of the desk. And behold, there is order! [1]

There are just about as many objects in sight as before. What has been done? Simply a great number of things which the attention could not encompass have been put into groups which fall easily within the attention grasp. To an angel with an attention grasp of ten thousand, for whom ten thousand things could be taken in with one intuitive glance as easily as we take in a group of five things, the desk before it was put " in order " would have appeared just about as much in order (as unconfused) as afterwards. To the angel our work consisted merely in shifting the various objects about so as to produce one kind of order in place of another, as if we had put the hat where the brief case was, and put the ash tray where the ruler was, and had reshuffled the pamphlets.

It is tempting to speculate what human life and art would be like if our range of attention should suddenly spread from seven or eight to twenty or twenty-five. Newspaper headlines would be laid out in twelve or eighteen snappy words instead of three or four. Billboards would carry a twenty-word paragraph to be seen in one quick passing glance. Orators would reduce their message to ten or fifteen main points, instead of three. Verse would not be written in pentameter or hexameter, but in clear flowing lines of nineteen or twenty feet. Architectural designs would be revolutionized, and the effects upon sculpture and painting can hardly be imagined. Needless to say, all this to us with our limited attention range would be utter confusion.

Not only all of our art, but all of our affairs of life are ordered by the demands of our attention in twos, threes, fours, fives, sixes, or sevens; or into groups of groups of groups of not more than sevens or eights. This is pattern. If pattern is not provided for us " objectively," the impulse of our attention does its best to put a pattern into things " subjectively."

It should now be added that *an objective pattern is particularly congenial to*

[1] Don't confuse " order " in the sense of unconfused objects of perception with the mathematical sense of " order " which is *any* arrangement of elements, and has nothing to do with aesthetic pattern.

the mind if it is arranged to fit the natural impulse of attention; that is, if it does "objectively" with the things to be ordered just what the attention would have tried to do with them "subjectively." That was why Fig. 3 was so satisfying to the attention in comparison with Fig. 2. In Fig. 3 the twelve spots are "objectively" arranged in four groups of three, which is just what the attention with something of a strain does to the twelve spots of Fig. 2 "subjectively." Fig. 3, in other words, gives the attention what it impulsively wants in Fig. 2 but cannot get without working for. It pleases the attention to get what it wants. Since this satisfaction is an instance of something liked for itself, it is an aesthetic pleasure. Many objects of common beauty owe their delightfulness very largely to pattern. Not that what most easily satisfies the attention always pleases most. A little suspense, a little search on the part of attention to find the pattern that lies in the object, may often increase the delight. But if no pattern is to be found in an object, then the object is a confusion. It is frustrating, unsatisfactory, and painful.

It is a minimum requirement of all objects of delight and beauty that they should avoid confusion, and accordingly that they should have pattern. But pattern may also be a source of delight in itself, since it is based on impulse, on certain demands of the attention which give immediate pleasure in their satisfaction.

Element Patterns

Complex patterns are made out of the groupings of simple patterns. Since the latter are the elementary materials for all complex patterns, let us call them element patterns. Element patterns are limited in number and have relations of contrast and gradation to one another, so that they constitute a scheme of discriminable elements like the scheme of pitches for sound or hues for color. For an understanding of pattern, it is important for us first to get a clear idea of these element patterns. Then we shall go on to see how they combine with one another to produce complex patterns.

Now, *an element pattern is the number of things taken in at one grasp of attention without grouping or other aid.* These may be from one to seven or eight. Taking eight units as the upper limit, we can get then a series of eight element patterns extending from a pattern of one to a pattern of eight. If short vertical lines are used as the unit, this series may be represented as shown in Fig. 4.

One can now see at once that this represents a graded series. It probably also has an effect of gradational climax for most people, since the longest pattern seems the biggest. Also the farther away two patterns are in the series, the greater the contrast between them.

These patterns in Fig. 4 are made out of units that are all alike. Accordingly

we shall call them homogeneous element patterns. In this instance vertical lines are the materials for the units. But the pattern series would be the same if the

FIG. 4

units were horizontal lines, or dots, or crosses, or squares, or trees, or columns, or men. The units may be anything that can be taken as units. Homogeneous patterns are very common. The Greek plate (Fig. 12) contains several homogeneous element patterns. There are four six-unit patterns of straight lines around the edge. There is a three-unit pattern of concentric circles around the center. And the star rays in the middle form an eight-unit pattern. Each of these is an element pattern (capable of being taken in by the attention at a glance) and homogeneous (composed of units that are all alike).

FIG. 5*a*

Element patterns, however, may be composed of units that are not all alike. These we shall call heterogeneous patterns. There are two distinct ways in which units making up an element pattern may exhibit differences. Look at the two patterns in Fig. 5. Both are three-unit element patterns, in which the outside units are alike and the middle unit different. But the difference between the units in *a* is perceived as a difference in the quantity of line. The middle unit has more line, it is a longer line, than the others. The difference between the units in *b*, however, is not perceived in that way. It is not a difference of quantity. The difference is that between the vertical and horizontal attitudes of the lines and distinctions of more and less do not apply to these attitudes. The difference is accordingly purely qualitative.

FIG. 5*b*

Heterogeneous patterns like a, composed of units which differ in some respect of more or less, we shall call quantitative. Those like b, which differ without respect of more or less, we shall call qualitative. In both patterns the differences are to be accepted as they are perceived by the senses, not as they may be ex-

pressed for some purpose by a physicist or mathematician. If differences of degree or size or number are perceptibly felt among the units of a pattern, then the pattern is quantitative. If the differences felt among the units of a pattern are not quantitative, then the pattern is qualitative. Actual patterns may, of course, and often do, have both kinds of differences at once. Lines in a pattern may differ in attitude and also in length. We may call these compound patterns. But for the present let us consider simple quantitative and qualitative patterns.

We are most familiar with quantitative patterns as they appear in the temporal rhythms of music and verse. Here they are composed of units of different degrees of stress or degrees of duration. Thus the *Tuḿ-tĕ-tĕ* rhythm is a pattern of one strong accent followed by two weak ones, and the *lāāā-lă-lă* rhythm is a pattern of a long duration followed by two short ones.

Though we may not have had our attention called to them so frequently, there are similar quantitative patterns in space. In fact, there are more modes of quantitative variation for patterns in space than in time. For in time there are only degrees of stress or duration that can easily be used to make quantitative patterns. But in space there are many modes of quantitative variation. For there are degrees of value and saturation in colors, degrees of size in areas, degrees of length and movement and number in lines, and degrees of interest in forms generally. This list is not exhaustive. A number of these modes of making quan-

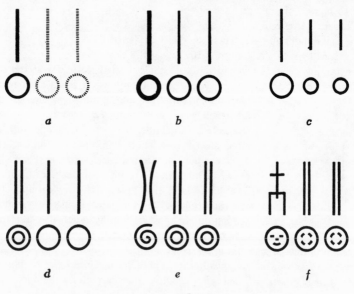

FIG. 6

titative patterns are illustrated by lines and circles in Fig. 6. Here are six three-unit visual patterns all of the same type (called dactyl in verse) with a strong unit first followed by two weak ones.

In *a*, a dark (low value) line is followed by two light (high value) lines. Here, it is the degree of contrast with the ground that gives the strong accent. The blacker the line the stronger the accent on a white paper, but on a blackboard the whiter the line the stronger the accent. In *b* width of line (more area of line) gives the strong accent. In *c* it is the length of line. In *d* the amount or the number of lines. In *e* it

FIG. 7*a*

is movement of line. The spiral form and the double bows have a feeling of movement lacking in the circles and the straight verticals. Lastly the suggestion of a face or a standing man is more interesting and so makes a stronger unit in the pattern than the purely formal units. In fact, actually it is increased interest in every case that makes the stress. But the distinctions among these different sources of interest are worth noticing, if only to make our discriminations of patterns more acute.

Now it is clear that a number of new three-unit patterns can be made by redistributing the accented and unaccented units. You may have *Tum̂-tĕ-tĕ, tĕ-Tum̂-tĕ, tĕ-tĕ-Tum̂, Tum̂-Tum̂-tĕ, Tum̂-tĕ-Tum̂, tĕ-Tum̂-Tum̂*. The same could be done with two-unit, four-unit, up to eight-unit patterns. If these were arranged in order, they would provide a scheme of the types and the number of patterns open to designers with the limit of two degrees of accent.

But, of course, a designer is not limited to two degrees of accent, as is illustrated in Fig. 7*a* where there are lines of three different lengths. Nor does he have to arrange his elements all in a central row, as may be seen from Fig. 7 *b,c,d*, all of which are arrangements of a five-unit pattern with a central strong accent.

Let us look at some of these quantitative patterns among our illustrations. The rim of the Greek plate (Fig. 12) has a pattern of four strong, four weak, based on quantity of line. The rim pattern of the Delft plate (Fig. 14) is one of five strong, five weak, based on the size of the motives. The Greek running pattern (Fig. 11) is a three-unit pattern of one strong, two weak, based on degree of interest. The center of the Baluchistan rug (PLATE III) is spattered with little quantitative patterns of varying numbers of elements. The big central motives produce for me a dominant three-unit pattern with the middle unit strongest mainly because of its heavy mass. At the two ends of the central area is a three-unit pattern with the middle unit weak. To the right and left of the lower central motive is a pair of patterns that may be perceived as five-unit patterns with two strong on the ends and three weak in the middle. And so on. The blue areas, by the way, in the Fra Angelico (PLATE I) make a pattern of two

weak and one strong in the mode of Fig. 7b — a strong middle unit and two weaker ones on either side and above. This three-unit quantitative pattern has a very important function in the organization of the picture. My reason for call-

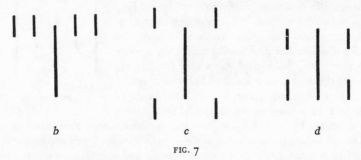

b c d

FIG. 7

ing attention to these illustrations is to make us aware of how extensive and often how important the use of these quantitative element patterns is.

Turning now to qualitative patterns, we can see that these cannot be quite so easily catalogued (even if we should care to), because there are so many ways in which units can differ in quality. However, given two qualities only, the number of element patterns possible can be made out just as with quantitative patterns. In Fig. 8 are the possibilities of qualitative three-unit patterns composed of vertical and horizontal straight lines extended in uniform rows.

Let us look for some simple qualitative patterns among our illustrations. In the Fra Angelico is a two-unit qualitative checkerboard pattern on the mat beneath the seated Madonna consisting of alternating black and red squares. Color differences would make qualitative patterns out of all the rows of crosses and other elements in the Baluchistan rug (PLATE III). The central group of dark forms in the Delft plate (Fig. 14) makes, for me, a five-unit pattern of three leaves and two blossoms all of about equal interest.

One must not think that element patterns are not equally pervasive of less decorative works than those we have been selecting for illustration. Look closely at Tintoretto's *Christ at the Sea of Galilee* (PLATE v). Christ and the

a

b

c

FIG. 8

d

e

f

FIG. 8

boat and the tree on the right can be felt as a central three-unit qualitative pattern for the picture. Study the patterns of the waves and the clouds. From whatever direction you read the forms, they group themselves into element patterns within the attention grasp. So with the folds on Christ's garment, and the leaves of the trees. This principle of keeping the elements of a picture within the grasp of attention was called by the Chinese "The Rule of Five." It is one of the basic rules of art, and wherever you look among objects that are pleasing to your perception, you will find it in operation.

Combination and Organization

So far we have been discussing element patterns only. Out of these, larger patterns are made by combination and organization. There is a distinction, important to bring out at this point, between an aesthetic combination and an organization. Things are aesthetically combined when they are experienced together. Any way of bringing two or more things together so that they will have an effect on each other in perception constitutes an aesthetic combination. The aesthetic effect of things perceived together or in some relation to each other is always different from the effect when they are perceived alone. Think of a vertical line alone and of a horizontal line alone. Then think of them combined in a т or a +. The effect of the combination is quite different from that of either line alone, although the character of the vertical and the horizontal survive in the character of the combination.

The name often given to this effect is *fusion*. It is said that the characters of the elements combined are fused in the character of the combination. To some degree fusion always occurs in an aesthetic combination. Sometimes it so overpowers the characters of the elements combined that it is difficult to make out the original characters of the isolated elements. So in a musical chord, and still more in a musical timbre, the fusion is so great that only a very acute ear can discriminate the pitches combined to give the effect. Something similar occurs with savors and odors.

Combinations which run over the limits of attention, however, will necessarily result in confusion. Consequently, so as to be able to combine a large number of element patterns and at the same time avoid confusion, it is necessary that combinations of patterns should themselves fall into patterns. A pattern that has this function of keeping other patterns in order is an *organizing pattern*. The total result is an organization or a system.

An organization of element patterns is, then, a special kind of combination. It is a structure in which element patterns are themselves combined in patterns, often extending through many levels, consisting of groups of groups of groups of elements, each group held within the limits of attention, so that the total

system forms a single whole easily apprehended within the attention span. We shall now examine in detail the way in which element patterns are combined, and then we shall see how these combinations are further organized in a work of art.

FIG. 9

There are two ways in which element patterns may be combined in space. The patterns may be laid out side by side (*combination in extension*), or they may be laid on top of one another (*combination by superimposition*).

COMBINATION IN EXTENSION. These may be either *metric* or *free*. A metric pattern is simply the repetition of an identical element pattern over and over again. Most of the element patterns we looked at in the earlier parts of this chapter were in fact the repeat elements of metric patterns. They were element patterns which were repeated in bands over the surfaces of objects. By contrast, a free pattern is one in which the element patterns combined on a surface are different or nonrepetitive.

In metric patterns the repeat may be element patterns of any of the sorts we have been studying — homogeneous, quantitative, or qualitative. The simplest of all metric patterns is the homogeneous, which amounts to the repetition of a one-unit pattern (a line, or a dot, or a flower, or an animal) over and over again.

FIG. 10

It is a remarkably common type of metric pattern in the visual arts. It comprises the stripe and the polka dot. It is the pattern of every cornfield and most flower-beds, not to mention the hundreds of textile and paper and ceramic patterns

that repeat a unit up and down and back and forth and diagonally over a surface. In the Baluchistan rug, for instance (PLATE III), are a number of homogeneous metric patterns running round the border.

FIG. 11

For a metric combination of quantitative element patterns take the Greek border (Fig. 11).

For a qualitative metric pattern, take the black and red checkered rug in the Fra Angelico (PLATE I).

Often in metric patterns there is a tendency to perceive the element patterns as overlapping. Thus in Fig. 9, which might be called the "fence pattern," we have not really a four-unit but a five-unit repeat, in which the terminal units are counted twice. The second long line, for instance, is at once the terminal unit of the left-hand element pattern and also the initial unit of the right-hand element pattern. It does double duty. Overlapping repeats like this occur in both quantitative and qualitative patterns, but they are particularly common in quantitative repeats. The reason is that the eye tends to pick up the strong units first and to arrange the weak elements symmetrically between them. Fig. 9 can scarcely be perceived in any other way. The eye resists perceiving it as a succession of four-unit repeats. Some people may feel the same about the Greek border pattern (Fig. 11). One may prefer to take this as a succession of four-unit element patterns overlapping each other, than as a succession of three-unit patterns without overlap, as I have described them heretofore.

FIG. 12

Notice, by the way, that in space one may read metric patterns from right to left, or left to right, up to down, or down to up indifferently. Our Occidental reading habit undoubtedly gives us a bias for the left-to-right way of taking a pattern, but this is not inevitable even for us. A good designer can induce a direction of reading in a spectator at will.

In general, however, there is a tendency in quantitative repeats to pick up the pattern on the strong units, so that it will be read from strong to weak rather than from weak to strong. For instance, in Fig. 10, even though the pattern begins and ends on weak units, we tend to pick it up in the middle on the strong units and take it as a fence pattern with a couple of incomplete element patterns on either end. Cover the two short units on either end, and you will see it does not change your mode of perceiving. See, too, how you pick up the strong elements in Figs. 12 and 14.

There may be overlapping of repeats in a qualitative metric pattern also, though the tendency is not nearly as strong as in quantitative patterns. Some people, for instance, take the red and black squares on the mat in the Fra Angelico (PLATE I) as either a pair of blacks with a red between or a pair of reds with a black between, producing a succession of three-unit element patterns overlapping.

Before leaving metric patterns, a word should be said about their extensive use in the visual arts. Carried over whole surfaces as they are in hundreds of repeats, why are they not monotonous? And if they are monotonous why are they endured? These questions are worth answering, for they bring out an important aesthetic principle in relation to the applied arts.

In the first place there are a lot of factors which render uninterrupted metric patterns much more endurable in the visual arts than in the temporal arts of music and literature. The ear has no way of escaping a stream of sound in its hearing. But the eye can roam over a wide space and even shut itself off from stimulation. So if the eye begins to tire of an extensive repeat like those on the border of the Baluchistan rug (PLATE III) it can turn to the other surfaces of the rug and get rested. A designer can thus safely use uninterrupted repeats over large surfaces, if he provides other surfaces in contrast. The spectator himself will save himself from monotony.

Moreover, a metric pattern on a rug or a vase is not an identical repeat to the eye. There is almost always a gradation of size because of perspective and foreshortening. There is also on a vase a gradation of light and shade. Such gradations owing to perspective and shadow apply also to nearly all architectural patterns. Rows of windows, steps, columns are not really metric patterns *as perceived*, but are gradations. In textiles, variation is given to metric patterns by folds, an effect well illustrated in the drapery behind the Fra Angelico Madonna (PLATE I).

But probably the chief reason why metric patterns are so common in the visual arts is one that has to do with the uses of visual objects. Metric patterns are most frequently seen in the applied arts, in furniture, utensils, drapery, clothing, and the like. These objects are not intended, as pictures and statues are, to be centers of attention. They are meant to fill the environment with comfort

and charm, to be delightful for the eye whenever it rests upon them, but not to hold the eye and monopolize attention. Metric patterns are suitable for this function. Their rhythm is pleasing. The way the pattern covers the surface can be quickly taken in. And the monotony of it permits the eye to leave the object and look elsewhere.

Now what about nonmetric or free patterns? In literature we are very familiar with the distinction between metric and nonmetric patterns, because it is the basis of the common distinction between verse and prose. Prose consists of non-repetitive unit patterns spread along in temporal succession. We are all familiar with beauties of prose rhythm such as we find in the King James version of the Bible. What corresponds to such rhythm in the visual arts? Actually every good picture and statue that does not contain repeats is a prose work in visual terms. Element patterns of different sorts are spread out, and so combined, over the surface.

Consider, as just one instance, the arrangement of the folds in the blue cape of the Fra Angelico Madonna (PLATE I). Any group of folds the eye picks out from the blue area falls easily within the grasp of attention, and is actually an element pattern. But no group of folds ever exactly repeats another. Take the folds at the bend of her left arm. These form a star of *five* deep blue rays. Much the same at the bend of her right arm. Then following down her right side there are *four* big concentric folds leading down to and including the hem of her cape. Following around the hem and up to her lap there is a pattern of *five* yellow folds. Then going down from her left knee, there are *two* groups of *three* or *four* zigzag folds. In short, the folds of the garment are *simplified* so as to fall into easily grasped patterns (element patterns) which are skillfully combined over the whole blue surface. And there are no repeats. It is a free pattern composed of combinations of element patterns spread out over this surface. And actually has not this rich blue surface much the same sort of rhythmic beauty as a Psalm in the King James Bible?

It is not easy to recognize the separate element patterns out of which this arrangement of folds is made, simply because they move into one another (that is, combine with one another) so naturally, and also because wherever the eye wanders the folds are grouped in such manner that the limits of attention are never overstepped. Did Fra Angelico think of these as element patterns as he was composing the folds of the Madonna's cape? Not analytically, no. But he was very sensitive to the demands of attention, and with the painter's skill he possessed he worked over the arrangement of the folds to satisfy these demands, and thus created a composition of great beauty. Seeing these patterns in his work, however, helps us to understand how these demands are met.

It should be added that the fullness of this satisfaction is not due solely to the ease with which the mind follows from element pattern to element pattern, and

always in each transition discovers a clarity of attentive grasp. It is also due to the skill of design that accompanies this skill of pattern — the effects of contrast, gradation, theme-and-variation, and restraint. Note also a dramatic movement in the arrangement of the folds with its tensions, climaxes and resolutions. And, lastly, it is not irrelevant that this drama goes on over the shoulders and the knees of a Madonna. The solemn beauty of this free pattern, like that of great prose, is a fusion of many contributory elements.

COMBINATION BY SUPERIMPOSITION. Metric patterns and free patterns result from combining element patterns side by side. Let us now look at some examples in which element patterns are superimposed on one another. A beginning of this mode of combination we have already met in the fence pattern, where there is an overlapping of adjacent element patterns (Fig. 9). Here the beginning of one element pattern is superimposed on the end of another.

For the full effect of superimposition look at Fig. 13, which is a simplification of a Japanese silk pattern. Here an undulating vertical stripe pattern is superimposed over a grill pattern which is itself a superimposition of vertical stripes over horizontal stripes. On the curtain behind Fra Angelico's Madonna (PLATE I) the repeat pattern of the black grill motive is superimposed over the gold pattern of medallions. In the border of the Delft plate (Fig. 14) there is an effect of superimposition of the big dark motives over an underlying spiral repeat pattern. And now perhaps we realize that interwoven patterns of braiding and basketmaking are also of this same general sort. Essentially here stripes of vertical strands are run alternately over and under stripes of horizontal strands. Consequently any grill or trellis pattern is a very simple instance of superimposed pattern, if it is taken not as a succession of squares but as a row of horizontals over a row of verticals. A good designer can at will emphasize either the internal squares or the outside intersecting lines.

All of the foregoing are instances of superimposed qualitative patterns. The

danger among these is that the superimposed pattern may not be kept sufficiently apart from the ground pattern to avoid confusion. In qualitative superimposition, therefore, in order to keep each pattern clearly distinct, strong contrasts are needed. In Fig. 13 the undulating obliques contrast with the straight horizontals. In the Delft plate (Fig. 14) the bold broad motives stand off from the delicate spiral pattern behind. In the Fra Angelico (PLATE I) the

FIG. 13

black grill keeps forward of the gold and red medallions.

We now turn to quantitative superimposition of patterns. Some people find this mode of superimposition somewhat hard to see. Whether analytically noticed or not, however, it is very common. What makes it hard for some to see is simply that its effects are so immediate and direct and so highly fused. Under certain conditions quantitative superimposition produces an effect closely analogous to syncopation in music.

FIG. 14

Musical syncopation is also something which we feel at once, yet very few people realize that it consists of a simultaneous combination of rhythms, in which the strong beat of one rhythm comes on the weak beat of the other.

Strictly speaking, every quantitative factor in a visual pattern constitutes a separate element pattern in its own terms. For instance, Fig. 15a is a quantitative pattern varying by two distinct factors at once. It is a two-unit strong-weak metric pattern, in which the strong unit is both wider and longer than the weak unit. In Fig. 15b and c these two factors are taken out and presented separately as the two distinct patterns that they are. When b and c are thus shown separately it is possible to see that a is actually a combination of b and c, in which the one is superimposed upon the other. The length of the strong unit of b is combined with the width of the strong unit of c to produce the length and width of the strong unit of a.

Now this matter might not be of sufficient importance for much attention except for the peculiarly striking effect that comes when such combinations are made with the accents crossed. This is given in Fig. 15d and the effect is the same in principle as that of syncopation in music. A unit that you would expect to be weak is made strong and vice versa. The second unit in d, which is weak in respect to length in comparison with the first unit, is nevertheless strong in respect to its width in comparison with the first unit. In the pattern d, the patterns b and c are moving at cross purposes and producing a unique and rather exhilarating effect.

Let us call combinations like *a*, in which the accented units correspond, " congruent patterns," and those like *d* " crossed patterns."

Fig. 15*e* shows what happens in quantitative superimposition when the contrast is made too great between the strong and the weak units. The strong units

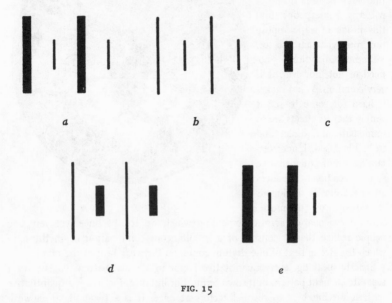

FIG. 15

here are so strong that they seem to deny relationship with the weak units. The result is a stripe pattern of strong units in the foreground and a stripe pattern of weak units in the background, which refuse to mix. Instead of a quantitative superimposition we get a peculiar variety of qualitative superimposition. This brings out the general principle: *For qualitative superimposition make the contrast of patterns strong to avoid confusion, but in quantitative superimposition avoid excessive contracts so as to keep the pattern units from separating.*

Now let us look for some of these quantitative superimposed combinations among our previous examples.

The rim of the Delft plate (Fig. 14) gives a good example of a congruent pattern. The strong accent on the large motive is stronger by virtue of three different factors — size, undulating movement of its lines, and interest in the intricate interior forms. Thus virtually three patterns are superimposed here. Similarly the strong accent in the rim pattern of the Greek plate (Fig. 12) is stronger both in quantity of line and in its movement resulting from the pointedness of the line. As an example of a crossed pattern consider either of the

tree-like motives in the center of the Baluchistan rug (PLATE III). The foliage-like mass at one end is stronger in mass but the root-like motive at the other end is stronger in quantity of line. So they balance in interest, for me, though some persons may find the foliage end a little heavier.

Crossed patterns are not necessarily balanced in the strength of their units. In Fig. 15d we made them of about equal weight. But often one of the patterns crossed may overpower the other. This is clearly the case in the Greek border pattern, Fig. 11. In terms of quantity of line the spiraling rectangular motive is stronger, but in terms of movement and interest the star motive is much stronger and overpowers the other motive so that the total effect is of a simple quantitative three-unit pattern with one strong and two weak. The syncopated effect is consequently lost and there survives only an added richness in the total pattern owing to greater quantity of line emerging on the weak units.

In any highly complicated pattern there are likely to be crossed rhythms. Various factors will stress things in different directions. Moreover, quantitative and qualitative factors fuse and interpenetrate. For instance, in the free patterns of the folds of Fra Angelico's Madonna (PLATE I) there is a great deal of both quantitative and qualitative superimposition. As one example of a qualitative sort, consider the succession of folds from the Madonna's right shoulder down to the hem of the robe and then the successions of folds moving at right angles under and over these across the Madonna's arms and breast, across her hips and knees, and along the hem of her gown over the mat.

Such discriminations help to increase our awareness of the cross rhythms of visual patterns in other works of art. For the more we learn to follow these patterns woven into the texture of a great work, the longer we can live within it and reverberate to its delights.

ORGANIZING PATTERNS. We come now to the subject of organizing patterns. Up to this point we have studied element patterns and combinations of element patterns. An organizing pattern is, so to speak, on the third level of pattern-making. At the first level separate units are taken up into element patterns. On the second level, these element patterns are combined side by side or by superimposition. On the third level, the combinations are themselves organized into systems. Such a system for holding together in clear order combinations of element patterns is an organizing pattern.

There are two main kinds of organizing patterns, which we shall call the *embracing* and the *skeletal*. An embracing pattern is one that embraces a number of other patterns within it. A very simple use of an embracing pattern may be seen on the Delft plate (Fig. 14). The area of the plate is divided into a two-unit pattern of rim and center. The rim embraces a five-unit pattern. Each strong element of the five-unit pattern itself embraces a five-unit pattern. The center of the plate embraces a conventionalized floral motive which embraces

a variety of internal patterns which themselves embrace still more detailed patterns.

The embracing principle can be carried up through many levels making a system as complicated as necessary to take in all the material requiring to be organized. So an embracing element pattern might contain three units, each of which might be an element pattern of four units, each of which might in its turn be an element pattern of four more units, and so on. Since at each level we meet element patterns easily apprehended by attention, the whole system is clear to the mind and orderly.

As a concrete example of such an embracing system, look at the Baluchistan rug (PLATE III). The total area of the rug is divided into a *two*-unit pattern which embraces the center and border of the rug. The border is itself a three-unit pattern which embraces a central strip with narrower borders on either side. Each of these narrower borders is again a *three*-unit pattern which embraces a central strip with its two still narrower borders. Every one of these strips embraces a homogeneous running pattern easily grasped by the attention because of its simple repetition of a single motive.

The center of the rug embraces a dominant *three*-unit pattern. The middle motive of this pattern divides the central area into two fields. Each of these fields embraces a number of rows of minor motives with different degrees of subordination to one another by reason of the intensity of interest they attract. The number of these rows is well within the limits of attention, though there are alternative ways of grouping the units. The number of units in a row varies from *two* to *seven*. Returning to the unit in the center of the rug, we find this unit embraces a *two*-unit pattern of square center and outer field. The outer field embraces a *four*-unit pattern of *two* units each. The square center receives wedge shapes from the outer field which causes it also to embrace a *four*-unit pattern. And so on through the other motives in the rug.

The complexity of the embracing structure of this rug pattern amazes one as soon as one sees how it extends to render clear to the attention the hundreds of items (and perhaps thousands) that the eye takes in. The clarity of this intricate design is deceptive. It makes one think the pattern is a rather simple one. Actually it is enormously involved, but perfectly clear because at every level of the pattern the units below are clasped in a pattern which is easily within the span of attention. So, confusion never invades the mind or disturbs the eye in the perception of such a rug pattern.

A skeletal pattern is one that brings order out of complexity on the principle of a tree formation or of an animal skeleton. A tree has a simple trunk from which grow a number of branches, from which grow a number of twigs, from which grow a number of leaves. If the number of branches falls within the limits of attention, and the number of twigs on each branch, and the number of leaves

on each twig, then the whole system will fit comfortably in the attention, and appear clear and well ordered.

Our Baluchistan rug includes also an illustration of a skeletal pattern. For the tree-like motives of the dominant central three-unit pattern have a skeletal structure. The main stem at one end carries *six* or *seven* branches. The leaves on two of these branches divide into *three* points. It is easy to see how this system could, like the embracing one, be expanded indefinitely. Incidentally, this rug also illustrates the possibility of combining embracing and skeletal modes of organization in a single system. But generally one or the other dominates.

The construction of organizing patterns is the crowning achievement of pattern-making. It gathers up all the elements of pattern that we have studied so far. If we do not say more about this subject now, it is simply because we shall be saying so much about it later. Each art has its characteristic ways of bringing order into its materials, its characteristic modes of composition. These are organizing patterns. We shall become familiar with many varieties of embracing and skeletal patterns before our study is over.

The Axis Patterns

There remains one more sort of pattern to consider. This is the kind that is organized about an axis, whence we shall name them *axis patterns*. There are three varieties which we shall call symmetrical balance (or just *symmetry*, for short), teeter-totter balance (or simply *balance*), and *unbalance*. All of these are characterized by a vertical axis, which sets up a demand that features on either side of the axis shall correspond in weight. In symmetry and balance the demand for equal weight on either side of the axis is satisfied. In unbalance the demand is there but one side is heavier than the other.

The strong human demand for balance (whether of the symmetrical or teeter-totter type) undoubtedly comes from the fact that men stand and move about precariously on two legs, so that they have to be constantly making fine adjustments to keep their balance. The difficulty babies have in learning to walk shows the amount of muscular adjustment that is required in balance. Men are, so to speak, unconsciously thinking about their balance all the time. Consequently whenever they look at an object they project into it their own unconscious muscular adjustment and are ordinarily uncomfortable if the object appears to be off balance and likely to fall. In practical life, whenever we see an object off balance — a bundle beginning to drop off a counter or a child about to fall out of a chair — we automatically act to catch it. We are very quick to notice when the equilibrium of an object is disturbed or unstable, and such instability disturbs us about as much as if the instability were in ourselves — as indeed it is. We project into the object our own disturbance, which may reach quite an

emotional intensity (think of a clown on a tightrope). This projection of our muscular adjustments and the fears and apprehensions which accompany them into objects is called *empathy*. The dynamics and power of balance in the visual arts comes from this projection or empathizing of our own acts into objects.

The importance of the vertical axis in visual art derives from this empathizing of our own balance. For, physically, balance is achieved only when the weight of our body is equally distributed about an axis of gravitation. This axis is, of course, vertical to the ground. That is why the vertical axis is so insistent and so much more important in patterns than a horizontal or diagonal axis. We insist on a vertical axis (with rare exceptions), but only recognize horizontal or diagonal axes when these are specially prepared. And in the auditory arts of music and literature axes do not literally exist at all. What is called balance there (e.g., a "balanced sentence" or a "balanced tune") is a temporal pattern in which sections of the pattern are made to correspond with each other in pairs. Such patterns have an analogy with visual symmetry but they entirely lack the sense of a dynamic or empathic axis, which is the defining character of visual balance.

The reason for calling this dynamic action of an axis in visual forms a pattern is that by that action a great mass of material is divided throughout into two parts. Every feature is coupled in the composition with another feature across the axis. The whole mass becomes an ordered system of pairs and can be taken in by attention with relative ease. This is particularly true of symmetry. There seems to be no limit to the power of symmetry to bring order out of chaos, so long as the features of the pattern fall within the field of vision and can be taken in at one glance.

This power of symmetry is strikingly illustrated by the ink blot experiment. Make a blot of ink on a piece of paper. Fold the paper at the edge of the blot and press the clean side against the blotted side. Unfold the paper, and a symmetrical pattern appears. The blot alone was a confused blob, but the symmetrical pair of blots you now have is a clear and ordered pattern. As this experiment shows, symmetry consists in an exact duplication of features on either side of a vertical axis, but in reversed positions. One side is the mirror image of the other. Complete balance of weight on either side is thus automatically obtained.

In the Delft plate (Fig. 14) we have a symmetrical pattern with the vertical axis going down the middle of the central motive. Also the strong unit of the Greek pattern (Fig. 11) is symmetrical. Notice that if the Delft plate is turned, it is no longer symmetrical, nor even balanced. One side is definitely heavier than the other.

In balance, as distinct from symmetry, although there is equal weight on each side of an axis, the estimating of these weights goes on in terms of a sort of aesthetic exchange based on a feeling for the teeter-totter principle — the princi-

ple (Fig. 16) by which a larger weight nearer the fulcrum (the central support) balances a lesser weight farther from the fulcrum. In aesthetic balance the visual axis corresponds to the fulcrum of the teeter-totter, and a variety of visual factors on either side correspond to the weights.

Now what specifically determines the location of a visual axis of balance? And what are the factors that count as heavy in visual balance?

Fundamentally a vertical axis of balance is deter-mined by the center of gravity of some dominant or controlling form or group of forms in a composition. When the controlling form is a rectangle in normal position, an axis is automatically set up vertically down the middle of the shape. Every rectangular picture, therefore, has normally a vertical axis felt perpendicular to the center of its lower side, passing through the middle of the picture to the center of its upper side. Even before a line is put on a canvas, this axis makes its demands for balance of weight on either side. It can be neutralized or shifted to some other part of the composition only with great difficulty. Similarly with the rectangular faces of buildings. Painters, archi-tects, and designers rarely try to disturb or fight this powerful axis. They accept it and co-operate with it.

FIG. 16

A circular form like that of a plate generates a vertical axis through its center. The various forms of pots and jars in pottery generate axes through the center of their central form (that is, neglecting handles, spouts, etc.). In all of such instances we are helped by the symmetry of the controlling form. Consequently, the center of gravity factor is perhaps rather more clearly seen in sculpture in the round where a symmetrical bounding form is usually absent — and most clearly in group sculpture. Consider the statues reproduced in PLATES x to xvi. See where the vertical axis lies for you in these statues. One way to do this is to ask yourself which features feel to you to the right in the statue, which to the left. The axis goes up between these. Are you not placing this axis in such a way as to make the statue balance? That is, are you not in fact placing the axis through what you feel to be its center of gravity?

If not, then it is even more interesting. What, then, causes you to place the axis elsewhere and consequently see the work as unbalanced? This might lead to the discovery of the other factor which can determine the position of an axis in a composition; namely, a center of interest. If there are some features of dominating interest, these also will attract an axis. A triangle of any kind, for instance, resting on its base is very likely to generate an axis not through its center of gravity but at a point perpendicular to its apex, even though the result is an unbalanced figure. There is thus a sort of competition between center of

balance and center of interest to capture a vertical axis. If, however, the center of interest occurs too far away from the center of gravity, so that the result is extremely unbalanced, then the center of gravity again captures the axis.

Our Baluchistan rug (PLATE III) offers a good example of axis rivalry when seen from the long side. The central diamond-shaped motive strongly attracts an axis for the whole rug on account of its dominant position and the approximate symmetry of the total pattern. But the axis of the rug's rectangular shape is slightly to one side of the axis of the diamond. The tension produced by this axis rivalry may be felt as one of the attractions of the pattern.

There are often several vertical axes in a complex composition — one main axis and a number of subordinate ones. For instance, in an architectural composition every noticeable rectangular member has an axis of its own — every window, door, etc. — but ordinarily these are all subordinated to the main axis of the controlling form of the structure. These subordinate axes are, of course, located in centers of interest, since doors and windows on the face of a building are all centers of interest. But the particular minor axis for each of these centers of interest is the center of gravity of the particular rectangle for that door or window (cf. Governor Smith House, PLATE XVII).

There is an instructive example of this sort of thing in Renoir's *Mme. Charpentier and Her Children* (PLATE II). The main axis of the picture clearly passes through the mother's head, which is exactly in line with the center of gravity of the rectangle of the picture frame. But notice a center of interest in the still life on the table in the upper right corner of the picture. This is sufficiently isolated to generate an axis of its own. This axis is determined by the center of gravity (aesthetic gravity determined by the factors that give aesthetic weight) of the whole group of objects in the right corner bounded by the yellow chair on the left. Moreover, so that there may be no mistake Renoir marks this axis at the top by the point where the diagonal line of the curtain intersects the edge of the canvas and at the bottom by the upward wave of the white flounces of the skirt.

A few other very minor axes may be felt through the center of gravity of the carafe, the wine glass, the plate, and the little picture on the wall. But notice that the vase of flowers, for all its interest in this group, denies an independent axis. (At least it does for me.) Renoir was arranging the flowers to determine the main axis of the whole still-life group and he did not want this main axis disturbed by a strong independent axis among the flowers themselves. Consequently, he blurred the shape of the vase, distorted its symmetry, weighted the flowers heavily on the left, and accented their linear relations to the lines of the total composition. For evidence of the latter, take the diagonal line at the upper edge of the flowers. This is picked up by the corner of the chair, and passes right across the picture under the chins of the two children. It is echoed

in the black edge of the mother's skirt, her hand, and her neck line, all of which are parallel. There is also a feeling of a diagonal line running through the flowers parallel to the curtain on the right, and parallel also to the chair legs under the table, the mother's left arm, and the lower little girl's left arm. In short, the flowers deny an axis because they are not balanced enough in themselves to suggest one and because they are tied in with other elements in the composition.

We learn, then, that a center of interest does not necessarily attract an axis. It will do so only if it is obviously balanced or symmetrical, and not too closely tied in with stronger centers of organization. So, the still-life group as a whole does acquire an axis, because it fulfills the above conditions. But, as we have seen, the flowers alone do not.

We now see also why the figure of the mother alone does not acquire an axis in spite of her dominating interest, nor those of the two children. None of these is markedly balanced in itself, for each is tied in too closely with the organization of the total group balanced on the central axis of the whole picture.

In sum, *vertical axes are attracted to the centers of (aesthetic) gravity of controlling forms in a visual composition and also to centers of interest.* One main axis in a visual composition is almost inevitable. The number of minor axes felt will depend partly on the presence of symmetry or balance in the minor centers of interest, partly on the degree in which these centers can be viewed as relatively individual organizations within the total organization.

We now come to the factors which give weight in aesthetic balance. There are six:

1. *Distance from the axis.* The further an object is from the axis, the greater its force in balance. This is the teeter-totter principle. A child on a teeter-totter can balance his parent, if the parent sits near the fulcrum. Similarly in aesthetic balance. Just visualize a picture of a teeter-totter with parent and child at equal distances from the fulcrum. It would feel out of balance.

2. *Size.* Any large area or object is heavier in aesthetic weight than a smaller one (other weight factors being equal).

3. *Depth.* The suggestion or presence of depth in a visual composition gives a feeling of weight. The representation of a thick object like a cube will appear heavier than that of a thin object like a card, even if the latter covers as much space on the canvas. Also a vista such as a view out a window or down a street is aesthetically heavy.

4. *Apparent weight of colors.* Dark colors feel heavier than light ones, and consequently count as heavier in balance.

5. *Movement away from axis.* Movement can be suggested in a visual composition in many ways. There is movement in lines, as in the folds of Fra Angelico's Madonna. But the sort of movement that generally has most influence on balance is the suggestion of direction. Pointed shapes always suggest movement in

the direction of the point. Also the front of any object, like the bow of a boat, the engine of a train, the head of an animal, points and suggests movement in the direction ahead. It is so even when the object is represented as perfectly still, like the dog in Renoir's picture. Movement is also noticeably suggested by the direction of a person's face and eyes. All these suggested movements, when directed away from the axis, make their objects heavier, and when directed toward the axis, lighter than they would be otherwise.

6. *Interest.* The more interesting an object in a visual composition, the greater its weight in balance. By interest is meant the power to capture our attention and hold it.

Obviously these factors may compete with one another in a composition, and the amount of weight ascribed to an object may differ from perceiver to perceiver. But on the whole there is rarely much disagreement as to the balance of a picture, statue, or building. This judgment is very close to the instinctive level.

Let us look at the Fra Angelico (PLATE I), the Picasso (PLATE XIX), and the Renoir (PLATE II) with an eye to balance. These are all clearly balanced compositions.

The simplest of them to study is the Fra Angelico, because it is so nearly symmetrical that it is easy to see how each factor present does its work. The first factor perhaps to attract attention is the great aesthetic weight of the large dark blue area of the gown on the left (factors 2 and 4). How is this compensated? Partly by the strong interest in the Madonna's face, which is slightly to the right of the axis, and in the head of the child (factor 6). But notice also the agitation of the folds of the gown far to the right (factor 5). There is also movement away from the axis in the direction of the Madonna's face and of her left knee. Notice also how much stronger is the directional force of the knee (being further from the axis) than of the face. These are partially offset, however, by the counter direction of the child's face and hands towards the axis. Finally, notice the dark gold vertical fold of the curtain at the extreme right (factors 4 and 1) and the little area of depth (factor 3) suggested by the small red and black squares of the mat also on the extreme right just under the curtain. It is these two rather inconspicuous things way over on the right that finally, with the other things, balance the big dark blue area on the left. Cut them off with a finger, and see what happens to the balance. Imagine them larger or more conspicuous and interesting, and again it would throw off the balance.

The Picasso presents an almost identical problem. The big dark blue area (factors 2 and 4) on the left is here compensated by the direction of the drinker's face (factor 5), the great interest in the small glass far to the right (factors 1 and 6), and the depths (factor 3) suggested across the table far to the right.

The Renoir, of course, presents a much more complicated composition. The main interest (factor 6) is here nearly all on the left of the axis. On that side are half of the mother's face, the two little girls, and the dog. In part, Renoir balanced this weight by the large black area (factors 2 and 4) of the mother's dress extending way to the right (factor 1). But this was not nearly enough. The function of the still-life group in the right upper corner is to give just the amount of interest (factor 6) necessary to balance the little girls and the dog on the left, yet not enough to draw the main attention away from the mother and children, who are the primary subjects of the picture. Renoir's problem was to give as much weight as he could to the still-life group without increasing its weight of interest to the point of drawing attention away from the portraits. To solve it he placed the still life as far away (factor 1) as he could from the axis and gave the group all the depth (factor 3) he could without breaking the unity of his picture plane. This composition is really very remarkable in the completeness of its solution of a very difficult problem of balance. Few people are aware of what a *tour de force* this was. Perhaps not even Renoir!

Now for the subject of unbalance. This is the situation in which one side of the axis is heavier than the other. From what we have said so far of the powerful instinctive demand for balance in visual compositions, the inference seems inevitable that unbalance would be displeasing and ugly. In general it is. And it always is, if the composition is one which seems intended to be balanced but failed. But there are many instances of deliberate unbalance that are striking, piquant, and charming. To begin with common examples, ladies often wear their hats on the side of the head, wear a bow or a flower on the side of the hair, or tie a sash on the side of the waist. There is an allure in a certain degree of unbalance of dress quite distinct from the demureness and propriety of symmetry and balance.

The same thing carries over into ornament and decoration and the arrangement of a room. A vase of flowers deliberately off center on a table or mantelpiece is often more effective than if fully balanced. Once we get the idea, we can observe that many architectural compositions are unbalanced to aesthetic advantage. It is particularly appropriate for certain types of domestic architecture where an air of hominess and informality is desired, in contrast with monumental structures where symmetry is appropriate. Of course, any house with a prominent wing or porch on one side only is unbalanced.

Though unbalance is not common in Occidental painting, I believe it is very common in Oriental painting. The Chinese painting (PLATE IV) is an example of the sort of thing I mean. For me a normal main axis runs down the middle of the controlling rectangle of this picture. Except for a sprig of the pine and part of the horse, all the interest and weight of aesthetic material lies on the right of the axis. The sprig and the horse do give a strong movement to the left, but

it is a negligible aesthetic weight compared to all the other material on the right. Most of the left is empty space. Some people who insist on seeking a balance for any delightful composition imagine a great depth of invisible vista in the void on the left. I suggest we permit this to be a very unbalanced picture and a very pleasant one.

So, there appear to be plenty of examples of unbalance that are aesthetically pleasing. The resistance of many people to accepting them as pleasing, however, suggests that the principle of habituation is at work here, and that there is an affective sequence running from symmetry to unbalance, with symmetry the easiest of axis patterns to appreciate and unbalance the most difficult.

And here it should be pointed out that symmetry grades imperceptibly into pure balance and balance into unbalance. A pattern like that of the Baluchistan rug (PLATE III) is mainly symmetrical, yet many of the motives are not mirror images across the axis. There is thus an element of balance in it. Similarly with the Fra Angelico *Madonna* (PLATE I). This composition suggests symmetry throughout, and yet it is mainly balanced. But when we come to the Picasso (PLATE XIX) and the Renoir (PLATE II), these are pure balance with no suggestion of symmetry. Then proceeding from pure balance we can pass through many degrees of unbalance. The amount of unbalance in the Baluchistan rug on its side (PLATE III) is much less than that in the Chinese painting (PLATE IV). A fully habituated taste for these axis patterns would have a capacity of enjoyment for any pattern in the whole graded series.

But then, someone will ask, how can any axis pattern be aesthetically bad? The answer is: None is in itself, or in the abstract. Any particular degree of symmetry or of unbalance may find an appropriate embodiment in some composition. But for any composition generating an axis of balance, some one pattern in the series is most appropriate, and that is the most beautiful pattern for that composition. Any strongly felt discrepancy from that particular pattern is ugly. The softened symmetry of the Fra Angelico (PLATE I) is exactly in keeping with the subject depicted and its treatment. Likewise the pure balance of the Renoir (PLATE II) suits that picture. Suggestion of symmetry in the Renoir would destroy its mood of intimacy. Such free balance in the Fra Angelico would destroy its mystical serenity. Any strong element of unbalance in either would be distasteful and ugly. But the extreme unbalance of the Chinese painting is likewise exactly appropriate in that work. None of these axis patterns is intrinsically ugly, but any one of them may be ugly if inappropriately embodied.

However, it may be added that unless there is some definite call for unbalance, the organism spontaneously asks for balance. The demand for balance is, so to speak, instinctively assumed by the organism, whereas the call for unbalance has to be specially justified by the occasion.

So far we have discussed only two-dimensional or right and left balance, and

conceived the axis as dividing a plane such as the picture plane or the face of a building. Our own complete bodily balance is, of course, three-dimensional. Our axis of balance passes through the center of our body, and we maintain our balance forward and back as well as right and left. However, right and left balance, which we have been thinking about so far, is the dominant feeling of balance projected into total visual compositions. We do not often empathize our forward and back balance into pictures, and demand equal aesthetic weight behind and before. For instance, even though we see the Fra Angelico Madonna (PLATE I) represented as seated some distance back from the edge of the mat fairly deep in the space of the picture, and are aware of a lot of interesting objects in front of her, we make no demands for compensating objects of interest behind her. There is no back and forth balance in the deep space of the picture. Moreover, in this picture there is not even an axis of balance felt within the volume of the Madonna's body, because Fra Angelico avoided stressing its material solidity.

There are, however, three-dimensional axes in many visual works of art. Such an axis is often felt running down the center of some visually well-defined three-dimensional volume or mass. It is very clear in any pyramid, or cylinder, or cone or cube. It goes down through the center of mass of the form conceived as standing upright on its base. Let us call it the *axis of mass*.

It is important to distinguish an axis of mass from an *axis of balance* which is the defining characteristic of axis patterns. The two are related but behave quite differently in the aesthetic field. An axis of balance always remains perpendicular, as we have clearly seen in all the axis patterns we have studied. But an axis of mass follows its form, and if the form containing the axis tips, the axis tips with it. So, when a cylinder is tipped, the axis of the cylinder remains fixed in the cylinder and tips too. But the feeling of the tip of the cylinder implies an axis of balance perpendicular to the lowest edge of the cylinder on which it is imagined as tipping. This lowest edge acts as the fulcrum of a teeter-totter balance, which automatically generates an axis at that point. The difference between an axis of mass and an axis of balance is thus clearly seen in the tipped cone, Fig. 17. The dotted line *ab* is the axis of mass, but the line *cd* is the axis of balance.

The two are easily confused because when a figure is upright the axis of mass and the axis of balance coincide for that figure. The two immediately disconnect from one another, however, as soon as the figure is tipped.

If now one grasps the distinction between these two sorts of axes, he will see that an axis of mass does not make demands over a visual composition in the way a central axis of balance does. An axis of mass simply indicates the attitude of the figure that contains it, showing whether it is upright, or tipped, or horizontal. It behaves in a composition the way a line does. Actually it is a

line of a particular sort connected with mass. The proper time to study it, accordingly, is when we come to the chapters on line and mass.

Let no one think, however, that an axis of mass is of minor importance because it acts as a line within a form and not as a peculiar sort of organizing pattern over the total picture plane. Indeed, there is a tendency among twentieth-century artists who stress solidity and three-dimensionality of forms in their painting, sculpture and architecture to stress the three-dimensional axes of their masses,[1] and to disparage the left and right axis of balance as something superficial, old-fashioned, and "two-dimensional." This attitude indicates the great importance that can be given to the axis of mass, but it is, of course, quite unjustified in so far as it slights the importance of an axis of balance. Very rarely does an artist create a visual composition that is not governed throughout (either well or badly) by an axis pattern based on a central axis of balance distributing weight right and left. The axis patterns of symmetry, balance, and unbalance will never go out of date. They will be demanded as long as men stand on two legs and project their muscular adjustments into the objects they look at.

FIG. 17

[1] For compositions in which three dimensional axes play a more important role than two-dimensional, consider the Cézanne (PLATE VIIIA) and the Ker House (PLATE XVIII).

TYPE

Type and Its Unifying Power

NOW THAT we have discussed pattern, we can profitably take up the subject of type. A type, as we saw in Chapter 2, is due to association or conditioning, and may be defined as a *system of associations recognizable as a whole*. It is any recognizable whole. Thus the system of associated traits that go to make up one's idea or concept of " dog " constitutes a type. What ties the traits together in one's mind is the principle of association or conditioning which makes one think of the traits when the idea comes up, and recognize them when some actual dog appears, or when a dog is represented, as in Renoir's picture of Mme. Charpentier and her children.

Type performs two functions in art. The first is as a means of producing unity or order. In this function it resembles pattern. The second is as an immediate source of delight through the power of recognition. The second is the function that we shall mainly dwell upon in this chapter. But the first is the one that makes type a principle of organization wherever it appears.

The fact that a type is a system of associations indicates at once that it has a unifying power. All the various traits of a dog would be so many separate items in confusion but for the unifying effect of association which draws them all together into a system. Take that set of forms and colors in Renoir's picture which we recognize as a Newfoundland dog. See how the nose, eyes, ears, paws, body, and tail, and the black and white splotches of color representing his hair are all unified through our idea of a Newfoundland dog. Notice, too, how specific our associations are as to the relations among these traits. That is, these traits are not associated together loosely in any old way, but in very specific relations to each other. The eyes are just so far apart in relation to the nose and the ears. The head has just a certain shape, broad at the top, narrower at the nose, and the forehead comes over sharply between the eyes. The body has a certain length in proportion to the head, so that we know it is the same dog that extends through under the little girl and comes out in the black area in the left lower corner of the picture. We know from these relations where the dog's body

goes out of sight behind the legs of the little girl, and that it is broad enough to support her. We know also that the little girl's hand is resting on the upper joint of the dog's hind leg, and that this is firm and gives adequate support for the weight she puts upon it. All these minute relations of the specific proportions of the body of a Newfoundland are also traits of this type of dog and enter into this system of associations. The unifying power of a type must now be very apparent. All these dozens of traits, which would otherwise be a jumble of confusion, are firmly united into a single system so that they become comprehensible.

See, furthermore, what this type of Newfoundland does to the whole lower left corner of Renoir's picture. Try to imagine the idea of dog away, and view the areas there as mere black and white pigment areas. For one thing the curve of the dog's back which is felt extending behind the little girl would be entirely lost. The hindquarters of the dog would become totally disconnected from the front quarters. The white areas of the dog's hind leg would be drawn away from the black area and would connect up with the little girl's white socks, and then the black area abandoned to itself would tend to slide out of the lower left corner of the picture frame. In short, from a purely pictorial viewpoint, the concept of Newfoundland dog unifies that whole left corner of the picture, generates lines and volumes without which that corner suffers disintegration. The concept organizes that part of the picture into *one* object; namely, a Newfoundland dog.

It is also type, of course, that permits us to see each of the little girls and the mother as a unit. It permits us to understand the sitting posture of the mother and the little girl on the right, and extends the invisible lines of the sofa behind these figures. It is type that keeps order among the legs of the chair and table in the upper right corner, and tells us which legs belong to which. It is type that keeps the grapes apart from the wine glass and carafe, and the flowers apart from their vase, since we *recognize* all these as separate objects. It is type that develops the yellow plane of the table top and the red plane of the tray in perspective, and the foreshortened plane of the seat of the chair and of the back of the chair, and all the other planes and volumes in perspective throughout the picture. For the concept of perspective is also a type, being a system of associated aspects of things *recognizable* from one point of view. These examples are sufficient to show the role of type (or of a *recognizable whole*) in bringing unity and order into art — and into human perception generally.

It is true, moreover, that both type and pattern can develop large integrated structures of many levels. The idea of Newfoundland dog contains within it the ideas of the dog's head, body, and limbs, for each of these is a recognizable whole in its own right. And each of these at the next level also contains ideas. The head contains the ideas of eyes, ears, nose, mouth, etc. — all of them rec-

ognizable wholes too.[1] Then the idea of eyes contains those of eyelid, pupil, iris, lens, socket, etc. Such an integrated system of types or recognizable wholes reminds one of organizing patterns, like the embracing pattern of the Turkish rug described on page 76. But the modes of integration in the two cases are entirely different. The levels of integration in a system of types are held together by the threads of association, but the levels of integration in an organizing pattern are held together by the "clasps" of element patterns — that is, by the attention span.

THE DELIGHT IN FULFILLMENT OF TYPE. So now we turn to the other function served by type — that of yielding a unique sort of pleasure, the pleasure of recognition. If pattern can be described as the psychology of attention applied to art, type can be described as the psychology of recognition applied to art.

The pleasures of the senses impress themselves on everyone but the pleasures of recognition are sometimes overlooked. The latter make themselves especially felt, however, when we recognize an old friend or an old haunt after a long absence. Here is Paris or here is dear old New York or San Francisco again.

Artists have refined these pleasures of recognition and have learned how to incorporate them in works of art for the greatest aesthetic advantage. The pleasures come from the fulfillment of type. Let us try to understand just what that means.

A type, as we saw, is a system of associations recognizable as a whole — such a system as enters into our concept of Newfoundland dog, which is made up of the traits of a Newfoundland so far as we know them. Suppose we consider three ways in which we might employ this type.

First, we might simply bring it up before our minds. The term "Newfoundland dog" appears on a page. We allow ourselves to dwell upon it, run over the traits of such a dog in our mind. Here there is no process of recognition of anything conforming to the type. We are simply examining the demands of the type itself.

[1] Is the reader beginning to be bothered by the thought of whether the type is the idea of a dog or some actual typical dog? If so, it may comfort him to know that many have worried over the very same problem before. Are all types "subjective"? Or are there also "objective" types? It is popular now to hold that all types are subjective. This seems to me a doubtful hypothesis, however, unless one is willing to consider such concepts as "good health" and "sanity" as fictions.

There is no question that as instruments by which we recognize objects, types are "subjective." That is, we have to have an idea of an object in our minds (as we say) in order to recognize it in our environment. There is also no question that we project many of our ideas into our environment, and so *see* it divided into the forms with which we *think* it. But are not some of our ideas about the divisions of our environment true? Would not some configurations of traits stand together apart from other configurations of traits even if no man were there to classify them? Would not rabbits differ from foxes even without men to classify them? And wouldn't a healthy rabbit be somehow significantly different from a diseased one without a man around to note the difference?

Second, we might have a practical use for such a dog, want him as a pet perhaps. Under these conditions, our drive to have a pet charges the type with the energy of our desire, and immediately the traits of a Newfoundland dog become a set of urgent demands to be satisfied. The importance of bringing up this practical use of type is to show clearly how under the urgency of a purposive drive every little trait of the type becomes a little desire in its own right demanding satisfaction. In fact, the demand for the fulfillment of the type becomes a desire of its own subordinated to the main drive of wanting a pet. How we happened to decide upon a Newfoundland for a pet is here beside the point. The point is that having somehow decided upon a Newfoundland, what we want is the fulfillment of the traits of a Newfoundland. Something approaching a means-to-end mutation begins to operate, so that we find ourselves looking for a Newfoundland, half forgetting that we want that kind of dog ultimately only as a means to having a pet. If the search goes on for some time, actually the desire for the Newfoundland may submerge the thought of a pet. And when a dog is at last found which satisfies the traits of a Newfoundland, the pleasure in the fulfillment of this type may quite overshadow the anticipated pleasures of having him as a pet. If so, we are experiencing the pleasures of recognition — that is, of recognizing in this *particular* dog the fulfillment of our type for this *kind* of dog.

In this *practical* example, however, it is hard to tell how much of the pleasure is an immediate pleasure in recognizing the fulfillment of the type, and how much comes from looking forward to playing with him as a pet. Only the first would be a pure aesthetic pleasure in the contemplation of the dog as a good instance of the type.

So let us go to a third example. Let us now be dog fanciers with a great deal of knowledge about the " points " of a fine Newfoundland. To make the example the more poignant let us be dog fanciers with small pocketbooks, so that we are never seriously tempted to buy a dog. It is friends of ours now who want the dog as a pet, and we are simply accompanying them for the fun of it. And we come upon a magnificent Newfoundland. He fulfills the " points " of a Newfoundland to perfection. Our pleasure at the sight of him is enormous. We become very excited about the dog, probably even more so than our friends who want to buy him. And in this instance it is beyond question that our delight is in the perfection of the dog itself, in the completeness with which he satisfies our demands for a fine Newfoundland. The pleasure here comes entirely from the fulfillment of type.

This is the sort of pleasure we shall be talking about in the remainder of this chapter. Works of art are full of such pleasures. These delights fall within our aesthetic field because we enjoy the fulfillment of the type for itself, and not merely as a means to some further end.

But the fulfillment of type is not always so pleasant. We chose our example rather carefully of a perfect Newfoundland, for a prize winning Newfoundland is a rare sort of animal. And it is the fulfillment of rare types, types difficult to fulfill, that gives the most pleasure. The fulfillment of common types — such as noticing any ordinary dog on the street — gives very little pleasure or none. Vice versa, the nonfulfillment of a rare or difficult type gives no pain, or very little. But the nonfulfillment of a common or easy type, which we always expect to see fulfilled, is ordinarily unpleasant. Since these basic correlations are important, let me set them out in a column thus:

1. Fulfillment of difficult type — great pleasure.
2. Nonfulfillment of difficult type — slight displeasure or none.
3. Fulfillment of common type — slight pleasure or none.
4. Nonfulfillment of common type — great displeasure.

It follows that in the fine arts where the highest perfection is sought, artists will seek out difficult types to fulfill, for only from these can great aesthetic delight be gained.

A distinction must here be made between the pleasure that comes from the fulfillment of a type and any other pleasures that a type may stimulate. For a type may directly arouse emotional or sensuous pleasures or pains quite apart from the pleasure in its fulfillment. A rose, for instance, has many sensuous pleasures in its color, odor, and the texture of its petals over and above the pleasure a rose fancier derives from its perfection as a fine example of the species. And a beautiful specimen of a snake can still be an object of emotional loathing. If the direct emotional or sensuous displeasure in the features of a type are not excessive, it is quite possible to get great aesthetic enjoyment in the fulfillment of intrinsically ugly types. Thus a skillfully drawn picture of an ugly house may be very beautiful, as the pictures by a number of good contemporary artists of the most distasteful examples they can find of American mid-Victorian architecture testify. Unpleasant subject matter in realistic pictures, novels, and plays is common enough. The pleasure comes from the realistic fulfillment of the ugly types of objects depicted.

The pleasures from the fulfillment of type are purely relational. They are entirely free from sensuous or emotional quality. People sometimes fail to notice them for this reason. Often, also for this reason, they are called intellectual pleasures, whence the conception of an "intellectual beauty." One of the many meanings of the term "classic" is that of an appeal to intellectual beauty, to the pleasures of the fulfillment of types in art rather than an emphasis on sensuous and emotional pleasures which are dubbed "romantic."

Kinds of Types

To get some idea of the extent of this sort of intellectual enjoyment through the fulfillment of types, we shall do well to make a list of the important kinds of types to be found in art. I offer the following classification and will make some descriptive comments on each kind:

A CLASSIFICATION OF TYPES

Instinctive

1. Goals of basic drives
2. Innate standard forms

Acquired

1. Types of natural objects
2. Functional types
3. Technical types
4. Formal types
5. Types of suspense

INSTINCTIVE: 1. GOALS OF BASIC DRIVES. After all we have said about types being due to conditioning, the idea that there should be "instinctive" types sounds like a contradiction. Most types are certainly learned through the process of conditioning, by which items of sensory stimulation are connected for us into a system. An instinctive type would be such a system given us at birth, or developed naturally as we matured without having to be learned. Are there any such innate associative systems?

The conception of physical beauty in man and woman is probably one of these. If the male has an instinctive desire for the female, and vice versa, then he must be innately endowed with a system of associated readinesses to respond to her, so that he can recognize her as an attractive female when she enters his environment. Hence, an object that completely fulfilled the demands of this system would give both the satisfaction of a type perfectly fulfilled and that of the sex emotion released by the fulfillment of the type. This would explain not only why we have a specific response to certain physical features in man or woman, but also why the response is so intense, so radiating, and so deeply engulfed in emotion.

The question of instinct has been a much-belabored one in psychology. At one time animals and men were supposed to be endowed with many instincts and the accounts of the way these worked made them out little short of magical. Whenever a psychologist could not understand a type of behavior, he laid it to instinct. Then in reaction came a period when there were not supposed to be any instincts at all. Now we seem to have reached a sort of balance. It is now

admitted that there are instincts in the sense of systems of readinesses to respond to environmental situations.

Many of these systems have been carefully described, such as the instincts of mating, nest-building, and rearing of the young among birds. Most of them require some learning to be perfected, some require a great deal. But it is now apparent that these types of behavior are quite orderly and in no sense mysterious as previously supposed.

Human instincts are, however, much more difficult to study than those in other animals. Much of man's behavior even as an infant is learned behavior, and this gets all mixed up with his instinctive behavior. Human instincts also seem to be rather sketchy in the sequences of their acts between the drive they start with and the goal they end with, and so most of the intermediate links are left to learning. For these reasons it is easy to be deceived into thinking there are no human instincts, and that all behavior is learned.

Take hunger. Here is an innate drive that periodically comes up and takes over big sections of our behavior. It vaguely stimulates our legs to convey us toward food, and our hands to lift it to our mouths. Once the food is in our mouths the sequence of acts from chewing to swallowing and digesting are more specific. There can be no question that there is an instinct at work in our feeding reactions, and that what is pleasant or distasteful is in a general way determined by the demands of the drive, and of the physiological mechanisms through which the drive operates. Nevertheless our specific tastes for food are to a large extent acquired. So much so that in general aesthetics we can completely ignore any innate type demands for the hunger instinct, and simply talk about the affective sequence of tastes, and recommend as much habituation as possible.

It is much the same with the sex instinct. Specific traits of physical beauty are largely acquired. This accounts for the fact that there are so many standards of physical beauty in different cultures. However, there seems to be a set of general demands which may be called the normal sex object, and which, like the keel of a ship, tends to bring the various cultural conventions of physical beauty back to normal if they tip too far one way or the other. As a rule, the extreme aberrations of taste in physical beauty which seem abhorrent to foreign cultures, such as the bound foot and long fingernails of the traditional Chinese, and the artificially exaggerated protruding lips of certain African tribes, are accentuations to abnormality of intrinsically attractive sex features. The reddening of lips and cheeks, lengthening of eyelashes, exaggeration of the size of the eyes by darkening, practiced by Occidental girls of the present decade are of the same nature. In short, on present information, there can be little doubt there is an innate type of physical beauty for man and woman. It consists in a system of general features which most fully satisfy the organism as the goal of the instinct, and

this system is filled out with a lot of associated particular features which are learned. The system of general innate features accounts for the universality of man's susceptibility to physical beauty. The added particular acquired features account for the variability of conceptions of physical beauty in different cultures, classes, social groups, and finally in individuals.

The same considerations apply to other human instincts such as the maternal instinct, and these instincts also furnish general forms of instinctively beautiful objects. The charm of the children in Renoir's *Mme. Charpentier* is probably based on the fulfillment of an instinctive type and would be felt the world over by anyone who loves children.

INSTINCTIVE: 2. INNATE STANDARD FORMS. But there is yet another whole genus of innate types. The instinctive types we have been describing so far are those of the goals of instinctive drives. Those I wish to consider now are in the nature of innate basic forms or patterns toward which we tend to mold our perceptions for ease of apprehension. There are apparently a good many such patterns, but the ones that particularly concern us are the three-dimensional forms of the sphere, cube, cylinder, cone, and pyramid and their simple derivative planes such as the circle, square, rectangle, triangle. Even naming them, we have a sense of their simplicity and naturalness. They were frequently believed to be the forms of beauty in ancient aesthetics, as if they contained a sort of magic. Even now they are sometimes presented in this light in a more or less disguised way. But, as with much primitive magic, there was a factual basis for their being picked out for special notice. The so-called Gestalt (i.e., pattern) psychologists have paid a great deal of attention to them and shown how they work in human perception.

a

b

FIG. 18

They are closely allied with pattern in the manner described in the last chapter. They are simple forms easily grasped by the attention. But they are more than that. There are plenty of other simple forms easily within the range of attention which do not behave the way these do. A plane bounded by four equal curves (cf. Fig. 18 *a, b*) is a simple figure easily grasped by the attention, but we have a strong tendency to make it into a square or a circle. It feels either as if the sides of a square had been bulged out, or as if a circle had been broken at four points and pulled out. That is, figures between the square and the circle do not feel stable and natural, but as if they were temporary distortions of these standard shapes.

So much is this the case that there are many illusions

of perception where we seem to see things in their standard shapes when no adequate objective stimuli are present, or even when the presence of rather weak objective stimuli contradict the standard shapes. For instance, if a segment is omitted from a circle, we invariably complete the circle in our minds, and refuse to accept the figure as a regular curve that stops with two ends. If the point of a triangle is omitted near the top, we subjectively complete the triangle. Similarly, on an even larger scale, with the three-dimensional figures. If we are given any encouragement to perceive a shape as a portion of a cylinder or a cube we will mentally complete half, two-thirds, or even much more of the form. If there is a representation of a number of cubical forms in a hit-or-miss pile, the visible projection of a very small amount of the corner of a cube will lead us to imagine the rest of it extended back into three-dimensional space.

This is the basis of Cézanne's famous statement that all the shapes of nature are cylinders, spheres, or cubes. An artist with a strong sense of form will project these standard forms into nature. This is the aesthetic basis of cubism. And no picture will have a strong sense of three-dimensional solidity that does not work upon this principle — that is, so depict the represented forms, however intricate they may be, that they suggest these innate standard solid forms. The same holds in sculpture and architecture. An examination of the Cézanne (PLATE VIIIA), which has a strong sense of solidity, in comparison with the Fra Angelico (PLATE I), which purposely has not, will show quite obviously what I mean. The only element of fairly pronounced solidity in the Fra Angelico is the Madonna's left knee which supports the infant's shoulders. Here the corner of a cubical form is rather definitely outlined. But notice that her right knee has no substance, for there is no suggestion of a basic cubical form.

We have, then, discovered two kinds of innate types. They are quite different in nature and operate quite differently in aesthetic perception. The objects of instinctive drives (such as the attractive man or woman) are rather general in their innate demands and get filled out in their details by learning. But the innate basic forms (such as the cube), though simple, are complete and exacting to the last detail of line and angle, and accept nothing from learning — or only as much as is necessary to acquire perception of the third dimension. Also, the instinctive goal objects have a major function in releasing, when they are fulfilled, the emotions of the drives that are attached to them. No such emotions are attached to the innate basic forms. These operate mainly as patterns to simplify perception and produce order. Finally, in both these instinctive types, the characteristic pleasure of recognition from the fulfillment of a difficult type, becomes rather submerged. The pleasure of recognition in the instinctive goal object fuses so completely with the upsurging emotional pleasure that it is usually difficult, and not very profitable, to separate them. But in the perception of innate basic forms there is usually not much pleasure of recognition because they

are so common. They operate rather to avoid the unpleasantness of their own nonfulfillment since they are so pervasively demanded, and they operate even to the extent of producing the illusion of their own fulfillment when often this is not objectively given.

Neither of these innate types works, therefore, quite according to the simple rule for the pleasures of recognition. But they are unquestionably types, just the same, and they have tremendous aesthetic force wherever they enter into perception precisely because they are instinctive.

ACQUIRED: 1. TYPES OF NATURAL OBJECTS. These are the most pervasive of the types that are learned. They include our concepts of animals, insects, and plants, rocks, mountains, clouds, waves of the sea, and all objects of nature whatsoever, so far as we recognize them as particular sorts of objects. For the most part we learn them simply in the experience of living, through finding them in our environment and learning to distinguish them one from another.

They are the sources of our delight in representation. For the pleasures of representation are the pleasures in the fulfillment of types derived from nature. Accordingly, these types figure prominently in the representative arts of drama, literature, sculpture, and painting. The first two arts fall outside the range of this volume. For a number of reasons the problems of realism — that is, of the representation of types of natural objects — are not as extensive and varied in sculpture as in painting. We shall accordingly reserve our detailed treatment of the means of employing representation in the visual arts for our chapter on painting.

In this chapter we shall confine ourselves to the question of what these types derived from nature are. This is not an easy question to answer. We all know roughly what types of natural objects are as soon as a few have been pointed out. It is the sort of thing that makes people say when they look at Renoir's painting of the dog in *Mme. Charpentier* (PLATE II), " Isn't that a dog for you! Hasn't the artist caught the very essence of a dog! " But exactly what is it to be " a dog for you " or to be the very essence of a dog? It is important for us to know, so that we can do justice to a picture by bringing to the perception of it the sort of type the artist expected us to have for the full appreciation of his work.

There are, in fact, several sorts of types derived from natural objects. They have been the subject of much controversy in the history of aesthetics and criticism, ever since the time of Plato.

To get some conception of the problem, compare the three pictures, Fra Angelico's *Madonna* (PLATE I), Renoir's *Mme. Charpentier* (PLATE II), and Picasso's *Absinthe Drinker* (PLATE XIX). Each of these makes a powerful representative appeal. Each of them fulfills a type of woman with great effectiveness and satisfaction. But what a different type of woman in each picture! Fra Angel-

ico's Madonna is the fulfillment of a type of spiritual beauty; Mme. Charpentier represents a type of mature, full-blown woman radiating vitality; Picasso's *Absinthe Drinker* is the depiction of a type of woman sunk in disease. An adequate treatment of the values of representation in art must account for the fulfillment of the types in every one of these pictures. For it is clear that in some sense there is a high degree of fulfillment of an idea of a woman in each of these pictures. And clearly the ideas are quite different.

As a point of departure, let us begin with type in the sense of a *class* of natural objects. Any set of particular objects which have one or more characteristics in common is a class. So whatever characteristics are chosen to define a dog, these are the characteristics of the class, dog. Any animal that has these characteristics is a dog. It follows that there are no degrees of fullness of characterization of a dog in barely being a member of the class, dog. Consequently, in order to say of any animal that it is a particularly good example of a dog, something more is involved than barely fulfilling the requirements for the definition of the class, dog.

This leads to another conception of the generation of a type of natural object which results in two other sorts of type. These we may call the *common average* and the *good specimen*. Both of these conceptions arise from detailed observations of the characteristics of individuals within a determined class. These detailed observations usually show that every individual in the class varies a little from every other. If each individual were represented by a dot within a large circle, this individual variation would be apparent from the distance between the dots. Also, there would probably be a greater concentration of dots about the center than towards the periphery of the circle. That is, there are a great many individuals in the class who do not vary a great deal from those about the center, and relatively few individuals who vary greatly from the characteristics of those at the center.

This spread of variation, accordingly, determines an ideal center or median for the total group. The characteristics of an individual in this center are then taken as the norm of the total group. An individual who exactly or very closely conforms to this norm is, thus, regarded as a " good specimen." Individuals of the class or species far towards the periphery, that fail by a great deal to fulfill the norm of the good specimen, are called " freaks " or abnormalities. Then the wide belt of individuals that are neither good specimens nor freaks make up what may be called the common average.

Now the point to note is that the freaks, the common average, and the good specimens are all members of the " class " type which is therefore fulfilled as well by the freak as by the common average or the good specimen.[1] These

[1] Don't misunderstand me here. A freak is by definition not a type, but an individual who breaks a type. A freak is an individual who breaks the type of the common average or of the

three last conceptions are quite distinct from each other and from that of a class, even though they take their point of departure from the conception of a class type. They are also the ones that function most fully in aesthetic perception. The good specimen is a relatively rare type, the very sort that, when fulfilled, can give the greatest satisfaction. And a freak by breaking the type of the common average is an outstanding source of ugliness.

It should be noted, also, that the conception of the good specimen is biologically very significant, for it indicates the traits towards which natural selection has been driving the species for its preservation in the struggle for existence. It represents a point of equilibrium in nature. In this sense it operates as a natural norm — an objective one, which men do not make but discover.

But this median norm or good specimen is the point of departure for another kind of norm, which we may call the *perfect specimen*. This is the biological ideal of the species. It is the conception of the perfectly healthy, fully adjusted, superlatively functioning individual of the species. This ideal, I think, is often confused with the median or merely good specimen. But only by coincidence would they be identical. The median is determined statistically by the distribution of variations, but the ideal is, so to speak, what natural evolutionary processes may be conceived as trying to achieve in the species. It is the conception of the evolutionary goal of the species, or of the maximum efficiency of functioning which the species could achieve within the specifications of the structure of the species.

It is, or at least I believe it would be, pedantic not to accept it as a scientific conception. It is unquestionably being employed constantly by medical men, in determining their conception of health. It is the controlling conception in any factually based program of social betterment aiming at individual and social health. It is, I believe, the conception of the normal man required as one of the conditions of sound judgment in art. This biological ideal for man conceives him in excellent organic condition, with the highest physical coordination, sensory discrimination, intellectual capacity, and emotional integration. And each of these terms can be fairly completely specified. It is, of course, not a static ideal. The ideal man is born a baby, grows, develops, and dies after the normal span of life. But it is a perfect baby (and notice how inevitably we say a " beautiful" one), or child, or youth, adult, or old man.

We find, then, four kinds of factually describable types of natural objects — the class, the common average, the good specimen, and the ideal or perfect specimen. Every individual of a species fulfills the definition of the class, otherwise it would not be a member of the species. Being so common a type, the class is not of much aesthetic significance in daily perception, unless the species

good specimen. But nevertheless a freak fulfills his class type. My point is that the class type is aesthetically negligible because so easily fulfilled.

as a whole is rare. Think of a botanist's excitement over the discovery of a rare plant. But no man is excited on seeing another man just because it is a man and fulfills the class type of a man. Much the same with the common average. But an exceptionally well-set-up man or perfectly proportioned woman will almost always attract a glance of admiration. For here we respond to the fulfillment of the ideal of the species; we respond to the perfect specimen or an approximation to it in a good specimen, and these are rare types.

So far we have been talking about types of natural objects in a rather general way, as if there were just one type for a dog, or a man, or a woman. Actually we develop quantities of types within any one of these species. The greater our experience, the more we develop and the more highly discriminated each type becomes. Among men, we acquire types for every profession and trade — the typical professor, lawyer, doctor, sailor, grocery boy, truck driver, saloonkeeper, political boss, and cop — and for all manner of actions and emotional expressions of men in different situations, which we sometimes call the "reading of character." Our repertory of natural types is enormous. And for practically all of them there is the class, the common average, and the ideal.

But there is yet another kind of type for natural objects that needs to be brought out. We have been assuming so far that these types are intellectually developed, and are subject to verification and correction in the light of experience. Many of our types, however, are emotionally biased. Sometimes this is unconscious, and would be corrected if the bias were called to our attention. But sometimes the bias is intentional. We have already come upon a few extreme examples of this sort of thing in the cultural conceptions of feminine beauty alluded to in the last section. It would often be hard to say how far our ordinary concept of a rose, or a fir tree, or a wolf, or a lion, or an eagle, or any other object of emotional interest to us is distorted from the biological ideal or the median to an emotionally biased conventional ideal. Is not the eagle in the zoo always a little disappointing in the light of our national symbol?

Santayana seems to think this emotional distortion is very common from the bias of either practical or aesthetic interest. Of the latter bias he says, "Not all parts of an object are equally congruous with our perceptive faculty; not all elements are noted with the same pleasure. Those, therefore, that are agreeable are chiefly dwelt upon by the lover of beauty, and his percept will give an average of things with a great emphasis laid on that part of them which is beautiful. The ideal will thus deviate from the average in the direction of the observer's pleasure." [1]

I incline to think Santayana exaggerates this bias — at least, for the present day. From its practical side, there is nothing so practical as the truth. And the aesthetic delight in the depiction of natural objects is overwhelmingly a delight

[1] Santayana, *op. cit.*, p. 122.

in the representation of the truth. There is a strong aesthetic drift in the formation of types to make them conform as nearly as possible to the truth. Nevertheless, ideal types generated out of an emotional bias make up a large part of our repertory of types.

Let us call such types *emotional ideals*. They are the projection of our emotional attitudes about things into our conceptions and even our perceptions of them. They have, moreover, a psychological truth about them, as true revelations of the emotional attitudes they embody. The heroic types of different cultures and social groups are generally of this emotional kind ranging from the emaciated medieval saints to the noble romantic Indians. So also are the gods of the various cultures. And there are emotional ideals of evil as well as of good. Conceptions of devils and dragons are as much emotional ideal types as those of angels and fairies and unicorns and centaurs. In such types the emotions have blown ideal conceptions far from their anchorage in biological fact. Peoples of the various cultures, nevertheless, often believe in their emotional ideals more ardently than in the biological types which their intellect could verify. For these emotional ideals are the coherent embodiments of their fears and wishes, and by the very mode of their creation are vividly appealing.

No one has more understandingly described them than Santayana who has given more attention than most writers to this important topic of the enjoyment of types. " Imaginary forms," he writes, " differ in dignity and beauty not according to their closeness to fact or type in nature, but according to the ease with which the normal imagination reproduces the synthesis they contain. To add wings to a man has always been a natural fancy; because man can easily imagine himself to fly, and the idea is delightful to him. The winged man is therefore a form generally recognized as beautiful; although it can happen, as it did to Michael Angelo, that our appreciation of the actual form of the human body should be too keen and overmastering to allow us to relish even so charming and imaginative an extravagance. The centaur is another beautiful monster. The imagination can easily follow the synthesis of the dream in which the horse and man are melted into one, and first gave the glorious suggestion of their united vitality." [1]

We have, then, distinguished five kinds of natural types: (1) the *class* which every individual of a species conforms to, since it consists simply in the sum of the traits common to the species; (2) the *common average*, made up of all those individuals who are not abnormal nor yet ideal; (3) the median, which is the *good specimen* sought by the collector, those specimens at or near the center of the spread of variation for the species; (4) the *perfect specimen*, which is the conception of a superlatively good specimen; and (5) the *emo-*

[1] Santayana, *op. cit.*, pp. 182–83.

tional ideal, which is a cultural modification of natural objects in conformity with emotional interests.

We are now in a position to consider the aesthetic values of the three types of woman depicted by Fra Angelico, Renoir, and Picasso.

Fra Angelico's *Madonna* is obviously a supremely successful fulfillment of an emotional ideal. He was depicting not a truth of factual observation, but an emotional truth of great depth. For though the conception of the Madonna is a medieval ideal that grew up in the cultural institution of the Catholic Church, it owes its great appeal rather to its embodiment of certain instinctive cravings of man.

This type is so beautifully described by Santayana that I must quote him again: " The Virgin Mary, whose legend is so meagre, but whose power over the Catholic imagination is so great, is an even clearer illustration of this inward building of an ideal form. Everything is here spontaneous sympathetic expansion of two given events: the incarnation and the crufixion. The figure of the Virgin, found in these mighty scenes, is gradually clarified and developed, until we come to the thought on the one hand of her freedom from original sin, and on the other to that of her universal maternity. We thus attain the conception of one of the noblest of conceivable roles and of one of the most beautiful of characters." [1]

Renoir's *Mme. Charpentier* is an equally successful fulfillment of a quite different sort of type. The Madonna is insubstantial and of another world. Mme. Charpentier is of this world. We have all of us at times seen a Mme. Charpentier. She is the essence of a contented mother and housewife, with every evidence of competence and amiability. She is not especially beautiful, but she is very real. She strikes me as a fulfillment of the natural median. She is not represented as anything exceptional, but just as a very fine example of a woman. On the other hand, the little girl sitting on the dog appeals to me as a fulfillment of the biological ideal for a child of that age. Certainly neither Mme. Charpentier nor her children are the common average.

Picasso's *Absinthe Drinker* depicts a human type of still another kind. As far as the woman part of it goes, she breaks a common type because she is abnormal and below the common average. The realism of it lies in the posture and all that this signifies of a depressed state of mind. The picture vividly presents a good specimen of an absinthe drinker. It gives us the essence of the disease. The tragedy felt in the representation arises from the realization of how far this specimen of a woman falls short of the essence of a woman in having succumbed to the complete fulfillment of the essence of a drunkard.

In this exposition of the sources for types of natural objects, I have sought to

[1] Santayana, *op. cit.*, pp. 189–90.

distinguish five kinds as distinctly as possible. Actually in most persons' minds these are considerably jumbled up. Nevertheless in appreciating the vivid realization of a relatively rare ideal type such as each of these pictures embodies, there is probably more clarity in a spectator's sense of the demands of the type than the spectator would believe. If he gets great delight from the recognition of something excellent in a natural object, or its representation, he probably has a rather acute intuitive awareness of the demands of that natural type. He might have great difficulty in putting the demands of the type into words, but he would be quick to recognize a shortcoming in its realization.

ACQUIRED: 2. FUNCTIONAL TYPES. Another kind of acquired type is that based on the purpose for which an object is made. The purpose sets up the requirements which the object must have in order to be of use to that purpose. The associated system of these demands constitutes the functional type. For these demands are called the functions of the object. The more fully and economically an object is perceived to fulfill its functions the greater the delight.

At first thought, this delight in the usefulness of an object seems to contradict our original definition of the aesthetic field as that of things liked for themselves, not for their utility as means to the attainment of other things. But on second thought it will be seen that there is no contradiction. The delight in perceiving that an object fulfills its functions is not the same as simply being satisfied with an object for doing what we wanted of it. The delight in the fulfillment of function is the immediate delight in the *recognition* that the structure of the object conforms to the concept of the purpose. One may have no personal use for the object, and still be delighted in the perception of its functional efficiency. It is a contemplative delight, exactly like that in seeing a perfect specimen of a natural object.

For a thorough treatment of the most important of all functional types in art, we shall wait till the chapter on architecture. Architecture is based on the functional type of human shelter. There we shall see on a grand scale how a functional type operates in an applied art. For an applied art is simply one in which the work of art is both an object of beauty and an object of utility.

But let me repeat — for this point is a novel one to many persons and requires emphasis — the aesthetic value in a useful object is not its instrumental value but the recognition of its fitness to serve its end. The pleasure in the recognition of fitness is a pleasure in perfection, and that is something liked for itself. The mere using of a tool without thought or delight in its fitness for its purpose is not an aesthetic act, however smoothly the tool works. The act may be entirely unconscious — a mechanized habit. But the vivid realization and delight in the perfection of the tool for its purpose even in (and perhaps particularly in) the process of using it — that is an aesthetic value. What is called *functional beauty* is precisely this awareness and delight in the perfect function-

ing of a tool or in its capacity to function perfectly. This delight depends upon the recognition of the fulfillment of a type, which consists of the system of demands required of the tool by the purpose it serves.

ACQUIRED: 3. TECHNICAL TYPES. Closely allied with functional types are technical types. These are the requirements of skill in the production of objects of any kind. Activities otherwise far from the central sphere of art acquire an aesthetic glow from these types. We even hear medical men speak of " beautiful operations," in admiration of the skill and dexterity of the surgeon.

That the knowledge of a skill is a concept of an associated system of actions, and therefore a type, needs no explanation. It is not necessary that one should possess a skill to appreciate the fulfillment of such a type. But just as the people who use things have generally a fuller appreciation of a functional type, so those who perform with the skill generally have a fuller appreciation of a technical type. It is the performer, for example, who can distinguish between that which is hard to execute and that which merely appears so.

Among the arts, technical types are likely to be the artist's particular domain of enthusiasm. An astonishingly large proportion of criticism has to do with technique. Since, moreover, the means-to-end mutation inevitably operates here — for a technique is primarily a means to an end — it is very easy for an excessive amount of attention to be given to technical achievement and perfection among artists. This leads to a thinning down of the aesthetic values of the work. The original ends served by the technique — the sensuous charm, richness of pattern, and emotional power — melt away and dry up, and all that is left is the intellectual perfection of technical form without any content. This is the essence of the " academic " in art. It reduces a work of art to the same capacities of aesthetic enjoyment as a surgical operation.

For these reasons, reference to excellence of technique as a mark of beauty is sometimes frowned upon by lovers of the arts. But if it is not exaggerated so as to crowd out other values of greater worth, it is as legitimate a source of aesthetic enjoyment as the fulfillment of any other aesthetic type. It falls as completely within the aesthetic field as representation, or fulfillment of function, or any other form of intellectual beauty.

There are, it is safe to say, no great artists who were not great technicians in what they were aiming to do. But their techniques are as various as their aims. Compare the technical methods, just the manner of putting on the paint, of Fra Angelico and Renoir. Fra Angelico might well have thought Renoir a very sloppy painter, and his picture a mere sketch that some day ought to be finished. The folds of dresses in Renoir's picture have not been carefully arranged, and the brush strokes are rough and thick. Where is the meticulous craftsmanship of Fra Angelico's *Madonna* in Renoir's *Mme. Charpentier*? Actually, of course, both painters were supremely skillful technicians, and the more one

studies their methods the more one admires their pictures. If one has painted a little, he is likely to have a livelier appreciation of the artist's technical problems, but practice is not absolutely essential for a quite adequate sense of what constitutes technical excellence.

ACQUIRED: 4. FORMAL TYPES. A formal type is an organizing pattern that, having been found particularly successful, becomes stereotyped and is then used over and over again with different filling. When this happens, a form has begun to make its own demands for fulfillment over and above its services as an organizing pattern. It has attained the status of a type, and is something that can be recognized as an old friend and can offer the pleasures of recognition. The fugue and the sonata form in music and the sonnet in literature are good examples of this.

Formal types are generally intrinsically beautiful as patterns, and difficult to fulfill with finish and distinction. The delight in recognizing a perfect fulfillment of a formal type is thus something added to the beauty of the work over and above the beauty of its materials, pattern, and design. A perfect sonnet is more than a perfectly organized lyric. It is also a fulfillment of a difficult type. It has a different flavor from a free lyric, from the very fact that it obeys the laws of a recognized form.

In the visual arts there is relatively little employment of formal types. But the use of "styles"[1] in architecture as forms of design for building amounts to

[1] This question of the appreciation of styles involves the controversial issue of cultural relativism. Cultural relativism (cf. Chapter I, p. 5) makes style its central concept, and maintains that the whole aim in the study of art is the description of the stylistic traits of different cultures and of their relations and transitions one to another. If a cultural relativist ventures to make aesthetic judgments on the value of works of art, the standards for his judgments are the cultural styles he has discovered in his research.

On the basis of my approach in the present volume, the cultural relativists are virtually elevating a certain group of aesthetic types to the level of ultimate standards for aesthetic judgment. Their procedure appears to me to limit the horizon of aesthetic criticism unnecessarily and without sufficient consideration for the universal traits of human response. But the sweep of their procedure shows how important a place stylistic types have in the history of art and in the history of aesthetic theory.

Since I do not wish to argue this issue here beyond the statements made in Chapter I, let me merely point out that it is one thing for a critic to use a stylistic type as a standard applied to a work of art from without, another thing for an artist to use a stylistic type as a pattern for the composition of his materials from within. It is one thing for a critic to judge the degree in which a twelfth-century cathedral in England represents the style typical of the period. It is another thing for an architect to plan a cathedral in Washington in the twentieth century in English Gothic style. The American architect of the Washington cathedral is employing Gothic style as a formal type inherent in his work of art and relevant to the appreciation of the building, just as a composer plans a movement of a symphony in sonata form.

In pointing out that stylistic types behave as formal types in some works of architecture, I am only referring to works like the National Cathedral in Washington. It is relevant to the appreciation of this building that a spectator should realize the degree in which it fulfills the character of English Gothic style. No such formal type is relevant to the appreciation of, let us say, Rockefeller Center in New York — and, moreover, never will be.

the use of formal types. When a nineteenth-century house was built in Elizabethan "style," or Francois Premier, or Georgian, or English cottage, or Mediterranean, or early Colonial, the patterns of these historical or local "styles" behaved as types to be recognized. They gave pleasure in the faithfulness with which they produced the spirit (that is, offered an imaginative fulfillment of the "stylistic" characteristics) of their sources.

We are at present so passionately involved in the issues over modern functional versus so-called traditional *beaux arts* architecture that I suppose it is useless to try to get some perspective on the scene so as to perceive "style" designed buildings as they were intended to be perceived. Some of the modern school talk as if a "style" building could not possibly fulfill its functions as a shelter. This is, of course, ridiculous. Many "classical" buildings are still serving the functions for which they were made, and serving them well. Nor in defending "styles" is one committed to defending all examples of "style" architecture, much less to opposing the functional modern movement. The only question is whether there are not some buildings composed in a "style" which are also objects of great architectural beauty, and which owe some of their beauty to pleasure in the recognition of how completely and with what distinction they fulfill the spirit of the "style" they exemplify — just as a perfect sonnet fulfills the spirit of the sonnet form without literally copying any other sonnet.

In short, a complete and imaginative fulfillment of a "style" in a building (or any other object of applied art) may be a distinct source of aesthetic delight. It would be pedantic to deny beauty to a considerable number of modern Gothic chapels and cathedrals. And quantities of very satisfying private houses are built in "styles."

ACQUIRED: 5. TYPES OF SUSPENSE. Suspense is due to a combination of type and impulse. It consists in the anticipation of certain future results on the basis of certain present conditions. The general form of the way events are likely to go is thus conceptually known and is a type. Its fulfillment is looked forward to. But just how the fulfillment of the type will occur, or even whether there will be complete fulfillment, remains in doubt, and this is the suspense. The suspense may be intensified by skillfully playing on the form and prolonging the doubt — by teasing the spectator, in short. The teasing may, however, be overdone, and get too unpleasant, and the spectator may then lose interest and stop following the developments rather than be irritated further. The fascination in suspense arises from the intensified tension in anticipating fulfillment of the type, and consequent intensified pleasure upon final fulfillment.

There are three pre-eminent types of suspense, all of them occurring, as one would expect, in the temporal arts — namely, plot structure in narrative literature, logical structure in essay literature, and tonality in music. In the spatial

visual arts there is nothing comparable. The nearest thing is the anticipations aroused from the exterior of a building as to its interior planning. Or in parks and gardens, some suspense may be aroused by the arrangement of hedges and paths.

Exceptions to the Law of Type Fulfillment

We have now completed our survey of the most important kinds of types, and the manner of their fulfillment. In all these kinds the general law we formulated on page 91 holds that the greatest aesthetic value comes from the intense pleasure in the recognition of the fulfillment of a difficult type. There are, however, certain important exceptions (or apparent exceptions) to this rule, which cannot be passed by. I will discuss them in the following order:

1. Negative types or aesthetic conventions
2. Hierarchies of types
3. Superiority to type
4. Comedy

1. NEGATIVE TYPES OR AESTHETIC CONVENTIONS. Negative types are a seeming, rather than an actual, exception to the general aesthetic law of types. Where they enter in they are very important, and, if not recognized, they lead to a complete misunderstanding of a work of art, and obstruct its appreciation.

We have been describing types as systems of association demanding fulfillment. Negative types present the apparent anomaly of sets of associations which one must *not* ask be fulfilled. These are very numerous, and most of them are so completely taken for granted that we do not notice them at all; which is quite the ideal condition for them to be in. For there is no pleasure to be got from them, yet if their negative demands are not accepted, they can completely disrupt a work of art.

They are such things as the conventions of the stage in which the spectator does *not* expect the duration of a scene to correspond exactly to the duration of the represented events in real life, but accepts condensation. The spectator does *not* require the action to be continuous, but accepts the convention of gaps of time between scenes. He does *not* expect an exact replica of the scene in real life, but accepts, even in the most realistic plays, the absence of one wall of a room and the orientation of all the actors towards the absent wall; or, as in many Oriental and modern plays, he accepts practically no scenery at all, and a chair will symbolize a house, a gesture of a leg will symbolize getting off a horse, and walking round and round the stage will symbolize a long journey through the country. The spectator does *not* require the actors to talk just as they would in real life, but accepts a more condensed and better articulated

speech, possibly blank verse, and, in the opera, singing of the words. These, and like conventions, are *not* to interfere with the sense of realistic representation. They are *not* to be taken as absurdities and failures on the part of the artist in the fulfillment of types of natural objects or events.

Such conventions have to do mainly with types of natural objects. Consequently, they are to be expected in the visual arts of sculpture and painting. These arts are full of them. One should *not* require a statue to be colored, *not* require pupils in the eyes, *not* be surprised that a head has no body. In a painting one should *not* expect the actual third dimension, *not* object if part of a figure is cut off by the frame, *not*, in short, expect one type of realistic rendering to follow exactly the demands of another type, or to be an exact copy in every detail of our conceptions of the real object represented.

From these last remarks, we get an insight into just what aesthetic conventions are. They result from conflicts between two conceptions of representation, or between a conception of representation and a conception of the appearance of the real object represented. The conflict consists in the fact that the fulfillment of one of these conceptions is incompatible with the fulfillment of the other. The conception of having characters of a play converse in blank verse or in singing conflicts with the conception that in real life they converse in loose prose. As long as the prose conception of representation has dominance over the poetical, it is impossible to enjoy the poetical conception as the fulfillment of a type of representation. To a prose-minded man, an Elizabethan play or an opera breaks his type of representation and appears silly or funny, even though the poetical type is fulfilled very well. Similarly, to a man who conceives that a statue should represent the whole human form a bust seems funny.

What an aesthetic convention does is to relieve one type of representation from the demands of another. An aesthetic convention, therefore, is only apparently, and not really, an instance of aesthetic value in the breaking of a type. It consists merely in requiring that a type, which is irrelevant to a work of art, should not be applied or allowed to interfere with the fulfillment of the types which are relevant and incorporated in the work. An aesthetic convention is simply a means of guaranteeing full enjoyment in the fulfillment of the types relevant to a work of art without interference from those that are irrelevant.

Mention of aesthetic conventions brings to our attention play activity and the important aesthetic principle of *psychical distance*. To an unsympathetic adult, children's play seems silly, just as to Tolstoy the opera seemed silly. Of course, the children's play is not silly to the children. It is fun. For the children " enter into " the game. That is, they all accept its conventions. They frankly begin their play with, " Let's play Indian," or " Let's play store, or house," and with immediate mutual understanding they set up the conventions of the game. Children's play is thus aesthetically very illuminating. It shows us that in a

profound sense our representative arts — drama, narrative literature, sculpture and painting — are adult play. The play theory of art made famous by Schiller and Herbert Spencer had its origin in this insight, and erred only in over-emphasizing this one point to the subordination of everything else. That well-packed phrase of Coleridge that the aesthetic attitude is a "willing suspension of disbelief" springs from this same source. That phrase is worth dwelling upon. It comprises the whole aesthetics of negative types — both their negative role of noninterference, and the spectator's positive role of submitting himself to them so as to enter into the game.

Now in order for children to play they have to have a sense that what they are doing is not actually "real"; they must keep a distance between what they are doing and "reality." This is the psychical distance, and when this is lost, the playing stops. When a couple of little boys playing Indian forget them-selves and really begin to fight, the game is broken up. The game depends on the maintenance of the psychical distance.

This example is a good one because it shows both of the two modes of psy-chical distance in mutual reinforcement — namely, (1) *emotional distance* and (2) *representational distance*. In order for the game of Indian to remain a game, the participants must not really get angry and fight to hurt, but only pretend to do so. They must maintain their emotional distance. But in this instance their emotional distance is maintained by means of representational distance. For as long as they do not forget that they are only playing Indian, they will keep within the bounds of playing and not get too serious and really fight.

The bearing of this on the fine arts must be clear enough. When a novel touches a reader so closely that he cannot read it any longer and has to put it down, the reader has lost his distance. When an audience at a play hisses the villain and warns the heroine, then the spectators have lost their distance. When a picture is too horrible to look at, it has lost its distance.

In all of these instances both emotional and representational distance are involved. But there are instances where each is involved without the other. A man in a boat during a storm at sea may enjoy the storm as long as he believes he is secure in the boat. Here the emotional distance is produced by belief in the security of the boat. There is no representation or make-believe involved. If he lost confidence in the safety of his boat, he would really become afraid, lose his emotional distance, and act to save his life. There are also instances where representational distance is involved without emotional distance. Ques-tions of emotional distance we shall leave for the next chapter on emotion. But representational distance is a matter of negative types, and should come up here.

Sometimes there is an unpleasant effect from the lack of sufficient representa-tional distance even when no serious emotions are involved. An experience of

mine at Mme. Tussaud's Waxworks in London will illustrate this. Extremely realistic wax figures were arranged in stalls about galleries. After passing through a number of galleries looking at famous men and scenes of the past, I thought I would rest a bit, and sat down beside a lady on a settee who was also gazing at the group before me. Presently a creepy feeling came over me. I glanced suddenly at the lady. She was made of wax!

Now she represented just any ordinary London lady, the common average type. As a real lady in the gallery, she would not have attracted a glance. As a figure in a painting, she would have pleased only because of the skill in her representation. My reaction, then, did not come from the fulfillment of a type, but from the breaking of one. I believed her to be real, and then suddenly became aware that she was not.

The first effect of this recognition was very disagreeable, like that which follows stumbling at the foot of stairs, when one has mistaken the last step for the landing. Of course, just as one does after stumbling off a step in the presence of company, I immediately laughed at myself and enjoyed this practical joke played at my expense. The people standing around, who saw me, got still more pleasure from it. The fascination for the Waxworks arose from this sort of incident. One went there to be shocked and amused by the breaking of type, and to see how scared he could get in perfect safety.

But the Waxworks were not great works of art. For all one's admiration at the skill in the art of illusion which they manifested, one never thought of them as masterpieces of realism like Velasquez's portrait of Pope Innocent X (cf. PLATE VI). The reason was that they lacked representational distance.

Naively one might think that in the fulfillment of a type of natural objects, the more like the real object the representation is the more complete the fulfillment of the type. But this is far from the case. A chair, for instance, made just like another chair, is just another chair and not a representation at all. No pleasure of representational fulfillment enters into the object at all. And, as we have just seen, a representation so close as to be illusory turns out actually to function as the breaking of type, not as fulfillment. Consequently, in aesthetically excellent representation care is seen that there is plenty of representational distance to keep even the suspicion of illusion far away.

A considerable thickness of aesthetic conventions is the principal means of producing this necessary distance. Paradoxically some of the most vivid realism is achieved while maintaining wide representational distance. The Chinese painting (PLATE IV) is an example. The convention here limits the artist to a minimum number of black strokes on a sheet of white paper. Yet a vivid realization of a horse with a man resting under a tree is achieved.

Frames for pictures and pedestals for statues are also means of helping representational distance. But great care must be taken with sculpture in the round,

since it lacks the limitation of two dimensions which pictures can always utilize. That is one reason why sculpture is rarely colored, or, if color is laid on, it is frankly conventional. The Greeks, we are told, colored their statues in this way with simple obvious areas of color and no attempt at realism. The Renaissance sculptors found the remains of Greek statues with the color worn off, and they thought they were imitating the Greeks by finishing their statues without color. Their aesthetic instinct was sounder than their archeological knowledge, for they must have felt the advantage of representational distance gained by the convention. Simplified and conventionalized modes of representation, of course, also serve the same purpose.

Aesthetic conventions are, therefore, of great importance in art, even though they are generally unnoticed, and are functioning best when they are so.

2. HIERARCHIES OF TYPES. Many types come in series of progressive difficulty or rarity of fulfillment, the last of the series being our conception of the perfection of the type involved. We have alluded to these hierarchies of types on occasion before, as, for example, in our discussion of how types of natural objects extend from the common average to the good specimen and thence to the perfect specimen. But the most notable example is that of the hierarchy based on degrees of skill among technical types.

An apparent exception to the rule of enjoyment in the fulfillment of types comes out among these hierarchies. An illustration will bring this out. A friend of mine who is a good amateur violinist and so has an intimate understanding of this instrumental technique, heard Heifitz for the first time at one of his earliest mature performances. My friend was amazed and tremendously excited at the concert. He exclaimed, " It is impossible! What that man does is beyond the powers of man to do! " In short, Heifitz broke the highest type on my friend's ladder of technical types for the violin. And my friend got an ecstatic delight in having that type broken.

This incident is, however, only a seeming exception, for the conditions determining this still higher type of perfection lay in the lower rungs of the ladder. Heifitz put another rung on the ladder beyond what my friend thought was humanly possible and thereby created a new and higher type of perfection which was fulfilled at the creation of it. For one who knows a kind of type well and has acquired a deep interest in it, there is no greater aesthetic enjoyment than the supreme satisfaction that comes from witnessing the complete fulfillment of a type beyond all expectations of the possible demands of such a type. It is the experience of being present at the birth of a new ideal.

This sort of satisfaction is one of the sources of fascination in sports — the thrill of seeing a record broken. One can learn a great deal about the fine arts from studying the sources of enjoyment in games and sports — for many of the sources are the same but appear in a simpler, more homespun way. The latest

record breaker in the pole vault had a skill at the top of a hierarchy of types which did the same for his admirers that Heifitz' skill did for his. But Heifitz is the greater artist partly because of the greater complexity of his skill, but mainly because his skill is embedded in rich sensuous delights.

Heifitz, by creating for my friend a new ideal of technical perfection, automatically dropped to a second level all the artists my friend had previously enjoyed for being at the highest level. Thereafter my friend could not get quite as much delight out of his former favorites as he did before. Did my friend then gain in the long run from Heifitz' surpassing his former easier standards?

This raises an interesting question. The one relevant general principle to remember is that low standards do not make for great aesthetic enjoyment, for the more difficult the type the greater the pleasure in fulfillment.

But the question also brings out a matter of practical attitude toward hierarchies of types which may not have occurred to everybody. One can keep his standards so high and insist on perfection so much that he makes life quite unpleasant for himself and everybody else in his neighborhood. There is, of course, no necessity for this. Personally I always suspect such a man of not being very secure in his standards, of being a perfectionist in order to bolster up his own doubts about his judgments.

Let us take an extreme case. A music critic is invited to come to a little party and listen to the playing of a violin teacher's beginning students. Now, in terms of Heifitz, all the playing, of course, is execrable. The critic could go and apply these highest standards to the children, if he likes, and have a miserable afternoon. On the other hand, he can have quite a pleasant time if instead, as each child comes up, he sets his standard for the performance at what he gauges would be very good playing for a child of that age and length of studying. This standard may then be fulfilled, with a degree of satisfaction accruing. Not that he can get a great thrill from such an arbitrary pegging of an intrinsically low standard. But he is putting himself in the way of getting some little thrills from unexpected proficiency in some of the children. And then he can honestly say that he enjoyed so-and-so's playing and can spread the little pleasure he has got among others.

The advantages of this sort of aesthetic consideration is clear enough with children. It applies equally to other performers farther along on the ladder. A sympathetic hearing does not mean a slovenly hearing. It usually means a more precise knowledge of the ladder of skills than that possessed by the hypercritical listener. One does not have to be sour and point out the shortcomings of everything but the best to uphold one's reputation as an exacting critic. Besides, works of art are made primarily to be appreciated, not to be criticized.

We have dwelt upon a musician's technique to explain the workings of the hierarchies of types, because here a technique is separated from the other ele-

ments in a work of art. But the same principles hold in the appreciation of technical skill in architecture, painting, and sculpture. There are hundreds of second-rate painters whose pictures can give a great deal of delight. One need not apologize for them as being less than a Renoir or a Picasso. Any sensible visitor who sees such pictures on your walls should know that you know that these are not among the greatest paintings in the world. In the basement of the National Gallery, Washington, I recently saw several rooms of second-rate primitives from the Kress collection. They are not on the top rung of technical achievement like those in the upstairs galleries. But anyone would be stupid to set his standards so high that he could not enjoy them.

3. SUPERIORITY TO TYPE. In what we are calling superiority to type, there is a literal breaking of a type, but at the same time a confidence that the artist who breaks it knows what he is doing and could have fulfilled the type to the letter if he wanted to. One of the clearest examples of this sort of thing is in speech. Correct English consists in following the rules of pronunciation and grammar for standard English speech. There is a rather rare pleasure in hearing the English language spoken perfectly. At the same time there is a reservation in one's satisfaction. Such correctness is more likely to be heard from the lips of a highly educated foreigner than from an American. From the lips of an American, perfectly correct English sounds a bit pedantic. It is " faultily faultless." From an American speaking his native tongue, we want more than correctness; we want vitality of speech. We welcome a little slang, and more or less unauthorized turns and twists of speech, which signify that the speaker is superior to his instrument and uses it to please his purposes and not as a limitation. But we are delighted with this freedom only if we have the sense that the speaker knows the rules he is breaking and is not breaking them because he does not know any better. We have to feel the speaker's superiority to the type. Otherwise we are simply amused or offended.

The same with good manners. For manners are types applied in our social life. The " gentleman to the manor born " differs from a " gentleman to the manner acquired " precisely in that the former is so at home in his good manners that he can break them without offense, whereas the latter dare not break a type of decorum for fear people would think he did not know any better.

Now great artists are men whose techniques are as natural to them as their native language. One of the surest ways of distinguishing a good student's drawing from a master's is that the student's work is so much more correct. It follows the rules but it misses the spirit. An academic work is precisely one that is too correct, one so confined by the literal rules of types that no vitality issues from it.

A close examination of practically every one of the illustrations used in this book will show slight (or often considerable) breaking of types in the interest of imaginative vitality. To point out one instance already referred to, take the

flowers and the vase in Renoir's *Mme. Charpentier* (PLATE II). According to the realistic demands of type for these objects, they should have been represented as faithfully and in as much detail as the other still-life objects in the corner. But Renoir seems deliberately to have blurred the outline of the vase and the right side of the bouquet in order to improve the pattern of the picture. He was not afraid to break the demands of realism for the improvement of the total composition. Yet we do not doubt he could have finished these items to the last detail and highlight. He was superior to this type. Similarly, see how carefully he painted the mother's hands, yet how sketchily he did her dress. He did not let the naturalistic demands of her dress lure him into dispersing his interest away from the essential features of the picture.

Superiority to type does lead to the literal breaking of type for the greater aesthetic advantages gained. Yet in a way it implies the fullest completion of the type. For the type is fully recognized even in its nonfulfillment. In fact, pleasure is taken in the implicit fulfillment of it just because it is so understandingly not fulfilled. So even here the exception to the general rule about types is more apparent than real.

4. COMEDY. In comedy the exception to the general rule about types is real and complete. For in comedy there is actual delight in the breaking of types. This is so paradoxical that it could hardly be believed if we were not daily so familiar with it.

Though many volumes have been written on laughter and comedy, the subject has never been completely exhausted. On the whole, three main ideas about it have descended to us out of the past. (We are not, of course, interested right here in physiological laughter which is a reflex from tickling. That is something other than comedy.) The first idea is little more than the proverb that " incongruity is the soul of wit." The second is the so-called degradation theory that we enjoy seeing people in trouble whom we have envied and towards whom we feel inferior. The third is Hobbes's " sudden glory " theory that we enjoy the mistakes of others because they make us aware of our superiority. The second theory has received a detailed expansion by the Freudians, the third along a certain line by Bergson. If we put the three theories together, we get a fairly satisfactory view of this peculiar phenomenon.

The incongruity idea picks out the necessary prerequisite of all comedy, but it is not sufficient. Incongruity, of course, means the breaking of a type. It is incongruous for an army officer on parade to slip in a mud puddle. It breaks the type of a proper officer. Without the incongruity it would not be funny. But, as we have plentifully seen throughout the preceding section, the normal reaction to the breaking of a type is not pleasure but pain. The army officer does not find it pleasant. The glee of the privates over the episode requires some added explanation.

The degradation theory furnishes it. The privates are the officer's inferiors, and have a lot of dammed-up resentment against the officer, and, by analogy, against the whole officer class. They are prohibited by the institution of the army from indulging their hostility. But when the officer slips, through no infringement on their part of army regulations, a permissible vent is given to their stored-up resentment and the release of this emotional charge is pleasant and comes out in laughter.

But the superior officers are likely to find it funny too. To some extent their pleasure may come from thinking how they would have felt if they were privates. But the reaction is probably more direct than that. This is where the superiority or " sudden glory " theory comes in. This officer's slip gives them a sudden sense of their superiority, and that is pleasant. They would not have slipped in the puddle. Notice, too, that there is a different flavor to the superiority joke. It is not quite so explosive, or so biting. It is much more indulgent. It may even be affectionate, and better termed " humorous " than " comic."

It should be added that for the full aesthetic effect of comedy much depends upon the " form " in which it is presented — its design and pattern. Its details should build up to a climax. The incongruity should break suddenly and with complete surprise. It should be fresh. And the presentation should be compact. There is nothing so dull as a stale joke, or so tiresome as one that does not come skillfully to the point.

This combination of factors, I believe, adequately accounts for the nature of comedy and for the pleasure it gives in the breaking of type. It also explains why the same incident will seem awfully funny to some people and disgusting or tragic to others. If the breaking of a type affects one too closely, one cannot laugh. Some emotional distance is required. Or put it the other way: as long as one can laugh at one's misfortunes, it shows that they are not overwhelming him, that he has a resiliency in handling them, that he can still stand off in spirit and look at himself as others see him. He still has a sense of proportion, a sense of humor.

This is why comedy is so great a social force. It is a wonderfully effective means of social criticism. George Meredith dwelt upon this side of comedy in his well-known essay, *The Idea of Comedy and the Uses of the Comic Spirit.* All social institutions are, from the aesthetic point of view, types. They are, furthermore, types containing a high emotional charge. They are the materials out of which most comedy is built. The conservative who is satisfied with them is, so to speak, above them and is amused at people represented as breaking them because he feels superior to such people. (If he is incensed, it means he is really afraid the institutions may not be sound, and is apprehensive about his security.) The liberals who are irritated with the institutions are below them,

so to speak, and are delighted when these types are broken because it releases their hostilities to them.

Thus through comedy the conservatives can make fun of the liberals, and the liberals of the conservatives, and neither will take offense at the other as long as both appreciate the comedy. The tension of hostility in each group is released in laughter, and the implied criticism has a chance to pass by the moral censor under the magic password " only joking," and so to penetrate the emotions which support the hostility. In this way comic criticism is tremendously effective, because it gets through our intellectual barriers and touches our emotions directly. It lays bare the grounds of the tension, and if it does not actually exhibit the truth of the situation, it uncovers some vital evidences from which the truth may be gathered.

It follows that there is nothing more serious than joking. At the end of Plato's *Symposium* Socrates, arguing in the wee hours of the morning with Aristophanes, the writer of comedies, and Agathon, a tragedian, maintains that the Spirit of Comedy is identical with the Spirit of Tragedy. This idea itself was a magnificent joke. It contains an essential truth. Both great comedy and great tragedy grow out of deep human conflicts. The material out of which they are made is the same. It is only the treatment that is different.

In PLATE VII is reproduced one of Daumier's pictures. He is one of the great satirical artists. He used his painting deliberately for social criticism. His cartoons appeared regularly in Parisian papers and were very popular and very effective. The picture reproduced in this book is a deeply thought-out satire directed against the popular love of the melodramatic. The concept of this popular attitude is a type. Daumier, like all sincere lovers of art, felt that it was a meretricious attitude, and hated it, and wanted people to see for themselves what an insidious thing it was. So, he satirized it. That is, he broke the type by exaggerating certain features of the popular attitude, so presenting it for ridicule. He picks out the juiciest possible scene of an enraged man standing over his prostrate rival with a woman tearing her hair, and puts this upon the lighted stage in the background of the picture. Then in the half-light of the foreground he paints the grimaces of released sensuality on the faces of the common Parisian audience, who swallow the scene bait, hook, and sinker.

This is not exactly an hilarious picture, perhaps because the satire is so effective a criticism that it touches a weakness in you and me. It raises an unpleasant question. What about our enjoyment of the modern movies? Are you and I, after all, much better than these common Parisians?

This picture of Daumier's is so serious that some may question whether it is comedy at all. But it has all the form of comedy. It exaggerates. It makes fun of this audience and this play, and if we can draw back from its emotional impact

and increase our emotional distance, it will produce a laugh. The field of comedy extends far beyond the after-dinner joke. Great comedy as in the Falstaff scenes of *Henry IV*, in Molière's plays, in *Don Quixote* may have all the depth of tragedy, and almost as great a sweep. Someone has said there is no more tragic figure in Shakespeare than Falstaff.

C H A P T E R 6

EMOTION

What Is Emotion?

EMOTION and type are at opposite extremes in the domain of art. For type represents the epitome of the rational element. It is form in its most intellectual aspect, form in the shape of a concept. But emotion is the term for the irrational element in art, signifying the presence of vital impulse.

Form and emotion have long been at odds in aesthetic theory and in the doctrines and ideals of critics and artists. Periodically there are classic periods when reserve and form and the ideals of reason are held up for approval, and then come romantic periods when emotion, vividness, and vitality are the thing. Each school looks down on the other. To the formalist the expressionist is vulgar and unrefined and has no discriminating appreciation of beauty. To the expressionist, who believes that the chief value of art is in the expression, embodiment, and communication of emotion, the formalist is academic, dry, sterile, and without feeling for beauty.

Our position in this book is that since both form and emotion are sources of immediate delight, they are equally important in art and aesthetics. They are, in fact, never completely divorced from each other, though the degree of appeal to one or the other may vary greatly from work to work. Indeed, when all that is signified by form and all that is signified by emotion are brought out into the open, the quarrel between the formalists and the expressionists may begin to seem even a little naive and pointless.

For we have seen that the traditional term " form " covers three quite different things. It includes design, pattern, and type. Similarly we shall discover that the term " emotion " covers a wide range of somewhat different things, which, however, are not so easy to discriminate as the distinctions of design, pattern, and type. For the latter are based on clearly understood psychological conditions — on sensory and attentive fatigue for design, attention span for pattern, and conditioning or the laws of association for type. The psychological conditions which divide the kinds of feeling generally called " emotion," however, are by no means so well understood.

One of the difficulties in studying the general field of emotion is that feelings are very hard to observe. When we turn a rational, analytical eye upon a feeling, it vanishes. At least the emotional activity is not what it was before the analytical activity began to pry into it. But if we can begin our study with an adequate theory of emotion at the outset, we should find the subject easier to examine.

I am going to suggest that "emotion" covers three different matters within the aesthetic field: namely, *sensory fusions, instinctive drives*, and *moods*. These have been much mixed up with one another in the past. They do have overlapping effects on one another. But I shall try to distinguish them for the better understanding of the subject. Then I shall discuss the ways of stimulating emotion through works of art, followed by the topic of emotional organization in art. Finally, I shall consider two peculiar problems of emotion in art — that of tragedy or painful emotion, and that of sentimentality or false emotion.

THE JAMES-LANGE THEORY. One of the most important steps in the clarification of emotion was made by William James, and simultaneously by Carl Lange, who developed what has since become known as the James-Lange theory of emotion. Reduced to simplest terms, the theory states that the substance of an emotion is simply a cluster of sensations psychically fused into a single quality which is taken as the quality of the emotion.

Formerly an emotion like fear was regarded as an unanalyzable mental state. Certain environmental objects, such as a bear or a cobra, were thought of as stimulating this emotional state, which was followed by the bodily expressions of the emotion, such as trembling, paleness, dilation of the eyes, disturbed breathing, increasing heart beat, and running away. On the old theory a man saw a bear, was afraid, and ran. On the James-Lange theory, a man saw a bear, ran away trembling, pale, and out of breath, and in the fusion of the sensations of running, chill, and being out of breath, felt fear.

The simplification resulting from this theory was enormous. Emotions were no longer mysterious hidden entities, private and incommunicable. They were merely fusions of common everyday sensations with which we are all familiar. The peculiarity of the emotion is the psychical fusion of these everyday sensations. This fusion produces a new psychical quality different from the qualities of the individual sensations fused, and yet related to these qualities quite recognizably, if you have been aware of these qualities separately.

The fruitfulness of such a theory of emotion for purposes of aesthetic analysis is obvious as soon as one begins to take stock of it. At least as a working hypothesis, no comparable theory has emerged since. I propose, therefore, that we accept it at least as a working hypothesis, and proceed on the assumption that much of what is ordinarily referred to as emotion is a fusion of sensations. In fact, I shall hold that with the exception of what I call "moods," everything ordinarily denoted as emotion is describable as a fusion of sensations.

These fusions, however, are of two sorts: those made up largely of *external* sensations as varied as the combinations of stimuli that impinge upon an organism in any environmental situation, and which I shall call *sensory fusions;* and those made up mainly of rather specific patterns of *internal* sensations which constitute the feelings we have of our *instinctive drives.* The latter I shall call drive emotions.

Both sensory fusions and instinctive drive emotions are of great aesthetic importance. But they function quite differently in the arts. The instinctive drives enter art as a body of aesthetic materials to be organized. But sensory fusions operate as organizing principles in gathering together a great variety of sensations into a single emotional quality.

SENSORY FUSIONS. Now, let me point out some of the characteristics of sensory fusions as they apply to art. What is meant by a sensory fusion? A couple of very simple examples will make it clear. The taste of lemonade, for instance, is a sensory fusion. It is composed of the sensations derived from water, sugar, and lemon. We know what each of these ingredients tastes like alone. Knowing this, we can trace the taste of each in the taste of lemonade. But the taste of lemonade is a distinct taste from the tastes of its ingredients. It has a character all its own. This distinctive character of the lemonade taste is the quality of that sensory fusion.

The same sort of thing can be felt in a musical chord. Take the familiar tonic chord composed of the tones C-E-G. We are familiar with the sound of those notes separately. When we hear them together in the playing of the chord, we can trace the quality of each in the quality of the chord. But the quality of the chord is a unique and distinctive quality resulting from the fusion of the qualities of its components.

Now let us apply this same principle to things much bigger. Take a quick glance at the Fra Angelico *Madonna* (PLATE I) and then quickly glance at the Matisse *Odalisque* (PLATE XX). Isn't there a shock from the difference of character between those two pictures? Now, you can analyze that difference in terms of the colors, composition, subject matter, and all the other elements that go to make up those two pictures. But the distinctive over-all character of each picture remains as something different from the characters of the elements. This intuitively grasped character of the total picture is its fused quality. And to grasp that character is to react emotionally to the picture rather than analytically.

I just spoke of the total fused character of the picture being intuitively grasped. An emotional intuition is nothing other than the capacity to get a fused perception of a thing. In practical life we do not talk very much about our intuitive perceptions because whenever a problem arises we have to analyze its source among the elements of the situation producing it. Thus there tends to be an opposition between intellectual practical analysis and intuitive aesthetic

perception, and a tendency to overlook the very common presence of the latter.

There are some who identify aesthetic experience with this sort of intuitive perception of the total fused character of a thing.[1] There is much to be said for the view, though we are not insisting upon it in this volume. We are simply pointing out that all well-composed works of art are susceptible to this sort of emotional grasp, and that it is something to be noted and sought after.

Since a sensory fusion is the fusion of just those sensations of which a work of art is made, it follows that the emotional quality of each work of any great degree of complexity is unique. Just that particular configuration of sensory elements which constitutes that particular work will never occur again. The emotional character of the Fra Angelico is unique to that picture, and that of the Matisse unique to that picture. Hence the stressing of the individuality and non-duplicability of all great works of art.

It follows, furthermore, that there is no way of communicating the specific emotion or sensory fusion of a work of art except through the stimulation of that particular work. Verbal analyses are no substitute, nor any other kind of analyses. For the peculiarity of such an emotion is precisely its fusion of that particular configuration of sensations. By words a spectator may be led into the presence of the emotional character of a work of art, but the intuition of that character must be achieved by the spectator himself. Only he can actually fuse the elements there to be fused. But that fusion is almost inevitable in a well-organized work of art, once the elements are discriminated — or for a sensitive spectator, even before they are separately discriminated.

There is good reason, then, to believe that well-organized works of art communicate their emotions, their sensory fusions, with great precision. A work of art is, in fact, as Tolstoy and other writers have insisted, a vehicle for emotional communication. If there is any question about just what is being communicated, the materials of the emotional fusion can be analyzed into their sensory elements and a verification obtained. If you wonder what the character of a musical chord is, you analyze it into its constituent tones. You are pretty well assured the fusion of these tones will be the same for different individuals if they agree about the constituent tones. Similarly with a well-organized work of art like the Fra Angelico or the Matisse.

This is the sort of thing Prall is saying about music when he writes, " Music can not be translated. It is never just fear or hope or exultation or love, but that precise sensuous structure of passion given in the sensuous medium. As music may be solemn or gay, or rhapsodic or triumphant, so obviously enough any particular music expresses its own particular degree, and in its absolutely

[1] For a consistent approach to aesthetics from this single viewpoint see S. C. Pepper, *Aesthetic Quality*, Scribner, 1938.

determinate pattern and fullness, just that precise, determinate feeling that is externalized in its determinate form and filling of sound." [1]

This, then, is one sense of emotion, and a very significant sense for the arts — emotion as any sensory fusion of environmental stimuli. When the environmental stimuli are complex, well-organized objects, such as works of art, these emotions are unique to each such object, specific in quality, and precisely communicable for all persons capable of a discriminating perception of the objects.

INSTINCTIVE DRIVE EMOTIONS. We now turn to the second sense of emotions as fusions of sensations connected with instinctive drives. Drive emotions differ from sensory fusions in that they consist of rather definite sets of sensations correlated with the sets of actions and readinesses to act which characterize the instincts. The drive emotions, consequently, can be named and classified in a way that sensory fusions cannot. There are as many basic drive emotions as there are instinctive drives. And since drives combine with one another in many ways, we get compound drive emotions consisting of the fusions of the sets of sensations characterizing the combined drives.

The evidence for these basic drive emotions is the same as that for the existence of basic human instincts. The latter are hard to disentangle from the enormous amount of learned activity which men acquire. The following is probably as reliable a list as can be made up at present. The list is based on the fundamental kinds of motivation that are employed in psychological behavior experiments.

Instinctive Drives [2]

> hunger drive
> thirst drive
> sex drive
> maternal drive (suckling)
> nurturance drive (protection of young)
> nesting drive
> rest and sleep drive
> elimination drive (urination and defecation)
> aggression drive (breaking down obstacles)
> fright drive (avoidance of injury)

Every one of these drives has its characteristic system of acts and innate readinesses to act. Accordingly, the fusions of the kinesthetic and organic sensa-

[1] D. W. Prall, *Aesthetic Judgment*, Crowell, 1929, pp. 215–16.

[2] This list is a slight modification of E. C. Tolman's list from *Purposive Behavior in Animals and Men* and from *Drives toward War*. For a fuller discussion of this subject by the present author, cf. A *Digest of Purposive Values*, University of California Press, 1947, secs. 10, 11.

tions correlated with these acts and readinesses constitute, by our suggested definition, drive emotions. Hunger and thirst, then, are drive emotions, on this approach to the subject, as much as love or rage or fear. This discovery seems queer at first, but on reflection it will be found clarifying to the whole subject. For it helps to bring emotions out of the mysterious limbo in which they have been hidden so long. The emotions of love and fear become things that can be observed and described and predicted in their risings and fallings and appearances and disappearances just as hunger and thirst. Love and fear are neither more nor less private and inaccessible than hunger and thirst, or the feeling of tiredness that accompanies the impulse to rest and sleep.

Theoretically there should be a name for the emotional feeling that accompanies each one of these basic drives. But actually there is not. And it will not pay us to invent names, since we can always refer to an emotion as the feeling correlated with such and such a drive.

The foregoing list of drives, however, gives a very limited set of emotions. Where are the rest of our familiar emotions? Where are pity, and grief, jealousy, hate, malice, scorn, disgust, awe, reverence, and the others? The answer is that these are feelings which result from frustrations of drives, conflicts of drives, or combinations of drives. Pity, for instance, suggests tenderness for an object in suffering. Grief is based on the frustration of love by death of the beloved. Jealousy is based on the frustration of love by a rival for the affections of the beloved.

From our experiences in living, we find certain sorts of situations frequently repeated and the complex drive emotions that accompany these situations get names such as grief and jealousy. We come to know many of these situations and to anticipate them.

The drive emotions, in short, consist of fusions of rather definite systems of acts and readinesses to act. These systems can be denoted fairly accurately. We know them not only in their basic manifestations in instinctive drives, but also in many complex combinations characteristic of typical human situations. Literally these fused systems of readinesses to act constitute recognizable *types* of emotion. It is in this role of being recognizable types of emotion that the drive emotions have a special significance in art.

For these typical distinctive drives are the dynamic sources of suspense and dramatic conflict. Each drive has a goal it seeks to attain. When the attainment of the goal is blocked, we become vividly conscious of the character of the emotion for that drive in that situation. Drives conflict with drives, and the stories of these conflicts are the material of the drama and the novel. Unless the characters of these drives were recognizably distinct and typical we could not keep track of them and enjoy their conflicts, their periods of doubt and suspense, and their consummations or catastrophes.

The gradual unfolding of drive emotions through a work of art can, obviously, happen only in the arts of time — in theater, literature, and music. But the arts of space appeal to these drive emotions, too, as we shall see. There is a delight and a release just in having these drive emotions stimulated. A picture or a statue can do this. In some respects a static spatial work can develop a drive emotion even more fully than a play or a dance. For a statue or picture can penetrate into the details of an emotional attitude with a refinement and an absorption that the speed of performance on a stage makes impossible. No scene of a play could more effectively draw out the emotion of grief than Michelangelo's *La Pieta* (PLATE XVI).

A sensory fusion is thus definitely distinguishable from a drive emotion. The first is a fusion of whatever materials are presented in a work of art, and the character of the fusion is unique for every work of art. But a drive emotion is a fusion of the acts and readinesses which characterize a drive, and the quality of the emotion is recognizably the same whenever it occurs. It is evident that sensory fusions may, however, include drive emotions.

MOODS. There is still a third sense of emotion which I am calling " moods." These are a sort of mental state which has not received nearly enough attention in the past. They are referred to constantly in books on art and aesthetics, but always rather casually as if they were things everybody understands. In a common-sense way, everybody does. But they have never been attended to seriously except twice by psychologists and then in such a strange way that they were promptly consigned to limbo again. Josiah Royce and Wilhelm Wundt suggested that moods (or at least one of them) might be second or third dimensions of affection — affection signifying the pleasure-pain series. This historical fact leads us naturally to compare what I am calling moods with the pleasure-pain series.

But, first, what are these moods? Like other elementary mental states, they can only be pointed at by referring to the conditions that evoke them. So, if you want to know what pain is we say it is the feeling you have when a pin pricks you. Moods differ from the two previous senses of emotion in apparently being simple states not consisting of fusions of sensations. Moreover the mood states run in series from one opposite to another. There seem to be just two series of moods, the *excitement-to-calm* series and the *strength-to-delicacy* series.

Here is a list of some typical stimuli for these moods:

STIMULI FOR EXCITEMENT AND CALM

exciting	*calm*
bright colors	grays and neutral colors
diagonal and zigzag lines	horizontals and gentle curves
loud sounds	soft sounds

STIMULI FOR EXCITEMENT AND CALM (continued)

exciting	*calm*
dissonances	consonances
extreme contrasts	gentle gradations
rapid rhythms	slow rhythms
unbalance	symmetry
suspense	regular fulfillment of type

STIMULI FOR STRENGTH AND DELICACY

strong	*delicate*
dark colors	tints
broad heavy lines	narrow light lines
low-pitched tones	high-pitched tones
loud tones	soft tones
large masses	small masses
solidity	thinness and lightness
deliberate impeded movement of rhythm or line	floating easy movement of rhythm or line

If, now, we have a sense of the feelings referred to, we see that there is a gradation of these moods from one extreme to the other, similar in form to the series of gradations from black to white through all the intermediate grays, thus:

Extreme Excitement	Mild Excitement	Mild Calm	Extreme Calm

and

Extreme Strength	Mild Strength	Mild Delicacy	Extreme Delicacy

Both of these are one-dimensional series, with maximum contrasts at the extremes, and steady gradations of intensity going from one extreme to the other.

Now, the pleasure-pain series is also a one-dimensional series. Superficially it resembles the moods, so that it is easy to understand how Wundt could have had the idea of putting them all together into a three-dimensional system. But examined more closely, the pleasure-pain series has a distinctly different structure, thus:

+		0		−
Intense Pleasure	Mild Pleasure	Neutrality	Mild Pain	Intense Pain

Pleasure and pain are opposites, as in the moods. But there is a point of neutrality in the pleasure-pain series which does not exist in the mood series. The feeling of pleasure gets less and less intense down to a certain point where it stops and then pain begins and gets more and more intense till it attains its maximum at the other end of the series. The quality of the feeling changes at a certain point where the two opposites are at a minimum, and from that point each quality increases in intensity in opposite directions. Now, there is no such point of neutrality or change of quality in either of the mood series. Mild calm is also very weak excitement, just as dark gray is a very low intensity of white and at the same time a rather high intensity of black. But one could not say that mild pain was at the same time a very weak pleasure.

There are also other differences between the moods and affections (pleasure and pain) which show that moods are not species of affection, but a distinct kind of mental state. Perhaps the most important of these has to do with mutations. As we have seen, the pleasures and pains found in objects are very susceptible to change. In this susceptibility lies precisely the significance of the various mutations studied earlier — the means-to-end mutation, habit, fatigue, and habituation. But the moods are much more stable and closely attached to their original stimuli. Rapid rhythms, loud sounds, and unbalance, for instance, always tend to be exciting. But whether we like them or not is another matter and depends on where these stimuli stand in some pleasure-pain mutation, or how they are related in some type or pattern. They may be liked at first and then become monotonous, or they may be disliked for breaking, or liked for fulfilling, a type. A burst of rapid rhythm which would be gay and pleasant by itself would be disliked in the midst of a funeral march for its inappropriateness — but it would be just about as exciting in one place as the other. Moods are remarkably stable in their attachment to their basic stimuli, and probably not directly susceptible to conditioning.

This trait renders them aesthetically very important. An artist can stimulate a mood of excitement or calm, or of strength or delicacy with almost as much assurance as he can stimulate the sense qualities of yellow or blue. Not that an exciting rapid rhythm or active composition of angular lines and slanting planes will always evoke intense excitement. A man may be very tired or in a state of depression. But so also may a man's eyes be fatigued to yellow or blue.

Cézanne's *Maison Maria* (PLATE VIIIA) would be exciting and strong, I believe, to anybody who looked at it long enough to be stimulated by its vigorous line movements, tipped axes, heavy masses, and broad brush strokes, and Seurat's *The Artist's Mother* (PLATE IXA) calm through its gentle gradations of grays and the serenity of its subject.

Of course, if a spectator took an initial dislike to either of these pictures for any of a number of reasons — unfamiliarity with the technique, inability to dis-

criminate the pattern, lack of habituation, uncomfortableness with the subject, or simply anger that the picture should not be perfectly understandable at a glance — he might miss the mood because opportunity enough was not given for the stimuli to evoke it. Moods like colors cannot be felt if we shut ourselves off from them.

ON THE THREE MEANINGS OF EMOTION AND THE RELIABILITY OF EMOTIONAL RESPONSE IN THE ARTS. Now that we have described the three sorts of experiences which the term " emotion " has been employed to cover in the arts, let us stop a moment to be sure we perceive just how they differ from one another.

First, the distinction between moods, on the one hand, and drives and sensory fusions, on the other, consists most strikingly in the fact that moods are ordered in one-dimensional graded series terminating in opposite qualities of feeling (see diagram page 124) whereas drives and sensory fusions are not so ordered. Moreover, the moods seem to be simple mental states not analyzable into fusions of sensations as with the other emotional experiences. That is perhaps why the moods have a relatively transparent and filmy feeling in the experiences they spread over, in comparison with the opaqueness or even " coarseness " of the drives, and the fullness of sensory fusions.

Now, let us examine the distinction between drives and sensory fusions. It lies in the fact that drives are based on fixed patterns of action, whereas sensory fusions are not. The feeling of a drive, consequently, is determined by a relatively fixed set of sensations, mainly organic and kinesthetic, derived from the fixed patterns of action. But sensory fusions may be made up of any combination of sensations whatever, so long only as they are felt as fused. The core of a drive is, to be sure, also always a fused feeling, since organic sensations are very difficult to discriminate clearly. Consequently when a sensory fusion consists entirely of the sensations of a drive, there is no difference between the two. But when a sensory fusion includes, as it would in most works of art, sensations that do not belong to the pattern of action of a drive, then a difference needs to be noticed. There are also sensory fusions like the taste of lemonade which appear to have practically no drive in them at all.

All three of these sorts of emotional experience are controllable and communicable — almost as much so as meanings. Otherwise how could persuasive speakers like Churchill and Roosevelt, to say nothing of other artists, move people to take on definite emotional attitudes? There have been a lot of loose utterances in recent years about the privacy, incommunicability, unverifiability, and general mystery of emotions. If the same arguments were used on meanings, these would be made to appear just as private and mysterious, and the transmission of ideas in a conversation would seem equally fortuitous. The way we control our ideas so that we can communicate them with reasonable certainty from one " private " mind to another is to see to it that identical stimuli such as

printed words produce similar responses in different minds. The control and communication of emotions is performed in just the same way. It is even possible that with suitably arranged conditions the communication of emotions is more complete and extensive than that of ideas.

Let us take the three senses of emotion that we have distinguished and see how far they are open to control and communication.

Sensory fusions are theoretically completely communicable. For if a physical work of art is regarded as a set of stimuli, then the responses to these stimuli give the sensations relevant to the work and the fusion of those sensations would be the specific emotional character of the work. The pattern of stimuli completely controls the emotional fusion. The only thing is to be sure that the spectator is sensitive to all the relevant stimuli in the work.

Instinctive drives, on the evidence available, are relatively constant. Moreover, the manner in which they combine to produce derived drives in the building up of personality structures appear also to follow regular laws. In any given situation there may be great variability of emotional reaction on the part of the persons present. And yet with sufficient knowledge of each person's character, each person's emotional reaction would be highly predictable.

So in the emotional reaction to a simple work of art there may be great variability on the part of persons viewing it, without this fact in any way affecting the predictable emotional character relevant to the work. Some persons have emotional blind spots. These persons' responses to a work to which they are emotionally blind are as irrelevant as a color-blind person's responses to the hues of a picture. Many emotional responses depend upon culturally charged symbols. These emotional meanings can be acquired. But if a spectator has not acquired these emotional meanings he cannot be responsive to the work any more than a man who has not learned a foreign language can be responsive to a poem in that language. Such considerations do not show the incommunicability and unpredictability of emotions in works of art. On the contrary, they indicate the conditions of emotional responsiveness and the high degree of reliability of emotional communication if these conditions are complied with.

Obviously, then, the conditions of emotional responsiveness must be met, if there is to be the emotional response. A deaf person does not jump at a crash of thunder. Nevertheless, the deaf person's nonresponse to thunder is, of course, as predictable as the response of a person with sensitive hearing. So with obtuseness and so also with sensitivity to emotional stimuli in works of art. When the conditions for emotional stimulation relevant to a well-organized work of art are met, there is every evidence that the emotional response is highly predictable.

Lastly our list of typical stimuli for evoking various moods implies a high degree of reliability of response in that quarter.

We shall hold, then, that emotions are just as controllable in a work of art

as most of the other elements it incorporates. So now, let us ask more particularly how this control is maintained. What ways do works of art employ to stimulate emotions?

Stimulating Emotion in Art

There are four ways of producing emotions in a work of art: (1) by *direct stimulation* of the senses which, under appropriate conditions, produces an immediate emotional effect, (2) by types and symbols charged with *emotional meaning*, (3) by the *representation of emotional behavior* which induces emotion in the spectator, (4) by evidences of *the artist's emotional expression*.

1. DIRECT STIMULATION. We have already found this way of producing emotions well exemplified in the section on moods. For there we identified the moods by listing the sense stimuli which normally produced them. These moods are directly stimulated by those sensations, provided the body is receptive and resonant to such emotional impact. And we referred to the Cézanne (PLATE VIIIA) for the strength of its broad lines and the excitement of its line movement and tipped axes. We spoke of the calm of Seurat's (PLATE IXA) grays and gentle gradations. And so on. These are all direct stimulations of moods.

Drives may also be directly stimulated, but because of the greater complexity of their structure, they call for more complex ways of arousal. A sudden loud noise is directly frightening. There are no associations required at all. Very big objects seem to be directly fearful too. But, for the most part, what seem to be direct sensory stimulations of drive emotions are probably the arousal of activities closely associated with something in the set of responses which make up the drive. Rhythm is an example. It can reproduce the movement of a drive in action and so by a sort of intimate analogy stir up the emotion of the drive. This can happen in the movement of lines and in visual rhythms as well as in the rhythms of music and verse. There is probably a good deal of it in the Matisse (PLATE XX). And is there not a rhythm of fear in the waves and clouds of the Tintoretto (PLATE V)? Such emotional stimulation by a kind of analogy is halfway between the mode of direct stimulation and that of emotionally charged symbols. There is an associational element present, but the emotional charge is instinctive, not acquired.

2. EMOTIONAL MEANING. An emotion can also be aroused by emotional symbols — things which have become associated with that emotion by conditioning. Instinctive drives become attached very easily to objects by this process, although as we have seen (page 125), moods do not. The reputed variability of emotional response among different spectators is mainly due to this free attachment of drives to objects in their path.

Although some emotional symbols are purely personal, others are practically universal. Among the latter are objects closely connected with the responses of basic drives, such as the basic sex stimuli. They include also all those objects in the environment which ordinarily cause the things which stimulate these drives directly. Heavy clouds, for example, which are ordinarily associated with fearful wind and rain, become themselves fearful. Whatever things in man's environment ordinarily lead to emotional consequences are likely to have those emotions projected upon them. If the environmental objects are universal, so almost inevitably will be their emotional meaning. Artists can, then, draw on emotional meanings with considerable reliability.

Let us pick out some of the more striking emotional meanings in Tintoretto's *Christ at the Sea of Galilee* (PLATE V). Take the black, low, cumulous clouds, the heavy sea, the signs of strong wind in the bulging sail, the bent mast, the blowing leaves and slanting trees — all these mean danger and fear. They would be emotionally understood by anybody who had lived by sea or lake and knew what storms were — and that is almost everybody. These meanings are not due to instinctive connections, but still are practically universal.

Then there are also in this picture some highly emotional meanings of a cultural sort. A halo in the Christian tradition signifies sanctity. It is a highly emotional symbol. Anyone in the Christian tradition would know that the three figures with halos were holy, and the emotional meaning of that symbol would spread to the character blessed with it. Moreover, anyone familiar with representations of Christ since the Renaissance would immediately recognize the figure on the left as Christ — from his carriage, his age, his long hair, and his beard. They would know that the person stepping out of the boat was not Christ, though many present-day Christians might not know who that person represented. For all who are familiar, however, with the Biblical story represented in this picture, the painting is emotionally enriched.

The incident occurs right after the miraculous feeding of the multitude by the lake: " And straightway Jesus constrained his disciples to get into a ship and go before him to the other side . . . and he went up into a mountain apart to pray. . . . But the ship was now in the midst of the sea, tossed with waves, for the wind was contrary. And in the fourth watch of the night Jesus went unto them, walking on the sea. And when the disciples saw him walking on the sea, they were troubled, saying, It is a spirit; and they cried out for fear. But straightway Jesus spake to them, saying, Be of good cheer; it is I; be not afraid. And Peter answered him and said, Lord if it be thou, bid me come unto thee on the water. And he said, Come. And when Peter was come down out of the ship he walked on the water, to go to Jesus. But when he saw the wind boisterous, he was afraid; and beginning to sink, he cried, saying, Lord, save me. And

immediately Jesus stretched forth *his* hand, and caught him, and said unto him, O thou of little faith, wherefore didst thou doubt? And when they were come into the ship, the wind ceased." [1]

Perhaps there is a more personal emotional symbolism in the splashes of sun that lighten the shoulder of Christ and the lush green hills in the middle distance. This means to me the promise of peace and happiness after the storm. To be sure, the sun enhances the storm by contrast with it. But it means to me also the benediction of God and the consummation of the religious story: the preaching of Christ that "by faith shall ye be saved." How many will follow me in this emotional meaning of the sun, I do not know. It is consistent with the picture. Personally, I think Tintoretto meant this emotional meaning — not my words but the emotion that brings these words to mind.

In here, then, are three levels of emotional meaning. The first two are unquestionably embodied in the picture, the third probably too, in a way. The idea that emotional responses are too variable to be discussed as objective elements in an aesthetic work of art does not appear to be true. There is a pervading emotion in this picture. The successive additions of emotional detail are all consistent and simply enrich the character of that emotion. Fear and excitement and a joyous ray of contrast of some sort are there from the beginning. But the richness of emotional meaning increases as we add details from level to level.

A Chinese or a Burmese who knew nothing about Christianity but realized the emotional significance of the storm, the activity in the boat, and the concern of the figure by the shore for the people in the boat, would get a strong emotional impact from the picture. That emotion would not be in any way displaced, but simply further enriched, if someone then explained to him the story here depicted and the significance of Christ in Christian culture. If later this Chinese or Burmese became a Christian and the figure of Christ became deeply charged with religious emotion, the former emotions in the picture would not be displaced but only that much more deeply enriched. And then if he and I met and we both found the significance of something like the benediction of God in the flashes of sunlight over the picture, still there would be no displacement of the more universal levels of emotion. This last addition would be a further enrichment shared by him and me and perhaps the artist and a few others. Whether this last addition can be considered part of the emotion of the picture would be debatable, but so long as it does not lead us away from the picture, so long as it is consistent with the more universal and verifiable emotional meanings in the picture, it cannot hurt the aesthetic judgment and appreciation of the picture and may help to vivify it.

Let me illustrate this point by a more obvious example. The storm painted by Tintoretto will sink much more deeply into your emotional perception if it can

[1] Matt. 14: 22–32.

remind you of some particular storm in which you were out on the water in a small boat. For myself, I think of a squall in which a companion and I were caught out in a sailboat in a bay off the coast of British Columbia. We were thoroughly scared. In responding to Tintoretto I discard the Canadian scenery as irrelevant but retain that personal fright as relevant. Tintoretto may well have had in mind some similar storm off the coast of Italy. Every spectator moved by this picture undoubtedly has some sort of personal experience of fear revived by this scene which serves to vivify it. Such private emotional meanings increase the emotional content of a work of art when integrated with its more universal meanings.

3. REPRESENTATION OF EMOTIONAL BEHAVIOR. When we see somebody expressing a strong emotion, we immediately feel emotion arising in us.)We do, that is, unless some stronger inhibiting influence is working in us — such as another emotion that absorbs all our energy, or some equally absorbing practical activity, or a habit of dealing with people in emotional states as " cases " for study or treatment. But if we do not shut ourselves off from emotional stimulation, there is no more powerful emotional stimulus than the sight of emotion in others. And the representation of persons in emotional action, as in plays and statues and pictures, is the same sort of stimulation — subject only to the mitigating effect of psychical distance.

The source of this stimulation is fundamentally instinctive. For what stirs us is the appearance in others of those sets of innate readinesses which also constitute our own emotional drives. These evidences of a drive in others start up a drive in us. A man raises his voice in anger. We know what it means. But we more than just know. Our own voice starts to go up in anger too. That is, we respond to drive emotions by a sort of sympathetic vibration.

These drive stimuli, however, are not altogether instinctive. They are tinged with cultural coloring. I remember waiting at a doctor's office in France, and suddenly hearing from a back room: " Aye-yi-yi-yi! " My drive response was immediate, and I never doubted for a moment they were cries of acute pain. But I had never heard such cries before. In America acute pain comes out " Ow-ow-ow! " Now, this difference does not mean that expressions of pain are entirely the result of cultural conditioning — as " chien " in French and " dog " in English are. The core of the two spontaneous yells is instinctive and identical. It is only a little shell of outer coloring that is culturally conditioned and different. Similarly, Latin peoples in extreme rage tend to strike with a knife, Anglo-Saxons with a fist. The instinctive act is the same, but there is a cultural coloring.

It follows that the representation of emotional action is highly universal. The actual outer form of the action may vary enormously from culture to culture, but there is no mistaking the instinctive intent of the act. We may not under-

stand a word a couple of Parisian taxi drivers are saying to each other at a congested street corner, but there is no mistaking the emotional drives involved. So, it is possible to listen to a play in a foreign language and follow it quite clearly if the action is mainly composed of common drive emotions well represented. And so the representation of emotional attitudes in painting and sculpture is a powerful emotional stimulus and almost universally understandable.

Consider Tintoretto's picture again. The representation of emotion in the various figures is quite clear and emotionally effective. Particularly, the feeling of urgency and excitement and overhaste in the figure of Peter is very intimately conceived. Whether one knows the Christian story or not, the emotional stimulus of that figure will not be missed. And when one knows the story, the completeness of Tintoretto's emotional development of Peter's attitude to fit this specific moment adds further to the feeling. Also, the figure of Christ is most sympathetically conceived. His dignity, his confidence in himself, and his concern about Peter — all are apparent from his bearing and gesture.

Michelangelo's *La Pieta* (PLATE XVI) is another work where the representation of emotion by the various figures is a strong source of emotional stimulation.

4. THE ARTIST'S EMOTIONAL EXPRESSION. In a fundamental sense, all the emotions embodied in a work of art, however stimulated, are put into it by the artist and so are a communication to us of his own emotion. Where we experience profound emotion in a work of art, it must have been felt first by the artist himself before he sought the technical means of communicating it through aesthetic materials to his audience. There can hardly be any doubt that Fra Angelico felt the mystical exaltation he communicates to us in his *Madonna,* and that Picasso felt the dejection he communicates in the *Absinthe Drinker.* If these men had not been guided constantly by the integrity of their emotions, they would have slipped up somewhere in the consistency of their embodiments and their pictures would have become either emotionally dull or false.

But while it is true that all deeply emotional art is in fact an expression of the artist's emotion, it does not follow that we are always aware of the artist's emotions when we are responding to his work. Some artists like Shakespeare, Titian, and Velasquez have a gift of concealing themselves almost completely behind their works. Consequently, they are said to be " objective " — which does not mean that their work is not highly emotional but only that they stimulate emotion by the three previous modes of emotional stimulation only. Other artists like Van Gogh expose their personal emotions in everything they produce. They do this by a special mode of emotional stimulation, which is the subject of this section. The stimuli act like gestures or the intonations and rhythms of the voice which betray the emotion of the speaker.

The chief ways in which an artist calls attention to his own emotions in a

visual work of art are by his brush strokes or chisel strokes, by emotionally dictated selection of details for representation and marked omission of other details, by distortion, and by breaks of line and pattern.

For a good illustration of all these signs of the artist's emotion as stimuli of emotion in the spectator, look at Cézanne's *Maison Maria* (PLATE VIIIA). This picture is as emotional as a windstorm, yet it is not a representation of a storm. The emotion is due to Cézanne's vigorous brush strokes, interrupted lines (as in the ruts of the road), and his rather violent distortions and rearrangements of forms, which tip to the left and produce a whirlwind rotary movement about the house. Cézanne is usually a rather "objective" painter, but here he leaves signs of his feelings all over his painting.

Picasso's *Absinthe Drinker* (PLATE XIX) is another extremely personal composition. In this instance, the vestiges of the artist's feelings show mainly in the rigorous dreamlike selection of details and the stark omissions. All the other modes of stimulation are here gathered into the service of exhibiting in their combination Picasso's own personal dejection. For nearly everyone the picture is emotional and touches him in some degree. But somewhat as a knowledge of the Biblical story enriches the emotional response to the Tintoretto *Christ at the Sea of Galilee*, so if anyone has known something of this depth of depression expressed in Picasso's blue period (and especially in this picture), he will recognize the precision of the emotional stimuli.

The selection of objects is scaled down to a slumped figure in a chair and an absinthe glass on a table. The posture of the woman is that of despair and unconcern for the world. The absinthe glass adds to the despair in signifying her one source of comfort. The blue of the picture is the blue in which fantasy images come in states of fear. The common expression "having the blues" testifies to the emotional meaning of this color. It is the blue of moonlight on the stage in traditional ghost scenes — *Hamlet* for instance. Most of the picture is bathed in this blue, but there is a yellow glow about the absinthe glass. Again this is psychologically correct. The unreal images of sadness float in blue, but if there is an item of hope anywhere, it tends to be picked out in yellow. These meanings, I suggest, are universal in just the sense that the symptoms of measles or pneumonia are universal. Any man is likely to get one of these diseases, and if he gets it, these are some of its typical characteristics. The symptoms of emotional states, however, have an aesthetic relevance because of the central place emotions have in art.

Notice also in the Picasso the browns and the emotional meaning of the repeated shapes. If you let them sink into your feelings, are they not rather disgusting? There is a good deal of psychiatrical evidence that brown for most people is deeply associated with fecal matter. If this emotional meaning is admitted, does it not explain another element in the emotional impact of this

picture? Then look at the shapes of the woman's brown locks. These are varia-
tions of the shape of the woman's body slumped over the table. Do not these
shapes suggest all sorts of dirty, slimy things you would not want to touch?

Whether you follow me in these emotional meanings is not exactly the point.
Perhaps you have never had this sort of emotional depression or even bordered
on it. So much the more fortunate for you. The picture then for you will have
the beauty of something like a Persian glazed vase with a skillfully designed
figure drawn upon it — and Picasso's picture does have that abstract beauty. But
for many people it has also a powerful emotional impact. I have suggested some
reasons for this impact. Not that Picasso knew these reasons in the outspoken
way I have referred to them, any more than Cézanne or Van Gogh thought of
the reasons for using emotional brush strokes. Picasso simply had a powerful
emotion and with an artist's sense for what is emotionally effective put down
the relevant symbols. So successfully has he put them together that all who have
had emotions like his or bordering on his will recognize his emotion and rever-
berate to it.

The means Picasso employed in the *Absinthe Drinker* are mostly emotional
meanings, but the figure itself is a representation of emotional action (or rather
passion), and there are also elements of direct stimulation, but the *manner of
selection* of all these stimuli so closely reflects the artist's emotion that this
amounts to a stimulus too. It stimulates one to think of Picasso's emotion in
painting this picture as much or more than it stimulates one to think of the
emotion of the figure hunched over the table. So, the picture comes out not as
an "objective" but as a personal treatment of emotion, and an example of
stimulation by signs of the artist's emotional expression.

Emotion "with" and "at"

Throughout the previous section we have been assuming that the emotion
stimulated was of the same sort as that presented in the work. We assumed
that the spectator was moved *with* the emotion of the artist, or of the figure repre-
sented, or of the meanings suggested. But sometimes the spectator is moved *at*
them. Sometimes this is the artist's intention. In drama, for example, where a
number of characters are on the stage emotionally reacting to one another, the
spectator cannot respond *with* all of them at once. He is led to identify himself
with one of them, the hero or heroine of the scene, and be moved *at* the others
just as the hero is.

In comedy emotion *at* is more commonly intended than emotion *with*. The
artist gets us to laugh *at* him, or *at* the characters represented or the meanings
presented, or even *at* ourselves in letting ourselves be directly moved by some-
thing that turns out to be trivial or a fraud.

The *Absinthe Drinker* which we have just been discussing is an excellent example of emotion *with*. Whether we think of the emotion as that of the artist or as that of the woman depicted, we are clearly expected to be moved *with* the emotion presented. If we are moved *at* the picture, despise the woman or feel sorry for Picasso that he should have to paint such a picture, then we have lost our aesthetic distance and missed the beauty of the picture.

For a fine example of the stimulation of emotion *at* a subject, look at Daumier's *Theater* (PLATE VII). Here the artist makes it clear by the exaggerated mode of depiction of the faces in the audience that we are expected to laugh *at* these persons' absorption in the melodrama. It is a satirical picture and an aloofness of attitude toward the emotions of others is characteristic of satire — aloofness in the sense of not entering into others' emotions but being moved at them. The attitude is one of emotionally charged criticism.

This picture is interesting in the present connection all the way through. You are moved *with* the artist's emotion, *at* the audience, who are moved *with* one of the characters on the stage *at* the other two; while you as spectator of the picture are mainly moved *at* the whole stage scene, though you have to be just enough moved *with* it to appreciate the significance of the satire.

The foregoing remarks apply mainly to drive emotions, in a lesser degree to moods, and not at all to sensory fusions. For a sensory fusion takes up whatever materials are presented and fuses them. Such emotion is always *with* the fused materials.

Organization of Emotions in Art

So far we have been considering emotions singly. When several emotions are combined in a work of art, how are they organized? By four main principles: (1) by *contrast*, (2) by *gradation*, (3) by *dominant emotion* (theme-and-variation), (4) by *natural emotional sequence*. The first three principles are simply those of design applied to emotional material. The fourth is an application of type to emotional organization.

1. CONTRAST. Emotional contrast is more clearly exemplified in the temporal arts than in the nontemporal. The emotional contrasts in successive movements or sections of musical compositions immediately come to mind. But there is plenty of this sort of contrast even in pictures and statues. The emotional calm of Christ in the Tintoretto, for instance, contrasts with the excitement of Peter. The spectator can identify himself with either, and, for the full realization of the picture, should feel himself successively into both. There is a similar contrast in the Picasso drawing (PLATE IXB) between the calm goddess and the struggling god. Emotional contrast acts like any other kind of contrast to hold off monotony and increase the vividness of the experience.

2. GRADATION. Any instance of emotional climax in a work of art is an emotional gradation. Again the Tintoretto will illustrate this way of organizing emotion. Just follow the transitions of excitement and calm in the picture. From the relative calm of the sea beyond the boat through the figure in the rear of the boat and thence to the agitated figures in the front of the boat, there is a gathering excitement culminating in the figure of Peter. Thence there is a gradation of increasing emotional strength in the rhythms and sizes of the wave forms as they approach the upright figure of Christ on the left, resolving into a mood of strength and calm assurance in Christ himself\ There is an emotional gradation in the cloud forms too, across the back of the picture, from the large dark shapes on the right to the smaller brighter shapes on the left, suggesting that the storm is breaking up on the left. The emotional gradations throughout this picture are very skillfully organized, and worth following in detail. There are two focal areas of intensest emotion — one with Peter in the center, the other with Christ on the left. These two centers are closely related, each figure represented as the emotional stimulus for the other, and mutually contrasted. There are other minor emotional climaxes distributed about the picture, with emotional gradations and tensions among them, some of which I have been pointing out.

The imaginative daring of placing the intensely significant figure of Christ way on the left in an intrinsically very unnoticeable part of the picture format is something not to be missed. When I first saw the picture in the National Museum, I did not observe the figure of Christ. I discovered him from the emotional and formal references of the picture. The emotional impact was the greater for this delay. And there is a possible significance in it — that Christ in all his greatness is constantly with us, though we may not notice him.

3. DOMINANT EMOTION (THEME-AND-VARIATION). By dominant emotion I mean the principle of emotional organization by which all the emotional stimuli point up to a single mood or drive emotion. It is the principle by which every part of a work echoes and reechoes every other part in the expression of one emotion. Picasso's *Absinthe Drinker* clearly exemplifies this principle. In the analysis of its stimuli (pp. 133 ff.) we were actually showing how these all led to a dominant emotion of deep depression. Michelangelo's *La Pieta* (PLATE XVI) is another example. Here the dominant emotion is grief. Seurat's drawing of his mother (PLATE IXA) has a dominant emotion of gentle quiet. The Chinese painting (PLATE IV) has for me a dominant emotion of some sort of deep serenity. Another sort of serenity unifies Fra Angelico's *Madonna*.

This mode of organization is so strong that it is almost sufficient in itself to unify a work of art. There are some pictures and some otherwise formless lyrics that are held together almost solely by the absorbing integrity of a dominant emotion. The Chinese painting might be taken as an example. So might Seurat's drawing. Not that either is formless, but an emotion dictates the form so com-

pletely that we do not need to think of pattern or design or type except as stimuli for the emotion.

I call the principle of dominant emotion a species of theme-and-variation because the response to each emotional stimulus is an emotional variation of a single emotional theme.

4. NATURAL EMOTIONAL SEQUENCE. This again is a mode of organization that comes out clearer in the temporal arts than in the nontemporal. There are some emotional sequences in music that feel convincing — as if the emotions belonged together somehow — and yet their satisfactoriness cannot be accounted for by any of the three previous principles.

It occurred to me that the explanation might lie in the hidden sense of a dramatic scene in which such a series of emotions would naturally follow one another. A composer consciously or unconsciously imagines himself in such a scene, and then plays or writes the music that expresses the succession of emotions appropriate to the scene. If he does this successfully, his hearers will be stimulated to the same emotions, and, if the imagined scene is typical, they will also be reminded half unconsciously of a closely similar scene, and the sequence of emotions will then be as convincing to them as it was to the composer. This is what I mean by a natural emotional sequence.

In a novel or a play such a sequence needs no explanation. The story gives the scenes explicitly. The reader or spectator perceives the appropriateness of the emotions to the scenes presented, and so automatically feels the sequence of emotions as convincing. In program music and opera the story is also explicitly given. But in abstract music the story is not there. If, however, the emotions in abstract music follow one another in the order they would in an acceptable story, the emotions will feel convincing still. A natural emotional sequence is a sequence of emotions that naturally follow one another either in a true story or in real life. The principle explains the satisfactoriness of such a sequence of emotions whether presented with or without the explicit story.

This principle often applies to a degree, in dramatic painting. For, at a single moment, different characters may be stimulated to different emotions by the same situation. A combination of emotions will be convincing if the situation is such that they could all be simultaneously stimulated. Such a situation is illustrated by Christ and Peter in Tintoretto's picture. Also in Picasso's drawing (PLATE IXB). But, strangely enough, our best example is the Renoir (PLATE II). All the emotions in this picture are gentle, and all under a mood of delicate excitement, but all are specifically quite varied. The situation is that of an artist painting the family portrait. Renoir caught the family, so to speak, at a moment when they were about to pose. The little girl on the dog is looking up enquiringly at her mother, having apparently just asked some question. The little girl on the sofa is looking down at her sister just a trifle superciliously. The mother

with maternal calm is listening to the older child. The emotional attitudes of the three are quite distinct. We can feel ourselves into each one, for Renoir has delineated them with precision. And they all go together because they all so plainly come out of that particular situation.

What holds such emotions together, it should be noticed, is the principle of natural type. We recognize a typical situation and the emotions that would typically arise out of it. But there is more than the pleasure of recognition in such emotional organization. There is also whatever satisfaction comes from the emotional responses themselves as they pass through our bodies.

Here we must bring this part of our discussion of the emotions to a close. I hope enough has been said to show that a great deal of emotional discrimination is possible in art. The principal point perhaps is that our emotional discriminations are far in advance of our vocabulary. Because we have not words precise enough to name what we often feel with great precision, we accept too easily the idea that we do not feel with precision. It is common everyday experience that emotional communication is often better understood than verbal communication. Just as a look or a gesture can make an attitude clear between two people which a thousand words would still leave ambiguous, so with many emotional works of art.

We are not, however, quite through with the topic of emotion. Two more questions remain: first, that of tragedy or painful emotion, and, second, that of sentimentality or false emotion.

Tragedy, and the Art of Relief

How does it happen that so much art contains painful subjects and arouses painful emotions? The question is the more disturbing because so much of the greatest art seems to be of this sort. Look at the *Absinthe Drinker* and Michelangelo's *La Pieta*. In literature even more than in painting we are aware of pain. " Our sweetest songs are those that tell of saddest thought," wrote Shelley. And if you would name the greatest plays, with few exceptions they are tragedies. Nearly all the greatest novels are depictions of misery and sorrow. And consider our greatest music — abstract as it is, without words or images — are not its emotions the heavy ones like those of the dramatic tragedies? Why does art indulge in pain? In our first chapter we tentatively defined the field of beauty as that of things liked for themselves. Can this definition take in these tragic features which so obviously belong within the field?

The problem of why the tragic is so often the subject of art is an ancient one, and many solutions have been suggested. Some of the principal ones are the following:

1. *Psychical distance*. The emotions evoked in art are not as intense as the cor-

responding emotions in real life. If we are stirred with sympathetic grief as spectators of Michelangelo's *La Pieta*, it is not as if we were witnessing the actual scene, much less as if we were one of the participants. It is grief softened by distance, as if recalled in memory.

2. *Charm and skill of presentation*. The pain of the subject is neutralized and overcome by the charm of the sensuous materials and their patterns and by the artist's skill in depiction. The sensuous pleasure in the rhythmic lines and masses and textures of *La Pieta* and the delight in Michelangelo's skill of representation and craftsmanship compensate for the painful subject matter.

3. *Truth*. The pleasure in the recognition of a truthful representation of an incident in life compensates for the pain. We recognize the acuteness of Michelangelo's perception of the attitudes of grief in the figures of *La Pieta*, and our pleasure in the truth of the representation conceals the painfulness of the subject.

This principle applies particularly to portrait painting. A great portrait is a truthful one, not a pretty one. A popular society painter softens the lines of experience and suffering and thereby sacrifices for the superficial pleasure of a conventionally pleasant face, the deeper satisfaction of truthful character drawing. Velasquez's portrait of Pope Innocent X is not a depiction of any conventional prelate, but of a very human man with marked character and a certain hardness.

The so-called *tragic flaw theory* of tragedy comes under the present heading. This, like the catharsis theory, to be described presently, owes its origin to Aristotle, who possessed a most penetrating insight into the sources of the values of tragedy.

The idea is this. The most satisfying fulfillment of natural type for man is a realization of the highest ideal of a man — the ideal of the adjusted man of quick intelligence, with emotional vitality, resourcefulness, power, and sympathy. This is a type difficult to find in even an approach to fulfillment. It is at the top of the hierarchy of natural types. All men respond to it by sensing their own potentialities for it, however inhibited and frustrated they may be in fact.

Here, then, is a rare type, affording the greatest aesthetic satisfaction in its fulfillment. How can an artist exhibit it most completely? Paradoxically, not by narrating in a play or a novel the plain history of a man who fulfills the type completely. A well-adjusted man by his very nature never gets into spectacular difficulties. He foresees the difficulties before they press upon him, and meets them appropriately. When they are unavoidable, even when they are serious enough to lead to his death, as in war or shipwreck, he handles himself so well that he is not particularly conspicuous. He does what is needed of him without heroics. The more nearly perfect a man is, the less, almost, he makes others aware of him. Like good health, we do not notice him till we lose him.

The way, then, to get us to realize the perfect man is to get us to feel that we are just losing him all the time. A weak, a convention-bound, or a dull man will not do, for he is too far from perfection to remind us of the ideal. What works is a character that has almost the full human potentialities but fails in some single essential trait. This is the tragic flaw, which leads the character into tremendous difficulties from the very power of the rest of the man's character. He is compelled to struggle to extricate himself with all his remaining potentialities, and we see vividly the heroic capacities of man.

Most of Shakespeare's tragedies conform excellently to the tragic flaw theory. Macbeth, Othello, Hamlet were all men of heroic build. But one was excessively ambitious, another excessively jealous, and the third excessively conscientious. The supreme human ideal emerges from the acts of each. The pleasure in being made vividly aware of this ideal and of its fulfillment compensates for the pain of the tragedy and of its inevitable catastrophe.

4. *Habit and habituation.* Many situations which we *call* horrible, are not *felt* so. Any big fire is called terrible, but actually people enjoy it and run to it eagerly. Yet if anyone asked if it was a pleasant fire he would be frowned upon.

It is possible too that we can become habituated to some degree of emotional severity. That this occurs in simple sensory fusions is implied in many of our illustrations in Chapter 2. We come to enjoy a dissonant chord. Similarly we may through habituation come to enjoy fusions of organic sensations not originally pleasant. Many people seem to relish a gentle sadness.

5. *Vividness.* Quite apart from pleasure or pain, vividness seems to be something desirable in itself. Painful emotions are among our most vivid experiences. In so far as vividness is sought in art, then, we should not be surprised to find artists giving emphasis in their works to the painful emotions.[1]

6. *Catharsis.* With the exception of the appeal to vividness, all the foregoing suggestions about the presence of painful emotions in art are in the nature of excuses for it. The pain is neutralized by accompanying pleasures, or is a necessary means for obtaining a greater pleasure. But these theories do not explain why so much art appears to gravitate toward painful emotions. Over and over again the artist does not seem to avoid the painful. He seems to court it. And the spectator likewise over and over again seems to act in sympathy with the artist, seems to find a special depth of satisfaction in experiencing a painful emotion embodied in an aesthetic work of art. It is as if by giving himself up to the painful emotion evoked by the work, the spectator was relieved of pain, and achieved a release of tension, and a relaxation of mind and body.

This is, I believe, what does occur. Aristotle in his *Poetics* makes a few brief comments suggesting some such idea. He called the effect " catharsis." He

[1] For the full exploitation of vividness of experience in aesthetic theory, cf. S. C. Pepper, *Aesthetic Quality*, Scribner, 1937.

seemed to think that a tragedy had some sort of cathartic or cleansing effect upon the emotions. His notes were so brief that it is impossible to be certain just what he did mean. Probably it was a hunch rather than a specific theory. But it was a very pregnant hunch. Writers on art and aesthetics have been working over it ever since. For in this notion lies without much question the best explanation of the presence of so much pain in so much of our most valued art.

There has been developing in late years, particularly among writers on emotional problems, a tension theory of pleasure and pain. If we can accept this theory, it leads easily to an explanation of catharsis and the satisfaction offered the spectator by tragedy. Emotional drives, says the theory, especially when frustrated, give rise to bodily and mental tensions. As these tensions increase they become very painful. A release of painful tension is a relief, and release of that tension below the point where it has become painful is a pleasure.

Now every person in the course of his life goes through many extremely frustrating and harrowing experiences which leave their marks behind in the form of sort of chronic tensions or " complexes," as they are called. These complexes are largely unconscious, inhibited, too fearful to be openly contemplated. But if they can be touched off so as to get some sort of expression, there is great relief and satisfaction to the organism, even if not a feeling that could be called a pleasure.

The catharsis idea, then, developing from this theory of repressed complexes is that a tragic work of art is one designed not for pleasure primarily, but for relief of painful tension. Such art we may call *art of relief* in contrast to purely pleasant art which we may call *art of delight*. The two sources of satisfaction may be combined in various proportions. And there is probably no great art of relief that does not contain some pleasure. But the point is that the value of the art of relief is not solely in the accompanying pleasure but largely, or at least to a large extent, in the relief of painful tension.

There is a saying that only those who have suffered deeply can fully appreciate great art. That is absolutely true of the art of relief. Such art appeals to the common universal modes of human suffering — to grief, frustrations of love and ambition, the cruelties of power, the sorrows of war. All of us in various degrees have suffered from these things or from things analogous. These sufferings have left scars upon us, in the form of painful tensions or dispositions to such tensions. Anything that will relieve these tensions we value as we value an understanding comforter. The art of relief performs this function.

So now consider Michelangelo's *La Pieta* (PLATE XVI). Here is a depiction of grief expressed with dignity and deep understanding. The very faithfulness of the realism in depicting the attitudes of the three figures about the body of Christ intensifies the emotion. These are the movements we would make about

the remains of one we have loved. Whether as mother or father or relative or friend, we find our attitude expressed here. A door we have kept locked in ourselves is opened. We let our emotion out. Our tensions of grief become relaxed, and we are relieved and satisfied.

The art of relief thus performs a sort of medicinal function. It overlaps the borders of religion and comes close to the practices of physicians. In fact, all religious art and nearly all religious ritual is of the art of relief.

There are many writers who affirm that the art of relief is the only genuine art and who tend to regard the art of delight as something trivial and low. But these are counterbalanced by others who think of art as intended solely for delight, and find the art of relief simply morbid. Both sorts of appeal, however, are made by works of art. And, if our hypothesis about the relations of pleasure and pain to tensions is approximately correct, we now see why both have great value. The value of the one is in the amount of pleasure it gives, the value of the other is in the amount of relief from pain it gives.

This observation leads us to reconsider our definition of the aesthetic field. At the beginning of this section we asked whether the appeal to painful emotions could be brought within our original definition of positive aesthetic values as that of things liked for themselves. It could, if liking is taken to include both experiences of pleasure and experiences of relief from pain. But if liking is restricted to pleasure, as we rather assumed, a revision would be needed to include the art of relief. A more precise definition can now be made on the basis of our tension theory of pleasure and pain: namely, that *positive aesthetic values consist in experiences of release of tension.*

Sentimentality

There remains the question of false emotion. This also is a paradox. How can an emotion be false? Truth and falsity belong to matters of intellectual judgment. Emotion and judgment seem to be opposites. The answer is that sentimentality does imply a judgment of some sort in connection with emotion.

There are two ways in which emotions stimulated by works of art may involve judgments. A spectator may express an emotion inappropriate to a work of art as if the emotion belonged to it. Or an artist may embody in a work of art an emotion which is contrary to some ideal of human character — an emotion which breaks an ideal type.

The first sort of sentimentality is associated with emotion in the mode of sensory fusion. When a spectator gives way to an emotional ecstasy over a work of art, and it is discovered that his emotion is not a fusion of the materials relevant to that work but a separate emotion of the spectator's own making, started by something in the work of art but not embodied there, then his re-

sponse is sentimental. The classic example of this sort of sentimentality is William James's description of a couple before Titian's *Assumption* whom he overheard saying of the Madonna there depicted, " What a *deprecatory* expression her face wears! What self-abne*gation!* How *unworthy* she feels of the honor she is receiving! " James remarks, " Their honest hearts had been kept warm by a glow of spurious sentiment that would have fairly made old Titian sick." [1] James's point is that this sentiment does not belong to this picture. The old couple's idea that it did was false. The emotion was, consequently, sentimental.

The second sort of sentimentality has to do with ideals of human character. Every culture develops its ideals of decorum. Among these are ideals of emotional decorum. Under such and such situations, such and such emotional expressions are proper or allowable. When a person shows himself excessively emotional as judged by these standards of emotional behavior, he is considered sentimental. The falseness of the emotion consists in its not being true to type.

This sort of sentimentality is attached to emotions in the mode of emotional drives. " Sentimental Tommy," for instance, a character developed in several novels by James Barrie, has this sort of sentimentality. Situations which normally called for action were taken by Tommy as occasions for prolonged emotional indulgence. Finally he fell in love, and attempted even here to carry out the same pattern. The state of being engaged seemed so sweet to him that he proposed to remain in that state permanently and never get married. His girl, needless to say, had another ideal. Sentimentality of Tommy's sort we associate more frequently with excesses of the teary emotions, with women who nurse long-past grief, or with any excessive softness of heart, with the " Woodsman, spare that tree " sort of thing. There are people who cannot bear to have a dog disposed of under any circumstances. Excessive softness of heart quite surely carries with it, incidentally, a callousness of heart in the opposite direction. What about the possible needs of the woodsman in cutting down the tree? There is a story about Bronson Alcott that he could not bear to kill potato bugs. So, he picked them off his own vines and threw them on his neighbor's!

People who are habitually sentimental in the above manner tend to develop gestures, attitudes, and facial expressions which mark them as such at a glance. The things they choose to talk about and to have about their rooms are also symptomatic. So, an artist can portray a sentimental person by emphasizing these symptomatic signs. More than that, an artist can betray his own sentimentality by exhibiting these traits in his work. And this is where this sort of sentimentality has a particular bearing on art. For to a spectator who feels that the emotion exhibited in a work is false to his ideals of emotional fitness the work is repugnant.

How far is this judgment of emotional excess a purely conventional matter

[1] William James, *Principles of Psychology*, Henry Holt, 1918, Vol. II, p. 472.

based on the customs of the period or of the social stratum in which the spectator happens to be? That the judgment varies with the times is obvious. It was considered appropriate for a young lady to faint in a tense situation during the hoop-skirt period. Today such behavior is considered sentimental. Murillo's teary Madonnas were appropriately emotional in his day. Today we find them sentimental. That these judgments are valid aesthetic judgments relative to the ideals of decorum for their respective times cannot be denied. A type of human decorum is fulfilled in one age and the act felt as charming. The type is broken in another age, and the act found ridiculous or disgusting. In both instances it is a genuine aesthetic judgment, relative to the age. But may not the ideals of an age themselves be sentimental?

The question is whether there is not a verifiable norm of emotional behavior which within a certain range of emotional expression can be regarded as a universal human norm of healthy emotional behavior, irrespective of age or convention. Can it be shown that a man like Sentimental Tommy is suffering from emotional disturbances which are as much a disease and abnormal as if he were tubercular? If so, it would not matter that for a period a whole society approved his behavior; the behavior would still be abnormal. It would be abnormal in reference to a scientifically verified description of a range of healthy emotional behavior. That is, healthy emotional reactions to situations would on this evidence be determined not by conventions of social decorum but by medical and psychological experience. The probability that such a norm of good health for the emotions is demonstrable seems to me great. I suggest that psychiatric practice is working on the basis of such a norm now.

If so, we can understand why the judgment of sentimentality may be regarded as such a serious one in art criticism. When a picture is called " sentimental " in the sense we are now discussing, it means that the picture is regarded as emotionally unhealthy. Moreover, if our hypothesis is correct, one of the great values of excellent art is that of stimulating emotional balance. This conclusion does not imply that sentimentality and all sorts of emotional excess may not be presented in an excellent work of art. *Sentimental Tommy* is not a sentimental novel, though it is about a sentimental man. Reading about Tommy, we are induced to correct any such emotional traits we find in ourselves. Excellent art is one of the most effective sources of emotional education. To be moved by the great works of Bach and Beethoven, of Tintoretto, Cézanne, Picasso, or Michelangelo is to have emotional attitudes set up so full and balanced that as we absorb them our own personalities are in some degree also built up and integrated. We ourselves then take on something of the emotional stature exhibited by these artists in their finest works.

Part Three

VISUAL MATERIALS

CHAPTER 7

A TRANSITION CHAPTER

On the Classification of the Arts

LOOKING back over the previous six chapters, what have we done? We have examined the kinds of general aesthetic principles which apply to any sort of art. We have taken note of the ways in which our immediate likings are subject to change — the mutation principles of conditioning, habituation, and fatigue. And we have taken note of the general ways in which the materials of our immediate likings are brought together to produce aesthetic works of art — by the organizing principles of design, pattern, type, and emotion.

We have been describing the general laws of aesthetics. It now remains to apply these laws to specific materials, to aesthetic works of art, and to the aggregations of these which are known as the arts. Earlier we spoke of the four main divisions of the arts: music, literature, the visual arts, and theater. The grounds for the divisions stressed then were the differences among the materials used. Music is concerned with sounds, literature with words, the visual arts with visual materials, and theater with the stage as a medium for synthesizing all these materials.

Now we have to observe, however, that the divisions among the arts are not fully explained by the differences of their aesthetic materials. For the visual arts of painting, sculpture, and architecture exploit the same aesthetic materials, and yet they are distinct arts. Moreover, a closer scrutiny of the four big divisions uncovers a great deal of overlapping of materials. This is frankly admitted in the theater, which claims no unique materials but only a unique manner of handling them by means of a stage or of a screen. But besides this, literature in its rhythms and the sonority of its words makes aesthetic use of sounds. Music has no monopoly of sounds. Nor has literature a monopoly of meanings, as we may see from program music and song.

There is a very important sense in which the arts are all one. The importance of this insight appears whenever the divisions among the arts are set up as rigid boundaries, and the boundaries used as criteria of criticism. If, for example, program music is disparaged as an impure form of art because it mingles images

with sounds, or opera because it mingles music with drama, or song because it mingles lyrics with melody, then is the time to insist on the essential unity of art.

Nevertheless, one of the noticeable characteristics of art in practice is its division into a number of arts such as painting, sculpture, and architecture. What is the basis of these divisions? Not, as we have seen, the aesthetic materials. They all organize color, line, mass, and volume. Not even the physical materials. For sculpture and architecture both use stone, wood, and metal. The basis for these divisions is, in fact, technique.

The art of painting is defined by a certain group of techniques which a man can easily master if he has mastered one. Similarly, the art of sculpture is a group of techniques in the handling of stone, bronze, wood, clay which a man can easily master as a group. But a boundary springs up between two arts when the difference between techniques becomes so great that rarely can a man in his lifetime become excellent in both. The divisions among the arts are divisions among men. They are divisions of crafts. They become the more marked because men working in a single technique have interests in common and so tend to gather together and exchange information and criticism, and to segregate themselves from those working in other techniques. So, painters consort almost entirely with painters, and sculptors with other sculptors, and so on. When a painter meets a musician, he is often as ignorant of the other's art as if he were a naive layman — and makes the same blunders. It is this separation of artists from one another because of their absorption in their own techniques which is the actual basis for the sharp divisions among the arts.

And then it does appear that there is some genuine aesthetic basis for recognizing these divisions of crafts in aesthetic theory and appreciation. For the appreciation of the fulfillment of types of technique, and the sense of the aesthetic potentialities of materials through techniques, follow the same contours as the practical divisions among the arts.

Accordingly, we shall define each art as we come to it in terms of the technique which in practice differentiates it from the other arts. Among the visual arts, the major divisions will be painting, sculpture, and architecture. But before we come to them, we must study the aesthetic materials which go into them.

Aesthetic Materials

We shall follow a uniform method of studying these aesthetic materials, proceeding from the simplest to the more complex. We shall look first for the most elementary characteristics of these materials, and shall try to specify the physical stimuli which produce them. We shall then construct, whenever possible, the scheme or natural order in which these elementary materials grade into one another. For instance, as soon as we have distinguished the character-

istics of colors, we shall then construct the color cone, showing how all the colors are placed in relation to each other. Such schemes bring out all the paths of gradation and degrees of contrast in which the elementary materials stand to one another. They are the basis of the application of the design principles of contrast and gradation to these materials.

Then we shall see what correlations can be found between these elementary materials and the moods. For this will be helpful in understanding the emotional organization of the materials.

Finally we shall see if there are not some generalizations that can be made about the simple combinations of these materials. For these will assist in understanding the effect to be anticipated when these materials enter into the total composition of works of art.

This is the method of element analysis, which is often objected to on the ground that it destroys the integrative unity of a work of art. There is some justification for the objection, especially if the critic gradually loses sight of the whole in which these elements are functioning. But the answer is that there is yet another way of missing the integration of aesthetic materials, and that is by failing to discriminate the aesthetic materials which are integrated.

The purpose of our analysis is precisely to become aware of the materials that enter into an aesthetic work of art, so that our perceptions may become more keen and our appreciation deeper and more lasting. For analysis need not disrupt appreciation. On the contrary, it is a prerequisite of a full appreciation, and sometimes of *any* appreciation whatever, of a work of art. People can look at pictures and statues, and not see them. The aim of our coming analyses is to lay the groundwork of discriminating perception. When a person has once seen what aesthetic materials are and how they are related in a work of art, he can fund these progressively toward a more and more complete and satisfying perception of the whole. Eventually the work is grasped by a sort of intuitive act in which past discriminations fuse with present stimulations in a total integrated experience. Analysis as a means to the attainment of the full aesthetic experience of a work of art does not lead away from, but directs one toward that experience.

We shall proceed, then, to a rather detailed study of color, line, mass, and volume as the aesthetic materials out of which the visual arts are made. Then we shall see how these gather together in the works of the three major visual arts — painting, sculpture, and architecture.

COLOR

Characteristics of Color

THE TERM " color " refers in common speech to three quite different things, which need to be clearly distinguished, the more so since they are closely correlated with one another. " Color " refers to (1) certain *visual sensations,* such as the sensation of blue; (2) it refers to *pigments* which are chemical substances reflecting rays of light, such as pigment blue, which reflects rays of about 485 millionths of a millimeter; and (3) it refers to the *rays of light* which stimulate visual sensations, such as a blue ray of 485 millionths of a millimeter.[1] These three different things are closely related because the " blue pigment " reflects the " blue ray " which stimulates the " blue sensation."

Now it is only the " blue sensation " which, so far as we know, has the blue quality of experience when, for instance, we look at the robe of Fra Angelico's Madonna. The pigment on Fra Angelico's panel is not blue in the dark — that is, not " experienced " blue. The pigment reflects the light ray which in turn has the capacity of stimulating the blue sensation in us. Similarly the ray of light reflected from the " blue " pigment is not the " blue " felt in sensation. It follows that the blue which is relevant to Fra Angelico's picture as an element in that aesthetic work of art is the immediately experienced sensation of blue in the spectator. When we speak of colors as aesthetic materials, then, we mean colors as sensations (or sometimes as images, since we can also imagine blue as experienced), never as rays of light, or pigments. The latter are merely the direct

[1] Light, as studied by physics, consists of electromagnetic vibrations such as are emitted by the sun. The rays of the sun appear to us as white light. But if these rays are passed through a prism, they spread out into a spectrum (like the rainbow), a series of hues running from red to violet. This is due to the refraction, or bending, of the rays by the glass of the prism. It proves that the sun's rays are composed of rays of different wave lengths, and that our sensations of the hues of color depend on the wave lengths of these different rays of light. But when all these rays are combined, we get the sensation of white. Light waves are presumably a good deal like water waves (so-called transverse waves) and the length of a wave is the distance from crest to crest. This distance for light waves is very, very small. As the text indicates, it is measured in *fractions* of a millimeter (0.03937 of an inch).

and indirect stimuli of color as materials for an aesthetic work of art. Colors as aesthetic materials are sensations.

In this chapter we shall be studying colors as aesthetic materials. We shall make frequent references to pigments and rays of light, since these are the stimuli of color sensation, and the means of controlling aesthetic perceptions. But these are not literally elements of appreciation.

Colors as immediately sensed materials have, like most other aesthetic materials, many characteristics. Some of these are more basic than others in developing the fundamental schemes or, as Prall calls them, the " natural orders " of the materials. Such characters I am calling the *primary characteristics* of the materials. For color, these are *hue, value,* and *saturation.* The whole field of color can be organized by means of these three characteristics. They constitute the fundamental dimensions of color.

Correlated with the primary characteristics of aesthetic materials are likely to be a number of other characteristics of considerable aesthetic importance. Such I am calling *secondary characteristics.* For color these are *color quality* (the vibrancy of a color), *apparent temperature* (warmth or coldness), *apparent distance* (advancing or retreating colors), and *apparent weight.* Often secondary characteristics have greater sensuous and expressive powers than the primary. They are secondary only in the sense that the basic structural relations among the sensory elements would not be affected by the loss of the secondary characteristics. The characteristic of apparent temperature (warmth or coldness) which most colors have could, for instance, be imagined away without the disappearance of any basic color sensations. But take hue away, and we should be left as if totally color-blind with only the series of grays. And take value away, and we should be left in the state of a blind man without any visual sensations at all. That is what is meant by saying that the primary characteristics are basic in a manner that the secondary characteristics are not.

Some of the secondary characteristics in certain aesthetic materials are quite surely due to deep-lying conditioning, and so are acquired associations arising from our common physical environment or from a long enduring cultural pressure. But some seem to have a constant physical or physiological correlation with the primary characteristics of the materials, and so are innate or practically so. In the present study we shall not greatly concern ourselves with the sources of the secondary characteristics. Speculation about these sources is often too uncertain. We shall simply take note of the characteristics, point out their nature, show some of their important uses in art, and indicate how they add to the expressiveness and enjoyment of a work.

We shall first discuss the primary characteristics, and then the secondary. Then we shall consider questions of color combination and modes of color organization.

Primary Characteristics of Color

Hue is the characteristic that we distinguish in the color spectrum. As we look along the spectrum we commonly name red, orange, yellow, green, blue, violet. These are names we give to some of the most noticeable hues.

A hue, of course, can only be defined by pointing at it or in some other way showing how to get the sensation of it (that is, by ostensive definition). It is an ultimate experience of immediacy, which simply means that there is no way of knowing what a hue is except to experience one directly. A man born blind cannot really ever know what a hue is. No symbol or group of symbols can ever give a person the meaning of a hue unless he has had an experience of one himself and learned a name to call it.

Practically all aesthetic materials — certainly all their primary characteristics — are of this sort. They are ultimate facts of immediacy. This is what makes aesthetics so different from most other studies. For in most sciences we study the relations of objects to one another, and the sensations used in perceiving the relations among objects are treated only as signs of the relations. Scientific objects are then defined in terms of their relations and no special sensations are needed to understand the objects. But in aesthetic studies, the materials are the sensations themselves, and if you do not have immediate experiences with the sensations themselves, you do not know what you are studying at all. It is very important, therefore, always in the arts to get as soon as possible into immediate contact with the sensory materials. Aesthetics is thus in one way the most concrete and factual of all studies. For it forces us to become aware of the ultimate, immediate quality of sensation and perception.

So now I shall assume that you are aware of what hues are in your experience, sufficiently so as not to need a picture of a spectrum to remind you. The spectrum runs from red at one end to violet at the other. The physical stimuli for these hues are electromagnetic vibrations. The wave length for red is in the neighborhood of 685 millionths of a millimeter, for yellow 585, for green 525, for blue 485, and for violet 390. Wave lengths longer than the 685 of red give infrared rays, which are invisible; those shorter than the 390 of violet give ultraviolet rays, which are also invisible.

The visible rays defined by the spectrum are a band of light rays that have the property of stimulating the cones in the retina of the eye. These tiny sense organs pass the impulse received on to the optic nerve, which carries it to the occipital lobe of the brain, whereupon the color sensations of hue emerge. The resultant "hue seen" depends on the length of the stimulating ray. There are also other little sensitive organs in the retina called rods which are sensitive to light but give only sensations of light and dark, not of hues. The band of hues

is a graded series correlated with the graded series of wave lengths in the band of visible electromagnetic vibrations.

The electromagnetic vibrations get shorter and shorter as we pass from the red end of the spectrum to the violet end, so that the greatest difference in the vibrations is between those at opposite ends of the spectrum, red being the longest and violet the shortest. We might then anticipate that the hue at one end of the spectrum would be in greatest contrast with the hue at the other end. Surprisingly, the reverse is true. The hue, violet, at the short end more closely resembles the hue, red, at the long end than any other hue except orange, which is next to red in the spectrum. The order of the hues in sensation, accordingly, does not exactly follow the order of the wave lengths in the spectrum. For after going through hues of greatest contrast to red (that is, green and blue), the order of hues begins to swing back toward red at the violet end. Still more remarkable is the fact that if we allow ourselves to be stimulated by a combined ray of red and violet light we obtain the intermediate hue, purple, which brings us right round to red again.

The moral of this observation is that we must not try to hold the order of the hues in too close an attachment to the order of the vibration lengths. The physical correlates of hues do not correspond exactly in their order with the sensory order of the hues. We cannot expect, then, to work out any helpful relations of harmony among hues by studying the physical wave lengths of their stimuli. This is worth noting because the study of sound waves has proved very helpful in developing the aesthetic relations of musical harmony. Some writers have sought for similar help from light waves. But clearly relations among hues are relatively independent of relations among light waves. We must look to the sensations of hues themselves for their aesthetic relations.

To repeat, then, if purple is put in between red and violet, we find that the hues return upon themselves and form a circle, as shown in Fig. 19. This is the natural order or scheme for the hues. We obtain this order by starting with any hue, such as red, and making just perceptible gradations towards some other hue, orange. The red slowly gets yellower till it reaches pure yellow and then we find that yellow can grade similarly into the greens and the greens into the blues, and finally the blues through violet and purple into red, the hue from which we started.

If we consider spectrum hues only, and the purples obtained by mixing spectrum red with spectrum violet, this circle is the only path of gradations possible, and the hues grade into each other only in the order shown in the circle of the hues. We cannot get from red to yellow, for instance, without passing through orange, or else going all the way round the circle in the opposite direction, passing through the violets, blues, and greens.

It is clear, then, that the hues close together on the circle are closely related

sensuously. They resemble one another. The violet and orange hues have some red in them. The violet and blue-green hues all have some blue in them. Such hues are, therefore, called analogous. They are variations of one another. But the hues far apart in the color circle do not resemble each other in this way and are contrasting. The importance for principles of design of the relations of hues in the color circle now becomes obvious. These relations determine gradation, variation, and contrast among hues.

FIG. 19

When these hues are given definite places in the circle, we have a *color scale*. Color scales differ depending on the intervals set up between the hues. Figs. 19 and 20 show two different ways of locating the colors in the circle and so constitute two different color scales.

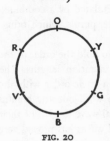

FIG. 20

Fig. 20 is probably the most familiar arrangement of the hues to most people. It is constructed by first dividing the circle into thirds and then placing what are known as the pigment primaries — namely, red, yellow, and blue — at each of these divisions. Then halfway between these hues are placed the so-called secondary hues — namely, orange, green, and violet. The latter are the hues that look as if they were halfway between the pigment primaries in color. Thus the color interval between red and orange feels about the same as the interval between orange and yellow. Actually the steps of just perceptible gradations from red to orange will probably be found to be just about equal to the number of steps from orange to yellow. Moreover, if yellow pigment out of a tube of paint is mixed with red pigment in suitable proportions, the result is orange; and if blue pigment is mixed with red, the result is violet; and if yellow pigment is mixed with blue the result is green.

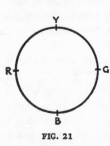

FIG. 21

The reader may now wonder why we put the hues down in the queer way we did in Fig. 19 when Fig. 20 looks so reasonable. The reason is that Fig. 19 is much closer to certain physical and physiological facts that are aesthetically important.

Chief among facts of this nature is the relation of *complementary colors*. If a ray of blue light is mixed with a ray of yellow light the result is gray or white (depending on the intensity of the rays). Whenever this result occurs from mixing hues we say that the hues are complementary colors, or complementaries. Every hue has a complementary in this sense. The complementary of red is a bluish-green, that of green, purple. The hues are arranged in Fig. 19 so that

each hue has its complementary diametrically across the circle. And the middle of the circle represents gray.

This relation of complementary colors is not only a physical relationship between rays of light. It appears also in the two rather surprising physiological effects of great aesthetic importance which we mentioned in Chapter 2 — *successive contrast* and *simultaneous contrast*. If a square of bright yellow paper is placed on a gray ground and looked at steadily for several seconds, and then the paper is pulled away, a blue square will appear on the gray ground where the physical yellow square was before. This is the phenomenon of successive contrast. Likewise after looking at a blue square of paper, yellow will appear. Yellow and blue are thus natural contrasts. Similarly with all the other complementary pairs as shown in Fig. 19.

Moreover, if we repeat the experiment of looking at the yellow square on the gray ground, and give our attention to the outskirts of the square, we shall see that there is a sort of bluish halo which develops around the yellow square on the gray ground. This is the " simultaneous contrast." Similarly, a yellow halo develops around a blue square on a gray ground. Moreover, if the yellow and blue squares are placed side by side, each of these hues is intensified by simultaneous contrast with the other. These facts are clearly very important aesthetically. We have pointed out already how Fra Angelico made use of them in his picture of the Madonna (Chap. 2, p. 40). Fig. 19 distributes the hues in the color circle so as to remain true to this very important relationship among the hues.

But Fig. 19 does more than that. It represents (to a fair approximation) all the relations of color mixture for rays of light as these stimulate the eye. For there are two main laws of mixture for rays of light of different hues:

1. If complementary hues are mixed, they give either gray (or white) or a grayed tone of one of the hues mixed, depending on the proportions of the two hues.

2. If noncomplementary hues are mixed they give a hue intermediate between the two hues, the nearness to one or the other of the hues depending on the proportion of the hues. (Of course, if the mixed hues approach complementaries, they are grayed.)

These laws of color mixture are represented in Fig. 19 by simply drawing a line between any two hues. The result of the mixture will lie somewhere along that line, depending upon the proportions of the hues mixed. Let the middle of the circle represent gray. Then a line from yellow to blue, which passes through the middle of the circle, indicates that if yellow light is mixed with blue light in the proper proportions the result is gray (which shows that these hues are complementaries).

But according to our first law of light mixtures, this line also shows something

else. It shows that there is a series of grayer and grayer yellows that develop as
you increase the proportion of blue to yellow. This series is represented by the
line from yellow to the center of the circle. This is, in fact, the series of satura-
tions from spectrum yellow to neutral gray. *Saturation* is, then, the primary
characteristic that represents the amount of gray in a color. The less gray a hue
has, the greater its saturation.[1]

A line between noncomplementaries in Fig. 19 shows the results according to
the second law of mixtures of colored lights. A mixture of red and violet gives
some hue of purple, depending on the proportions. A mixture of blue and or-
ange would produce low saturated mixtures in the neighborhood of gray, as the
line between them would indicate, but would never give pure gray. And so on.

The summary of these facts about mixtures of hues and complementaries,
together with the fact that the true physiological opposites have their proper
place opposite each other on the circle, constitute the reasons for the arrange-
ment of hues in Fig. 19.

It is true that Fig. 20 is roughly true to facts about the mixtures of paints.
But these facts are of no significance to the spectator, nor aesthetically in any
other way. A paint is a fluid or viscous chemical substance with colored particles
in it suitable for applying to a surface so as to reflect colored light to the eye.
What is seen and appreciated is the reflected colored light. When paints are
mixed physical and chemical effects often take place which do not correspond
with the laws of mixtures of light. Red and yellow paints mixed give orange, as
the second law would indicate. But when yellow and blue paints are mixed, the
result is a green paint, contrary to the result with hues of light. For in light, as
we saw, yellow and blue are complementaries and give gray or white. Paint mix-
tures are too variable to be reliably schematized. Vermilion and dark blue in
paints give a dull reddish violet, in lights they give bright purple. Orange cad-
mium paint mixed with ultramarine blue gives a green paint, in lights they
give a dull violet. Yellow and black paint give olive-green, in lights dark
yellow. Paint mixtures are of course very important for painters to know for
the technical control of their pigments, but of no importance to the spectator
in enjoying the results in a picture — just as knowledge of the technique
of typing is important to a writer, but of no importance to his appreciative
reader.

It is often maintained that the color intervals in Fig. 20 are more evenly dis-
tributed than in Fig. 19. For in Fig. 19 there is clearly a crowding of the hues
between blue and red in comparison with the distribution of hues between blue

[1] Saturation is sometimes called the "intensity" of a color. But "intensity" is also often
used to denote the brightness of a color, or the energy of light in it, which is quite different from
saturation. For instance, a light blue is brighter than the more saturated but darker spectrum
blue. So the term "saturation" seems preferable.

and green. But in Fig. 20 there is a crowding of hues between yellow and green in comparison with the distribution between yellow and red. If evenness of distribution were what were sought, Fig. 21 would probably be the most nearly correct.

In fact, the scale of hues in Fig. 21 has much to be said for it. For red, yellow, green, and blue are the *psychological primary colors*. They are the four hues which appear to the eye to be pure and without mixture of other hues. Orange clearly looks as if it had yellow and red in it; purple, as if it had red and blue in it; and the yellow-greens and blue-greens betray in their very names how these hues appear to the eye. But red looks only like red; there is no sense of blue or of yellow in it. The same with blue and yellow. It is true that many people think they see yellow and blue in green. But many do not, and this leads to the suspicion that those who seem to see yellow and blue in green are merely associating this hue with the hue of paint which they have learned can be made out of blue and yellow paints. Moreover, blue and green are as strong a contrast as yellow and red; and are much stronger than yellow and orange. And this is the important fact aesthetically.

The three hues, red, yellow, and blue, on which Fig. 20 is based are called the *pigment primaries*. Their selection originated in the fact that from mixtures of paints in these three hues, paints of all the other hues on the circle can be produced to some approximation. This is an interesting technical fact, but has no aesthetic significance. It means no more to the spectator than the kind of brushes the artist uses.

While we are speaking about primary colors we should also mention the *physical primaries*, which are red with a touch of yellow, blue with a touch of green, and blue-violet. Out of these three colored lights all the other hues in the circle can be produced by mixture. This is an interesting physical fact, but is also of no aesthetic significance.

Only the psychological primaries have any immediate aesthetic significance. For these four hues are immediately felt as uniquely contrasting hues and the hues lying between them are immediately felt as analogous hues. That is, the psychological primaries directly reflect our feelings toward hues as neither pigment nor physical primaries do.

We have compared these scales of hues at some length because out of the comparison we learn a lot about the relationships of hues to one another. I believe that Fig. 19 is the most revealing of the three. The color scale in Fig. 21, however, brings out some important psychological relationships. As for the color scale in Fig. 20, this has traditionally been regarded as a source of reliable color harmonies. There is some truth in this tradition. But like many traditions this scale and its color harmonies have perhaps done more harm than good in developing rules which have sometimes been taught with superstitious rigor. To

avoid such superstition there is probably some advantage in keeping all three scales in mind.

So far we have spoken only of hue and saturation. There is still one other primary characteristic of color that we have not discriminated, that of *value*. The value of a color is the lightness or darkness of it. It happens that there are colors which possess only the characteristic of value. These are the grays. And these are the colors to which the rods in the retina of the eye are sensitive. The physical correlate of value is the amplitude or energy of electromagnetic waves. The higher the wave or the more energy in it, the higher the value. The color of highest value is white, that of lowest value black. Black, incidentally, is a freak color. Pure black is the sensation we get when *no light* is reflected from a surface. But in order to have this sensation the surrounding area must be illuminated. We get true black by looking at black velvet or into a well or cave. The blacks we get from paints are really very dark grays. One is often astonished to find how far from pure white or pure black the whites and blacks in a picture are. Mme. Charpentier's gown, for instance, in Renoir's picture looks very black. But put a piece of black velvet beside it and see. Also put a piece of white paper beside her white neckpiece and see what becomes of that. Then ask yourself how Renoir produced the effect of so great contrast.

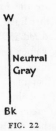

FIG. 22

White and black then are the values correlated with the greatest and the least energy of visible rays. In this instance the greatest contrast in the sensed colors corresponds with the greatest difference in the correlated stimuli. So the natural order of values is not a circle, as with the hues, but a straight line, as in Fig. 22. White is at one end of the series, passing through darker and darker grays to black at the other end.

Now the next thing is to show the relation of the series of color values to that of the hues and to those of the saturations. This is brought out in Fig. 23, the so-called color cone, which shows the relations to one another of all visible colors. This map of the colors is somewhat simplified. Actually the circle of the hues is irregular, for some spectrum hues are farther out from neutral gray than others. Also there is a saturated blue-violet that is darker than spectrum blue.

What strikes one first about the color cone is the severe tip of the plane of the hues. The reason for this is that spectrum yellow is very high in value, very near white, while spectrum blue (and violet) is very low in value. That is, saturated yellow is as light as a very light gray, and saturated blue as dark as a very dark gray. Look at these hues and see. So the circle of hues has to be tipped to make it true to its color value relationships.

Another point that comes out is that when a most saturated spectrum hue is

made either lighter or darker, its saturation is reduced. As spectrum yellow gets darker it comes nearer and nearer to the gray axis of the cone and finally becomes black. Similarly as it approaches white. This latter fact is somewhat surprising. You might think that the greater the wave amplitude in the stimulus of a sensation of color the stronger and more saturated would be the hue. That is not the fact. The strongest blue is dark in value, so that a light blue, which has more energy or light in it, has also less blue.

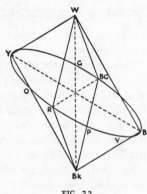

FIG. 23

Now, these relationships are aesthetically very important. We see at once why spectrum yellow and blue make a stronger contrast than spectrum red and green. Yellow and blue contrast both in hue and value. But red and green contrast only in hue, for they are about equal in value. We see also why saturated yellow is the most cheerful of the hues and why blues and violets are somber. For light itself is cheerful for most people, and dark is somber. Yellow is the hue with most light in it, and saturated blues and violets are intrinsically dark. The cone also exhibits the multitudinous paths of gradation that colors can follow. A painter can start with a blue and grade into the dull violets and then into the browns and oranges and then into the dull yellow greens — as Renoir does in the peacock panel behind Mme. Charpentier. He can wander all about inside the color cone and over its surface.

It is not that a painter actually has this map of the colors in his mind's eye as he works. The painter is just very much at home in the realm of colors and knows how to get from one to another and how far apart they are and their relative elevations in value and many other peculiarities. But when these relations are mapped out for us who are not so familiar with this realm, the result is the color cone. This map may reveal many relationships that we should otherwise miss, and may thus increase our enjoyment of many visual works of art.

There is one fact about the physical correlates of color that we have not brought out. Hue is correlated with wave length, value with wave amplitude; saturation is correlated with wave composition. By composition is meant the number of simple waves out of which a complex wave is made. We saw how low saturated yellow consisted of a mixture of some blue light with yellow light. That meant that the wave which stimulated the sensation of dull yellow was composed partly of a yellow wave and partly of a weaker blue wave. The shape of the dull yellow wave was a resultant of these two waves mingling and modifying one another. In short, the physical correlate of dull yellow sensation is a composite wave of a specific form.

Perhaps we should also note that in this chapter the term "color" denotes any color in the color cone. Black, white, and gray are colors in this sense, just as much as the hues. It has been estimated that there are about 35,000 distinguishable colors.

Secondary Characteristics of Color

The secondary characteristics of color named earlier were color quality, apparent temperature, apparent distance, and apparent weight.

Color quality is the effect of two or more colors reflected from the same surface. It is the most sensuously appealing of all the characteristics of color. It is what makes a color rich and alive, and could well be regarded as aesthetically the most important of all color characteristics. It is what makes the difference between a color in wool or silk or velvet. For take any color, say red, and match it exactly for hue, value, and saturation in those three materials. Still the color will be somehow different. One will be the red of wool, one the red of silk, and one a velvet red. This is the difference in color that corresponds sensuously to timbre in music. Play a note of the same pitch and intensity on a violin, a piano, and a clarinet. Still there is a difference which is the timbre of those instruments.[1] Similarly with color quality in different materials. And just as a single beautiful timbre like the tone of a gong is something that can stand by itself to be dwelt on for its solitary beauty, so a single color of beautiful texture like the glaze of a Chinese vase or a piece of jade is a thing to contemplate all by itself.

We are all susceptible to the beauty and variety of color quality, as the universal love of textures over and over again testifies. But few of us are quite aware of what there is in a color that makes us cherish it so — what it is that silks and velvets and ivory and pearls and precious stones and semiprecious stones, and the petals of flowers and the wings of birds and butterflies have in their colors that attract us so. It is the quality, the vibration of their colors.

Perhaps the best way of getting an understanding of color quality is to show some of the ways in which it is obtained. For the idea that two or more colors can come off of one and the same surface seems at first fantastic. But think of the woven texture of a fabric. Suppose it consists of a white thread spun in one

[1] *Psychologically* musical timbre and color quality are exactly the same sort of thing. For the perception of timbre consists of a perceptual fusion of a lowest tone (the "fundamental") with other tones ("overtones") sounded at the same time. The fundamental gives the pitch of the tone. The overtones fusing or half fusing with the fundamental give the timbre to the fundamental. Similarly in a crackled glaze, the color of the crackles mixed with the main surface color gives "quality" to the surface color.

Physically, however, musical timbre is correlated with the composition of air waves, and in this respect corresponds with color saturation. This fact is another reason for not trying to develop a theory of color relations too closely on the analogy of musical relations.

direction and a black thread in the other. Then we have a piece of gray cloth. But the gray of this fabric is quite different from the gray of a cloth woven in both directions with gray threads. For the black and the white threads reflect their light separately and mingle more or less in the eye, but not so completely that the eye does not distinguish a greater " vibration " in the first fabric than in the second.

Now increase the size of the black and white threads and we get a " pepper-and-salt " fabric. Here the separate blacks and whites are clearly sensed at the same time that the cloth is felt as gray. There is still a sense of a gray quality. But if we increase the patches of black and white much more we get a definite checkerboard effect, and then the gray color quality disappears.

This shows us that color quality is a mingling of colors that lies halfway between a plain color and a combination of distinct patches of color. Unless we have worked with colors, we generally think of them as plain hues covering a surface; so much so that it often comes as a surprise to see how rarely a skillful artist uses plain hues in his color areas. There is, of course, a certain simplicity, and directness, and impact in areas of plain color, which many moderns like Matisse have exploited. But by far the greater number of painters have sought to enrich their color areas with quality so that these would be a source of sensuous delight and inner variety in themselves. So it is conspicuously with the Fra Angelico, the Renoir, and the Picasso reproduced in color in this book.

Take the Fra Angelico. One is immediately struck with the beautiful quality of the gold background. On examination we see that the gold is drawn over a ground of red which shows through the gold and creates a rich reddish gold. And notice the granular or broken quality of the blues, especially in the light areas where it looks as if Fra Angelico drew a dry brush of whitish pigment over a darker blue ground. See what a vibrant blue that creates.

The Renoir is so obviously rich in color quality as to need only to be pointed at. His colors are constantly moving into one another. Examine, for instance, the peacock screens in the background. Rapid gradations of overlapping colors here produce the color quality. Perhaps the black dress is the most remarkable color quality in the picture. It counts almost as a plain black area, yet the color on examination is filled with greens and blues and violets — unfortunately lost to a considerable degree in reproduction.

And the Picasso, which may at first be taken as just a big area of two or three shades of blue, proves on examination to be scintillating with greens, and creams, and purples and browns, like reflections playing over a dark pool. The blue surface is in a constant movement of gradation with these other colors drawn over it or coming up through it. Neglecting the subject of the picture and the forms altogether, we can respond to the surface as to a single resonant tone of blue, as we might respond to the timbre of a gong.

Underpainting with opaque and overglazing with transparent colors is another important way of producing color quality. This was the characteristic means employed by Titian and other Venetians, and also by the Van Eycks, El Greco, and Rembrandt.

These illustrations should give some idea of the great intrinsic beauty of color quality. Nor should we imagine that this source of beauty is the particular concern of painters. It is a primary concern in all the minor visual arts — in textiles, ceramics, metal work, glass, etc. The color quality of their surfaces is one of the principal charms exploited by these materials. Sculpture is deeply concerned with the color quality of its materials. The choice of marble, the grain of wood, the patina of bronzes all bear witness to the sculptor's interest in color quality. Likewise the architect gives thought to this characteristic in his surfaces. He often selects his materials as lovingly as a sculptor. The character of stone is felt partly as tactile (from its associations of weight and touch), but partly as color quality. A brick wall may be perfectly plain and utilitarian, but it may also from its selection and distribution of bricks of varied color gradations be as resonant as a surface of bronze. Roof surfaces of tile and slate may similarly achieve great charm of color quality. Likewise there are many varieties of stucco texture. A skillful mason can make a beautiful surface by a soft irregularity of trowel marks, which catch the light at different angles. Observing the charm of such surfaces, some ambitious masons, not aware of the principle of restraint in art, have inferred that the greater the undulation and trowel disturbance of a plaster surface the greater its attraction, and developed a decade ago a fad of jazzing plaster to the point of comedy. But this misplaced zeal shows indirectly how much architectural surfaces are enhanced by color quality.

The second of the secondary characteristics we named was the *apparent temperature* of colors. Reds, oranges, and yellows are felt as warm colors; blues and blue-greens are felt as cool. These feelings of warmth and coolness are so reliable that artists can count on them almost as confidently as on the relations among the primary characteristics in the color cone. Color warmth may be due to association with fire, but quite as likely red and yellow flames look hot because red and orange are hot colors. That is, many psychologists question the view that color warmth is due to association with flames. For the hottest flames, like gas jets, are blue! But whether these feelings of warmth and coolness in colors are instinctive or acquired, they are as uniform as if they were instinctive.

They are aesthetically important in two ways: First, as sources of emotional effect. Literal warmth has all sorts of emotional connotations. It suggests fire, comfort, friendship, love, and a whole nest of similar associations. Warm colors can be used to express these emotional associations with extraordinary immediacy. The reddish gold and yellows and reds in Fra Angelico's *Madonna* are unquestionably used with such expressive intent. Second, the opposition of

warm and cold in colors provides another means for color contrast besides those provided by the primary characteristics. Artists have always been susceptible to the demand for the warm and cold color contrast in pictures. The demand became an academic rule in the eighteenth century. Gainsborough's celebrated *Blue Boy* was supposed to be a refutation of the rule. Picasso's *Absinthe Drinker* would be an even stronger refutation. But in both these pictures browns and yellows are introduced. And if these warm colors were eliminated, the pictures would lose much of their vitality and be threatened with monotony. The old academic rule is very nearly sound. Any but the very simplest use of color, as in textiles and ceramics and glass, seems to call for the warm-cold color contrasts. Fra Angelico's *Madonna* makes obvious use of it. And it is a delight to follow the way in which Renoir plays cool against warm as his hues move over the surface of his pictures (cf. PLATE II).

The third of the secondary characteristics is *apparent distance*. Roughly speaking, the cool colors are retreating and the warm colors advancing. If a blue square is placed on a ground of yellow, and a sheet of tissue paper is laid over the colors so as to blur the boundaries, the blue will look as if it lay behind the yellow. The effect is not so strong but that it may be missed if the boundaries are not blurred. For a figure on a ground (as here the square of blue on a background of yellow) is usually perceived as if it lay in front of the ground. A clear boundary about a figure accentuates the figure and pulls the figure forward. This forward pull of a clear boundary about a figure generally compensates for and overpowers the intrinsic backward pull of a cool color. But if the forward pull of the figure is reduced by blurring the boundary, then the backward pull of the cool color shows up.

The reason for this characteristic of advancing and retreating colors is not definitely known. The associationists say it is due to association with atmospheric effects in nature. Distant mountains look blue because the hue of atmosphere neutralizes the local color of distant objects. ("Local color," incidentally, is a very convenient artists' term and means the color of an object in standard illumination, not influenced by colored lights, reflected lights, mist, smoke, haze, or atmosphere.) Others believe the effect is due to some physiological process in the eye. Whatever its reason, the effect can be universally relied on. But, as pointed out, the effect is not very strong and can be easily compensated by visual cues which definitely indicate that a surface is meant to be forward whatever its color. Thus the effect is completely neutralized in Fra Angelico's *Madonna*, where many cues indicate that her seated blue form is to be perceived in front of the warm gold background. Similarly with the two little girls in blue in Renoir's *Mme. Charpentier*. But the effect can perhaps be positively seen in the upper right corner of Picasso's *Absinthe Drinker*. To me that yellowish unoutlined corner advances from the rest of the purer blue background. This has the

important aesthetic result of folding this corner forward into the picture, not letting the plane run off outside the picture frame. It does more subtly what the concave curve above the woman's shoulder does for the upper left corner.

This example is almost enough in itself to show the uses artists can make of the apparent distance of hues, if they care to utilize the effect. Their use of it to give distance in landscapes is, of course, obvious. But in late years it has often been employed for modeling forms in color. Instead of modeling forward by light and back by dark (as Fra Angelico does, for instance, in the folds of his Madonna's blue robe), they model forward with warm colors and back with cool colors. Cézanne is credited with first doing this consciously and systematically. The device tends to increase the variety and emotional vividness of a color composition. Picasso made considerable use of it in the modeling of his *Absinthe Drinker*. The forward planes of the folds of the woman's shawl are brought forward with a dull yellowish tone. Her face is also modeled forward with yellows and back with blues. Imagine this modeling done with grays and blacks and see what the picture would have lost. Also observe that the front part of the table is yellowish and grades back to blue. Someone may suggest that perhaps all that this signifies is simply that the café lamps were yellow, so that naturally the illumination was yellow. So it may be, but observe the effects just the same of the cool to warm modeling.

Lastly, we come to the secondary characteristic of the *apparent weight* of colors. Roughly, the darker a color, the heavier it is. Pinks, light blues, light yellows, light greens weigh less in balance than maroons, dark blues, browns, and dark greens. This can be clearly felt in the weight of the dark blue masses on the left in Picasso's *Absinthe Drinker* in comparison with the lightness of the light blue areas to the right. Also in Renoir's *Mme. Charpentier* the mother's black gown is heavy in comparison with the children's light blue dresses. These examples show one of the principal uses of heavy colors in painting — namely, its employment in balance. The other principal use of it is to express the moods of delicacy and strength. The appropriateness of the light blue to express the delicacy of the children in *Mme. Charpentier* is an illustration.

Having mentioned this correlation of the moods of delicacy and strength with the light and dark colors, we should here call attention to the correlation of the highly saturated hues and black and white with the mood of excitement and of the neutral hues and middle grays with quiet. The most exciting colors seem to be the highly saturated warm hues between red and orange; the quietest those grouped around neutral gray.

Here we will cease talking about single colors and turn to the question of combinations of colors.

Color Combination

There has been much speculation about color harmonies, especially in connection with the pigment color scale (Fig. 20). Most of this is hardly worth commenting on. The character of a color combination is, like the character of a musical chord, a fusion of the characters of its constituent colors, their proportions, and their space relations to one another.

Certain color combinations are much easier to appreciate than others. We have already remarked on this in connection with the law of habituation. Moderately close hue intervals of warm colors seem to be the most difficult to appreciate. These are consequently often called harsh and unpleasant combinations, as if they were to be avoided in objects of beauty. For the fully habituated taste they are, of course, delightful, and moreover, being warm colors, the most stimulating and exciting of all color combinations. To illustrate this point I have put in a brilliant painting by Matisse (PLATE XX), whom many prize for his superlative color sense. Pink and orange, purple and red, violet and vermilion are favorites with many artists. If one does not enjoy them, that does not mean they are ugly. It merely means that one has not yet become habituated enough to the combinations to enjoy compositions in which they appear. The law of habituation indicates that there are no intrinsically ugly color combinations.

It does not follow, however, that there are not better and worse color compositions, some that exhibit unusual sensitivity to color, others that show insensitiveness. In the two preceding sections we have seen some of the characters colors have. When colors are combined, these characters are what are combined, and the possibilities are unlimited. It is a feeling for these possibilities that constitutes sensitivity to color. Moreover, colors are never combined in isolation but always in areas and shapes and in the company of lines and often with represented forms. It is the success of the total composition that determines the success of the colors combined. This success depends upon all the principles we have been studying in the earlier chapters, but particularly on pattern and design. Some of the ways in which colors are employed to produce patterns have already been described in the chapter on pattern, and need not be amplified here. But there are certain applications of the principles of design to color composition that deserve special mention.

Modes of Color Organization

There are three main modes in which colors can be organized: (1) contrast, (2) gradation, and (3) tone. (The last is really theme-and-variation among colors.) These modes of color organization are thus simply the application of

the first three principles of design to color. Some great colorists in each of these modes are represented by the color reproductions in this book. The Fra Angelico is a good example of the mode of contrast for easily appreciated colors, the Matisse for highly habituated colors; the Renoir is an example of the mode of gradation; the Picasso of the mode of tone.

By the mode of contrast is meant the combination of rather large areas of color in which each area behaves as a relatively independent unit. Thus in the Fra Angelico we have certain blue, gold, red, and yellow areas, which stand out rather independently in contrast relations to one another. One area may echo another, and one may act as a ground on which the other acts as a figure. So the blues appear on a gold ground, and the yellows on a blue ground. And the various blue and yellow areas seem to call to one another. But still each area is a rather independent unit standing in contrast to all its surrounding areas. This is typical of the mode of contrast.

It is the simplest and most primitive of the modes of color organization. Children naturally employ it. It is also the most emphatic and potentially exciting. Its weakness is that if many different contrasting colors are used it tends to produce confusion. However, if there is a very strong organizing pattern, a multitude of areas in many colors may be kept in order even under the mode of contrast. Such is the achievement in the Persian rug (PLATE III). Persian miniatures are also frequently very intricate color designs in the mode of contrast. But this mode of color composition ordinarily invites rather simple large areas of color, as in the Fra Angelico.

The *Madonna* is an extremely beautiful example of this mode. The painter clearly loves his colors. We have already called attention to the rich quality of his gold and blue. Now we should observe how he enhances each color area by contrast with the other. How skillfully he brings his color composition to a sort of climax on red in the center of the picture, and echoes this area by two small red areas on either side with a streak below after an expanse of blue! It is, of course, also the red that gives the color quality to the gold. The little areas of black also have their function in giving variety and spreading attention over the wide background and foreground areas.

When we turn to the Renoir, who is another great colorist, we come upon a totally different conception of the way to get delight out of colors. There are some broad areas of color in *Mme. Charpentier* — her black dress, the children's blue dresses, some red stripes in the background — but it is not to the contrasts of these areas that Renoir primarily draws us for the enchantment of his colors. His inclination is toward the mode of gradation. In the original picture one can follow the gradations of hues, brush stroke by brush stroke, over the lustrous curls of the nearest child and then down over the flesh tones of her face. There is no more entrancing area of color transitions in the history of painting — ex-

cept in some other Renoirs. But we must be satisfied with less subtle areas of gradation, such as those in the couch, the screen in the background, or the flowers. Look at the flowers carefully and you will see they have no sharp outlines. The petals grade into the spaces between them and into each other. A Renoir, and in fact most great pictures, should be seen from two points of view: from a distance to obtain the total composition, and near to in order to follow the technique and the color. To follow the paths of Renoir's color gradations is like following a brook or a trail in the woods, constantly coming on new pools and waterfalls, ferns and flowers, and here a meadow and there a lichened cliff. Start with the red flower near the center of the bouquet. It shades down into tones of deep violet; then the colors grade into strong greens; then they move up in value to creams and pinks; and then to white; this area shades off the other side into yellows and down into a pool of neutral green grays and reddish grays and even a quality of reddish green. These paths of color gradation are an unending source of delight. One can return over and over again to such a Renoir for the relish of the color transitions.

All of the painters (generally called impressionists) who apply color in small brush strokes of different hues — Monet, Pissaro, Sisley, Seurat, and also Cézanne — appeal to the sensuous delights of combining colors by the mode of gradation. These artists are, of course, doing other things with their colors, too. They are achieving color quality, they are modeling forms, they are balancing their color areas in a total pattern. But beyond all these, they are enticing the sensitive eye by paths of color gradation all over a beautiful pigmented surface.

Once one has discriminated and acquired the delight of following color transitions in the mode of gradation, one can find them in areas of nearly all excellent painting. The Venetian painters delighted in it. The gradation in Titian's flesh tones are as famous as Renoir's. After enjoying a picture at a distance for its total composition and its representative character, do not fail to come up close to it to discover what it may yield in its color gradations. For in many paintings there is both a macroscopic and a microscopic aesthetic point of view.

When we turn to Picasso's *Absinthe Drinker* we come to another mode of color organization. This picture is completely under a single blue tone. What you see here is what is meant by the *mode of tone*. There is not a color in the picture that is not blued. How this tone is produced by using shades and tints of blue, and blue-greens, and violets which have blue in them is easy enough to see. But what may surprise one when one notices it is that the browns and even the yellows (the complement of blue) are also blued. These colors are rendered blue by color quality. Particles of blue show up through the browns and yellows, so that the miracle is achieved of a color taking on the tone and quality of its complement (without turning gray).

The great advantage of tone in color organization is that it automatically

achieves a unity of color for the whole composition. For under a tone every color is experienced as a variation of the one color of the tone. Every color in the Picasso is, as we saw, a kind of blue — including the browns and yellows. The aesthetic danger of the mode is a tendency to monotony. Some may think that the coloring of the *Absinthe Drinker*, for all of Picasso's subtle use of warm tones and constant gradations, is still subject to this criticism. But the insistency of the blue has here an added aesthetic justification in the emotion it invokes (cf. p. 133).

The mode of tone was habitually employed by the Venetians, painting in the manner of Titian. With these colorists the tone was a warm ivory hue. It is such a gentle tone that it may pass unnoticed. But it accounts for the gracious harmony of their colors. Since the Venetians have always been admired as among the greatest and most sensitive colorists, the mode of tone has in them its most conspicuous representatives.

It would be folly to regard any one of these modes of color organization as superior to the others. Three of the most highly admired colorists in Occidental painting, Matisse, Renoir, and Titian, are supreme exponents of each of the three modes. Who could safely say that one of these is a greater colorist than the others?

The modes may be mingled to some extent. *Mme. Charpentier* is a good example of such a mingling. The picture, as we have seen, is predominantly in the mode of gradation. But viewed from a distance it presents areas of contrast — blacks, blues, yellows, and reds. And each of these areas considered singly is virtually under a tone. The whole background through all its gradations is under a yellowish tone. The mother's dress consists of many hues all under a deep gray (that is blackish) tone. So gradation, contrast, and tone are all in different proportions represented.

The essential thing is to become aware of these modes of color organization so as to miss as little as possible that color can give. For dogmas about some one mode of using color have often stood in the way of perceiving other modes and of appreciating them.

Open and Closed Color

One more consideration about the handling of color remains to be brought out. That is the distinction between what some recent writers have called " closed " and " open " color.

We generally think of color as filling a space within a bounded form. Objects have surfaces and the surfaces of these objects are ordinarily conceived as clearly bounded, and the color of any one object is conceived as clearly distinct from the colors of neighboring objects. We see a red apple beside a green pear and a

yellow banana, all on a white fruit stand sitting on a brown table — at least, we *think* we see these objects clearly colored in this way. If now we draw outlines of these objects and fill in the areas between the outlines with the colors of the objects, then we have what is called " closed " color. The areas of color are enclosed within the outlines of the forms, each color area corresponding to the area of a form. There is thus a sort of unison between the colors and the forms.

Fra Angelico's *Madonna* is a good example of closed color. The shape of the Madonna's outer garment is clearly defined and colored blue, the inner garment red, the Madonna's face and hands are flesh color, the child likewise. The background is gold, the angels blue. To each shape a color, and the color is bounded by the shape. If there are shadows, as in the Madonna's blue robe, these also are clearly defined areas, and each area has its shade.

Now if we look at the Renoir we shall see that the colors are not quite so definitely confined to the shapes of their objects. This is particularly noticeable in the bouquet of flowers. Just where does one flower stop and another begin? Where are the edges of the vase and of the leaves? It is more or less like this all over the picture. Just where is the edge of the mother's brown hair, or of her black dress? The colors spill over most of the edges. Renoir paints with relatively open color. The edges of his forms are continually " lost and found."

This device of " lost and found " edges is periodically much admired among painters. It is characteristic of Titian, Velasquez, Vermeer — to mention three great painters of very different schools. It gives softness to forms, charm and variety to the edges, and permits a gradational flow of color across the forms. But strangely enough the device is also truer to vision than closed color. If you look at the edges of shapes very carefully with your eyes (and not with your mind) you will observe that Renoir's rendering comes closer to what you *see* than Fra Angelico's. Especially in the shadows outlines tend to disappear, and in fact wherever there is no strong contrast of values. So the dog's left ear in Renoir's picture would really be lost in the shadow under the couch, and the white edge of the little girl's dress would really be hard to find against her skin, which is of about the same color value. Of course, by the concepts of your mind (your types) you *know* that the dog has a left ear and what its shape is, and you will read it into the picture with the slightest suggestion on Renoir's part. But to your vision the shape would be just as blurred as Renoir paints it. So the lost and found edges of these painters have not only an aesthetic value in design but also the satisfaction of a perceptive visual realism.

Moreover, much of the delight in lost and found edges comes from a feeling of gentle conflict, a sort of counterpoint, between the clear shapes which the mind projects into the pictures and the lost edges every now and then where light and color blur these shapes and slip over their edges.

This counterpoint between color and shape reaches a culmination when color

areas shake themselves entirely loose from the surface shapes of objects, in the manner characteristic of the modern French painter Dufy. It is said that Dufy first lays down his color patterns and then implants his linear shapes over them. The effect is like that of two distinct themes which interweave. The color pattern is one thing; the linear pattern of shapes another; and the two interweave and play a counterpoint with each other. This is the way of completely open color. The boundaries of the shapes have very little control over the areas of the colors, and yet there is a tension and a sort of suspense developed between the shapes and the color areas as if the colors were playing hide and seek with their shapes. Color shapes and linear shapes respond to each other at the same time that they evade each other. Generally it is the color shapes that are felt as secondary and as if they were escaping from the primary linear shapes.

Once open color is seen in this light, it appears as an instance of a very ancient device — the interplay of primary and secondary shapes in a picture. The shape of a shadow on a form is, of course, a secondary shape that falls across the primary shapes of objects represented. Since the time of Masacchio in the fifteenth century secondary shapes have been used for enriching and completing primary shapes. Often a composition would be quite unbalanced except for the value and color shapes which cross the boundaries of objective forms. Rubens and even Rembrandt cast shadows forward of the source of light, forcing the use of secondary shapes quite out of the manner of natural appearance. Matisse makes extensive use of such secondary shapes. Look carefully and you will see them at work all over the picture reproduced in PLATE XX, particularly on the flesh and drapery of the reclining form and on the yellow jar.

Open color as exuberantly used as Dufy uses it — so emphatically that the color shape is as prominent as the linear shape if not more so — is a rather novel development. But the principle turns into a very old one as soon as we begin to notice the interplay of primary and secondary shapes in pictures and see that open color is simply an extension of such interplay. Moreover, there was a beginning of open color in the work of artists who delighted in lost and found edges — and that also was very early.

C H A P T E R 9

LINE

What Is Line?

THE AESTHETIC line is not the line of geometry. The geometrical line is pure concept, a product of mathematical definition, a thing of the intellect. The aesthetic line is something perceived and felt in sensations. Yet the distinction ordinarily made, to the effect that the visual line has thickness while the mathematical has not, does not happen to be true. The fundamental aesthetic line has no thickness either. Only one of many varieties of aesthetic line has thickness. All the others have not. Every artist knows this fact intuitively, yet many artists will be surprised at the statement of it.

The study of aesthetic line needs much more development than it has received. There is, for instance, no fully satisfactory theory as yet about the perception of visual line. I shall present the traditional "local sign" theory as a working hypothesis. It works extremely well in the aesthetic field. For this reason I believe it must have a strong basis of truth, in spite of some serious difficulties in its present formulation. According to this theory the perception of line is based on kinesthetic sensation (muscle-joint sensation), and such will be my hypothesis throughout the present chapter. Quantities of aesthetic facts about line which otherwise would have no connections with each other fall into place on this hypothesis.[1]

[1] The only noteworthy rival theory is one developed by the Gestalt psychologists, particularly by Köhler, which treats line as an electromagnetic phenomenon arising in the brain. Köhler holds that as a result of external sensory stimulation portions of the brain are thrown into action in the manner of a charged body generating an electromagnetic field. The boundaries of such a field in the brain and the tensions between different centers of charge produce, on this view, perceptions of line. This theory explains certain aesthetic facts which the "local sign" theory, or, more generally, the kinesthetic theory of line, leaves in the dark. But the electromagnetic field theory of brain activity is still in rather a speculative stage. Moreover, the two theories are not entirely contrary to each other. The kinesthetic theory stresses observations that can be made on the surface of the body. Köhler's theory stresses activities within the body in the recesses of the brain. The two theories might be fitted together. Line may be kinesthetic response at the surface of the body which, when transmitted to the brain, takes the form of an electromagnetic field phenomenon. But we leave this idea of an amalgamation of the two theories as a suggestion only, as something to be worked out elsewhere. We will take our stand on the kinesthetic theory for the purposes of the present chapter.

Line, then, we hold is kinesthetic sensation. Accordingly, line is felt wherever the body moves. Common sense *tacitly* accepts this fact in recognizing the linear meanings of gestures. You move your arm in a circle, and you feel that you have produced a circle, and everybody understands the gesture. Telling how big a fish you caught, you spread your arms far apart, generating a long horizontal line. Your auditor understands you perfectly. The kinesthetic theory of line merely affirms that these feelings of the linear quality of bodily movement are fundamental to the perception of line. In short, the awareness of kinesthetic movement is line.

Now, the eye, as well as the bony joints of our body, is a sort of joint. The eyeball is held in place and rotated with great precision by six muscles working in pairs. By means of these muscles the pupil of the eye can be rotated in any direction and turned upon any point within its field of rotation. These movements of the eye are, on the kinesthetic theory, the basis of visual line, just as the circular gesture of an arm constitutes the awareness of a bodily circular line through that gesture. Visual line, in short, is based on muscle-joint sensation in the eye just as the perception of line in other parts of the body is based on movements at the joints in these other parts.

Visual line, however, has acquired so predominant a position in the arts in comparison with the perception of line in other parts of the body that it is convenient to distinguish two sources of line perception, as if they were different species of line. We shall accordingly speak of " visual line " and " bodily line." By bodily line we shall mean the perception of line by any other source in the body except the eye. We shall hold that visual line and bodily line are essentially the same sort of thing. Both are the immediate awareness of muscle-joint movement. But by visual line we shall mean the awareness of an eye movement, or a tendency to such movement. By bodily line we shall mean the movement (or incipient movement) of any other joint in the body. Most of our attention will fall upon visual line. But bodily line, as we have defined it, has much more aesthetic importance than is usually accredited to it.

BODILY LINE.[1] There are two ways in which bodily line is a source of enjoy-

[1] A person reading this section commented: " I twist my back, give my shoulders a turn; I stretch muscles of my chest by pulling my shoulders back, but though the words ' pull ' and ' stretch ' and ' turn ' and ' twist ' may suggest *line* to you, I honestly don't think they do to me." — They don't necessarily " suggest " *visual* line to me either. Most people think of line solely as the visual draftsman's line (cf. p. 179) drawn with a pen or brush. But an artist knows that this is only one (though perhaps the most emphatic) stimulus of visual line, and that the linear structure of a picture, statue, or building reduced to draftsman's lines would be reduced often to nothing at all and almost always to a mere fraction of its aesthetic effect in linear feeling. When other line stimuli are included (cf. p. 177 ff.), the kinesthetic basis of line comes out on the evidence as probably a common character of all the stimuli. When it is further seen how important bodily empathy (p. 174) is to the appreciation of visual line, the probability of the kinesthetic hypothesis is increased still more. And then with muscular

ment. The first way is that of enjoying the movements of our own bodies while we are in the process of making them, as in dancing, figure skating, and the like. In any sport or skill where we get personal delight in the co-ordination of our bodies, there is probably some of this direct enjoyment of bodily line. When we are enjoying our own dancing or skating we are making compositions of bodily lines within our bodies. As skaters we weave eights on the ice, or threes, or spirals, and the swing of the movement goes through our bodies progressively from the turn of the shoulders, through the hips, to the knees and ankles. We wind our body up and unwind it in a little drama of linear movements that takes in every joint in the body from the neck and arms to the ankles and toes. In turning the three there is a gradation of tension as the body winds up to the climax where the foot turns and then a denouement as the body relaxes in the completion of the figure. The co-ordination of movements in this little drama of the three-turn in skating when performed with perfection (or even with a bare approximation to perfection) is an experience of great beauty. It is an integration of lines in their most primitive and completely expressed forms. Much of the fascination of figure skating comes from the delight one can get from making compositions of movements within one's own body.

The first time one goes to a figure skating session he is amazed at how so many people can go on for hours paying very little attention to one another, working so hard in little patches in the middle of the rink or circling endlessly round and round. What can be the fun of it? Some of the best of them, of course, are aiming for competitions and exhibition skating where the visual aspect of their work, their skill and the visual grace of their appearance to the eye of a spectator will count. But most figure skaters never expect to compete, or to be looked at by audiences, at least to any degree that would compensate them for their effort. The answer is that they enjoy the effort itself. They are enjoying the movements of their own bodies. They are literally creating and appreciating compositions of bodily lines, and this is so fascinating that they will continue in the exercise for hours on end — even when frequently they never get to do it very well.

One of the sources of enjoyment of bodily lines, then, is in the direct creation and appreciation of them. The other, and even more important, source is an in-

movement accepted as a probable basis for the feeling of line, there remains no good reason for including only certain muscular movements as linear and excluding others as nonlinear.

It does at first sound queer to speak of the expansion of your chest as a linear feeling. But isn't the sight of the expansion of a telescope or balloon a linear feeling (cf. Chap. 12, section on three-dimensional mass)? Then why not accept the feeling of the expansion of your chest as a feeling of increased three-dimensional mass, realizing that in so far as you feel the *dimensions* and *directions* of the expansion, you are feeling lines?

When we are trying to be as precise as possible in the description of some element, and so aim to make that description clearer than it is in common speech, we cannot expect the description to correspond exactly with its use in common speech.

direct appreciation of them, which is known as *empathy* or *Einfühlung*. Empathy means literally "feeling in," or in-feeling. It refers to the psychological act of projecting our bodily movements and tensions into outside objects which stimulate them. At a race or a football game we often see the spectators straining and leaning in the direction of the runner. The spectators are not directly aware of the movements they are making, but these movements — projected and fused into the object they are looking at — give substance and vividness to their perception of the efforts and movements of the running man. The spectators cannot directly feel the athlete's efforts and movements. But what they can do is to project their own muscular tensions and movements into their perception of the athlete, and so come to feel indirectly as if they were feeling the athlete's own movements. They do not feel their own movements as if they were their own. Nor, of course, do they feel the athlete's movements. But paradoxically they feel their own movements as if they were the athlete's. That is empathy.

Now, we empathize not only the actual movements made by other men but the representation of such movements in statues and pictures. In looking at Michelangelo's *La Pieta* (PLATE XVI) we take on the attitudes of the figures if we contemplate them intently. We feel something of the limpness of the figure of Christ, and project our limpness into the statue. To the degree that we can empathize in this way, the vividness of our perception is increased. Similarly with the attitudes of the other figures of the statue.

But in the present context in which we are discussing line, empathy has still a wider application. For we tend to reinforce visual lines by bodily lines. We look at a vase, and see the curving lines of its shape. These visual lines induce muscular tensions in us. We may actually reproduce these lines with a gesture of our arms, as if we were running our hands down the sides of the vase. This gesture, or the muscular tensions which would turn into this gesture if they were allowed to expand, is often quite unconscious and projected right into the visual lines of the vase. The lines of the vase are then felt much more vividly and forcefully. For the visual lines are thus reinforced by our bodily lines.

Without the reinforcement of bodily lines, the perception of visual lines would be rather thin and intellectual. As the body of a violin gives resonance to the vibrations of the strings, which would otherwise sound weak, so the unconscious motions of the human body give resonance to the otherwise rather weak stimulation of purely visual lines. There is no rich or vivid perception of visual line that is not largely made up of bodily line unconsciously projected into it. The movement of the body may not be observable, but the tension for the movement must be there, or at least the image of it. A man who has a keen perception of line literally puts his body into it.

VISUAL LINE. Bodily line is clearly kinesthetic. There is, however, some diffi-

culty in understanding just how visual line can be explained in terms of kinesthetic sensation. As stated earlier, the *local sign theory* is just now the best available theory on the subject. Briefly, it goes as follows:

The eye is shaped like a hollow globe and the interior of the eye is covered in the rear with a sensitive membrane called the retina. Scattered over this retina are two sorts of sense organs called " rods " and " cones." The rods give us black-gray-white vision, the cones, hue vision. There is a special concentration of these end organs near the center of the retina called the " fovea." It is at this point that our vision is most acute. There is consequently an instinctive tendency to bring the fovea of the eye upon any object that catches the attention on the outskirts of the eye. We get a good conception of the strength of

FIG. 24

this tendency when anything off to one side is going on which we can see out of the corner of our eye but which politeness forbids us to look at. It is all we can do not to turn our foveas upon it.

Now, according to the local sign theory a visual line is created whenever the eye turns its fovea upon an interesting object seen at the outskirts of the eye. So suppose something interesting stimulates the retina at *a* (Fig. 24). To get a good look at it, the eye instinctively turns its fovea upon it. That is, the eye moves along the line *f* to *a* so that the object seen at *a* can be seen at *f*. In making this muscle-joint movement of the eyeball, a line in terms of a certain amount of kinesthetic sensation has literally been produced. The movement of the eyeball from *f* to *a* is (on the kinesthetic theory of line) literally a kinesthetic line. It is the muscle-joint line which indicates the distance from *f* to *a*. The same would be true if the eyeball moved from *f* to *b* or to any other point on the retina.

So far, visual line is explained just like any bodily line, just like the gesture of an arm. But we know that we can perceive visual line without moving the eye. Focus on one end of a line, for instance, and you can perceive the length of the line easily without moving the eye. The *local sign* theory explains this essential fact by means of habit or conditioning. As a result of much experience moving the eye from *f* to *a*, the point *a* on the outskirts of the retina gets to be associated with the amount of movement required to bring the fovea upon that point. A definite amount of tension for movement is then generated whenever an object stimulates *a*. This is the " local sign " for *a*. Whenever an object stimulates *a*, the tension for the associated movement to bring *f* to *a* is also stimulated. It is then no longer necessary to move the eyeball actually from *f* to *a* in order to sense the amount of the movement, since the tension, or local sign, at *a* gives that information without the movement. The tension gives the feeling of the

line and of its length. We found the same thing for a gesture. We can get the feeling of the gesture of a circle in the arm from the tension of the muscles without moving the arm. Similarly for the movements of the eyeball. With experience, every point on the retina gets its local sign of the amount of movement that would bring it upon the fovea. With the retina thus all surveyed with local signs, it becomes unnecessary for the eye to move in order to get the feeling of a line between any two or more points stimulated on the retina. When all these local signs are established the eye can focus on the center of a circle, and the line of the circumference will be clearly defined by the ring of local signs stimulated on the outskirts of the retina. With its local signs established, the eye can now see a circle just as well by focusing immovably on the center, as if it followed the track of the circumference with its fovea. This is the explanation of visual line by the local sign theory.

FIG. 25

The most striking objection to the theory which one is likely to hear is that observation of the movements of the eye in following a line such as the curve of a circle shows that these movements are not smooth but jerky and angular. The eye does not literally follow a curve the way a finger would. It jumps along a line like a grasshopper.

This objection is not as serious as it seems, however. It is not in any way an objection to the manner of *perceiving* the line but only to the manner of *feeling* it. The discovery that a curved line is perceived through a series of jerky movements does not disprove the view that line is kinesthetic movement; it tends to confirm the view. But a curved line certainly feels like a smooth line rather than as a succession of jerks. The suggested answer here is that the feeling of the smoothness of a curve is probably derived from bodily lines empathized in the visual line. That is, the feeling of visual lines is thought to come mainly from the empathized bodily lines, rather than from the eye movements themselves. Moreover, the amount of jerkiness of an eye movement in following a circle is much less than in following a line that feels jerky, such as the representation of a lightning flash.

But we do not claim that the theory is entirely adequate, only that it is the best at hand, and a remarkably good working hypothesis for the aesthetic facts it covers. Its usefulness will come out still clearer in the next section where we take up the stimuli for lines.

Stimuli for Visual Lines

There are as many stimuli for visual lines as there are inducements to draw the attention of the eye from one point to another. The following list includes the commonest of these. The importance of listing them is to make us aware of all (or, at least, many of) the different sources of line in visual works of art, so that no linear contribution to aesthetic enjoyment may be overlooked.

Any *pair of interesting points* with a relatively clear space between them generates a line. The two points must both be in the field of vision simultaneously. Such a pair of points, as the local sign theory would indicate, is the basic stimulus for lines. You have it between each of the three dots in Fig. 25. Between each of these dots a line is generated, and the three dots make a triangle for the eye as definitely as if three black lines were drawn (that is, three draftsman's lines, of which we shall speak presently). Any " dotted line," like those in Fig. 24, are instances of the same thing. The eye connects the dots into a continuous line. That is, the eye makes a colorless kinesthetic line between the dots, and it is this kinesthetic line that is the true line, the continuous *felt* line from *f* to *a* or *f* to *b*. The dots are discontinuous, and are not a line at all. They are merely stimuli for the kinesthetic line that runs through them.

The dots, of course, do not have to be literally dots. The row of black squares on the mat in front of Fra Angelico's *Madonna* generates a continuous line through them; also the black grills on the curtain behind her. Dots, squares, grills all count as interesting points generating lines. The generating points may, in fact, be any objects that count as distinct units. The mother's hand and the four hands of the two children in *Mme. Charpentier* are all in a row and generate for the discriminating eye an important line in that picture. They are points of interest with relatively clear space between them, and a line leaps from one of these points to the next.

By " relatively clear space " between the points is meant that nothing appears between the points of nearly as much interest as the points themselves. In Fig. 25 there is nothing but the bare surface of the paper between the points, nothing at all to catch the eye between them. A line leaps across inevitably. There is nothing to stop it. In the curtain of the Fra Angelico, however, there is a very interesting pattern of red circles between the black grills. But when your attention is on the black grills (and they do catch the attention first because of the insistence of their color and shape in contrast to the reddish gold ground), the space between them is relatively much less interesting than they are, and the eye leaps from grill to grill over the intervening ground. (By the way, when I say " the eye leaps " in an instance like this, do not take this literally. The eyeball probably does not even move. But the expression which the poetry of com-

mon language has developed to express precisely the kinesthetic feeling of lines stimulated between points of strong interest is so true to the kind of facts we are talking about that it would be pedantic to avoid using it.)

But now if your interest passes off the grill motives to the red and gold circular patterns beneath, you will find that these in turn become stimuli for lines which leap from circle to circle across the relatively plain gold ground between them. But to do this the black grill motives have to be somewhat deliberately neglected. That is, by a momentary convention we inhibit our interest in the black motives, so that for the time being the red circles (intrinsically much less striking in interest because so much less strongly in contrast with the reddish gold ground) stand out in major interest. As soon as that happens the lines spring up between them.

This brings up another consideration. Two points that are similar in nature tend, so to speak, to become interested in each other, and thus increase each other's interest, and so stand out from their surrounding objects. Just because of their similarity they tend to become points of major interest with a relatively clear space of minor interest between them. So a red circle is a stimulus for a line to another red circle, and a black grill to another black grill, but hardly a black grill to a red circle.

Now we have further insight as to why the line through the five hands in *Mme. Charpentier* is so strongly designated. They are *similar* objects. Not only are they intrinsically very interesting just because they are human hands, but because they are similar also. We become interested in them as a group. The eye inevitably seeks them out across the relatively much less interesting spaces between — even though these spaces are filled with a lot of rather interesting things. And now notice that the mother's right hand on the back of the sofa is paired with her left hand in her lap, and that an important line leaps from one to the other even though a very interesting child's head partially intervenes. This diagonal is continued on down the mother's skirt and acts as a contrast and foil to the main diagonal of the picture which is the line we have been noticing running through the five hands.

All of these are lines generated through pairs of interesting points. You will find our illustrations of pictures and statues full of such lines if you begin looking for them. It will pay you for a while deliberately to look for such lines in works of art, if you have not consciously noticed them before, for you may have been missing some of them, and the appreciation of them can greatly increase your delight.

A second stimulus for line is a *boundary*. A boundary is generated wherever two areas of different colors meet. Thus the edge of the Madonna's blue robe (PLATE I) against the gold background is a boundary. Why a boundary generates

a line is particularly clear when the areas on either side of the boundary are perfectly plain. Then there is obviously nothing to attract the eye on either side of the boundary. The eye inevitably gravitates to the meeting of the two areas at the point of contrast, and then runs along the boundary. The boundary is the most interesting thing in the two areas. It seems to be intrinsically a very interesting thing, particularly if the boundary is sharp and the color contrast strong. Then a boundary will draw the eye away from the interior of areas that have even a great variety of interest within them. The boundary of the Madonna's blue robe is a good example. In spite of the pattern of the gold curtains behind, and the folds of the blue robe in front, the eye is drawn strongly to the boundary between the two. Notice also how much stronger the boundary line on the left of her is than that on the right along her knee. This is due to the greater contrast of color between the areas on the left than on the right. The strength of a boundary line can also be weakened by blurring. And a boundary can be completely obliterated by a gradation from one area of color to another.

In comparing the Fra Angelico (PLATE I) and the Renoir (PLATE II) one can feel that Fra Angelico made much of his boundary lines and loved their movement while Renoir played them down and made little use of them. Look at the delight Fra Angelico took in following the edges of the Madonna's robe. There is nothing like this in the Renoir. Renoir purposely blurs most of his edges, they are lost and found, and often there are none. For Renoir sacrificed the sensuous charm of the arabesque movement of line along sensitive edges for the even greater sensuous charm perhaps of the gradations of hue over a total surface. But do not fail to observe the beautiful arabesque of Fra Angelico's boundaries. Look at what he does with the mat at the very bottom of the picture.

We are now ready to speak of *the draftsman's line*, which unreflectively most people identify with line. A draftsman's line, a line made with a pencil, or a pen, or a brush, is actually a pair of boundaries running close together and roughly parallel with each other. The vertical line in Fig. 26 is a draftsman's line. There is a narrow area of black ink contrasted at the edges with a broad area of white paper. The two long boundaries to right and left are much more prominent than the little boundaries at top and bottom. The eye runs inevitably up and down, and neglects the little top and bottom boundaries. Moreover, since the up and down boundaries are so close together and have exactly the same direction, they are taken as just one eye movement and so as just one line. So the draftsman's line is a sort of visual illusion in which a pair of boundaries very close together and parallel (or nearly so if the line comes to a point at one end) is felt visually as if it were a single line.

The peculiarity of the draftsman's line is that it is the only line stimulus

which generates a line felt as having width. And this width, of course, is filled with color, so that this line acquires all the color characteristics. We shall come back to this peculiarity again in the next section.

In spite of the popular idea that the draftsman's line is line proper, it is surprising, when one begins to notice it, how comparatively little the draftsman's line is used in works of art. There is hardly a single draftsman's line in the Fra Angelico, the Renoir, or the Picasso painting. It is rare in sculpture or architecture, though a narrow moulding on a building may count as a draftsman's line. This line is characteristic only of certain limited techniques which employ instruments that naturally produce draftsman's lines, such as pencil drawings, etchings, lithographs, and the like (cf. Picasso drawing, PLATE IXB).

FIG. 26

I do not wish to be taken as disparaging the draftsman's line. It is, as we shall more and more fully see, a remarkably sensitive source of line stimulation. But it is exceedingly important for all of us to get out of the idea of regarding the draftsman's line as the typical sort of line, as if this were the "real" line and other line stimuli were only "subjective" or pseudo lines. If any of these sources is to be taken as basic, it should be the first (a pair of interesting points). The great importance of perceiving that the draftsman's line is no more fundamentally line than any of the other line stimuli is that all such stimuli may be taken on a par and felt in their mutual effects on one another in a total composition without any one sort sticking out in attention and getting an illegitimate emphasis.

It is true the draftsman's line is a particularly emphatic sort of line. If there is any question that three dots may not be taken as a triangle, we draw draftsman's lines between them so that there may be no more doubt. But any strong boundary can be as emphatic as a draftsman's line, a fact shown by the boundary lines of the Fra Angelico. Moreover, what line could be more emphatic than the diagonal from lower left to upper right in Renoir's *Mme. Charpentier,* which is essentially a "dotted line" with five emphatic white hands as the principal dots?

The draftsman's line is just one sort of line stimulus — an important one but no more important than several others.

A fourth stimulus for lines is *any break in a line,* such as the terminus, a point of intersection, or a meeting of two lines. In Fig. 26, for instance, a line may be felt connecting the four upper termini of *a, b* and *c,* and also a parallel line at the bottom connecting the four lower termini. That is what we mean by saying the three motives are "lined up."

Then there is also a line connecting the meeting point of *b* with the point of intersection of *c.* Such lines will be found all through pictures and statues and

visual works generally. For example, in the Fra Angelico there is such a line from the crossing of the Madonna's hands to the angle of the child's right leg with his body. And the child's left hand, as a terminus, generates a line to his right elbow, which follows up his forearm to his right hand, thence across a gap to the gold on the mother's sleeve and on across to the intersection of the edge of the sleeve with the upper line of her wrist. Notice the lines, too, that go off the tips of her fingers — and so on all over the picture.

A fifth stimulus is *the completion of any figure.* A break in a nearly completed circle is completed with the rest of the curve (Fig. 27a) — not usually with a straight line as the preceding fourth kind of stimulus would indicate. A pair of converging lines completes the angle (Fig. 27b), even though there is no stimulus point at the angle. Accordingly, the Madonna's halo in the Fra Angelico is completed behind her head, and the oval of the table in the Picasso is completed as the feeling of a line, even though it passes right through the woman's body.

a

b

FIG. 27

The completion of such figures is probably instinctive. For these are the simple shapes which we suggested in Chapter 7 were probably among the instinctive types; namely, spheres, circles, cubes, rectangles, pyramids, triangles, and the like.

But lines are also generated in the completion of acquired types, when the outlines of these forms are well known. Thus in the Fra Angelico the curve of the child's right leg is strongly felt behind the straight upper edge of his left leg. And the curve of the child's body is felt behind his left arm. Also the curve of the cushion is completed behind the Madonna. In the Renoir, the line of the dog's back is completed under the little girl, the line of the sofa back behind the figures on the sofa. The line of the mother's skirt is projected outside the picture frame and comes back in again, and likewise the line of the hindquarters of the dog. These are all forms the shapes of which we have learned from experience. They, too, will generate lines when there are gaps in the boundaries of the forms.

Another way in which this sort of stimulus operates is illustrated in Fig. 26. You may have noticed that the line generated by the intersection of *c* to the angle of *b* is actually felt as projected through to *a* even though there is nothing special at the center of *a* to attract a line. The projection is due to the demands of the total set-up of these three motives. The upper and lower parallel lines extending the whole length of the composition from *a* to the farthest termini of *c* tend to encourage any line between and parallel to them to extend to an equal length. So the internal line at the intersection tends to be projected not only to *a* but even to where this line intersects with the vertical line generated by the extreme right termini of *c*.

This is a very prosaic illustration of an important fact — that the context of a group of figures in a composition may generate line stimuli which are determined by the total context. The results are explainable enough in the context but would be inexplicable without it.

A sixth line stimulus is the imagined *center of gravity of a form*. The four circles in Fig. 28 are connected by their centers. A horizontal line springs up, if you notice, between the centers of the two big circles, and a vertical line between the centers of the two small circles. Secondary lines connect the centers of the little circles with the big ones. This example shows two things about this sort of line stimulus: not only that the centers of gravity of forms are line stimuli, but also that the lines tend to spring up between similar in preference to dissimilar figures.

FIG. 28

In the Fra Angelico this sort of line is clearly seen springing up between the two blue angels and the blue Madonna. It connects these three figures in an inverted triangle and the angles of the triangle are at what we take to be the centers of these figures. The dominant blueness of the figures has a lot to do with our connecting them in this way. The effect of the color similarity in connecting these blue forms is confirmed if we happen to observe that the three red areas consisting of the Madonna's dress and the two red tassels of the cushion on which she is sitting also generate a triangle. The similarity of color in this instance is all that relates these three shapes. And notice that the apex of this triangle seeks out the center of the red area on the Madonna.

If forms have a strong three-dimensional sense, their centers of gravity will be felt inside the forms and lines will be developed in depth between these centers. Thus in Fig. 29 the three cylinders are represented at different depths from the forward plane. They can be distinctly felt as standing in a triangle in deep space. That is, lines can be felt as connecting them forward and back, not merely up and across. These lines may be felt as connecting the centers of the bases of the cylinders, or of the tops, but more likely as connecting their centers of gravity in their middles. Some artists like Poussin make a great deal of this type of line stimulus in their compositions. All artists who do not paint entirely flat make some use of it. Probably most people will take the centers of the triangle of the blue figures in the Fra Angelico as standing back somewhat in depth, even though the picture is purposely conceived in very shallow space. But in the Renoir the figures go back in rather deep space and the two children and the mother count as solid figures with a line felt (for me at least) going

FIG. 29

diagonally backwards through the centers of their bodies to the chair back — a line parallel to the one connecting their hands and going back in depth.

Lastly, *a point moving in space* generates a line. Thus, a shooting star, a rocket, a swinging lantern in the night gives a line in the path of its movement.

FIG. 30

The Japanese in their prints habitually represent the sparks of fireworks with sprays of curving lines — and that is literally the way we aesthetically perceive a bursting rocket. The Japanese also represent rain by diagonal black and gray lines across the landscape — and the effect is exceedingly realistic and wet. These are, to be sure, only representations of the paths of moving points in terms of draftsman's lines. But the paths of moving forms are literally utilized for aesthetic effect in the modern sculptural compositions known as "mobiles." And, of course, in the dance the paths of gestures and of the whole body moving in space are among the most important linear elements in dance composition.

There are, no doubt, other line stimuli, but these are the ones most commonly met.

I have given a good deal of space to these various stimuli of lines because attention to them is one of the best ways of getting acquainted with lines in art. Too many people have an idea that the draftsman's line is the only true line. People know better than that in their actual perceptions of pictures and statues and buildings, but the idea still disturbs them and may blind them to the presence of very important lines in a visual composition.

Primary Characteristics of Line

The primary characteristics of line are *length, attitude,* and *degree of curvature.* Every aesthetic line has these characteristics and the absence of any one of them would mean the total absence of the line.

The scheme or natural order for lengths of line is a one-dimensional series from the shortest perceptible line to the longest (Fig. 30). This is obvious enough.

By attitude of line is meant the way it stands in a composition in reference to the base of the composition. For in art you cannot change the position of a line without changing its character. A vertical is a very different line from a horizontal; and has different effects on a spectator. Turn a picture on its side, and every line in the picture changes its nature as completely as a shift from a yellow to a blue illumination of the picture would change all its hues. For every vertical line becomes a horizontal and the direction of every diagonal is reversed.

The scheme for the attitudes of line is a circle. In Fig. 31 the gamut of the actual attitudes of all straight lines is given in *a* and the scheme correlated with these attitudes in *b*. The relation of the scheme to the actual attitudes in this instance is confusing to some people, because they tend to take the gamut of

FIG. 31*a* FIG. 31*b*

actual attitudes *a* for the scheme.[1] But just note the gamut, attitude by attitude, and you will see that it comes out a circle. Start with the top vertical, swing through the intermediate attitudes to the 45° right oblique, then on to the horizontal, thence through obliques which tip to the left till you come out again at the vertical at the bottom. The vertical at the bottom is the same attitude as the vertical at the top. So you have gone around a complete *circle* of attitudes, as shown in *b*. There are no *new* obliques on the left of the vertical line in *a*. For instance, continue the 45° right oblique through to the left of the vertical. It remains the same attitude, a 45° oblique tipping to the right.

The scheme *b* shows at a glance not only the manner in which the attitudes grade into one another but also shows that the strongest contrast to the vertical is the horizontal, and that the strongest contrast to a right oblique is a left oblique. We intuitively sense these oppositions. Here they are exhibited in diagram.

When we examine the degrees of curvature of line, we find their scheme is again one-dimensional. The degree of curvature of a line is the degree to which

[1] Another possible reason for trouble arises if a person thinks of an attitude as also having a *direction*, and then thinks of the 45° right oblique as having an upward direction on the right in Fig. 31*a* and a downward direction if continued through to the left. But the direction of a line is a kind of line *movement*, one of the secondary characteristics of line (p. 186), and should be clearly discriminated from line attitude, a primary characteristic.

Possibly the distinction between "gamut" and "scheme" is not familiar, as employed in these pages. By *gamut* I mean the complete array of actual sensations or perceptual materials of a certain sort. The actual array of all the grays, hues, and saturations is the total gamut of colors. By *scheme* I mean a geometrical diagram of one or more dimensions in which geometrical points are correlated with the gamut of actual sensations. A scheme generally shows up the relations among the elements of a gamut more clearly and conveniently than the actual gamut does. The diagram of a color cone is a scheme. I may add that *scale* is the term for a selection or arrangement of elements from a gamut or scheme.

it is bent. A straight line has zero curvature. The more it is bent the greater the curvature, which reaches a maximum when it is bent completely round into a circle. The actual gamut of curvature of a line is exhibited in Fig. 32a. The scheme for this series of curves is given in Fig. 32b. Here we see how we can

FIG. 32a FIG. 32b

grade from a straight line into gentler curves, thence to tighter and tighter curves to the tightest of all in the circle. It becomes clear that gentle curves contrast strongly with tight ones.

The straight line and the circle should perhaps be excluded from the gamut of curves for aesthetic purposes. For a straight line has a unique quality and contrasts rather strongly with any other curve — so much so that we generally speak of straight lines *and* curves, as if they were different species of lines. Aesthetically they are. And a circle, being a completely enclosed form, is also felt as different from curves with free ends.

The attitude of a simple curve, incidentally, is that of the straight line which joins its termini. So in a way a curve is always a compound line. It is the curve plus the straight line generated between its termini. Notice the attitudes of the curves in Fig. 33.

In curves which enclose forms such as ovals, the attitude is that of the long axis of the total figure. The two ovals in Fig. 34 tip towards each other. This indicates, by the way, that since we do not feel any tip in a circle (compare the circle with the ovals in Fig. 34) we must feel that it is balanced on a vertical axis. But a circle is so perfectly balanced in every direction that the feeling of an axis (and, consequently, of an attitude) is almost absent.

Vertical Oblique Horizontal Horizontal

FIG. 33

These primary characteristics of lines have not only all the capacities of contrast and gradation which these schemes indicate, but they are also markedly correlated with the moods. Short lines tend to be exciting, long lines quieting. Tight curves of high curvature tend to be exciting, gentle curves of low curvature quieting. A straight line, however, is felt as tense and relatively exciting in contrast to the gentle curves that grade into it. The horizontal attitude is the most quieting, the vertical next, and the obliques in various degrees are exciting. A picture made up of horizontals and verticals is said to be static. When obliques enter, it is called dynamic. These moods of lines are so widely accepted as to need no further comment.

Secondary Characteristics of Line

The most important secondary characteristics of line are apparent *movement*, *width*, *intensity*, and *quality*. Only the first of these may accompany any line stimuli. The other three are characteristics of the draftsman's line primarily.

Movement. Line movement as a secondary characteristic of line must be clearly distinguished from the relation of line to eye movement. Every line by the local sign theory owes its perception to kinesthetic tendencies to movement in the eye. But what we are calling attention to now is that some lines seem to be in motion or to induce a sense of motion, others not. That is why movement in line is not a primary characteristic of line. All lines do not have it. Tintoretto's *Christ at the Sea of Galilee* and Cézanne's *Maison Maria*, for instance, are full of movement in comparison with the relative stillness of Fra Angelico's *Madonna*. This contrast is due largely to the kinds of lines used by these artists. What induces the sense of movement in these lines is the thing we are now talking about.

FIG. 34

We must first distinguish between *movement along a line* and the *movement of a line*. The former is the feeling we have of following the course of a line. Not all lines induce this feeling. It is something we can hardly help feeling, however, with the lines of the folds and hem of the Fra Angelico Madonna's robe. Whether our eye actually follows these boundaries is not the point. It feels as if it did. Or rather *we* feel as if *we* were following those lines. And by empathy undoubtedly we are.

This is a wonderful aesthetic feeling for those who have developed it. It is worth developing if one has not yet acquired it. It is in a subtle imaginative way the same sort of feeling one has when skiing, like coming slowly over the crest of a hill, dropping into the rapid descent, a rise over a hump at the bottom, and

a gradual slowing off at the end — or possibly a quick fancy finish at the end
with a flourish. And there are leaps, too, and slewey turns, and even tumbles
and recoveries. A line thus becomes a little drama of its own, a life with its mo-
ments of intensity and relaxation. Not all lines are worth following, or even
tempt you to follow them. But some artists take great
delight in the drama of a line, and Fra Angelico was
one of these.

Just start with the hem of the Madonna's robe as it
comes over her right arm. Follow the line under the
child, over her right knee, down almost to the floor;
make a thrilling yellow turn and then with a long gentle
S-curve come to a temporary rest. Turn your eyes left
and meander along the lower rim of the garments, turn
back at the edge of the picture and up over her shoul-

FIG. 35

der, over her head, and down the undulating, softly agitated line bordering her
cheek. Perhaps your glance moves on under her hand, comes out at the edge of
the garment over her left arm, swoops down under the child, and up and down
again for another turn on the fold of the Madonna's lap. The picture is full of
such lines inviting you to follow them for the sheer delight in the exercise. But
they are also all related to each other so that there is a drama in all of them to-
gether as well as in each singly.

The Orientals are particularly deft with this sort of narrative movement of
lines. The flexible brush they habitually use is the most sensitive of all drawing
instruments to the movements and emotions of the hand. It spreads in thick-
ness with the pressure of excitement, thins to a thread at the thought of tender-
ness. Each line of a great Chinese or Japanese artist is the record of the mo-
ment's thought with all its overtones. A dozen of these lines fitted to one
another often compose a whole picture, and miraculously represent a scene by
river or mountain or bamboo grove. The Chinese and the Japanese have much
to teach the West on the use of line.

But now we must turn to the *movement of line*. Here it is as if the whole line
moved bodily. There seem to be four main types of movement of lines: (1) those
due to superficial association with moving things; (2) those due to deep-lying,
almost instinctive associations with movement; (3) those due to the attraction
of attention; (4) those due to the habit of reading.

1. Those of the first type, due to *superficial association*, are such as are sug-
gestive of growing plants, fountains, rockets, waterfalls, waves, and the like. In
these the eye does usually move along the line, but the final effect is one of
movement *of* the line (cf. Fig. 35). If a line suggests a waterfall, the whole line
seems to fall. In a wavy line, the whole line seems to undulate. The spectator is
not the active one following the path of the line. The line itself is in action.

Many lines with this sort of movement will be found among the patterns in Figs. 11 to 14 and in PLATE III.

Among movements of this type must be included movement suggested by the

front or face of an object. A head tends to have movement in the direction of the face and eyes. That is very clear in the angel heads in the Fra Angelico. An animal body in profile has movement towards the head. The bow of a boat gives a little movement to the whole boat toward the bow, even if the boat is represented as stationary. These movements can be clearly detected in the weighting of balance (Chap. 4, pp. 81–82). For instance in the portrait of Pope Innocent X (PLATE VI), the movement of the half turned head to our right may not be noticed till we see that the weight in balance of the large area of his right shoulder and most of his head on the left of the axis is balanced by the suggested movement in the direction he is facing to the right of the axis.

Of course, all the cues suggestive of the actual movement of represented objects, as of the wind blowing trees and smoke, running horses and men, racing trains, automobiles, and airplanes, and drifting clouds and floating angels obviously give movement to the objects represented and so to all the lines incorporated in those objects. But such cues are the crudest kind of suggestion of movement. On careful examination one will generally find these are relatively ineffective unless reinforced by deeper-lying stimuli for movement. That is why the photograph of a galloping horse, or a bird in flight is often rather disappointing. An exact anatomical study of the positions of the legs of a galloping horse or a running man may produce an almost static picture. An artist who feels the movement as he paints trusts more to what we may call the intrinsic movement of his lines than he does to the superficial suggestions of wind, or dust, or steam, or the positions of arms and legs, or the blur of spokes. The deeper associations are what I am referring to under the next heading.

2. By *deep-lying associations* of line movement I mean a certain group of line movements that are so dependable as to seem almost instinctive. There are four of them: the oblique, which moves in the direction it leans; the curve, which moves in the direction of its bulge; the angle, which moves towards its apex; and the vertical, which moves up or down depending on whether you imagine it above or below a ground line (cf. Fig. 36).

FIG. 36

Of these the angle has the strongest movement, and the sharper the angle the stronger the movement. The bulge, I feel, comes next, and the greater the bulge the greater the movement. Next comes the oblique. Sometimes this seems like a pole resting with its lower end on the ground and tending to fall towards its lean. So, especially, when an oblique is standing all alone. But an oblique may seem to be moving bodily in the direction it leans, like a man walking. So, especially, when a number of obliques are in a row. Then they generally feel as if they were all marching along. The strength of the movement increases with the degree of the tip, until the oblique approaches the horizontal, and then the movement seems to get weaker. But under all conditions the oblique is an active line and felt so in contrast to the vertical and especially to the horizontal.

(a)

(b)

(c)

FIG. 37

But even the vertical has some movement if it is imagined or seen starting from a ground line. If you think of it as going up like a tower, it has an upward-going movement. If you think of it as going down like a pendulum from a ceiling, or a rope in a well, it has a moderate downward movement.

We shall presently exemplify many of these line movements in the Tintoretto (PLATE V).

3. The movement of lines produced by drawing *attention* to one end of a line is illustrated in Fig. 37. For most people the relatively motionless horizontals in *a* start moving strongly to the right when accented at one end as in *b*, and strongly to the left when accented at the other end as in *c*.

4. For the action of *habit* in line movement, look at Fig. 37*a*. To Occidental readers these lines are likely to feel as if they were moving very slowly to the right. If so, this movement is due to our reading habit. An Oriental would not feel it. It is very slight, and easily neutralized by the presence of stronger line movements in a pattern.

Now let us bring all these stimuli for line movement together by seeing how they work in such an active picture as Tintoretto's *Christ at the Sea of Galilee* (PLATE V): My first impression is that most of the picture is moving violently to the left except for the firm countermovement to the right created by the figure of Christ. The contrast of these two main movements is part of the central theme of the picture. How are these movements obtained?

Take first the movements to the left. There are many suggestions of a storm and wind blowing toward the shore. But notice how these superficial associations of clouds, waves, and blowing leaves are reinforced by the deeper-lying associations or intrinsic movements of lines. The movement of the clouds is due chiefly to the multitude of bulges to the left. The movement of the leaves is also

due to angles and bulges and obliques to the left. The left lean of the tree on the right edge of the picture, of the boat's mast, and of the tree form on the ledge above Christ's head are very important in telling about the strength of the wind. The long diagonal of the shadow on the sea that passes through the boat to the distant headland adds strongly also to this leftward movement. The movement of the waves to the left is due largely to bulges and sharp angles in the wave forms.

The boat is clearly drifting toward the shore in spite of efforts to keep it out to sea. The lines in the boat reflect both these movements. It is facing out to sea. The bulge of the bow and sail and several of the men's attitudes are towards the sea. They are relatively gentle bulges, however, compared to the contrary bulges of the clouds above them. In the boat itself are strong contrary movements of many men facing toward the land. The bulk of the stern of the boat and the prominent figure of St. Peter stepping dramatically out into the sea draw attention to the left end of the boat and, with the other leftward cues, pull the whole boat towards the shore.

Look at the movement of St. Peter, eagerly stepping on the water towards Christ. This is not a literal drawing of how a man would step out of a boat under any condition. The attitude of St. Peter is that of a runner at top speed. It is physically impossible, but poetically true. For it is the attitude of intense eagerness to reach Christ. But Tintoretto does not dream of trusting our superficial association with a running movement to carry the feeling of movement which he wants to get into this figure. He emphasizes the left tip of the man, and sees to it that the man's head, the end of his extended right arm, and the end of his right leg develop a bulge to the left. And so that there may be no mistake, he echoes that bulge just ahead of the man in a curve representing the stern line of the boat. The same curve is echoed in opposition in the figure of the man pulling on the rope.

Finally the whole boat, and in fact the whole picture, moves to the left because of the dominating interest in the large figure of Christ at the extreme left which pulls the attention to that side of the picture. The direction in which Christ faces and the gesture of his arm generate a line to the boat and specifically to St. Peter. But that line is marked with an overwhelming interest by the size and the meaning of Christ at its left end. The line, accordingly, pulls strongly to the left, and pulls the whole boat with it.

But Christ also generates a countermovement to the right. It is a movement of great dignity, and calm and firmness. In part the mood of this movement is due to our associations with the meaning of Christ and of this miracle of his walking on the water. But Tintoretto would not trust any such external literary associations to depict the emotional significance of this act. He disposes the figure of Christ in a very large mass (by far the largest single mass in the pic-

ture) and shapes the mass in a long gentle bulge in the direction of the boat. It is not by the suggested motion of Christ's legs that he walks upon the water, but by the intrinsic movement of the gentle bulge of his approaching form. And by this means Tintoretto makes it that Christ walks lightly and almost floats across the water. The lightness of Christ is asserted by an upward movement of the vertical attitude of Christ's figure, and, we should add, by the lightness of the color of gown below his waist.

So much time spent on line movement is not too much to signalize its extraordinary expressive powers in the visual arts. It is often not observed, because it is so completely empathized. The casual spectator would probably attribute all the sense of turmoil and activity in this Tintoretto to the suggestions of storm and the suggested actions of the men. Actually most of the agitation comes from the intrinsic movements of lines.

As to mood, the greater the movement, the more exciting; the gentler the movement the more quieting.

Width of line was the next secondary characteristic of line mentioned. Only draftsman's lines have width. This characteristic is chiefly important for the moods of strength and delicacy correlated with it. The broader a line the stronger, the narrower a line the more delicate.

By *intensity* of line is meant the degree of contrast of a line with its ground. A very black line on a white ground is of a strong intensity; and also a very white line on a black ground. A gray line in either case would be of weak intensity. It follows that a boundary line, as well as a draftsman's line, may have degrees of intensity. For the degree of contrast of the colors on either side of the boundary would give degrees of intensity for the boundary line.

A line of great intensity is felt as strong in its mood and generally called " strong," one of low intensity is felt as delicate, and called a " light " line. One would, accordingly, speak of Picasso's line drawing (PLATE IXB) as delicate since his lines here are narrow and light. Whereas Cézanne's picture (PLATE VIIIA) gives a mood of strength since the lines in it are wide and heavy.

These moods in the width and intensity of line undoubtedly are closely connected with our feelings in drawing draftsman's lines. If we are feeling vigorous and put a flexible pen to paper, we bear down hard and the line comes out wide and dark. If we are feeling in a tender or gentle mood, we put our pen down lightly and the line comes out narrow and light. So by lines in pen or crayon or brush an artist's moods are interpreted. And especially in movement along a line we follow an artist's feelings in the very progress of his creative emotion.

Last of the secondary characteristics of line we shall mention is *quality* of line. This characteristic belongs primarily to the draftsman's line. It is the color quality of the narrow surface between the boundaries of the draftsman's line.

Compare, for instance, the hard mechanical lines used in the diagram of Cézanne's painting (Fig. 42, p. 221) with Cézanne's own brush lines in the painting itself. The former are hard in quality, those of Cézanne's are vibrant. For in Cézanne's lines are overtones of the ground color showing through the main color of the line.

In general a painter avoids a hard quality of line. Hard lines are characteristic of the work of mechanical draftsmen. Architect's plans, for instance, which require precision, are of necessity made of ruled mechanical lines all of equal thickness drawn with a hard pencil producing a clean hard quality totally lacking in vibrancy. Most architects when they take to painting and sketching carry this line with them. The habit of the drafting board follows them into their painting and their pictures acquire a stiffness and hardness due primarily to the quality of their lines.

A painter usually avoids a ruled line for another reason. Even if the surface of the line is vibrant, the edge of a ruled line will be hard. This shows that even a boundary can have quality. A slightly uneven boundary has an effect just like particles of a foreign color showing through a surface color. So there are hard boundaries and vibrant boundaries. Again this can be seen in comparing the diagram with Cézanne's painting. Take the lines of the tree at the right. Compare the diagram's ruler-like boundaries with Cézanne's lost-and-found boundaries of the trunk and branches. Notice how much longer you tend to look at Cézanne's tree. A hard line with clean boundary and glazed surface is intrinsically monotonous. A line with a vibrant boundary and surface is constantly varying. You perceive at once what a hard line is from top to bottom. You are drawn in to see what happens to a vibrant line all along its course. So an artist generally avoids a hard line as he does all monotonous things.

Consequently when able artists deliberately use a hard line you look at what they are doing with particular interest. Many modern painters, especially among abstractionists, are using hard lines — and ruled ones at that. I suspect most of them are overdoing it in reaction against everything nineteenth century painters did, including their vibrant line. But there is a certain clean emotional tenseness and tautness that we have come to admire in the lines of machines and engineering construction — in bridges, airplanes, battleships and all things that express mechanized power and efficiency. The modern eye has grown to admire the clean line of function. It has always admired it on the edge of an axe handle or a knife or a paddle. Now it admires it in the infinitely more numerous machines of our age. This clean functional line has naturally invaded architecture and even moved into the domains of pictorial and sculptural composition which normally have very little to do with mechanical function. It unquestionably has a certain beauty of its own, which is being exploited to the full especially in abstractions by men like Brancusi, Léger, Feininger, Mondrian,

Picasso. (Yet not all abstractionists by any means confine themselves to the hard functional line.)

When, however, a great painter successfully employs the hard line in a representative drawing, then particularly do our eyes dilate. Picasso is famous for the " wire line " he uses in many of his drawings. One of these is reproduced here (PLATE IXB) entitled *Death of a Monster*. The more one looks at this drawing, the more one is filled with admiration and delight. Let us stop a moment to examine its lines.

In the first place, it exhibits extreme economy of line. One line from neck to wrist tells the story of the monster's whole arm. And one line from hip to toe of his left leg. The line is not only a beautiful thing in itself, but as it moves along it tells the story of what goes on beneath it of soft flesh, or ligament, or hard bone. Moreover, in concert with the line opposed to it, it tells all about the rotundity of the limb it is modeling. You see how the leg rounds in narrowly at the knee and broadly at the thigh. For fulfillment of a difficult type of technical virtuosity together with that of sensitive anatomical representation, these lines are amazing.

But amazing, too, is the fact that these lines are of a sort that is ordinarily of the least intrinsic interest. They do not vary in width or intensity (except very slightly). They are hard in quality with no vibrancy of surface nor of boundary. That is why they have been called " wire lines " — hard as wire. Picasso has foregone every agency of charm in his lines but one. That one is the flexibility of the line responsive to his hand and mind. He has elected to use the mechanical draftsman's line for its very uncompromising precision. But the precision he seeks is not that of a straight edge, but that of responsiveness to a perceptive, emotionally charged mind. The lines are interesting because they are constantly changing direction significantly. That is, the modulation of the line is always for a reason, or for several reasons at once, in addition to that of pure variety's sake. The line, accordingly, gives a sense of a vibrant quality even though it is drawn as a hard line. The vitality of the line comes, however, from its constant variation of direction, not from the vibrancy of its surface or edge.

There is something ascetic about the hard line, nevertheless, however beautifully modulated. Vibrant quality with line as with color is the most sensuous and ingratiating of the characteristics of line. And as with color it is associated with materials. Charcoal, crayon, pen, pencil, brush, lithograph, etching, wood block each has its distinctive line quality or range of qualities. And in sculpture and architecture different materials have different characteristic boundary edges. The edges following the surfaces of plate glass or steel are hard, but the edge of a stucco or brick wall may be soft and vibrant in quality. The treatment of a surface is generally reflected in the treatment of its edges, so that we do not ordinarily pay much attention to the quality of the edges of things, thinking

only of the more conspicuous quality of the surfaces. Hence quality of line is considered mainly and properly as the quality of the surface of a draftsman's line.

On Combining Lines

When lines are put together they produce abstract patterns or else the boundaries of represented objects. The use of lines in both these respects has already been treated at length in earlier chapters, and needs no further comment. But there is one aspect of the combining of lines that would seem to need attention. That is the question of proportion.

Proportion has been the center of a great deal of aesthetic interest in the past. It means at least three quite different things, which should be distinguished at once: First, it means simply the combining of lines of different lengths. So we say the proportion of a rectangle with sides 2 inches by 4 inches is different from that of a rectangle with sides 3 inches by 4 inches. Secondly, proportion may mean the relation of different shapes to one another in a pattern. Thus we speak of the relation of windows to doors in the exterior of a house, or the relation of the width of columns to the spaces between them in a colonnade, or of the relation of one building to others in a group of buildings, as a matter of proportion. Thirdly, proportion may mean " scale." The scale of a building is the relation of its various features to the size of a man. So a doorway that looks bigger or smaller than it should for a man standing under it is said to be " out of proportion." The last two senses of " proportion " will receive attention in the chapter on architecture. But the first sense of proportion is the one that will be taken up here.

There have been many attempts to set up canons of better or worse proportions in the sense of combinations of lengths of line. The success of musicians in developing a theory of harmony on the basis of ratios of air vibrations has probably been the principal inducement. And harmony theory goes back to the Pythagoreans, who had also a mystic feeling for numbers and anything that could be turned into numbers. The tradition of number magic has followed us ever since in dealing with anything aesthetic that lends itself to numerical treatment. Since lengths of lines can be measured and numbered, this was obviously a wonderful domain for numerological mysticism.

From the Greeks down there has been a great spawning of theories of harmonious proportions or perfect proportions. The most popular at present is Hambidge's *Dynamic Symmetry*, to which many artists have been attached. It is an impressive system combining the aura of mathematics with that of the experimental laboratory. It does not seem to me that Hambidge has adequate evidence for his thesis. But the reader must make his own judgment.

I will simply offer the following general considerations. The hypothesis of the existence of certain perfect aesthetic relations among aesthetic materials is becoming psychologically less and less tenable. Whatever the law of habituation signifies in detail, it offers a wide range of evidence for an extensive spread and growth of appreciation for aesthetic materials rather than for a fixed selection of certain elements to the exclusion of others. That is, psychologically it is improbable that certain proportions are aesthetically better than others in any absolute sense such as Hambidge implies. Secondly, the support from music, which theories of perfect proportion seemed to lean upon, is now gone. Modern theories of musical harmony treat consonance and dissonance as relative, or, at least, as not determining in any way that certain intervals are good and others bad. Lastly, length of line is only one of a number of characteristics of line. It is certainly no more important aesthetically than attitude. For instance, a long rectangle on its side is aesthetically a totally different thing from the same rectangle on end. The dominant horizontal or vertical lines of the figures quite overcome the proportion of the sides of the figure, which is identical in both attitudes.

By this comment I mean that the excessive attention given to linear proportions in the past and by some writers on aesthetics even now greatly distorts the aesthetics of line and spatial forms. There are other characteristics of line just as important, and the effect of lines in a total composition fuses the effects of *all* linear characteristics — everything we have been discussing in the last two sections and much more.

However, the persistency of this subject of proportion probably will not let us go without saying something at least about the golden section. This is the proportion $a : b :: b : a + b$ i.e., a is to b, as b is to a plus b. Roughly this is the proportion $3 : 5 :: 5 : 8 :: 8 : 13 :: 13 : 21 :: 21 : 34$. . . etc. But you never get to the real proportion, because it is incommensurable. For $3 \times 8 = 24$, but $5 \times 5 = 25$, and $24 = 25$ is not true. The very idea of the golden section is, thus, something fascinating, a perfection you can approach infinitely but never reach. Hambidge includes the golden section among his perfect proportions. But its fame rests chiefly on the extensive experimental work done by a noted psychologist, Fechner, upon it. In fact, Fechner's studies of this proportion are regarded as marking the beginning of experimental aesthetics.

Fechner had large numbers of men and women draw what they felt was the most satisfying rectangle, and also proportions of a cross, and divisions of a line. He presented alternative proportions and asked them to select the most satisfying. He measured the dimensions of popular objects such as playing cards, and cakes of soap. He measured proportions of well-known buildings. Then he gathered all this material together statistically. His conclusion was that the golden section is a preferred proportion.

An analysis of his statistics, however, proved not quite so decisive. While it was true that no rectangle received so many preferred choices as the golden section, nevertheless the majority of the people preferred other rectangles. For playing cards, he found the Germans manufactured a rather fat shape and the French a rather slim shape, but that the average of the two shapes was the golden section. But, of course, neither selected the golden section! There were other questionable elements in the statistics.

So there was room for further study of the proportion, and a good deal of laboratory work has since been done upon it. The net result of this work does seem to show some sort of gravitation of human preferences towards the golden section. It may mean no more than that this is the center of a set of proportions most practical for most human uses. Perhaps Fechner hit the secret of it when he measured playing cards. A square playing card would be very inconvenient to sort or hold in the hand. A very narrow playing card also would be hard to handle. It just turns out that something in the neighborhood of the golden section is generally most useful. The same would be true of soap and all packages for common utility. If this is true, we develop a type for the " general utility rectangle," and there perhaps is the explanation of the golden section.

But I merely offer this as a hypothesis. The amount of influence the preference for the golden section has on the creative work of artists is probably about the same as that of our Occidental reading habit from left to right upon the feeling of movement in visual compositions. The influence is probably there. An artist can make use of it, if it serves his aesthetic purposes. But the influence can be easily compensated and neutralized, wherever the artist is led to develop other proportions for his emotional or compositional effects.

So here for the time being we shall leave the topic of line, to pick it up again later when we find it functioning as an element lending its extraordinary variety and character, in the company of other elements, to the total compositional effects of painting, sculpture, and architecture.

MASS

Primary and Secondary Characteristics of Mass

Mass is the perception of filled space. Cut a circle out of colored paper. The colored area inside the circumference of the circle is the mass of the circle. Only its boundary is a line. Mass is totally different from line, and can never be literally made out of line. For, as we saw, line literally has no thickness. Only the draftsman's line has thickness, and this comes from its being two boundaries close together with a little mass, or filled space, between. You can cover a surface with mass by running a lot of draftsman's lines over it because of the accumulation of the little masses in these lines, but no number of actual kinesthetic lines would ever fill a space. Mass or space filling is a basic perceptual quality, not analyzable into anything else.

Mass has only one primary characteristic, namely the feeling of filled space. We may call it mass quality. It comes from the stimulation of areas of skin on our bodies. Consequently, we sense mass only where many similar sense organs are spread over an area of membrane or skin and are simultaneously stimulated. So we have tactile mass when an area of touch organs on our skin is stimulated. And we have visual mass when an area of rods and cones on the retina of the eye is stimulated. But sound and smell have no mass, because these sensations are not aroused by areas of homogeneous stimulation. Probably the sense of taste does have mass since the taste buds are distributed widely over the oral membranes. But tactile sensations always accompany taste in normal stimulation so that it would be hard to distinguish taste from tactile mass. For all practical purposes we can say that there are two main kinds of stimulation of mass — the tactile and the visual. But the mass quality, the primary characteristic of mass itself, is just the same whatever its source of stimulation. *It is a vague feeling of filled space.*

It is important to realize just what this basic quality of mass is, because, through its secondary and closely associated characteristics, mass so quickly takes on and absorbs the traits of its associates. We perceive mass so habitually in involved contexts that it requires a little effort to feel what mass is in its basic simplicity.

What I would like you to realize is that mass in itself has no shape. All the shapes we associate with mass come from elsewhere. Mass itself has no sharp boundaries, and no clear dimensions. It comes to us simply as a big or a small mass. For boundaries and dimensions come from line, from muscle-joint sensation, not from area stimulation.

So, in order to get a primitive simple feeling of mass we must pick out areas of skin which are not usually associated with movement. The eye is at once excluded. That is all mapped out according to the local sign theory. But the back of your hand will do very well. Shut your eyes and put a fifty-cent piece on the back of your hand. You will feel a light pressure over a moderate area. Just where is the boundary of that area? You cannot clearly tell. Now put a quarter on. This is a smaller area of pressure, without question. But just how much smaller you would find it hard to say. If you still are not convinced, let somebody press objects of different sizes on your back and see how near you can come to guessing their size and shape.

Don't you notice, too, that the idea of dimension does not seem very relevant to this sort of skin stimulation? All you get is a feeling of a bigger or smaller spread of pressure. If you were forced to say whether the feeling was two-dimensional or three-dimensional, you would probably answer two-dimensional. This is correct, if you have to answer. And you can test your answer by observing how areas of pressure feel on parts of your body where your skin can move rather freely. The skin of your cheek and chin, for instance, can be pulled around easily. Actually the skin comes down the cheek and angles rather quickly into the third dimension under the chin. Your skin gives you no information about this three-dimensional shape of your chin. Try this experiment: press a soft object on the skin of your cheek and chin in normal position. Now pull the skin up from under your chin so that it comes above the jaw, and press the soft object on the same area of skin. Notice that the skin returns the same report in both positions. It returns a simple two-dimensional report of vague size, no matter how the skin is turned or folded over the bones. Clear boundaries and the clear discrimination of three dimensions come only from muscle-joint sensation. Only when these kinesthetic sensations merge with tactile sensation do you get clearly bounded two-dimensional mass and three-dimensional mass.

There are as many secondary characteristics of mass as there are kinds of filling. Roughly we distinguish two main species of mass in respect to filling, namely, tactile mass and visual mass.

Four kinds of touch sensation yield feelings of tactile mass: pressure, cold, warmth, and prick. These sensations, accordingly, with their respective intensities, are secondary characteristics of tactile mass. There are separate sense organs in the skin for each of these four qualities. The weight of a coin on the hand, or any other pressure, gives pressure mass. If the coin is cooler than the

hand, it will stimulate cold mass; and if warmer, warm mass. A rough object like a brush will stimulate prick mass. But tactile mass is generally identified with pressure.

Tactile mass is to visual mass much as bodily line is to visual line. It is appreciated for itself in the handling of objects. It is a source of aesthetic delight in all utensils — cups, bowls, and plates; spoons, forks, and knives — in tables and chairs (especially the arms of chairs), in the textures of cloth, and in the materials of all those things we loosely call *objets d'art*. Primitive art appeals constantly to the qualities of tactile mass, for nearly all spatial objects of primitive art are meant to be handled.

But tactile mass also enters by a sort of empathy into a great deal of visual art. There is one very important type of sculpture that makes a major appeal to tactile mass. It tempts one actually to touch the works and run one's hand over them. But we touch them imaginatively anyway. Some pictures also appeal in part to tactile mass. Its appeal through textures of materials in architecture is obvious.

Visual mass consists of areas of color. All the characteristics of color, accordingly, become secondary characteristics of visual mass; namely, hue, value, saturation, color quality, temperature, apparent distance, and apparent weight. For all these enter into the aesthetic effects of filled visual space. Actually, we have already made many remarks about visual mass. We have talked about areas of color over and over again, but not till now have we given that feeling of an expanse of color its name, or pointed it out expressly for the unique feeling that it is.

But mass has other secondary characteristics besides those of its varieties of filling. Its formal characteristics which come from line, namely shape and dimensionality, will need much comment, even though we have already become familiar with them in many of their aesthetic bearings. I will first take up two-dimensional and then three-dimensional mass.

Two-dimensional Mass

From now on I shall be speaking only about visual mass — except in so far as tactile mass is empathized into it, in the way you can feel the smoothness of an egg by just looking at it. Let me begin by pointing out that there is always a sort of competition between mass and line wherever the two mingle in a visual area. Each, so to speak, competes for an area, usually as a linear composition with masses filling in between the lines, or as a composition of interrelated masses with lines playing over it.

This competition can be seen in one of its aspects in the very perception of the draftsman's line. How wide can a draftsman's line be before it ceases to be

taken as a line, and begins to be taken as a mass bounded by separate lines? In Fig. 38 the first item (*a*) is definitely a draftsman's line, and the last (*e*) is definitely not a line but a dark rectangular mass. The items *b, c,* and *d* are somewhat ambiguous, though *b* would probably be taken as a line and *d* as a rec-

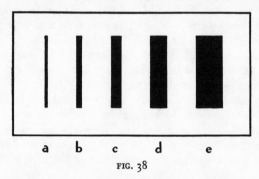

a b c d e

FIG. 38

tangle. Evidently it is the degree of emphasis given to the short boundaries at top and bottom that makes the difference, together with the amount of mass that develops between the lines. But the linear effect may still dominate the mass effect, if the short boundaries can be suppressed in some degree, as happens in the *stripes* of the flag (Fig. 39).

This little example gives us the clue as to the agents which tend to produce a linear as against a mass effect in a composition. The larger the mass in proportion to its boundaries, and the less the emphasis on its boundaries, the stronger the sense of mass, and vice versa. We can then infer that if boundaries between masses are altogether or very nearly suppressed, the mass effect will be at a maximum. With this principle in mind look at the Seurat drawing (PLATE IXA) and compare it with the Picasso drawing (PLATE IXB). Here we have a fine opportu-

FIG. 39

nity to see the difference between mass drawing and line drawing. Notice how totally different the aesthetic effect is.

In the Seurat there are no hard boundaries, and, in fact, practically no boundaries at all. One area of mass grades over into another. You hardly know where one mass ends and another begins. The nearest thing to a boundary is down the woman's left sleeve. But this is a very soft boundary. There is not a single draftsman's line in the whole drawing. By contrast, every line is a draftsman's line in the Picasso, and a firmly bounded line, too. Moreover, in the Seurat the masses are distinguished and emphasized by their color value differences. The woman's black dress is contrasted with her

white neckpiece, and these with the light gray face and fingers and gray background. In the Picasso the uniform white of the paper is the color of the ground on which the forms of the figures are delineated, and also the color of the forms themselves. There is no contrast of masses to emphasize the masses.

To stress still more the great difference between these two modes of drawing, look at the way the eyes are represented in the two pictures. In the Seurat the eyes consist of subtly modeled masses. In the Picasso the eyes are drawn with draftsman's lines. Both modes of drawing are equally expressive and equally true, but the aesthetic effect is totally different.

It is sometimes said that mass drawing is essentially visual and line drawing essentially tactile. There is something in this observation. Mass drawing is based on very keen perception of light and shadow effects on objects, which is necessarily visual perception. Line drawing feels for the outlines of forms and suggests their shapes to the touch. Moreover, the lines in linear drawing are strongly empathized with bodily lines. But this distinction may be overdone. For a visual line is after all visual and meant to be seen, and in mass drawing exceedingly sculpture-like tactual effects may be obtained. The Seurat is a good illustration of a tactile quality in a mass drawing. Observe the oval solidity of the woman's hand. For all its softness of drawing it has almost a sculptured feeling. And see how the hands are modeled so that you could almost put your own hands around them. And her shoulders and bosom are as clearly modeled by Seurat's masses as the bodies of Picasso's figures by his lines.

Having now distinguished line drawing from mass drawing, we are in a position to realize the different degrees of emphasis which different painters put on the one or the other. Compare the Renoir (PLATE II) with the Fra Angelico (PLATE I). Is it not clear that Renoir depends mainly on masses and Fra Angelico mainly on lines? In the Renoir all the boundaries are soft and often entirely lost in the grading of colors along the edges. In the Fra Angelico the boundaries are clean and firm, and the masses are contrasted color areas between these strong linear boundaries.

The reader will find it a rewarding study to observe the different degrees of emphasis given to line and mass by different artists, and schools of art. Are you drawn mainly to the boundaries and to the flow of line, or mainly to the surfaces, or is the interest more or less balanced between the two? Sculpture and even architecture exhibit this competition between line and mass. In fact, the characterizing trait of baroque architecture might be considered its emphasis on masses of light and shade in its design and the frequent suppression of linear boundaries. Modern functional architecture, by contrast, emphasizes the firmness of its boundaries, which compete with the strong, uninterrupted masses between the lines.

SHAPE. When the linear boundaries of a mass are clear, there develops what is

called *shape*. In a certain sense, shape is nothing more than a combination of line and mass. But the fusion of these in perception produces something so specific that it almost amounts to another aesthetic element. The shape of a circle, a square, or a triangle is a specific quality in its particular fusion of line and mass. In fact, we have already spoken of these particular shapes as probably instinctive types (Chap. 5, pp. 94–96). For this reason they have a controlling power among shapes and a sort of final satisfactoriness.

But, for this very reason, because, so to speak, we have them in mind all the time, they are the least stimulating of shapes. They are fine for organizing purposes, for bringing order out of confusion. But they do not serve very well to produce vivid or stirring impressions. One of the ways, accordingly, in which an artist can exhibit imagination is in the invention of novel shapes. This is not so easy as one might think. For the novel shape must not be confusing to attention, and must fit in with the other shapes in a composition. Just try and make a few novel shapes on a piece of paper. The attempt will sharpen your discrimination, and increase your respect for the inventiveness of artists. You will find it is not very easy to escape from obvious banal approximations to the instinctive shapes, or to avoid copying shapes you remember from textiles and dishes about the house, or to avoid making something messy and unapprehendable. After you have tried your hand at it, then take a look at the shapes that appear in some of our illustrations.

Begin with Picasso's drawing (PLATE IXB). Most of the shapes within the boundaries of the figures purposely approximate spheres and cylinders (though far from banal approximations, you notice) in order to emphasize the three-dimensional bulk of the figures. This is particularly clear in the figure of the goddess. So, for present purposes, let us pay less attention to these. But look particularly at the shapes that develop between the shore line, the horizon line, and the outlines of the figures through the central zone of the picture. Look at the shape above the monster's right thumb, the shape below his left knee, the one above his knee, and the shape bounded by the left edge of the paper and the goddess's body. Like a good melody, they are neither banal nor confusing. Look, too, at the shape of the mirror, and, while we are about it, at the shape of the arrowhead and of the monster's ear, lips, and eyelids. The last three, by the way, are variations of one another and of the shape of the horns.

Now look at the shapes in the Fra Angelico (PLATE I) — the shapes of the folds, the yellow areas, the red areas. Look at the shapes cut out by the flesh areas, the shapes of the angels' heads and necks, of the Madonna's head, her hands, and the shape of the child.

More remarkable still are the shapes to be found in the Renoir (PLATE II) — more remarkable because, as we saw, he tends to suppress lines. Yet more or less cloudy shapes of extraordinary complexity and interest develop all over this

picture. Suppose we pick out the whites and see what sort of shapes they make. Take first the white area on the mother's bosom, then the white bows and sashes of the children, and the white spottings on the dog.

You say, could Renoir really have intended these shapes? Aren't they accidental? Or aren't they the shapes the ribbons actually had? Wasn't the dog actually spotted that way? Well, if you have tried making some shapes, I can safely leave the answer to you. Renoir probably did not have just these shapes in mind in a clear image before he put his brush to the canvas. But he certainly intended to make a beautiful picture full of interest and variety, and he *felt* for such interesting shapes and observed wherever such shapes were suggested in the objects before him. They are assuredly the products of his imagination. Wherever dullness threatened, he felt the threat and converted the dull spot into a vital one. Look at the three vertical red stripes in the background. He might have left them three long rectangles to function as foils merely for the quantities of curves below. They were quite adequately justified as contrast elements only. But they would have been dull shapes in themselves. Look at what he did with each one. He scalloped the left edge of the left stripe. The mother's head draws a long curve into the middle one. The chair and the picture break up the righthand one. The triple stripe motive is there but each stripe has become a thing of variety and delight in itself. Notice, too, that these things are not done ostentatiously. They are not disturbing. They simply raise these areas to a high point of interest where they function to their greatest co-operative effectiveness in the whole picture.

We have so far been talking about shape as if it were entirely two-dimensional. It is easier to call attention to it in these simpler terms. But there are, of course, three-dimensional shapes bounding three-dimensional masses just as well as two-dimensional shapes bounding two-dimensional areas. We shall not, however, make any special reference to these. For the general aesthetic function of shapes is the same whether they are thick or thin. However, three-dimensional mass, out of which the shapes of cubes, cylinders, spheres, pyramids and other such forms are ordinarily developed, is not something that can be inferred from two-dimensional mass. In fact, the quality of mass itself could never develop such shapes. We shall see why in the next section.

Three-dimensional Mass

The perception of three-dimensional mass depends upon line working in three dimensions. Certainly its visual perception does. We do speak of a " full chest " or a " full stomach." We know that these come from touch organs distributed through the cavities of our body. But whether such vague masses of **feeling** should be called literally three-dimensional masses without any very clear **sense**

of dimensions at all, is doubtful. The clear sense of dimensionality comes only from kinesthetic sensation, from line. Moreover, it comes from bodily line, not from visual line. The eye has many depth cues, but the eyes cannot literally move around objects and envelop them. The full sense of the third-dimension comes only from acts like grasping objects. Here the muscles and joints of the hand literally move in three dimensions in relation to each other and to any object enclosed by the fingers, and we are thus directly apprised by our muscle-joint sensations of the three-dimensionality of the object.

Suppose the object is an egg. We clasp it in our hand. Our fingers close over it, the palm of the hand curves to the shape of it, the skin of the hand reports a continuous pressure all over it, and we have the direct tactile perception of the three-dimensional mass of the egg. What is the basis of this perception?

Clearly, the perception is based on the linear framework of the muscles and joints, which report the curves of the egg in three dimensions, plus the continuous pressure on the skin, the tactile mass, felt over this kinesthetic framework. The mass, in other words, is not in itself three-dimensional. The mass feeling is just the feeling of continuous area filled with pressure sensation. But this continuous pressure sensation is drawn over a three-dimensional framework of kinesthetic sensation, as a canvas is drawn over the frame of a tent. This mass of pressure sensation fuses with the kinesthetic sensation in a single total perception of a three-dimensional mass. The continuity of pressure sensation gives no dimensions. The kinesthetic sensations give no mass. But the two fused together give both mass and the three dimensions merged into one. And that is the basis of the perception of three-dimensional mass.

This three-dimensional perception of tactile mass is direct and strong. When, moreover, the mass is heavy and resistant to intense pressure we get the aesthetic perception of solidity. In fact, our tactile perceptions of three-dimensional mass are very discriminating as a result of much experience with the masses of materials. We take up a rock or a chunk of wood and we sense the continuity of its material solidly right through it. This sense of the solidity of the material has a pronounced aesthetic effect in our response to works of sculpture and architecture. Likewise the sense of hollowness in a bowl or vase has its characteristic aesthetic effect. These effects are all primarily of tactile mass.

Turning next to three-dimensional visual mass we can now understand why this must depend so greatly upon three-dimensional tactile mass. For when we look at a three-dimensional object — say, a block of granite — and perceive it as a solid three-dimensional mass, we must somehow through our eyes sense its kinesthetic three-dimensionality as a framework over which we stretch surfaces of gray granite color. The gray color areas come up to edges at the boundaries of the surfaces. We know from our chapter on line how the eye senses the lengths and attitudes of these boundaries and the angles they make. But how

does the eye give us the directions in depth? The eye does have certain depth cues of its own — perspective, shading, and overlapping, and for short distances the convergence of the eyes and the focusing of the lens of the eye. There is also the stereoscopic effect, which comes from the fact that the view of a scene from one eye is not quite the same as that for the other. The fusion of these two views produces a powerful depth cue. But none of these factors is effective in actually giving the sensation of a movement or of a line in the third dimension. The actual quality of movement in depth, which is needed for the full sense of bulk or three-dimensional mass, cannot be got from the eye alone. This quality must come from bodily movement, and that is bodily line, projected by empathy into the visual perception. The bulk of the granite block, in the visual perception of it, is only barely symbolized by the depth cues of the eye. The dynamic force of its three-dimensional mass is imported into it from our body. The kinesthetic framework is mainly that of bodily line over which surfaces of color (in substitution for touch) are stretched.

In short, I believe that the framework for three-dimensional mass is always that of bodily line. The difference between tactile and visual mass is solely in the filling. In tactile mass the framework is covered with touch sensation, in visual mass it is covered with visual sensation.

It follows that the feeling of three-dimensional mass is more intense in tactile than in visual mass. For in tactile mass the explicit movements of grasping and the like are made on the object, whereas in visual mass these movements are only tentatively made and empathized. That is why it helps in the realization of the masses of a statue to imagine yourself actually touching it and running your hand over it; or, better still, if occasion permits and the statue is your own or belongs to an indulgent friend who will let you handle it, actually to do so.

Now, it is not so essential for the full effect of three-dimensional mass to suppress the boundaries as it is in the two-dimensional mass. This is because the third dimension practically guarantees a feeling of mass if the surfaces are filled with color or touch sensation. In fact, in visual representation we get the strongest sense of solidity if the forms represented constantly suggest or approximate those instinctive three-dimensional types of the cube, pyramid, cylinder, or sphere. Emphasis on the boundaries of these forms does not seem to detract seriously from their solidity or massiveness. Apparently three-dimensional forms tend to attract mass and repel line, whereas two-dimensional forms tend to attract line and repel mass.

Comparison of Cézanne's *Maison Marie* (PLATE VIIIA) with Loran's diagram (Fig. 50, p. 252 — constructed to show the dynamic movements in the picture) illustrates the foregoing point. Take the forms on the left of the road. In the picture these are all approximations of cubes and spheres and very solid. Whether the boundaries are accented as in the house shapes, or are not accented as in the

tree shapes, the solidity still dominates. But in Loran's diagram where strongly outlined planes are substituted for the solids of Cézanne, a linear effect tends to dominate — and that in spite of the fact that the succession of overlapping planes determines a movement in depth.

Elsewhere we have remarked on the dominant two-dimensionality and linear emphasis in the Fra Angelico (PLATE I). The only exception is the left knee and here there is an approximation to a cubical form.

As regards three-dimensional mass, the Renoir (PLATE II) stands midway between the Fra Angelico and the Cézanne. The shapes of the dog, the children, and the mother are quite solid, as also the seat on which they are sitting and most of the still life. Renoir achieves most of his solidity by suggesting cylinders and spheres. See what the dog's collar and the boundaries of his white spots do to round over his body. Similarly note the effects of the neck lines on the children and mother, and the use Renoir makes of the mother's bracelets. A comparison with the neck lines in the Fra Angelico will show the difference. Renoir is delineating a cylinder by his neck lines, and solidifying the bodies of his figures. Fra Angelico draws flat curves with hardly any sense of depth, for he is etherealizing his figures.

The Seurat drawing is remarkable for its solidity, obtained moreover with a minimum suggestion of line. But wherever a line is suggested it delineates a spherical shape. The rest is done by shading. The head counts as a very simple egglike spheroid, and so is exceedingly solid. Similarly the body rounds over, and the hands and fingers form spherical wholes.

The difference between the expressiveness of the solidity of three-dimensional mass from the lightness of two-dimensional mass must now be clear. For some reason many people do not discriminate three-dimensional mass very easily. Yet one modern school of painters puts so much emphasis upon solidity that it is reluctant to ascribe greatness to any artist who fails to develop it. This attitude is scarcely justified in the face of such artists as Fra Angelico and Botticelli, who probably avoided solidity intentionally. But it does seem to be true that most great artists are very sensitive to the effects of three-dimensional mass and that their weaker followers generally failed to discriminate these effects.

Masses in Combination

As regards two-dimensional masses in combination, there is little to add beyond what has been said under various headings earlier. A visual mass is always an area of color, and, if it is a shape, it is an area bounded by lines. So, when we were discussing principles of color combination we were inevitably describing how masses of color could be advantageously related.

Thus in discussing the method of color gradation we were showing implicitly

how color masses could be modulated over a surface without marked bound-
aries (pp. 166–67). We pointed out passages in Renoir's *Mme. Charpentier*
(PLATE II) to illustrate such color modulations. Now look at these same pas-
sages with an eye to the modulations of the *masses* having these colors — look
at the transitions of the *areas* into one another through the gradations of their
color filling.

Likewise in discussing the method of contrast for combining colors we were
implicitly calling attention to the contrasts of clearly or fairly clearly bounded
areas of color. The relative sizes and distribution of these clear-cut *areas* of color
and the degree of contrast of their color filling make up the two-dimensional
mass composition of such a picture as Fra Angelico's *Madonna* (PLATE I). We
have already remarked on the spotting of the blues and reds in this picture. Now
consider the spotting and contrasts of these *areas* of blue and red. Notice the
pattern of these areas — the large blue in the middle flanked by two smaller
blues above, the large red in the middle flanked by two smaller reds below, and
the curve of red below these, and the stripe of red at the lower rim of the pic-
ture. Observe the spacing of these areas and the intervals between. These are
very simple patterns of color areas, and rather obvious. Often this patterning is
very subtle, and comes to the spectator only in terms of a feeling of a highly sat-
isfying color balance. Many painters intent on these relationships paint on all
parts of their canvas, so to speak, at the same time. If they place an area of color
at the right of the picture, they will place their next patch on the left, and so
the areas are filled in all over the picture plane in an intricate balance of hue,
value, saturation, texture, apparent weight, and all the other aesthetic characters
that can affect the filling of a visual area.

In our discussions of linear patterns, we were inevitably often describing the
shapes of masses. These become motives for repetition in metric patterns, and
themes for variation.

There are two important modes of relationship among masses, however, that
have not received any sort of attention before. One of these is the piling-up
principle for three-dimensional masses. This I shall describe at once. The other
is the figure-and-ground principle, which is so far-reaching in its effects on aes-
thetic perception that it deserves a section all to itself.

The *piling-up* principle is the name I give to a unique sort of organizing prin-
ciple that develops out of three-dimensional mass. I think it must have been
architects who first became conscious of its aesthetic significance. But small
children have known its attraction from the beginning of man. Its dynamic ap-
peal is the fun of piling blocks one by one on top of one another. In order that
the pile of blocks may stand, it is necessary on gravitational principles that the
blocks support each other in a pyramid, or arch, or tower, or wall. Inevitably a
direction and a form enters into the pile unifying the blocks that compose it.

The gravitationally controlled form of the pile of blocks, therefore, acts aesthetically as an organizing pattern.

Though this principle has been known intuitively to artists of all ages, no painter has exploited it so fully and deliberately as Cézanne. Let us see, then, what goes on among the three-dimensional masses of the *Maison Maria* (PLATE VIIIA). At first glance one cannot but be impressed with the massive forms in the center of the picture. The three cubical sections of the house pile up in steps one above the other, each step larger than the preceding in climactic gradation. And the big central form of the house is the climax of the whole picture.

Now, compare the massiveness of these forms in Cézanne's picture with the corresponding forms in the photograph. There is some piling up feeling in the photograph. But the walls of the house seem to flatten out and thin out in comparison with Cézanne's treatment of the same theme. What Cézanne does, of course, is to lessen the sense of the wall surfaces of the house and accentuate the signs of its cubicalness. More space is given to the roofs, the depth dimension under the eaves is heavily accentuated, the little window in the ell which disturbs the cube of the form is hidden by a spray of foliage, the thin boundaries of the walls against the sky are thickened by a heavy line. Such things Cézanne does to build up the house forms. Now, observe how he builds up the earth and foliage forms below the house, so that these also pile up from the edge of the picture towards the climax of the house forms. These are also all cubical forms stepping up one above another.

Next, turn to the right of the picture and you will see the same stepwise piling of form above form towards the secondary climax of the building on the right. This house too has a stepwise effect as if it were trying to build up towards the main house, but a block is left out, so to speak, between the two, leaving a wide gap through which the main dynamic movement of the picture rushes (as shown in Loran's diagram, Fig. 50, p. 252), circling the house in depth, thus still further accentuating its cubical form and its climactic position.

Look closer at the picture and you will see that even the brush strokes pile up stepwise within the larger forms they mold. You will see that the sky is also built up into shapes, as the foliage beneath is.

Such complete architectonic structures of three-dimensional masses are rare. Even in architecture they are rare. For the sense of the stone or brick wall as a plane often dominates the feeling of blocks of stone piled up. But a surprisingly large proportion of the works of the masters in the visual arts makes some appeal to this principle.

Once we are aware of the principle, we see that such a piling up of forms is going on in Renoir's *Mme. Charpentier* (PLATE II) from the lower left-hand corner up into the still life of the upper right. In Tintoretto's *Christ at the Sea of Galilee*, the waves and mountains and Christ's figure in relation to them are

also piled-up forms. Velasquez's *Pope Innocent X* (PLATE VI) is a solidly piled-up pyramid of three-dimensional forms. Much of the power of the picture comes from the massiveness of the shoulders, neck, and head. And note the function the curved cylinder of the white collar performs in building up the pyramid. Cover up the collar and see what is lost in the portrait. In many more of our illustrations you will find this same principle at work.

The Figure and Ground Principle

The modern school of Gestalt psychology makes the figure and ground principle practically the basis of its whole theory of perception. The principle is so basic that we have been able to take it for granted all along. Nearly all of our illustrations have assumed it. This, however, is the proper time for us to make ourselves thoroughly conscious of it. For in visual perception the " ground " on which a " figure " appears is always an extended *mass* of color.

Let us look back at our first illustrations of pattern. Take Fig. 12. When we were talking about these patterns of lines, we were abstracting them from the "ground" on which they appeared, but, of course, in talking about them we had to assume the " ground," for the intervals between the lines were intervals of the " ground " color. The ground here is a mass of white on which the patterns stand out.

Similarly the other Greek pattern (Fig. 11) is drawn on a simple ground color that extends, so to speak, behind it. In fact, it is characteristic of the figure-ground relation in visual perception that the ground appears to be *behind* the figure even in a purely two-dimensional design. It is the very thinnest sort of depth, however — paper thin. It does not of itself induce the feeling of three-dimensional mass for there is no stimulus to kinesthetic movement of line in depth.

In certain patterns, figure and ground may change places. None of our illustrations shows this. In the more serious works of art the artist generally seeks to avoid this kind of ambiguity in a composition and indicates clearly what is figure and what is ground. An ordinary black and white checkerboard pattern, however, illustrates the effect. The pattern may be taken as black squares on a white ground, or as white squares on a black ground, depending on which squares you place foremost in your attention. (It may even be taken as contrasting squares in sequence with no sense of a ground.)

It should not, however, be assumed that the ground need be a plane mass of color. The ground itself may be complex. Such a series of overlapping figure-ground relationships constitutes a particular variety of organizing pattern of the embracing sort. We can see it working beautifully in the Fra Angelico (PLATE I). The blue figure of the Madonna is against the patterned ground of the cur-

tain. And then the black grills on the curtain stand out on a red and gold ground. And then the complex pattern of the gold lies over a red ground that peeks out between the gaps in the gold.

The figure-ground relationship is, accordingly, a relative one. What is ground for one figure is itself figure for another ground.

The ground in the figure-ground relationship is, then (for vision) *a plain or patterned mass of color on which a figure appears and takes shape.*

What is the figure in this relationship? A *figure is any object that stands out as a unit and without confusion against the ground.* This means that a figure must be either a unit of pattern or a type. For these are the only things we have found in our study that count as units in aesthetic perception.

The lines, medallions, etc., which we have so far been pointing at as examples of figures on grounds are, of course, all units of patterns. The kind of type that generally functions as a figure on a ground is that of some represented object which we recognize, a natural type such as a man, a tree, a house. Thus the baby in Fra Angelico (PLATE I) is a figure on the colored ground of the Madonna's lap. And each of the Madonna's hands is a figure against her breast. And her whole draped form is a figure, for all its multiplicity of colors, against the gold curtain.

But the way a type functions as a figure is most strikingly brought out in a drawing such as Picasso's (PLATE IXB). Here the figures of the monster and the goddess are not in any way contrasted with their ground. Yet they stand out clearly against their ground, because we recognize them for the types of beings they are. In fact, if you concentrate on the figure, say, of the goddess, you may notice that she seems lighter than her ground. If you do get this effect, it is hard to believe the water in which she is standing is not " really " a trifle darker than her body. This is the action of the *Gestalt* (of the figure in relation to its ground). Ordinarily, the color of a figure has some contrast with the color of the ground. So the mind, recognizing a figure, projects on it a different color from the ground to make the figure clearer for perception against the ground.

For maximum clarity of visual perception, a figure should be completely represented and silhouetted against its ground. It has been pointed out that children naturally silhouette complete forms without any overlapping in their drawings. It is a sign of considerable advancement in visual perception when a child begins to overlap forms (unless the child is imitating an older person's drawing, which is quite a different matter). Something of this insistence on the clarity of a figure, even to the point of distortion in other respects, persists in the most sophisticated art. For clarity of form is one of the principal means of getting vividness of perception.

To illustrate this point, look at the Picasso drawing again. Notice that, in spite of the fact of the monster's being represented as confusedly crumpling

down at the shock of seeing himself as others have been seeing him, Picasso has managed to depict every major feature of his body clearly as a figure against a ground. Each of the two hands is so turned that you see all five fingers. Both arms and the left leg are completely represented practically in profile (even at the expense of some distortion). Almost all of his back and shoulders are there. His head is in profile. There is a profile of enough of his right knee for you to complete the whole of that leg. The mouth is drawn at three-quarters so that it stands out clearly against the face. So, every important feature is silhouetted against its ground. It is the clarity of each of these features which makes their interrelation in the totality of his attitude of shock so significant and vivid. The literal prosaic truth of an actual man in the comparable position would be dull and psychologically false in comparison.

(In this connection, observe the suppression of the goddess's left hand, so as to concentrate attention on the mirror, and the clarity of the shape of the mirror against its ground.)

With this drawing of Picasso's in mind, now turn to the Renoir (PLATE II). Observe how he, too, has arranged to have every major feature of his objects a well-clarified figure on a ground. Each head is set off to advantage — full face, profile, or three-quarters — from that of the dog to that of the mother. Every hand and arm and paw is clear or well understood. The vividness of the attitudes of these figures also depends on the clarity with which their forms have been disposed against their grounds. Don't think that the disposition of these features was accidental. The artist makes them feel natural and does so with a minimum of distortion. But just shift these figures about a little. Turn the dog's head and body toward the sofa. Turn the girl sitting on his back so that her profile does not show and the left arm is concealed. Let the mother's right arm drop behind the child on the sofa, whose head then conceals the mother's bosom — and so on. There were dozens of such group positions which would have concealed the forms and confused them, to this one which revealed them clearly as successive overlapping layers of figure and ground. Thus the stepwise piling up of three-dimensional forms noted in the last section now appears in the new light of a succession of figure-ground relationships, each rear figure acting as ground or part of the ground of the figure in front.

One last point about the figure-ground relationship. It has become customary lately to speak of the area of the figure on a ground as *positive space* and the areas of ground in relation to the figure as *negative space*. There is a natural tendency to place most attention on positive spaces (the figures) and neglect negative spaces (the areas of ground left between the figures). But one of the signs of excellent composition is the consideration of the shapes of negative spaces. When we were calling attention to the shapes of spaces outside the figures in Picasso's drawing (PLATE IXB) as objects of aesthetic interest particularly

worth noticing, they were negative spaces. If negative spaces are sources of delight as well as the more obvious positive spaces, clearly the richness of a picture is increased.

There are also three-dimensional negative spaces, namely, the unfilled open space in a volume within which objects are placed. So, in a room furnished with chairs and tables the space about these objects is a negative three-dimensional space. The space about an altar or a fountain in a church — in fact, all free space within a building or about a building — is three-dimensional negative space. The aesthetic effectiveness of such open spaces in architecture and city planning may be very great.

Three-dimensional negative space functions also in painting wherever much use is made of the representation of depth. It is relatively negligible, I feel, in a picture like Fra Angelico's *Madonna* (PLATE I) or Picasso's drawing (PLATE IXB). But in a picture like Cézanne's *Maison Maria* (PLATE VIIIA), it is as important as in the nave of a Gothic cathedral. We have already called attention to the interval or gap between the small house on the right of the road and the Maison Maria itself on the left. This is clearly a negative three-dimensional space, and this space encircles the Maison Maria, fills in between the house and the front of the picture, and rises up to the sky overhead. Two-dimensional negative space so prominent in the Fra Angelico is relatively inactive in this picture, but the intervals between objects developing a three-dimensional negative space is here an outstanding feature.

When, however, we begin talking about the empty three-dimensional space in a picture we are already calling attention to a new source of visual interest, different from color, line, or mass. We are calling attention to volume or depth, which is the subject of the next chapter.

VOLUME

Visual Volume

VOLUME is space itself. The volume of a room is all the space in it whether filled or unfilled. We ordinarily conceive this space as cubical, extending the sides of the cube as far as necessary to take in all the locations included in any volume before us. If we are feeling speculative, we may allow the sides to extend to infinity, which then gives us Newtonian cosmic space, the conception of an infinite three-dimensional field containing all possible space locations. But in our ordinary daily conceptions we keep the volume of any surrounding space we think of within fairly confined bounds.

This three-dimensional volume which we set up whenever we locate things is, of course, a *scheme of locations*. It does for space locations what the color cone does for colors. The physicists call it a reference system. If you want to know the location of anything, or the distance between any two or three things, you make these facts clear to yourself by reference to the three dimensions of this conceived volume. The hummingbird's nest, you say, is about twenty feet up in the apple tree between the house and the barn. The location of the nest is here placed in a volume of locations which includes the house and the barn and the ground and the top of the tree.

How we psychologically build up this conceptual scheme of locations out of our experience in reaching for objects and walking about them and in correlating such kinesthetic acts with our visual perceptions, lies outside our present task. The scheme is, we should suggest, kinesthetic in origin, quite similar in origin to the three-dimensional linear framework that underlies the perception of three-dimensional mass. And just as that linear framework is projected by empathy into our visual perceptions of three-dimensional mass, so this kinesthetic scheme of three-dimensional volume is empathically projected into our visual perceptions of volume.

But the feeling of volume is different from the feeling of three-dimensional mass, even though the two qualities are closely related through their kinesthetic linear origin. For the one involves the feeling of mass or filled space, and the

other does not. Volume may be filled or empty or may include three-dimensional mass. But it is characteristically conceived as empty. To obtain the most striking effects of the aesthetic sense of volume, think of the expanse that opens up before you as you enter a cathedral, or as you look down into a canyon, or come out upon a view that opens before you from a mountain top. Yet the feeling of coziness in a cottage also comes from volume. Every room and court, every city street, every avenue of elms, every forest vista depends upon a feeling of volume for its aesthetic effect.

The amazing thing, moreover, about this feeling of volume is that though it comes to us, let us say, out of a mountain chasm apparently as directly as the roaring of a torrent there, yet it is a projected, empathized feeling and not by any possibility an object of pure visual stimulation. The physical volume is, of course, actually there and measurable by a physicist. But the eyes alone could never have made us aware of its great distances without much past experience of the locomotion of the body. And movements alone of the body within the chasm could never have given us the impact of its huge expanse in one synoptic perception without the vision of the eye. The body and the eye and the mind are all necessary for the effect of volume: the eye to receive the stimuli and apprise us that there is a great space before us in which we might move unimpeded, the body to give dynamics to that space and significance to the very idea of unimpeded movement, and the mind to conceptualize these possibilities of movement into a scheme which gives order and location to the visual stimuli. The perception of volume is an extraordinary thing. Its complexity is concealed in the simplicity and directness of its impact. As material for aesthetic delight it seems as elemental as mass or color. But its actual complexity accounts for the flexibility of its representation, as we shall immediately see.

There is reason to believe that there is a high degree of uniformity in the human conception of volume — that is, in the three-dimensional Newtonian scheme of locations itself.[1] What I mean is that we all project the same scheme of locations into a room when we look at it, no matter what our cultural background. We conceive its dimensions as rectangular and about so many feet long, wide, and high. Anybody who failed to do so would get into a lot of practical difficulties as soon as he started moving around the room. But clearly this scheme of locations is not directly presented to the eye. The eye sees the room directly through a *perspective*. Consequently, there is a conflict between the "real volume," as we call it, meaning our conceptual scheme of locations for the room, and the perspectives through which we become aware of that volume. This is why perspective becomes a matter of great aesthetic importance in the visual arts.

[1] The philosopher Kant was so impressed with this fact that he thought space was an innate form of perception, through which we saw natural objects as through colored glasses.

LINEAR PERSPECTIVE AND THE PICTURE BOX. A perspective is the manner in which a volume is represented to the eye from a point of view in space. There are many different kinds of perspective. We do not become clearly aware of them till we see painters actually representing them on a two-dimensional surface. In our ordinary everyday perceptions of objects in space we read right through our perspectives to the volume outside. Our perspectives are representatives of the volume. Consequently, in looking at a statue or a building actually standing in three-dimensional space we do not take the distortions of a perspective very much into account. We compensate for them. We see men all of about the same size all the way down the street in front of us. By a happy illogicality of our minds, we can look down a row of columns and get the climactic effect of the gradation of their sizes as they converge in perspective and at the same time see them all as columns of exactly the same size. In ordinary perception, the concept of the true volume dominates over the distortions of a perspective, so that in the arts which use all three dimensions — as in sculpture and architecture — the problem of perspective is a secondary one. But in painting where volume is to be represented on a two-dimensional surface, the problem of perspective is one of primary concern. In the following sections, then, we shall be thinking only of the way perspectives appear in painting.

How does a painter make objects look as if they were going back in space? Or, how can you locate objects within the represented volume of a picture? That is the problem of perspective.

First, let us take note of what is meant by the represented volume of a picture. This concept requires us to distinguish between the picture plane and the represented volume behind it. The *picture plane* is the plane on which the spectator judges that the drawing or painting is made. It is the plane of the paper or the canvas. The spectator perceives this plane so-and-so far away from where he is standing and, in general, expects the composition either to be developed *flat* on this plane, as in our plate patterns (Figs. 12, 14), and in the rug (PLATE III), and also perhaps in the Chinese painting (PLATE IV), or to be developed in *depth* representing some volume behind this plane. The depth of this volume is sometimes clearly marked by the rear wall of a room, or by mountains, or foliage, but sometimes it is more subtly signified and felt as stopping at a certain distance back without any definite wall to mark it. The Velasquez portrait (PLATE VI), for instance, has an undifferentiated background without any depth cue. Theoretically, the represented volume of the picture could be conceived to infinity. Actually, we conceive the rear plane as a little behind the Pope's back, for there are no effective forms behind that. The picture is composed that deep and no deeper.

It is usually felt as a fault if any feature in a picture appears to protrude in front of the picture plane. This is partly an aesthetic convention in the interest

of maintaining the psychical distance. For if an object seems to stick out in front of a picture, we tend to take it as a real object in the room and not as a part of the picture. But mostly this demand is in the interest of unity of organization. Once in a while, however, an artist will break out in front of his picture plane

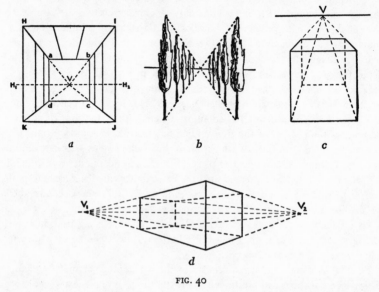

FIG. 40

successfully, especially if he does so in a spirit of humor or a kind of mischievousness or conceit. Baroque painters sometimes depict the foot of an angel who appears to be sitting near the edge of a picture as if the foot hung over the frame or molding. If the spectator can take this effect as a sort of sprightliness or extravagance of spirit, it may stir up a bit of delight, but otherwise it is disturbing. Normally the picture plane is scrupulously respected, necessarily so in highly serious art.

The distance of the rear plane from the picture plane determines the depth of the picture. Accordingly, if a picture is not flat it has either shallow space or deep space. Compare Matisse's *Odalisque* and Tintoretto's *Christ at the Sea of Galilee* in this respect. The Matisse has very shallow space, the Tintoretto very deep space. The rear plane of the Matisse is close to the picture plane, that of the Tintoretto is far back. Fra Angelico's *Madonna* is deeper than the Matisse, Renoir's *Mme. Charpentier* deeper than the Fra Angelico, and Cézanne's *Maison Maria* is deeper than the Renoir. But the Tintoretto is deeper still.

In all of these pictures, in contrast to the rug pattern (PLATE III) there is a three-dimensional composition. Objects are arranged in relation to one another

within a volume that lies between a picture plane and a rear plane. Now comes the question of perspective. How are objects located and organized within that volume?

The first thought that probably comes to the modern man familiar with photographs and aware of the general laws of linear perspective is that objects in a picture representing depth should be located and organized according to the principles of linear perspective. The image on the retina resulting from light rays passing through the lens of the eye necessarily obeys the laws of linear perspective. Why, then, should not a picture obey these laws?

In Fig. 40 are some diagrams which show the main principles of linear perspective. Imagine yourself standing up and looking straight out in front of you from the back of a garage with its doors wide open. Suppose the garage looks out across a perfectly open plain. In the distance you will see a line, the *horizon* line, where the earth meets the sky. Of course, actually, the earth never meets the sky. For suppose the day to be overcast so that the sky is literally a ceiling of clouds. The clouds are, of course, as high off the earth in the distance as they are near to. But it looks as if the ceiling of clouds meets the floor of the earth in the distance. The rounding of the earth has nothing to do with this effect. The horizon line is a purely optical effect. It is seen directly in front of your line of sight where the ceiling plane and the floor plane meet. This horizon line is the key to the laws of linear perspective. All horizontal ceilings and floors if extended in perspective would meet at the horizon line. If you should extend the lines of your garage ceiling and the lines of the floor, these also would meet at the horizon. You can test this fact in the very room you are in now. Shut one eye and hold up your pencil so that it exactly parallels the beam of the ceiling along the right wall. Hold your pencil there and then look at it with your two eyes. You will see that it tips down and in. Do the same with your right floor beam. You will see that this line tips up and in. If you continue those two lines till they meet, they will come together on the horizon exactly in front of your eyes. They will also meet the lines of your left ceiling and floor beams. This point at which all these lines meet on the horizon is called the *vanishing point* for these lines.

Now let us represent these facts on paper. Draw a horizontal line H_1H_2 (Fig. 40*a*). Select a point, V, on that line to be your vanishing point. Draw a horizontal line *ab* above the horizon to represent the top beam of your doorway. Notice where the horizon line crosses your doorway probably about two-thirds the way down the opening. Then draw the horizontal *cd* the proper distance below the horizon. Draw the verticals *ad* and *bc* the proper distance apart to make the rectangle *abcd* the same proportions as your actual doorway. Now take a ruler and lay it down against the vanishing point, V, and the upper corner of your door, *a*. Draw the line *a*H, which is the extension of V*a* to H. Draw it as long as

you like. Draw it right off the paper, if you want the edges of the paper to be your frame, and if you want it to look as if you were standing inside the garage. Similarly draw bI, cJ, and dK. Draw the horizontals HI and JK, and the verticals KH and JI. To your astonishment, perhaps, you will find the combination of these mechanically ruled lines gives you the appearance of looking out through the garage to the distant horizon. Add a couple more vertical joists on each side, and a pair of crossbeams overhead directed at the vanishing point, to increase the illusion, and the effect is really striking. You have here the basic principles of linear perspective.

Until you have drawn such a picture, you may find it hard to believe that this is actually the way lines run in our retinal perception of depth. Is it any wonder that men do not easily discover the principle; and that they are fascinated with it when they do discover it? Fig. 40b is the same as Fig. 40a, except that we are looking straight down an avenue of trees rather than out the doorway of a garage. Fig. 40c shows what happens to the lines of a cube when you see it from above. The vanishing point on the horizon is, of course, simply above the top plane of the cube, and everything else goes according to schedule. If you were looking up from under a cube, the vanishing point would simply be below the under surface of the cube. Fig. 40d shows what happens when a cube horizontal to the floor is turned so that its planes are at an angle to the eye. When a cube is tipped up on one corner, the tip is indicated by the vanishing points' being above and below the horizon line.

From these diagrams it is clear that through linear perspective a number of things happen to the sizes and shapes and relations of objects. The eye automatically registers all these changes in the retinal image. The mind, however, immediately interprets these distortions due to perspective back into their "real" sizes or shapes, taking the distortions simply as signs of the distances and positions of objects from the spectator. The reason for this translation is that the judgment of the "real" size and shape is almost always of more practical importance than a judgment of the apparent size and shape on the retina. When you look into your garage, the most important thing is to judge whether your car will fit within it. Consequently, you do not notice that the image of the rear wall is much smaller than that of the doorway. All that you notice is that on the indications from the image on your eye the walls of your garage are *parallel* and the size of the rear wall is *equal* to that of the opening.

One can see how this rivalry between the mental perception and the retinal image makes quite a problem for the painter. In the first place, it takes a lot of observation and training to discover just what is going on in the retinal image. In the second place, it is questionable whether the reproduction of the retinal image (that is, the painting of the scene in literal linear perspective) is a good thing to do aesthetically. What strikes a critic is the relatively small number of

recognized painters in the history of art who have used literal linear perspective
— or, at least, used it in such way that it is a prominent feature in their
paintings.

There are two drawbacks to literal linear perspective in a picture. The first is

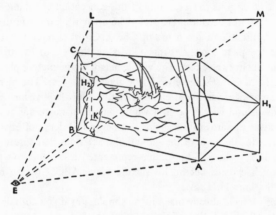

FIG. 41

that the convergence of lines to a vanishing point makes a hole in the picture.
This effect can be seen very clearly in the perspective of the avenue of trees,
Fig. 40b. The trouble with such a hole is that there is so little that can be done
in the organization and pattern of the rest of the picture other than follow the
lines of that hole. The lines of perspective are so powerful that they force all
other lines to follow them. Just imagine yourself trying to get the drama of ten-
sions among planes and volumes such as occur in Cézanne's *Maison Maria* into
the perspective of this avenue of trees. Or try to imagine yourself laying a pat-
tern of line movement such as occurs in Fra Angelico's *Madonna* over the in-
sistent convergence of those perspective lines. It cannot be done. The richer
forms of organization refuse to keep company with a strong emphasis on linear
perspective.

The second drawback has to do with the sort of volume that develops behind
the picture plane. We have seen how the lines of perspective converge to vanish-
ing points in the far distance. There is an exactly opposite effect if we attend
to the volume of vision opened up to the eye in terms of strict linear perspec-
tive. Close to the eye the range of objects that we can see right and left is very
narrow. But far from the eye at the horizon the range expands to miles in
width. The volume of visible space opening up before the eye, then, is an ex-

panding cone extending out into space with the eye at the apex. This volume of space is represented in Fig. 41. E represents the spectator's eye. The possible range of his vision is the cone of dotted lines diverging from E.

If he were painting a picture of what he saw by strict linear perspective, he would conceive the picture plane cutting this cone at some section ABCD. On this picture plane he would project what he sees behind it. Tintoretto's *Christ at the Sea of Galilee* gives you a fair idea of this conception of volume (with certain qualifications to be made presently). The artist is clearly painting his picture some feet this side of the figure of Christ. Christ is represented as just a little back of the picture plane. From Christ on the left to the trees on the right would be about twelve feet. The visible height at the picture plane judging from the height of Christ's figure would be about eight feet. The picture plane represents a range of vision about eight by twelve. Now look at how the visible range expands behind widthwise to a whole mountain range and a stretch of open sea, and way upwards to the clouds and beyond. It does not expand downwards, however, for the level of the ground and sea stops that spread of vision, as it does in most pictures. The volume represented in Tintoretto's picture is, then, that which extends behind his picture plane ABCD to the rear plane bounded by the lines H_1H_2LM.

But perhaps we have already made it too simple. For if you consider the ceiling of clouds, rather than the infinite space of the blue sky above, as defining the volume behind the picture plane, this ceiling comes into the field of vision and slopes down to the horizon H_1H_2. Notice that the first clouds you can see at the top of Tintoretto's pictures are those floating over the bay a quarter of a mile or so behind the boat. This ceiling of clouds slopes down to the distant horizon cutting off the top of one of the mountains. To avoid confusion in the diagram, however, let us take this ceiling as sloping down from the top of the picture plane, CD. Considering this ceiling of clouds as defining the upper plane of Tintoretto's pictorial volume, the shape of this volume behind the picture plane within which Tintoretto places his various depicted objects is the complex one bounded by the picture plane ABCD at one end, and the sloping plane CDH_1H_2 at the other, flanked on either side by the flaring planes ADH_1 and BCH_2, over the floor ABH_2H_1.

Now I am sure you as spectator of this picture of Tintoretto's had no idea you were looking into any such strangely shaped chamber of space. Tintoretto (probably intuitively) did a number of things in his composition to keep the spectator from being disconcerted by such a number of disturbing energetic diagonal planes. When you see what the small diagonal planes of the boat sloping one way and the sail the other do to the movement of the composition, you can imagine what the diagonal backward-sloping plane of the sky would have done, and the flaring planes on the two wings, if Tintoretto had let them be

felt. He broke up the ceiling plane with a lot of overlapping cumulus shapes, and concealed the flaring wings on the one side with trees and on the other with a nearby point of land. The net result is that the spectator is induced to project into the picture a simple *cubical* chamber which is visually impossible

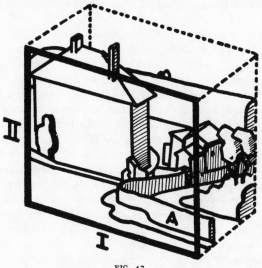

FIG. 42

Courtesy Erle Loran, from *Cézanne's Composition*, University of California Press, 1943.

but mentally and kinesthetically utterly convincing. The space behind the picture is pictorially felt as a cubical stage within which are placed objects of different sizes, their sizes getting smaller as they go back so as to *represent* their distance. The pictorial space of most pictures is not presented in strict linear perspective with the side planes *felt* as flaring towards the rear. But it is presented as a rectangular box with the side planes at right angles to the picture plane and the rear plane at various depths producing deep or shallow space.

Consequently, when Loran in his analysis of the deep space of a typical landscape by Cézanne represented that space as a cubical box (Fig. 42), he was precisely following the artist's intuition (and the spectator's too, unless the spectator begins to reflect and possibly gets mixed up about it). Notice how Loran draws the distant house smaller than the near one in the cubical space. By this means the rear house gets its distant effect and yet the planes of the picture box are kept rectangular.

From these remarks, it should not be concluded that no pictures are presented in strict linear perspective. Nevertheless once one's attention has been called to the matter one will be surprised to find how few pictures by artists of

repute have been so painted. The reasons for avoiding the effects of strict linear perspective are, to repeat, first that the vanishing points when emphasized make holes or converging funnels of lines in the composition which disturb any other possible patterns in the composition, and second that the diagonal planes of a flaring perspectival space interfere with any other possible spatial organization within the picture.

Even when the principles of linear perspective are rather carefully followed in details, as in the Tintoretto and the Renoir, the total effect is broken up so that the disturbances are not felt and a boxlike rather than a flaring space develops behind the picture plane. To illustrate once more, notice that the Renoir is quite faithful in all its details to the principles of linear perspective. The parallel lines of the rug design and of the couch converge toward a vanishing point. So do the parallel lines of the table and chair. The horizon line is clearly just above the top of the chair at about the level of the mother's eyes. All objects are rather consistently depicted in relation to this line. Yet the effect of linear perspective is constantly broken up by overlapping forms which dominate the perspectival lines. As a result the organizing lines of the pattern — for instance, the strong diagonal from lower left to upper right, and the counterdiagonal up the mother's skirt — count most heavily and attract our attention. Renoir here uses linear perspective merely in a subordinate capacity as a subsidiary depth cue.

Or again compare Loran's photograph of Maison Maria with Cézanne's picture (PLATE VIIIA). See how the foreshortened wall makes a hole in the photograph under the wing of the house, and how the converging lines of the road, not being adequately blocked off, lead the eye through so that the sky in the upper right corner recedes infinitely into a spatial vacuum. Cézanne blocks off these lines by horizontal shadows across the road, by the plane of the house at the end of the street and an enlargement of the mountain behind the house, and he fills the vacuum in the upper corner by the foliage of the tree in the foreground. No hole develops (cf. Fig. 42). In the photograph the perspectival lines make the composition into a funnel converging to a vanishing point in the right background and flaring out like a gaping mouth over the whole foreground. The forms of the house are thus crowded off into the left corner behind the wall where they can have little pictorial significance. At the same time the spatial volume of the photograph, especially above the wall, flares back in the manner of the Fig. 41 diagram. The space opens out indefinitely into the rear. All these pictorially disturbing factors are either eliminated or brought under control in Cézanne's picture.

We can now, perhaps, understand why emphasis on linear perspective is relatively rare and not at all essential to great painting, even when deep space is being represented. The next question is to ask how depth of space is represented when linear perspective is suppressed or eliminated.

Various Forms of Perspective

The answer to the foregoing question is, "By compromises with linear per spective." In our ordinary vision there is a constant compromise going on be tween the three-dimensional conception of the Newtonian cube, which we pro ject into our visual field, and the perspectival space of the image on our retina. We are likely to call the first "real space" and the second "visual space." We say that "visual space" is the way objects in "real space" look to the image on the retina of the eye. Both of these schemes of space may in a sense be called purely physical. They can both be measured with precision. For this reason they are often said to be more "objective" than other organizations of space.

But our actual perceptions rarely correspond exactly with either of these physically "objective" spaces. Psychological experiments show that our actual perceptions exhibit a compromise between "real Newtonian space" and "visual perspectival space," with the bias strongly for "real" space. We see objects very nearly in their "true" sizes — though not quite. If we have nothing to go by, no outside clue, and no special practice in judging the sizes of distant objects, we tend to underestimate the "real" size of a distant object. And vice versa, if we *know* that a distant object is big, we overestimate its apparent size — that is, its size on the retina, or its representation on a picture plane. We are often sur prised to see how small a big mountain appears in a photograph. A painter, con sequently, has to exaggerate the apparent size of a mountain in his picture to make it look true to the size it seems to be as we look at it in nature. Cézanne has done this in the *Maison Maria*. He has raised the mountain on the right in the picture to the height of the central house. In the photograph the mountain is hidden behind some trees, which have grown since Cézanne made his paint ing and which barely reach half the height of the central house.

I mention these things to show how much we compromise with the physical schemes of space in our actual perceptions of depth. Awareness of these com promises should make us more prepared to notice and to accept the great variety of perspectives employed by painters of different schools throughout the ages. Let us call any perspective that is not strict linear perspective a "compromise perspective." It is a question whether the various compromise perspectives of different periods of art are not the actual modes of perceiving depth which the artists and their public employed in looking at nature. Strange as some of the compromise perspectives of other cultures look to us, such organizations of space perhaps represent faithfully just the way nature looked to the artist who painted the pictures. Quite probably a scene appeared to a Persian just as it is painted in a Persian miniature, and to a Chinese just as it is painted on a Chinese scroll.

But observe the following peculiar fact about the compromise perspectives of

FIG. 43

other cultures. Strange as they may at first appear to us in comparison with the perspectives to which we are accustomed, we can generally read them off intuitively. They are not like the symbols of a foreign language, that have to be learned from the beginning to be understood. They seem rather like dialects of a common language. In a sense, I believe this is just about what they are. The common basic language is strict linear perspective (projected into the cube of Newtonian space). The various compromise perspectives are selections and combinations of the depth cues that are embedded in strict linear perspective. What are these depth cues?

1. *Height on the picture plane.* For all objects below the horizon, the higher an object in our field of vision the further away it is. Since most objects of interest are on the ground, and so *stand* below the horizon, this cue of height in the field of vision is a strong depth cue. Of course, for objects above the horizon the reverse is true. But relatively few of the objects we notice stand above the horizon, and most of these, like clouds, stars, and the moon and sun, really are very far away and so by the height cue should be high. True, moun-

FIG. 44a

tains extend above the horizon, and so do most objects of normal vision, but they *stand* (and accordingly are located) below the horizon. (Cf. Fig. 43.)

FIG. 44b

2. *Diminution of size.* The further away an object is in space, the smaller its image on the field of vision. Accordingly, smallness of size is a depth cue. (Cf. Fig. 44.)

3. *Overlapping.* Nearer objects overlap more distant objects standing behind them in the field of vision. This is probably the strongest of all depth cues. Even a small object overlapping a big one will push the big one back. And a higher object overlapping a lower one on the picture plane will also easily push the lower one back. (Cf. Fig. 45.)

4. *Foreshortening and convergence of lines.* The convergence of parallel lines to a vanishing point in

depth is a defining characteristic of linear perspective. So it comes about that any convergence of lines, or any effect of foreshortening such as results from the convergence of lines in linear perspective, or, in fact, *any diagonal line* acts as a depth cue. It acts so, even if the foreshortening of one object is totally incon-

a b c d

FIG. 45

sistent in terms of linear perspective with that of other objects in the same picture. In Fig. 46 we should assume from the convergence of the lines of the foreshortened side of the box on the left, that the horizon line (or eye-level) for the picture was about at the level of the top of the wineglass and the bottom of the cupboard on the right. Nevertheless, the top of the wineglass is drawn as if it were visible from above, and the bottom of the cupboard as if it were visible from below. These objects, consequently, represent three different eye-levels in the same picture. Nevertheless, we read off the spatial relations and relative locations of these objects without difficulty.

Strangely enough, even reversed convergence (that is, convergence of parallel lines *forward* instead of backward in space) will often be accepted as a depth cue. Thus the table in Fig. 46 will probably be read off by most people as a rectangular table in depth, in spite of (or rather, on the cue of) its reversed perspective. The convergence cue is there and accepted, and its reversal may not at first even be noticed.

FIG. 46

Now, compromise perspectives are made up for the most part out of these fragments of linear perspective taken out of their systematic physical context and recombined in various ways. All of these four cues — height on the picture plane, smallness, overlapping, and converging in diagonal lines — are generally present in various proportions. But the laws of strict linear perspective may be greatly distorted. Such distortions can be easily observed in the Cézanne *Maison Maria* (PLATE VIIIA) and the Matisse (PLATE XX). Both of these pictures rely largely on overlapping and height on the picture plane for their depth cues. Diminution of size could scarcely come into action in the Matisse because the picture is composed in such shallow space. The cue does function in the deep space of the Cézanne, but the sizes of distant objects are much larger than they would be in linear perspective.

Foreshortening at different eye levels is employed by both. For instance, in the Cézanne look at the two levels of roof on the ell of the house. Compare the photograph with the painting. Judging by the convergence of the ruts in the road, the horizon line would be at about the eaves of the lower roof. In the photograph the top of the stone wall slopes down a little (put the edge of a paper along it, and you will see) so that the horizon is a little lower than the top line of the wall. Consequently, the spectator is looking up at the roofs of the house. Consequently less of the upper roof will be visible than of the lower roof. This is correctly represented in the photograph. But Cézanne lets us see much more of the upper roof than would be possible in linear perspective. Consequently he has shifted the eye level. Also look at the line of the left wall of the house and of the eaves above it. Though on the house these are parallel lines of equal length (and so we interpret them) yet in the picture the line of the eaves is visibly longer. Consequently, there has been a shift of standpoint. The eaves are painted as if the eye were more to the left than it was when the wall was painted. In brief, Cézanne uses foreshortening as a depth cue but without consistency, just as in Fig. 46.

Matisse uses foreshortening in the same way. Compare the eye levels for the neck of the jar, the top of the table, and the top of the box in PLATE XX.

Is there any aesthetic advantage in so much inconsistency? In breaking the type of linear perspective and the sense of realism that might have been achieved, are these men not irritating rather than pleasing us? For an intuitive answer, look at the photograph and the Cézanne picture. If you have acquired some discrimination of the dramatic tensions in the Cézanne, does not the photograph look tame? The photograph does indeed fulfill the demands of linear perspective to the letter. It looks like reality, and pleases so far. But that is such an easy type to fulfill, especially in a photograph. Moreover, photographic realism does not satisfy the demands of, shall we say, aesthetic realism. Where in the photograph is that big mountain in the distance? The aesthetic advantage

of Cézanne's free mode of depth representation is negatively the avoidance of the holes and of the flarings of linear perspective, of which we spoke earlier, and positively the greatly increased freedom of pictorial composition in depth. Besides, if we accept his conventions of depth representation, we have no difficulty in reading off the spatial relation of objects in the space volume behind his picture plane. In fact, the inconsistencies of eye level and the like add zest and surprise and vividness to the forms. Matisse also quite obviously distorts linear perspective to give liveliness to his pictures. See (in PLATE XX) what the twist of the table top and of the top of the box does to vivify these two planes.

FIG. 47

Having thus seen how depth representation is handled by men who completely abandon strict linear perspective, we can now take a more discriminating look at men like Renoir and Tintoretto who are much more conservative with reference to these visual principles. Renoir's *Mme. Charpentier* nowhere seriously contradicts strict linear perspective. But do you notice how he has composed his picture so as to emphasize the depth cues of overlapping and height in the picture plane and foreshortening, and to suppress strong linear convergencies? In spite of his consistency with linear perspective, Renoir's picture is more like Cézanne's picture of the *Maison Maria* with all its inconsistencies than like the photograph of that house with all its consistency.

There are two other depth cues that have no connection with linear perspective, but often cooperate with the linear perspective cues in the perception and rendering of depth. These are light and shade and what has come to be known as aerial perspective.

AERIAL PERSPECTIVE. This is the effect of mist, haze, or atmosphere on objects at a distance. It is very obvious on a misty day. Nearby objects are in their full intensity of color, and color contrasts are strong. As objects recede into the distance they become grayer, details are dissolved, and contrasts are diminished, till finally an object becomes merely a dim gray mass. These effects become a depth cue in themselves. In Fig. 47, A advances and B recedes because there is no strong color contrast at B. This is the effect of aerial perspective and acts independently as a depth cue even in such an isolated strip as is shown here.

But also on a clear day there is aerial perspective. For the atmosphere is blue so that objects in the distance become bluer and gradually lose their color contrasts and detail just as in a mist but much more gradually. Everybody notices the distant blue mountains. But it takes closer observation to notice the effects of atmosphere on objects in the middle distance, where it shows mainly in the shadows. In his *Christ at the Sea of Galilee* Tintoretto makes use somewhat

loosely of the effects of aerial perspective to help give depth to the coast line as it recedes to the horizon.

The fact that warm colors are advancing and the cool receding (cf. pp. 163–64) is by some ascribed to the blue distance of aerial perspective. For blue is the most receding hue.

LIGHT AND SHADE. The effects of light and shade as a depth cue and as a means of organizing a whole picture in a unity of illumination are quite equal in importance to those which grow out of linear perspective. As with linear perspective, these effects are objectively measurable. They can be measured by photometers, if one questions the eye. They constitute a system of the true values of illumination. Few painters abide exactly by it. But the effect of luminosity, for which the Dutch school of seventeenth-century painters culminating in Vermeer of Delft are famous, derives from an extraordinary faithfulness to this system of true values.

For one whole side of the appreciation of painting, we ought to know something about the principles of light and shade. Vermeer is only half appreciated unless we have some understanding of the controlled interrelation of color values which make his pictures give the impression that light fills the room. But not only the Dutch painters, the whole European tradition from the Venetians to the extreme moderns and including many of the most radical moderns, rely for many of their effects on the principles of light and shade.

So, let us examine these principles in terms of a simple condition of illumination which is generally regarded as typical. Let us imagine a room lighted by one window facing the north. We will think of ourselves (our eyes) as stationed in the west end of the room looking east at an object in about the middle of the room. For simplicity, let the object be a cylinder standing upright in the full illumination of the window. In Fig. 48, *a* and *b* is a condensed representation of these conditions. The reason we stipulated a north window is that we may eliminate the complications that come from the direct illumination of the sun. Moreover, artists prefer a north light in their studios because it is a relatively constant illumination throughout the day (not affected by the position of the sun) and does not vary very much between clear and cloudy days.

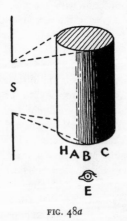

FIG. 48*a*

Nearly all portraits are painted under a north light. We may think of our cylinder as a greatly simplified human head.

A glance at Fig. 48*a* will show at once why light and shade are a depth cue.

When an object is illuminated from a source of light, the surfaces facing towards the source are in bright illumination, those facing away from the source are in shadow. The shape of an object can thus be quite accurately judged by the way the light falls upon it.

Let us see just exactly how the light falls on our cylinder. The dotted lines represent the angle of rays directly illuminating the cylinder. Consequently the surface of the cylinder, namely A, receiving these rays is in full illumination and the color of this surface is what is called the *local color* of the object. For the local color is the color in standard illumination, and such north light illumination is what is commonly taken as standard. It is *the* color, in common sense terms, of the object. If you want to see *the* color of a sample of cloth in a department store, you take it out into the daylight but *not* into the sunlight.

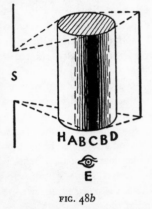

FIG. 48*b*

Where the fully illuminated surface diminishes, the shadow begins to appear. In a rounded object like this cylinder the shadow gradually deepens towards the back provided there are no reflected lights. The lighter parts of the shadow towards the illumination are called half shadow, B, the darker parts full shadow, C. This simple shading is what is commonly taken for granted, and many painters using shading as a depth cue carry their observations no further than this.

But ordinarily a room is not so deep or so dark that there are not reflected lights coming off the wall opposite the window. Fig. 48*b* shows what is seen when closer observation is given to the details of illumination. Now we notice that the rear wall becomes a secondary source of illumination and by its reflected light produces an area of secondary illumination on the back of the cylinder. As a result we discover that the darkest shadow is not on the surface furthest from the window, but on a surface nearly facing the observer. So now as we go round the cylinder, we shall find an area A in full illumination giving the local color. Then an area of half shadow B, then the full shadow C, followed by another area of half shadow, B, followed by the area, D, of reflected light.

But even this is not all. If our observations have gone thus far, we shall be sure also to have observed a high light in the midst of the illuminated area, A. Suppose the cylinder is, as we say, blue. Then this means that most of the light that comes from the source, S, and is presumably white reflected sunlight containing (as a prism would show) all the wave lengths that give all the spectrum colors, penetrates the surface of the object and has all of its rays absorbed ex-

cept the blue ones which are reflected to the eye and give us the impression of a blue cylinder. This happens over most of the surface, A. But if the surface is the least bit shiny (and this is just what "shiny" means) there will be a streak in the middle of this surface which is not blue, the local color of the surface, but white, the color of the source of light. This white streak is the highlight. It appears at the point where the angle of illumination relative to the curve of the surface is equal to the angle of reflection to the eye. That is, it comes wherever light is directly reflected to the eye. The "shinier" the object, the larger the highlight, and the more completely it reveals exactly the colors of its source. A brass bowl will give you in its highlight a complete picture of the window and the trees and houses and sky outside from which the light of the window comes. But for most less shining objects these detailed sources of illumination are fused in a single white ray, so that the highlight is simply a streak of white.

To get a full sense of luminosity such as one finds in Vermeer, these relations of illumination, shadow, reflected light and highlight are very carefully observed. A reflected light, of course, carries its hue onto the surfaces and into the shadows where it is reflected, so that the hue seen is a mixture of the hue of the object and of the reflected light.

The best picture reproduced in this book to show the principles just described is the Velasquez portrait of Pope Innocent X (PLATE VI). The spectator is more in front of the object than in Fig. 48b, and he is on the other side of the object, so that the shadows are seen on the left rather than on the right. But the areas of local color, half shadow and full shadow with the transition between, are clearly indicated as are also the highlights and some effects of reflected light. And the power of light and shade as a depth cue to model the head and shoulders and the details of all the features is plain to see.

Velasquez, as this illustration shows, follows the laws of light and shade rather faithfully. And a close observance of these laws has a great unifying and integrative effect on a picture, because, as we have seen, every object becomes related to every other object in terms of the illumination. This relatedness comes not only from the reflected light where, so to speak, the different surfaces in a picture directly communicate with each other, but even more it comes from the consistency of the light and shadows throughout, a consistency which when present draws all the objects together, detail by detail, into a common system. This unity can be developed as well in outdoor as in indoor painting. It can be found in artists as diverse in their styles as Vermeer and Velasquez and Monet and Cézanne. There is a rather high degree of consistency in our Renoir, *Mme. Charpentier* (PLATE II). We are standing slightly to the right of the source of illumination, so that the area of local color is very wide. Shadows fall to the right. Notice the modeling of the mother's head. See the use of highlights to bring out the textures of the still-life objects in the upper right corner. See the

reflected light of the red tray on the under surface of the carafe. Notice the warmth of the shadows generally, indicating a wealth of reflected light.

But the great majority of painters select fragments out of the system of light and shade representation, just as they select fragmentary cues out of the linear perspective system. Fra Angelico, for instance, uses just enough shading to round over a face or an arm, or model a fold. Each object is separately modeled without particular concern for matters of source or distance of illumination. Much the same with the Matisse (cf. PLATE xx). The suggestion of highlights is quite consistent and indicates a window over our shoulder to the right. But he plays fast and loose with his shadows, putting them in if he wants to, leaving them out if they do not serve his composition. The same with the reflected lights.

In short, light and shade may be an enveloping organizing principle and an enveloping type in the recognition of which a large part of the delight of the painting consists, or again it may be merely a casual depth cue to round out the shape of some object, merely one element among others in the picture, like a color contrast or a line movement contributing its mite to the value of the whole.

Part Four

THE VISUAL ARTS

Part Four

THE VISUAL ARTS

C H A P T E R 12

PAINTING

Painting Techniques

WE ARE now in a position to study the visual arts themselves. We have in Parts I and II examined the general principles having to do with basic psychological laws and the organization of a work of art, and in Part III we described the visual materials capable of being organized. Now in Part IV we shall see some of the characteristic ways in which these materials actually are organized in concrete works of art in painting, sculpture, and architecture.

In practice, the fine arts are, as we found in Chapter 7, distinguished by their techniques. Accordingly, we may distinguish the art of painting as *the aesthetic art defined by the techniques of applying marks to smooth surfaces.* It is generally assumed that painting is not an applied art — not primarily serving some utilitarian purpose such as printing or bookbinding. However, if the painting techniques stand out ahead of the utilitarian techniques, the works are still considered painting — as in manuscript illumination and wall painting. By " aesthetic art" I mean the skilled production of objects so created as to become things liked for themselves.

Painting is really a whole nest of skills, for there are many techniques of applying marks to surfaces for the pure delight of it. There are pencil drawing, pen and ink, charcoal, sumi, pastel, water color, oil, tempera, fresco, mosaic, stained glass. There are also etching, lithograph, wood block, engraving, and the like, often distinguished as the graphic arts. There is also photography, which has acquired an aesthetic life all its own. Each of these is a separate art in terms of its materials and of the techniques that grow out of them. Individual painters have their preferences for one or a number. A painter may even invent a technique, or virtually invent one by his own particular mode of handling his instruments.

If there were time to go into the potentialities of each of these techniques, it would be very much worth the trouble. For there is a great deal of truth in the maxim that a successful work of art is one that grows out of its materials. Physical materials make certain demands upon aesthetic materials. Some of the de-

mands are obvious enough, others delicate and subtle. For physical materials like paper and crayon or canvas and oil have special capacities of sensuous effect in terms of the aesthetic materials they evoke of line, mass, color, and volume, and the organization of these in pattern and design. These demands develop into types of technique and a spectator who has got the feel of them can derive a great delight in the recognition of their fulfillment.

So, these techniques are worth studying. Reading about them will do something. Working out the artist's methods and inferring his intentions in the picture itself is better. Practice in the technique itself, so as actually to feel the resistance and the pull of the physical materials, is best of all.

Just to have a little idea of these techniques, let us consider the potentialities of a few of them. Begin with the two pencil drawings by Picasso (PLATE IXB) and Seurat (PLATE IXA), for we have all used pencils. Picasso chose a hard pencil on a smooth paper to make the most of the wire line that a hard pencil can draw. Seurat worked with a soft pencil on a granular surface which invites effects of mass and a texture quality of gray. But no pencil can give the flow and ease of the Oriental sumi (or, as some call it, India ink) applied with a flexible badger hair brush (cf. PLATE IV). No technique can rival sumi for suggesting movement along a line or for dexterity of gradations of gray and accents of black and white.

Water color among Occidental techniques resembles most closely the Oriental sumi but invites brilliance and variety of hues, whereas sumi is monochromatic. Water color is a lyric sort of painting. It normally has to be done in one sitting. The theme of the picture may have been done over and over again by the artist, so that he knows just what he wants to do. But the final painting may well have been done in a very few minutes. A labored water color is almost inconceivable — I say "almost" only because such generalizations are so often shattered by genuine exceptions, in this instance possibly by some miniatures in water color. But ordinarily spontaneity is the very essence of water color. There are no water colors among our illustrations, but the Matisse (PLATE XX) is painted in the spirit of a water color. It is spontaneous, and clear, and swift. Each stroke is left as it was put on. In water color there can be no corrections. But Matisse evidently wanted for this painting a greater weight and impact than water color would have given. So, he chose oil.

Oil is the heaviest of painting techniques. It is slow to dry, and consequently invites continued painting. An artist may be many weeks or years on an oil painting. It admits of a great deal of correction and working over without ill effect. Most of the paintings reproduced here are oils. And their diversity of treatment shows what a wide range of use there is even for a single medium. Compare the Matisse (PLATE XX), the Renoir (PLATE II), the Picasso (PLATE XIX), the Tintoretto (PLATE V), and the Velasquez (PLATE VI). These are all different

ways of using oil and amount to so many distinct subtechniques. But they all
have the common characteristic of a heavy viscous pigment even when painted
rather thin, a pigment that can be moved about and almost modeled on the
canvas. In what is called " impasto " the pigment is actually applied in lumps.
Some painters apply it with a palette knife, or even with the thumb. The effects
of Van Gogh's heavy brush strokes are familiar to everyone. Only oil could be
used in this way. But oil can also be used in transparent glazes thinly as was
done by the Venetians. A succession of thin glazes applied one above the other
gives a depth of hue as if the color came from way inside, and produces a reso-
nance of color quality peculiar to this use of the medium.

Tempera, even more than oil, is a deliberate sort of technique. But it has not
the flexibility of oil. The pigment cannot be manipulated on the surface. Tem-
pera is ordinarily applied to a carefully prepared white gesso ground. The pig-
ment is mixed with yolk of egg, and dries quickly, and corrections are difficult.
It requires the complete planning of a picture ahead. In oil, a picture can grow
under the brush. Tempera invites simple areas of color and simplicity in model-
ing. The Fra Angelico (PLATE I) is a typical tempera painting. It calls for a
sort of craftsmanship like that of an expert cabinet maker. Consequently gold
leaf goes well with it.

These examples may give some idea of the effect of a medium on a painting
and of the sort of delight that comes from seeing the fitness of a medium for
the aesthetic organization that develops out of it.

The art of painting is enormously varied. Still, for the sharpening of our dis-
criminations in this field, three sets of traits may be singled out for particular
attention. They are (1) the concept of the picture plane and its implications,
(2) modes of pictorial representation, (3) modes of pictorial organization of
materials abstracted from any associative references — the so-called plastic
values.

The first of these traits was taken up in the last chapter. For there a discus-
sion of volume led inevitably to a discussion of the representation of volume,
and this led to the description of perspectives, the picture box, and the picture
plane. These features are peculiar to the art of painting and accordingly most
of the last chapter concerned painting. Moreover, it was a crucial topic for this
art.

A thorough understanding of the function of the picture plane is probably
the quickest way of getting the sense of what constitutes a picture. No other
art has a picture plane, nor a represented volume behind it, nor represented
perspectives to interpret a spatial order within that volume. All of these things
are thoroughly pictorial. Only sculpture in relief has a trace of these things,
and only because relief sculpture is semipictorial. Had we been minded to define
painting as the art which develops the picture plane, that definition would have

been entirely adequate. We may say, then, that the first of the three character-
istic traits of painting was the main subject of the preceding chapter. It remains
for this chapter, then, to describe the other two sets of traits chosen: namely,
the modes of representation peculiar to painting and the "plastic values."

Modes of Pictorial Representation

VISUAL REPRESENTATION IN PAINTING. Representation is a trait shared with
other arts besides painting. The novel and the drama are also representative arts.
But the peculiarity of pictorial representation is that it has to be absolutely
specific about its mode of representing the visual appearance of things. A
painter is forced to declare himself as to just the manner in which nature really
appears to him, or, at least, in which he wishes it to appear to the spectator. For
the painter has to put actual shapes on flat surfaces. He cannot leave the per-
spective to the eye of the spectator as a theatrical director can who (apart from
some painted scenery) deals with actual bodies in the actual volume of a stage.
In what perspective the spectator perceives the characters on the stage is no-
body's concern. But a painter must commit himself. There on the paper he
must put down certain shapes, and these must be either in photographic conical
perspective, or in some readily understandable compromise perspective, and, as
shown earlier, he generally chooses the latter. His realism is thus generally
openly conventional. Similarly with his colors and everything else he puts on
paper so far as he intends his picture to be a representation of the scene he per-
ceives. It follows that there are many modes of pictorial representation all
equally legitimate.

In the present decade we are in a relatively nonrepresentational period of
painting. Our modern bias, however, must not blind us to the fact that in one
sense or another the great mass of painting through the ages has been over-
whelmingly representative. Strictly nonrepresentational painting is very rare
even in our own time. Some suggestion of natural objects is almost always pres-
ent. In much of our modern art these suggestions are literally only suggestive (as
probably in the Matisse, PLATE XX). But it is unwise to conclude when looking
at pictures from other times and cultures that shapes of natural objects which
seem to us only suggestive were not intended by their painters to be highly rep-
resentative. The line between mere suggestion and actual representation of
things perceived is a hard one to draw. I am not going to try to draw it. But
wherever a picture appears to illuminate a natural scene with perceptive detail,
I shall assume that it is representative, and reveals the artist's perception of that
scene, and communicates that perception to any spectator who understands the
idiom.

I shall now point out and describe some typical samples of these idioms or

modes of perception. In a way each new school, style or period of representative painting exemplifies a new way of perceiving nature. There is more than a little truth in Oscar Wilde's quip that nature imitates art. A perceptive artist, Constable, or Monet, or Cézanne, shows us specifically by his determinate shapes and colors what to discriminate in nature and how. A whole generation follows in the perceptions of this artist. In this manner a style of representative painting comes into being. If the style is widely appreciated, a large public also sees nature with the eyes of this painter, and enjoys it as he enjoyed it. So, the more ways in which we can see nature and enjoy it as sensitive artists have seen it and enjoyed it, the wider our range of enjoyment not only in the pictures of the painter, but in nature itself.

It is a fact, however, that the painters themselves are not usually very tolerant of one another's modes of perception. Each painter, as a rule, maintains that his perception is *the* perception of nature, the one and only. The attitude is perhaps necessary for most creative painters. In order to achieve the superlative excellence they seek in depicting nature as they see it, they perhaps need the utter conviction and intensity of drive which only a dogmatic faith in the supreme truth of their outlook can supply some men. But this is also why few artists are reliable critics outside their own style of painting. Surely it is not an attitude to be emulated by those of us who are not artists. For it is open to us to spread our enjoyment much more widely. Those of us who are not artists have no excuse for dogmatism of taste. (Possibly dogmatic artists have none either; but let's excuse them anyway!) For to be dogmatic in our perceptions is to shut ourselves off from an enormous amount of enjoyment in the perceptions of other men and other cultures, and from an enormous amount of true understanding of the world in which we live.

If any philosophers happen to have read this far in this book, let me suggest to them that right at this spot is an opportunity for them to ponder over one of the most revealing object lessons in dogmatism within the range of human experience. We hear in philosophy much about dogmatism of creed and theory, and most philosophers today are aware of the dangers of dogmatism in these spheres. But there are still many philosophers who think that our immediate perceptions do not distort or deceive. As these philosophers perceive colors, and lines, and shapes, so they believe these sensuous materials are in fact given — given as data, sense data, data of immediate experience, or whatever they may call them, on whose firm and immutable foundations theories of perception or of the world structure can be reliably built. But philosophers are not usually painters, and have never ventured to depict specifically what these sense data are which they maintain are so basic and certain in fact as to lie beyond controversy.

I am suggesting that all philosophers who put a claim of certainty on such

sense data are behaving like the artists of a school who put a claim of supreme truth on some particular mode of representation. So, I invite philosophers particularly to reflect upon the material of the sections ahead. For there we shall observe painters being specific about sense data. And traditionally, as we have just said, most painters have made as dogmatic claims for the certainty of their perceptions as traditionally most philosophers have for the certainty of their impressions, sensations, sense data, and perceptions. And as in painting we gain in the understanding of nature by relaxing our dogmatisms and our provincial certainties, and considering the insights of all these sensitive perceivers of nature, so also in philosophy.

I now proceed to describe a few samples of painters' modes of perception. These are only samples and intended only to lead people into the way of becoming susceptible to artists' perceptions however strange and varied they may seem.

THROUGH-THE-WINDOW OBJECT REALISM. Let us begin with one of the commonest man-on-the-street conceptions of painting. The idea is that a picture is the representation of just exactly the objects a person sees in front of him. To be sure, there is the limitation of what one can get inside a picture frame, that is, inside the rectangle of a canvas or of a sheet of paper. This limitation is like that of a window or door frame. So a picture is like a painting of what you can see out of a window, or through a door.

Now what you see out of a window is a variety of objects. You see trees, houses, men, women, and children, and their clothes and ornaments. Every one of these can be painted by a competent painter. Here is the canvas. There is the window. The artist transfers to the canvas object by object what he perceives out the window. The picture corresponds item for item with the things seen through an imaginary window frame. The school of Van Eyck paints very much in this manner. Take a Van Eyck picture, say of a Madonna sitting on a throne with her child on her lap, a niche on the right with a vase in it, a leaded window on the left, a Persian runner on the tiled floor in front of the throne. Every one of these objects is painted with the most meticulous care — every tile, every motive on the rug, every pearl on the edge of the Madonna's velvet robe, almost every hair in her tresses. The artist turns his attention to each one of these objects in turn, looks at it carefully and paints it, and models it, and, if its texture permits, puts a highlight on it.

It is unquestionably an extremely realistic sort of painting. There is a danger connected with it, however, and that is that with so many different objects to depict the picture may become confused and ununified. To compensate for this danger, which Van Eyck was clearly aware of, he saw to it that the objects before him were arranged within the strongest organizing patterns available to vision. Most of his pictures are very nearly symmetrical in arrangement, and

often there is a skeletal organizing triangle besides, which draws together all the inner details of the subject. A certain stiffness of composition is, consequently, to be expected, or else a subject artificially arranged so as to contain only as many objects as the attention can take in.

Most fifteenth-century painting in Europe was in this mode of realism. Fra Angelico (PLATE I) could be regarded as a borderline example. In so far as he is realistic, his realism is of this mode. Notice how each object is painted with a concentrated attention, whether it is the Madonna's hand or a tassel of the cushion. He models each object separately. There are few shadows, and these are not permitted to conceal any details of objects within them. There is the characteristic formality of organization to avoid possible confusion. The composition is nearly symmetrical, and the Madonna and child are framed in a triangular shape. Moreover, the subject is artificially arranged so that there are very few objects to fill the attention.

The only reason I call him a borderline example is that Fra Angelico simplifies many of his forms in a way an object realist like Jan van Eyck would not. You feel Van Eyck loved detail, wanted to get in every object with every wrinkle, thread, and jewel, and that he sought out details to paint, multiplying objects rather than eliminating them, whatever it might require in formality of organizing pattern to hold so much material together. Fra Angelico was only a realist incidentally. He was primarily a painter of emotion. Consequently, he was willing to select and simplify in the service of emotional intensity. And consequently he almost equally exemplifies the next mode of realism.

SELECTIVE REALISM. The selective realist looks upon the object realist as rather childish. Nobody, he says, can ever see every object out in front of him. We see what we are interested in. We select from the thousands of objects we might look at within the sweep of our vision just those that our interests at the time pick out. So, if we really want to paint what we see we must paint what comes into our visual attention, and leave out the rest. Real visual realism is a discriminating realism. It discriminates what one sees in a single vivid perception of a scene. What stands out in a single perception may be composed of only three or four objects. Then just paint these objects and suppress or leave out the rest. Only such a painting will be a truthful representation of what one perceives.

For consistency in this mode of realism there are no men to rival certain of the Oriental painters. Our illustration of a Chinese painting (PLATE IV) is an excellent example. Here is a horse, and a man, and a tree. That is all, the rest of the picture is blank. In the intensity of this perception only these objects were seen. True to this perception, only these objects are depicted.

Furthermore, this Chinese artist is not burdened with an organizational problem. Since he paints truthfully only what the attention grasps (what falls

within a single attention span, here *three* objects only), obviously the attention will easily grasp what he has painted. He can then give his mind to the most lively disposition of these objects within his format. He can safely present them to us in an emphatically unbalanced composition (remember our discussion in Chap. 4, pp. 83–84) that has a freshness which no Occidental object realist would dare risk.

A great deal of Occidental painting also is in the mode of selective realism, though not often carried through to the extreme of consistency — to the limit of the single attentive grasp. Tintoretto's *Christ at the Sea of Galilee* (PLATE V) is typical of Occidental selective realism. The picture contains much more than can be taken in at a single perception. Yet there is a great deal of selection. The foreground apart from the figure of Christ is treated very broadly. The growth on the bank and the foliage of the trees are just suggested. Advantage is taken of shadows and of the effects of aerial perspective to obliterate details. Essentially two objects stand out in the picture — the boat in distress out in the sea and the figure of Christ. All other objects are kept relatively low in interest or eliminated.

Daumier's *Theater* (PLATE VII) is another good example of the Occidental way of handling selective realism. What stands out is the scene on the stage and five or six tense faces in the foreground. Even the scene on the stage is reduced to the bare attitudes of the characters, so as to draw the attention back to the faces. All else in the picture is eliminated by heavy shadows.

This use of shadows by Occidental selective realists is worth noticing. One of the characteristics of typical object realism is the lack of shadows, or the sparing use of them. For shadows really do conceal details, and so have to be suppressed by the object realist who wants to get in all the details. But the selective realist welcomes them. They afford an inconspicuous way by which he can eliminate quantities of objects without seeming to do so deliberately. Rembrandt, of course, offers an outstanding example of a painter who habitually selects what he shall paint or reject in a scene by his manipulation of light and shadow.

LIGHT-AND-SHADE REALISM. Selection by the use of light and shadow leads over to the idea that the true way to depict what the eye sees is to paint the way light falls on objects and is reflected to the eye. Emphasis on this phase of perception produces what we shall call the light-and-shade realist. He argues that actual visual perception is what comes to the eye. It is the illumination of the visual scene. So he undertakes to paint the exact color values of the objects before him. This is the realism of Vermeer and of all who are of his school or have been much influenced by him. The source of the beauty of this sort of painting we had occasion to point out in the last chapter. Here we merely add that it is one of the modes of visual realism. In Vermeer's hands, it produces one of the most complete and consistent types of realism in the history of art.

It is a paradox of the pursuit of realism that every revolt from object realism on the ground that the new idea gives "realer" realism than that of a correspondence, detail by detail, of the objects on the canvas with the objects in the scene outside, gains its aesthetic success not primarily on the plausibility of its argument for realism, but on quite a different basis. Each of these new modes of realism turns out to be also a new mode of unity for pictorial composition. We noticed the freedom of composition the selective realist achieved in comparison with the object realist. Something similar comes out in light-and-shade realism. The gain is not essentially in greater freedom. Light-and-shade realism is very demanding, and encourages very detailed observation. The gain is derived from the permeating consistency of illumination which endows every part of a picture such as Vermeer's with a unique integrative unity. This mode of realism directly creates this mode of unity. Without that happy alliance of perceptive truth with an aesthetic unity, light-and-shade realism would never have had the aesthetic attraction it has repeatedly attained. Here, as in other modes of realism, an accompanying formal principle had great influence.

FOCUS-AND-FRINGE REALISM. If visual realism is seriously to be regarded as truth to the image on the retina of the eye, then it can be argued that light-and-shade realism is partially repeating the error of object realism. For Vermeer studies the colors and the light on each object before him with attentive care.

He is painting, says our new kind of realist freshly aware of the focus-and-fringe principle, not one picture but many. He is painting as many pictures as there are objects he separately focuses his eyes upon. And he mixes all these separate visual views together into one conglomerate canvas. The result is a network of inconsistencies. For, says the focus-and-fringe realist, the actual image perceived on the retina, as anyone can observe who focuses on any object in his visual field, consists of a clear image of the object focused upon in the middle of the field, and a fringe of increasing blurredness toward the edges. Real visual realism would, accordingly, call for a picture with a clear center of vision at the center of interest and a shading off to less and less clarity of detail toward the edges. Says the focus-and-fringe realist, we achieve by this means the unity of selection that is so desirable and at the same time there is no arbitrariness of selection such as occurs in selective realism, which is based only on subjective interest. We simply record on the canvas what truly appears upon the eye in any single visual perception.

Velasquez is said to have been the first painter to compose pictures in this manner deliberately. A portrait of the Infanta, for instance, depicts the girl's head in great detail, but renders the dress and background in a relatively sketchy fashion. Unconsciously, the same has been done by many portrait painters before. Titian and Tintoretto often paint virtually a focus-and-fringe picture. *Christ at the Sea of Galilee* might almost illustrate this type of realism, too, for

there is a strong focus on the ship and the picture is relatively blurred at the edges. But there is also a focus on the figure of Christ, so that this is not a fully consistent example.

The unifying power of this mode of composition is obvious. It amounts to a gradational convergence of detail and interest from the edges of a picture to the center as a climax. Perhaps its obviousness is the reason it is not used more frequently.

FRINGE REALISM OR IMPRESSIONISM. Strangely enough a much less easily understandable realism has achieved much greater popularity. What is known as impressionism is virtually a painting of the fringe without any focus. Says the impressionist, we should paint only what stimulates the eye. Light stimulates the eye. Therefore, a picture that is true to the sources of stimulation should seek to paint the pattern of the light that impinges on the retina. So far as possible, all influences of the mind should be kept out, such as classifications of objects as types of things, as trees or animals or men. According to this mode of realism, an object is just a set of reflecting surfaces for light. Whether it is a reddish rock, or a tuft of green grass, or a yellow cow, or a pinkish human back — they are all the same — all surfaces reflecting light.

These impressionists, of whom Renoir was one, though probably Monet and Seurat carried it through most consistently, made a careful study of light, particularly in its complicated out-of-door relationships. They tried to eliminate the mental preconceptions of what the color of an object should be. For the mind is a great neutralizer of colors. Even so plain a thing as a blue shadow cast by a tree on a sunny day cannot be seen by some people. They will look straight at it and call it gray. The leaves of the tree they will call green, though some of the leaves are yellow in the sun, and some blue in the shade, and many vibrate with reflected lights. Even the impressionists' trained eyes had difficulties in shutting off the mind, and they devised many tricks, such as squinting, looking at a scene upside down, or glancing quickly across an object so that the colors would speak before the mind could classify the object and predetermine its hue. What they learned they put on canvas. They painted in small brush strokes of different colors. The surface of the object was thus broken up into a lot of little color areas. The color effect of the total surface was the resultant on the eye of the effects of all these little areas. The background of Renoir's *Mme. Charpentier* gives a good idea of this technique. Look also at the little girls' light blue dresses which consist of lots of little strokes of various shades of blue intermixed with strokes of white. The visual resultant is the vibrant light blue we see.

There is no question that perceptible nature has the colors the impressionists discovered, and that a new and genuine mode of realism was developed. Yet the appeal of impressionism was probably due very largely to the new possibili-

ties of gradational color organization which emerged from their manner of painting.

DYNAMIC REALISM. The fringe realism of the nineteenth-century impressionists presently produced a reaction. It was headed by one of their own number, who never abandoned the impressionists' technique of handling color. But he revolted against the atmospheric insubstantiality of their method. This man was Cézanne. He said through his pictures and often in words: " Nature is not really as thin and static as the impressionists paint it. It is not merely a film of colors, however beautiful. What we perceive in nature is dynamic, solid things."

Cézanne retained, however, the impressionists' impersonality of outlook toward the stimuli of perception. Be it a man, or an apple, or a tablecloth, these are but so many three-dimensional masses in the three-dimensional volume of an illuminated space. A pure impressionist perceived only the multicolored surfaces of things — or better say " multicolored surfaces," period. For, argues the impressionist, pure perception of nature is purely the image on the retina. This image is the flat juxtaposition of many simultaneous color stimuli, and in this image there are no distinctions of things (no lines either, for lines, too, we know are acquired by the learning of movements and of " local signs "). So, a pure impressionist picture is, in correspondence with the pure retinal perception, a juxtaposition of many colors, flat, unconcerned with the distinctions of things, and devoid of lines.

In contrast, Cézanne breaks through the flatness of the impressionists' retinal image, brings back line, particularly in its action, as a three-dimensional linear framework for three-dimensional mass, stresses line movement and all the kinesthetic tensions of lines and planes and masses. He perceives nature as dynamic. It is full of *things*, resting on one another, leaning toward or away from one another. And yet he still resembles the impressionist in the impersonality of his perceptions. There were no " things," as we said, in the pure multicolored retinal perceptions of the impressionists. The haystacks or lily ponds of Monet are but reflecting surfaces for colors. In a mature Cézanne there are indeed plenty of " things." But Cézanne's " things " are as impersonal as the impressionists' reflecting surfaces. They are not animate things nor even kinds of things. They are just things, solid masses with dynamic tensions.

I am, of course, exaggerating. But the exaggeration is very near the truth about Cézanne's mode of perception — and that of his school. Cézanne paints a portrait of a man with folded arms (cf. E. Loran, *Cézanne's Composition*, Pl. XIX). The solidity of the head and body, the cylinders of the arms, the movement and tensions of overlapping and tipped planes are studiously perceived and recorded. But at the same time the depth and seriousness of Cézanne's dynamic discriminations working over this subject bring into being almost surprisingly a human character. Why, it dawns upon us, this is indeed a

man (as well as a "thing") with such a nose, and ear, and mouth, and over-hanging eyebrows, and thick neck, and somewhat stooping shoulders, and large hands — a sober man, thoughtful, and perhaps a little suspicious of the world. As Loran says, it is a fine portrait, "a revelation of human character that brings Rembrandt to mind."

Or turn to our own reproduction of the *Maison Maria* (PLATE VIIIA). This is also clearly a portrait, a portrait of a house. I believe any who have learned to fol-low Cézanne's idiom of painting will agree that Cézanne's picture is a better, more deeply discriminated characterization of the house than the photograph. But here, too, as with Cézanne's portraits of men, I feel the depth of characteri-zation does not come so much from Cézanne's desire to get at the personality of his subject as from the intensity of his realistic perception of solid things. In all his consciousness he was painting just another *thing*. But in the zeal of his realism, in his eagerness to record just the dynamic forms of that thing before him as he actually perceived these forms, he brought to life as a by-product a deeply probing portrait of a house.

So I find a great difference between a Rembrandt and a Cézanne. Rembrandt paints a man or a house. Cézanne paints a thing which turns out to portray a man or a house because he painted the dynamic forms of this thing so faith-fully.

Dynamic realism, then, is primarily the perception of the linear forms, ten-sions, and masses of things. It is primarily a painting of things, not of objects as the mind conceives them in terms of natural types. To an object realist like Van Eyck there would be nothing realistic about Cézanne's *Maison Maria*. Really, you can hardly tell a tree from a bush, or a roof from a mountain! There is just a hodge-podge of shapes. Yet Cézanne tells us that he is painting nature, as nearly as he can, just as he sees it. And hundreds have followed him in his perceptions. Anyone who wishes to get the delight from the tensions of intervals and balancings of the three-dimensional masses of nature that is available through such pictures would do well to adapt himself to this dynamic mode of perceiving.

DREAM-WORLD REALISM. Any survey of pictorial realism would not be complete without calling attention to the realism of phantasy. This mode of realism has had many glimmerings in the past but has only come into full illumination in modern times. In the psychologies of the past there was nothing so unreal as a dream. But in the psychology of today, a dream is a part of nature. The truth-ful representation of the dream world is now recognized to be just as realistic as the truthful representation of a rural landscape. In fact, we now know that our dreams permeate all our perceptions, if we but depict literally all that goes on behind the eye as well as what barely stimulates the eye to action. Even a rural landscape literally depicted as some naive artist thought he saw it is, says

the dream-world realist, actually the depiction of a dream. Why did the artist pause to paint this peaceful meadow, those undulating hills, those flocks on green Arcadian pastures? Was not this landscape that artist's dream? Would not another artist interpret the same landscape quite differently? Indeed, there is no real realism, says the painter of inner vision, but that which paints our dreams. The previous forms of realism are simply selections from what goes on in our minds, picking out shapes which are imputed to a world outside and omitting all the other shapes that are actually passing at the same time within the theater of our mind. The dream-world realist takes his place deliberately inside his mind and paints what he sees there. What he sees may be entirely a dream with the doors to the outer world shut. Or it may be a picture of the outer world as seen from deep inside the mind. The thoughts, emotions, images which we habitually try to shove back out of sight, so as not to interfere with our normal perceptions, are now shoved forward to be seen mingling with these perceptions, as in truth they do if we do not inhibit them. On this basis, can you not see how a dream-world realist could plausibly regard his mode as the only real realism?

Picasso's *Absinthe Drinker* (PLATE XIX) is an example of this sort of realism. Picasso undoubtedly saw such a woman at a table in a café. He might have painted her impressionistically, or in the mode of object realism, doing his best to inhibit his emotions. But he chose to paint her as she appeared to his mind enveloped with the emotion he felt at the sight of her. How far her hunched over form is an image out of his mind, how far it is the attitude she took at the table, it would be hard to say. But that her attitude and the ghostly light about her was a vision that vividly rose before Picasso's mind, there can be no question. This picture too has a haunting realism.

SUMMARY. These types of realism have been arranged in a series that roughly follows a course from outer to inner vision. The series is very revealing of our modes of knowledge of the external world and of ourselves. We start from the naive idea of depicting objects just as they are supposed to be, and as they are supposed to look, out there in the world beyond our eyes. Then we notice that there is some action of the mind in selecting the objects we see in the outer world. Then we become aware of the systematic selection due to light-and-shade effects in the perception of external objects relative to the eye. Then the radical action of the structure of the eye in its focus-and-fringe effect is seen as controlling our visual perceptions. Next we realize that vision is simply the sensations on the retina of light rays from the outer world, and impressionism emerges. Then someone sees that the muscular tensions inside our bodies also enter our perceptions, and that these are projected into our retinal impressions, whence the dynamic realism of the Cézanne school. Finally, someone suggests that many other things go on within us and get projected into our perceptions,

and that, in fact, a whole inner dream world of images is available for representation. Here realism leaves the outer world entirely and depicts the events that go on completely behind the eye.

Every one of these stages exhibits a type of visual representation. If we understand the aims of the artist for each stage, and the demands of the type of representation employed, we have open to us the satisfaction of the fulfillment of type appropriate to each stage. Every one of these types is difficult to fulfill with distinction, so that excellence of fulfillment furnishes great pleasure when it is recognized. And except that some of these types are perhaps more comprehensive than others, they are all equally realistic modes of human perception.

It is true that, physiologically speaking, a representation combining conical perspective, light-and-shade effects corresponding as closely as one's pigment range will permit to photometric effects, and strict anatomical correctness of proportions, constitutes a sort of underlying center of reference for our realistic dealings with the objects of our environment. Photographs approximate this type of realism. But actually we rarely see things according to this mode of realism. Photographs often do not seem true even to us who are used to them — particularly where violent foreshortening occurs. And the object realist who leaves out the shadows comes closer to our usual practical mode of seeing an object than a light-and-shade realist. It is told that a primitive tribesman, seeing for the first time a shaded portrait, asked if the model was half Negro! A painter can report our actual perceptions much more faithfully than a camera.

What we may call physiological realism is a sort of scientific construct of laboratory experiments. It reports to us the cues on the retina of the eye from which we start in forming our perceptions of environmental objects. These cues are always with us in visual perception, because, of course, visual perception is always perception through the eye. But it requires special training to get a pure physiological perception, consisting only of retinal cues. Visual realism never gets entirely away from these cues — not even in dream-world realism — but neither does it make these cues an exclusive demand. That is why so many modes of visual realism are equally legitimate aesthetically — all equally sources for delight in the recognition of natural objects and scenes.[1]

Though we have passed rather rapidly through these stages of visual realism, they suffice to show the amount of aesthetic emphasis that has been placed on

[1] If one should ask me to classify the paintings illustrated in this book in terms of these seven types of realism (and, of course these seven are only samples and many more types would be differentiated in a history of painting), I'd say the Chinese painting was selective, the Cézanne dynamic, the Velasquez light-and-shade, the Daumier selective, the Tintoretto selective with some focus-and-fringe, the Picasso drawing selective, the Seurat drawing impressionistic, the Fra Angelico object realism but also selective, the Renoir selective but also impressionistic, the Picasso painting dream-world, the Matisse selective with a touch of dream-world but with its main interest appeal to abstract plastic values.

representation in painting throughout the ages. A representational painting should be enjoyed for its realism, whatever the mode. If a spectator fails to appreciate a realistic painting for the excellence of its realism he is missing a large part of its aesthetic value. It may seem strange that such a statement should have to be made. But recently there has been a reaction against realism in painting, and some respected critics have asked spectators to disregard the representational side of painting as something foreign to the aesthetic values of a picture. Of course, that point of view itself is the strange thing. It is as one-sided as the opposite point of view of some critics of the past, and of many laymen today, that the sole aesthetic value of a picture lies in its truth to nature.

Representation and the sensuous and formal appeals of a picture (which are coming to be known as its "plastic values") are both genuine sources of aesthetic delight. Sometimes one of these sources is emphasized more than the other. There are some purely abstract paintings of great beauty that contain no representational elements at all. And there are some realistic paintings (certain pictures of Thomas Eakins might serve as examples) which have almost no sense of composition and yet are beautiful from the sheer intensity of the artist's perception. But most great painting is excellent both in its plastic and in its representational values. We now turn to the subject of the "plastic values" in painting.

Plastic Values

By plastic values in the visual arts is meant the aesthetic satisfactions in everything that has to do with pattern and design applied to color, line, mass, and volume. In what is called "abstract" or "nonrepresentative" painting these values are regarded as the sole source of appeal. But in most painting these values are integrated with the representative values and the beauty of the work resides in both.

What these plastic values are specifically has been our main concern through most of the preceding chapters. Moreover, in dealing with color, line, mass, and so on I have chosen my illustrations mainly from painting, so that already this subject has been rather extensively dealt with. The thing that remains to be shown here is how these values are brought together and integrated in individual pictures.

There are, of course, many modes of integration. I might describe a selection of these as I have just done with the modes of representation. But I do not believe there is the same need to stress varieties of plastic integration as there was to stress the many varieties of equally legitimate representation. I shall instead restrict myself to one picture — to Renoir's *Mme. Charpentier and Her Children* (PLATE II) — which has already received a good deal of attention. I shall

gather together a number of elements of plastic significance and show how they are brought together in this one painting. At the same time I shall whenever advisable compare or contrast some of these elements with corresponding features in other paintings. The idea is that we may become fully aware of the convergence and interrelations of these values in at least one instance, so that we may have a clue as to how to discriminate them and enjoy them in the limitless variety of other instances with which generations of sensitive painters have provided us.

Let us begin by looking for the main patterns in the painting.

1. As our first plastic element, the picture clearly exhibits *balance* in relation to a vertical axis down the middle of the picture plane. This axis institutes tensions on either side, making demands for equal aesthetic weight on the opposite side. The balance in this picture is very complex without the least suggestion of symmetry. At the same time it avoids unbalance.

Balance, as we recall, lies between symmetry as one pole of an affective sequence and unbalance as the other (cf. p. 84). In all sorts of ways any suggestion of symmetry would have been inappropriate to this picture, but particularly in respect to the homeliness of the subject. For a contrast, compare this picture with Fra Angelico's *Madonna*, which appropriately approaches symmetry in its axial pattern. But neither is Renoir's picture unbalanced — like, for instance, the Chinese painting (PLATE IV). The intricacy of detail contained in Renoir's picture demanded a stronger axial pattern. The Chinese painter's extreme selectiveness of representation permitted a freedom of composition which Renoir could not have risked. Nevertheless, the balance in Renoir's picture is at the very edge of unbalance and very daring. With most of the interest on the left of the axis, and a nearly vacant foreground on the right, he, so to speak, brought back the balance at the last moment by means of the interest in the still life well in depth on the extreme right. Renoir got as near unbalance as he could, and a lot of the dynamic tension of the picture comes from this fact.

2. There is also for me in Renoir's picture a feeling of an *axis in depth*, such as Cézanne frequently employed for a unifying force in his compositions. For instance, in Cézanne's *Maison Maria* there is a clear sense of a movement and arrangement of masses around the central mass of the house. Up through this central mass I feel a vertical axis as the center of rotation of these movements, and as the center of reference for the arrangement of masses throughout the picture. Similarly, I feel the mother in Renoir's picture as a central mass generating a vertical axis in depth as a center of reference for the other masses throughout the picture. Renoir was never as deeply concerned with three-dimensional mass organization as Cézanne. But in this picture I feel he was achieving part of the organization of his masses by means of an axis in depth.

3. In connection with the organization of masses, we must not overlook the

piling-up principle for three-dimensional masses. We have already referred to the Cézanne and the Renoir (pp. 206–07) to illustrate this principle of plastic organization.

4. Next, let us consider the *organizing patterns*. These, we may recall, can be of two broad kinds — the skeletal (like the branching of a tree) and the embracing (like the structure of a regiment into company, platoon, and squad). Occidental and Far East painting tend to employ the skeletal organization. Persian painting tends to use the embracing. In painting these are essentially two-dimensional modes of organization operating on the picture plane, in the same manner as symmetry and balance.

There are two varieties of skeletal pattern, both linear in their structure. They can be contrasted as the closed and the open pattern. In the closed variety the basic organizing pattern (the spine or trunk of the system) is a closed form like a triangle or rectangle or oval or festoon (Fig. 49a). In the open variety, the basic organizing pattern is a single line or group of lines intersecting and free at one or both ends (Fig. 49b). The closed form is the simpler to grasp, the firmer in its organizing control, and the less interesting. Where there is need of a powerful organizing pattern, the closed form is likely to be used. Of all the closed forms, the upright triangle is the most stable and effective in unifying power. The apex of the triangle (or its center) makes a natural focus and climax for the composition. The spreading sides reach across the picture plane and easily gather in all the details. And the base pulls the whole system together.

The Fra Angelico *Madonna* offers a splendid illustration of the upright triangle as an organizing pattern. The Madonna's head is at the apex and the silhouette of her gown defines the base and sides. All the interior lines of her form

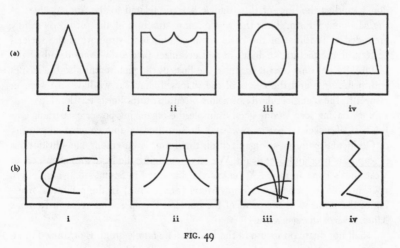

FIG. 49

are ordered by their relations to the primary lines of this triangle. The curves outlining her face and neck, the diagonals of her arms, and the horizontal curve of the child are secondary lines branching off the primary ones. Tertiary lines branch off the secondary ones, as, for instance, the folds of the sleeves — and

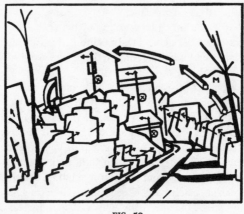

FIG. 50

so on. Moreover, the lines outside the triangle are also related to the triangle and may be felt as lines subsidiary to it. Thus the arc of the halo comes off the Madonna's shoulders and is concentric to the curves of her head. The folds of the gold curtain converge upon the figure of the Madonna. The blue angels in the upper corners develop a secondary triangle with the dominant blue Madonna, and so the lines of this triangle become related to the primary lines of the Madonna's form. Thus the whole linear structure of the picture is solidly grounded in the lines of the basic triangle. This total structure is the skeletal pattern of the picture. It draws in and organizes practically every detail of the picture, for not only does it organize the lines of the picture but also the shapes within the lines and the colors of the shapes. In fact, as we have just seen in respect to the blues, similarity of colors often institutes linear relationships.

Now, having seen in one good example the organizing power of a triangle as the base of a skeletal pattern, we shall be surprised to observe what a quantity of Occidental painting is organized on this form. Even among our illustrations it reappears over and over again. We see it outlining the head and shoulders of Velasquez's *Pope Innocent X* (PLATE VI), suggested in Seurat's drawing (PLATE IXA), utilized in Cézanne's *Maison Maria* (PLATE VIIIA) in the pyramidal massing of the forms with the point of the house at the apex, and again in Renoir's *Mme. Charpentier* (PLATE II).

I shall not dilate on its use in the Renoir. The family group is organized in an

upright triangle with the mother's head at the apex. The spectator can easily follow the skeletal structure developing from this form once he is made aware of it. The organization is not so rigid and all-inclusive as in the Fra Angelico, for Renoir has other organizing principles in reserve, but this is one of the important organizing forces in the picture.

For a more complex form of closed skeletal pattern, we may take Tintoretto's *Christ at the Sea of Galilee* (PLATE v). The principal organizing lines here are determined by the figure of Christ on the left and the trees on the right and a drooping curve connecting these uprights with the curve of the boat at the center, and (I feel) a base line connecting the feet of Christ with the foot of the trees. One of the examples in Fig. 49a gives the form. This picture approaches the open skeletal pattern, for the base line is not unequivocally presented. However, the essential feeling of the picture is for me that of the closed pattern.

For an example of the open skeletal pattern, look at the Chinese painting (PLATE IV). This is not as striking an example as most Chinese paintings would be, for we chose this example primarily to illustrate the charm of unbalance. But it does have a very simple open pattern — that of a single curve loose at the ends. Starting from the horse's neck, the curve swings through the trunk of the tree and out to the tips of the foliage above. The curve of the man under the tree may be felt as a strong secondary line in the basic pattern or as one of the primary lines. Clearly the pattern feeling of this painting is quite different from the Tintoretto and markedly contrasted with the Fra Angelico. The lines seem to open out into space rather than to enclose it.

Since the middle of the nineteenth century Occidental painting has been tending toward the use of open skeletal patterns, too. Whether this change is due to Japanese and Chinese influence, or to a freer and more selective mode of realism which invites open patterns, I shall not try to judge. The open skeletal patterns can easily be seen. Look at the composition of the Daumier, for instance (PLATE VII). This is not in the manner of the traditional Occidental composition. There is a strong diagonal from the lower right to the head of the standing man upper left. To be sure, there is a hint of the upright triangle in the organization of the foreground, but rather as a subsidiary than as a primary organizing pattern. Then there is the horizontal band of the illuminated stage intersecting the strong diagonal just below the standing man's head. The result is essentially an open pattern of two intersecting lines — a broad converging horizontal and a steep diagonal — quite Oriental in feeling. But, at the same time, the streak of white contains a whole picture of its own within it, and this is composed in a thoroughly Occidental manner. The three figures on the stage are all enclosed in a sort of parallelogram. The Daumier mingles open and closed skeletal patterns.

It happens that the Renoir does the same. For the most impressive line of composition in the Renoir is the powerful diagonal from lower left to upper right. This cuts right across the traditional triangle of the family group. The total skeletal pattern of the picture is a combination of the two varieties of skeletal patterns. The feeling of the picture reflects the mixture of solidity and freedom this combination affords.

For an illustration of an embracing pattern in painting I can point to the Matisse (PLATE xx). Matisse was strongly influenced by Persian miniature painting, which had developed an embracing pattern, probably on the analogy of the beautiful rug and ceramic designs for which the Near East is renowned. The description of the organizing pattern of the rug design (p. 76) may be recalled at this point. The embracing principle there consisted in the division of the rug into a number of areas not exceeding the grasp of attention, which areas were subdivided into lesser areas and so on down to the smallest details. Thus a basic space pattern embraced subordinate patterns and so on down.

If we look at the Matisse we shall see the same mode of organization. The picture, like a Persian rug, is divided into a small number of basic areas. I see this primary division as a pattern of five areas — the large red area upper left including the yellow jar and the green table, the purple area next it, the dark red area upper right, the long light area enclosing the reclining figure, and the thin red area lower right. These are not symmetrically arranged as in a rug, nor repetitive. But it is a division of the total space into an element pattern of five units easily grasped by the attention. The space organization of the Matisse is like rhythmical prose rather than verse.

Each unit of the primary element pattern is in turn subdivided. The thin red area at the bottom contains a roughly repetitive subordinate pattern consisting of a wide-narrow rhythm — five wide and four narrow. It can almost be taken in at one attention grasp. Each of these areas has its own interior treatment roughly repetitive of its corresponding repeat areas. Strict repetition is avoided here, as throughout the whole picture. The variation gives an impression of sketchiness or even of carelessness to the picture. The unwary spectator will possibly dismiss the painting as childish and technically deficient. The technique is, to be sure, swift and spontaneous. But it is so far from being technically deficient that if Matisse is ever to be criticized for his technique it is on the score of its virtuosity. One of the delights of his pictures is the feeling of repetition they induce without actual repetitiveness. So, in this red strip lower left one has the feeling of the repetitive pattern of the textile it represents, but actually one senses theme and variation. Hence our eye is constantly drawn back to the design, teased by the changes in color and shape.

If now we look at the white strip above, we see that this, too, like the red strip is a semirepetitive pattern (going from left to right), white-flesh-white-

flesh-white-flesh. (We ignore the fact, for the moment, that the pattern spreads over a woman.) There is in addition a grayish area above her head, and a greenish one below. In spite of these added complexities, the internal pattern of this total white area is easily taken in at a grasp. Of course, the shape of each of these areas is different, extremely interesting in itself, and internally subdivided on its own. For instance, the folds of the white cloth over her left shoulder make a semirepetitive pattern of four white stripes and five dark.

The spectator can easily follow similar modes of treatment in the three upper areas of the picture.

This sort of organization is clearly quite different from the skeletal organization of the pictures previously considered. Yet it does happen that there are fragments of embracing organization in the Renoir. The background of the Renoir, for instance, has much in common with the background of the Matisse. So also the patterning of the rug, the dog, the little girls' dresses.

Before leaving the Matisse, let me point out the theme-and-variations across these organizing areas. There are four themes running over the picture — the criss-cross, the dot, the stripe, and the half-circle. The criss-cross dominates the upper left area, and is softly echoed in the purple area. The dot stands out on the anklets, on the lower red strip, in the nipple, mouth, eyes, in the purple area, on the iris in the vase. The stripe, itself a variation of the criss-cross, appears in the rim of the jar, in the purple area, in the dull red area, in many variations in the white area, and in the lower right red area. The half-circle may be picked up first on the sides of the vase, then it appears on the table legs, in the red shape under the table, the white fold over the hips, and in nearly all the drapery folds, the anklets, the cheek and forehead, and several times in the jar, and in a number of other places. The variation of these motives by echoing one another bind the picture together, as also do the color repetitions of red, blue, purple, green, and yellow.

This combination of contrasting areas in an embracing organizing pattern with theme-and-variation working within and across these areas is an example of what we called "segregation" (p. 57). It is the operation of pattern and design merged into one principle of composition. It is the fundamental mode of organization in music. Consequently, this Matisse has much in common with music. It is a sort of music of line, mass, and color. There is, of course, a harmony of these elements in the Renoir, too. But the analogy to musical composition does not suggest itself there, because the organizing pattern of the Renoir is predominantly skeletal. A Persian rug is like music and architectural design has actually been called "frozen music." For these are segregative organizations based on an embracing pattern. The analogy is genuine because the basis of their composition is actually the same.

5. Next to organizing patterns, we must mention the principle of the *picture*

plane as one of the plastic values. We have already described the picture plane and the picture box that ordinarily develops behind it. The relation of the picture plane to pattern and design, however, has not been touched upon.

If the picture is purely or nearly two-dimensional there is no problem. For then the pattern of the picture spreads over the picture plane. The Chinese painting (PLATE IV), the Fra Angelico (PLATE I), and the Matisse (PLATE XX) are all relatively flat. The space depth in the Chinese painting is practically negligible — just a suggestion of a plane in depth extending under the seated man. To be sure, there is a sense of a mystical expanse infinitely receding into a vague distance. But this is a symbol the Chinese painter manages to induce as an emotional value of his large negative spaces. It is not, strictly speaking, a plastic value. No definite volume in depth is depicted with tensions of planes and masses, as in the Tintoretto (PLATE V). Quite the contrary. The sense of mystical infinity is without weight and formless. That is why I see the picture as unbalanced. To imagine into the open space on the left a vista with a horizon line and thus to balance the picture with the physical weight of a piece of represented Newtonian space, is for my feeling to destroy the emotional harmony of the picture. It would also destroy the plastic harmony, for it would push a hole of very deep space into the left side of the picture which is otherwise composed in very shallow space, if not quite flat. I see the picture as a two-dimensional composition barely suggesting a few depth cues, and maintaining a marvellous suspense of unbalance. The picture exhibits the highest sophistication of restraint and aesthetic tact. The artist seems to me scrupulously to be avoiding the disturbances of the third dimension, and to be holding his composition steadily forward on the picture plane.

The Fra Angelico and the Matisse are not quite so two-dimensional. They exploit a very shallow space, so shallow that the problem of relating a three-dimensional organization to a two-dimensional picture plane does not arise. The problem becomes very acute where deep space is depicted as in the Cézanne (PLATE VIIIA) and the Tintoretto (PLATE V).

The problem is how to relate the organization of masses and line movements in deep space to a pattern on the picture plane. If the picture is two-dimensional, there is, as we have seen, no problem. The whole composition is confined to the picture plane. But this solution would be at the sacrifice of the richness which depth can give. Theoretically, the problem could also be evaded by ignoring the picture plane and confining the composition to the organization of objects in depth. Practically, however, this cannot be done in a picture. The picture plane is insistent. It is defined by the frame of the picture. But, more important, certain patterns spontaneously develop there, particularly the two-dimensional axial patterns of symmetry, balance, and unbalance. A vertical

axis on the picture plane is almost inescapable. The balance of a picture is de-veloped on the picture plane even when some of the elements of balance are depth cues. A painter cannot escape a great deal of pattern and design on his picture plane. In short, organization of a picture in depth alone without any effects from visual elements on the picture plane is out of the question.

The painter's solution, then, becomes obvious. For the most highly integrated effects, he must consider his lines, shapes, masses, movements, colors, and so on in such a way that they function doubly. They must constitute a satisfying com-position in depth within the three-dimensional picture box. They must at the same time constitute a satisfying composition in relation to one another on the two-dimensional picture plane. In practice this means that forms in the back-ground depth of the picture will be deliberately related in design and pattern to forms in the foreground. In other words, the background will not be allowed to drift away into space. It will be tied into the foreground, so that background and foreground forms unite in a total satisfying pattern on the picture plane.

How is this tying in done? By many means. By the continuity of lines which bind forward and back forms together. By skeletal patterns. By theme-and-varia-tion, repetition of shapes forward and back. By colors echoing one another in different parts of the picture. Ultimately by the simple integrity of the total pattern on the picture plane which pulls every item of the picture together onto that plane.

The Cézanne, the Tintoretto, and the Renoir are fine examples in which to study this integrative result. In many contexts I have called attention to the con-tinuity of lines in the Renoir. Now observe their action is pulling all parts of the picture together onto the picture plane, whatever the depth that may be represented by these parts. See how the strong diagonal from lower left to upper right draws this whole row of objects up onto the picture plane (without deny-ing their recession in depth). See how the counterdiagonal of the curtain upper right repeated in the diagonal of the left arm of the mother, in the diagonal of the hair of the child on the sofa, in that of the face and arm of the child on the dog, in the nose of the dog and in many other places in this picture, bring all these together on the picture plane in an intimate contrast relation with the dominant diagonal first mentioned. See how the leftmost red stripe on the screen is brought forward by its continuance down the body of the girl on the dog. Then since this vertical red stripe is repeated in the background, and the leftmost stripe is drawn forward, so are the others, for they are all in one row. See how the repetition of the white bows on the children's shoulders repeated with variation in the white opening at the mother's breast, the white of her sleeve, and in the flounce of her skirt, draw all these together in a pattern on the picture plane, And, of course, the organizing skeletal pattern springing from

the triangle that enfolds the family group pulls that whole group with all its details out onto the picture plane. That is the way in which deep space is integrated with the picture plane.

Many very competent pictures which somehow lack in power and richness owe their weakness to lack of such integration as we have been observing in the Renoir. The spectator can see for himself the same sort of integration of deep space with a flat pattern on the picture plane in the Tintoretto and the Cézanne.

The photograph of Cézanne's subject (PLATE VIIIB) may now be looked at with a new eye. There are practically no integrative lines or repetitions in the photograph. The upright tree which almost continues the right vertical of the house window is about all. The background drifts away from the foreground. Beyond perhaps some pleasant associations with a country road, there is nothing to hold one's interest in the photograph. Yet Cézanne's *Maison Maria* is something the eye can wander over many times with increasing interest and a cumulative satisfaction.

Here we must rather arbitrarily stop enumerating the sources of plastic values, or, in other words, of the delights in the nonrepresentational elements of a picture. Almost everything we have said about the effects of line, color, and mass and the operation of the principles of pattern and design in pictorial composition goes into what is meant by the plastic values. There is no need for us to repeat ourselves. All that is needed is for us to see how these elements can be integrated within the limitations and the potentialities of a picture. Nowhere are these possibilities better illustrated than in the integration we have just been discussing of the composition of deep space with composition on the picture plane. For, as we emphasized earlier, the principle of the picture plane is a unique and defining feature of the art of painting.

Integration of Representative and Plastic Values

Before leaving our study of painting, I want to make sure I have not given the impression that there is some sort of inner opposition between the representative and the plastic values. On the contrary, each can enrich the other, and the two may be fully integrated one with the other. When a painting appeals to both of these sources of satisfaction, it should rather obviously be perceived and appreciated for both together. Moreover, a painting that exploits some type of representation will almost surely have its plastic qualities affected by this fact. What I mean is that a painting which includes representation should not be looked at from a purely plastic point of view. From a purely plastic point of view, for instance, the right lower corner of the Renoir might be considered lacking in interest. But this judgment comes from considering the family group

as just so many planes and volumes and colored shapes. Accord to these masses the intense interest they possess as representations of lovable human objects, and then the need of a neighboring restful area to compensate for all this concentration of interest becomes clear. The restful area is called for in the total integration of plastic and representative values.

Lastly, in stressing the role of representative and plastic values in painting, I do not wish to leave the impression that the emotional values are not equally important. There is a great deal of painting in which the representative and plastic values are definitely subordinated to the emotional. Picasso's *Absinthe Drinker* is obviously an example. Besides representational and plastic organization, there is also emotional organization. A number of pictures were used to exemplify modes of emotional organization in our chapter on that subject (Chap. 6). But emotions behave in much the same way in all the arts. I wish only for us to be reminded of this important fact. It is a fact to keep well before our minds equally in the arts that follow.

SCULPTURE

Sculptural Techniques

SCULPTURE is the aesthetic art defined by the technique of modeling. By modeling is meant the shaping of a single block or mass of material into a three-dimensional form. Modeling is contrasted with building, which is the putting together of a number of blocks or pieces of material. Some statues, to be sure, are made of several blocks, and a statue like the Statue of Liberty is really a building in the shape of a statue. The techniques overlap. But the fundamental difference is clear enough.

There are two main species of modeling — the subtractive and the additive. Subtractive modeling is that of the stonecutter and woodcarver. These men cut away the material from a block of stone or wood and gradually reveal the shape they seek. Additive modeling is that of the clay modeler who adds lumps of clay to a core of clay (or sometimes of wire or wood) and so works out to the shape he seeks. This shape of clay may then be glazed and baked, producing statues in terra cotta. Or molds may be taken from it, from which statues in various materials may be cast, notably in bronze.

The principal materials of sculpture are stone, wood, terra cotta, and bronze.

In sculpture more than in any other art the qualities of its physical materials enter deeply into its aesthetic character. There are some sculptors, particularly those who work directly in stone or wood, who love their materials as if these were personalities. They will collect pebbles and driftwood from the beach, weathered beams from old barns, branched shapes out of the woods, shells, eggs, pieces of metal. Sometimes they work these up into sculptured forms. Often they leave them around their premises as sources of inspiration, things they love to touch and look at.

Let us give a few moments' attention to the character of these four main traditional materials of sculpture. Stone is hard and brittle. It needs plenty of support. Consequently it invites a compact treatment on a firm base. But stone itself has many varieties. There is the extremely hard basalt and diorite. There is fine-grained marble, tough granite, and the more easily workable sandstone.

Each of these has different technical possibilities, and different sensuous and emotional overtones. Basalt from its blackness and hardness suggests something stern and sinister. Marble, however, has dignity without coldness. It is the choicest in feeling of all the traditional materials. Its fine grain, its pure color usually white or ivory, its crystalline sparkle, make it a material of rare sensuous charm. It is well suited to the sculptor's chisel, can be carried to the finest finish, is resistant enough to offer a challenge without demanding excessive patience. Granite has a coarser grain and a less ingratiating color. It suggests larger works and a rougher treatment. Sandstone from its very softness suggests relatively broad treatment, and invites more casual subjects that might seem frivolous in heavier materials.

Wood is lighter and softer and more welcoming than stone. Its grain affords a charm of texture quality and a challenge to the sculptor to utilize its lines in the modeling of the forms. Wood as much as stone requires a rather compact treatment, but it invites intricacy of carving, undercutting, concavities, and the like not so congenial to stone.

Terra cotta is emotionally, I feel, the most tender of sculptural materials. It is not surprising that Della Robbia selected this as his favorite medium for in any other material his subjects must have become excessively sentimental. Glazes on terra cotta provide it with unlimited variety and brilliance of color. A great deal of Chinese sculpture is in this medium, as is also a lot of ancient Peruvian sculpture. Here the line between sculpture and ceramics becomes very vague. And perhaps it occurs to us that in the shapes of Greek and Chinese vases we had a sort of abstract sculpture long before Brancusi. Terra cotta lends itself particularly to small things like the Greek and Chinese figurines.

Bronze, however, returns us to large-scale sculpture. This is the medium that invites open composition and dramatic subjects. Since the metal is generally cast hollow, and has great tensile strength, relatively little concern has to be given to support. Moreover, the metal emotionally suggests movement and activity. In bronze the sculptor does not have to contrive artificial supports for extended arms and legs. He can model a whole figure like Mercury resting on its toe. Thus marble and bronze, the two choicest materials of large-scale sculpture, are in strong contrast with each other. The one invites stability and quietness, the other activity and drama. Subjects intended for the one cannot be well translated into the other. Their very colors are opposed — the soft whiteness of marble as against the usual dark greenish patina of the bronze or its yellow glaring sheen.

Speaking of color, we usually think of sculpture as an art that works in the natural color of its materials. Even glazes on terra cotta may be regarded as natural to the medium through association with ceramics. However, a great deal of the world's sculpture has or once had a painted surface. Primitive wood carv-

ings are almost always painted. Most sculpture in wood probably has been painted in all times but the present. The Greeks painted their statues at least in part. Our modern idea of sculpture in the natural material is said to have originated in the Renaissance when sculptors imitated the remains of Greek and Roman statues which they admired, and which had lost their color through the wear of time. The ideal of unpainted sculpture is thus something of an accident. It may well be in our age an overrefined ideal. For there is a joyousness in color, and we may be taking the art too seriously. In smaller things or when the material is not too choice, we often' crave the lift of color. But for anyone who loves materials as most sculptors today do, the thought of covering a beautiful natural surface with pigment is repulsive.

Subjects Suitable for Sculpture

We have just been showing how deeply the qualities of physical materials enter into the enjoyment of sculpture. These materials have an effect also on the subjects open to sculpture. We do not think of this sort of restriction in painting. There may be questions about the emotional propriety of a pictorial subject, or as to the adequacy of its treatment, but it would never occur to us that some subjects are inappropriate to the medium itself. Yet there actually is such a limitation upon the subjects open to sculpture, and the principle of it is illuminating of the art. Moreover, once the principle is clearly seen in this art where it appears rather obviously, it may then be seen occasionally operating in other arts producing a certain disharmony which we may have felt but could not quite lay our hand on.

The principle is this, that the weight and cumbersomeness of sculptured materials, especially in the larger statues, imposes an obligation on the sculptor to make the subject of his statues important enough to justify the space they must occupy, and the effort to transport them and put them up. A statue must justify its boulder of rock, its block of wood, or the mass of metal it is made of.

Let me illustrate by an analogy. I am walking through the woods, and I see a pretty fern, or a colored leaf. I pick it up, and bring it home, and press it in a book to be enjoyed at some other time. On the same walk I see a lichened, moss-covered boulder. It is more beautiful than the fern or the leaf. But do I bring it home? It would take a derrick and two men to load it onto a truck. And when I got it home, where would I put it? No place in the house. No suitable place on the lawn, or even in the garden. A special place would have to be made for it. For all its beauty, it is not worth the trouble. The beauty is not sufficient to justify my treasuring it.

So, similarly, I see a painter's drawing. It is delightful. It is on a sheet of paper. I can put it in a portfolio at home or even frame it and hang it on the

wall. It does not take much room. So, I buy it. The same afternoon I see a rather attractive piece of sculpture. Apart from its being in stone, it has perhaps more beauty than the drawing I bought. But do I get it? No. It is too bulky. It would displace too many other things. It is not really worth its size. Moreover, these relations reflect back onto the piece of sculpture itself and neutralize its very beauty, may even turn it into something ugly, because its simple composition of lines and planes is not worthy of the weight of stone it was put into. On a sheet of paper it might well have been justified. Not on a fifty-pound boulder. Actually, it would not even have justified a five-foot canvas. It was only a five-inch conception.

That is to say, there is an appropriateness of subject to size of medium. When this balance is violated in a work of art, the effect is unfortunate. Now, nearly all sculpture is somewhat bulky, and most great sculpture is quite heavy. The aesthetic principle of justifying the medium is consequently one that hits this art with exceptional impact. Practically it means that the subject of a statue must be something of exceptional interest — something so intensely interesting that men will be willing to expend the effort to transport it and arrange a special spot where it may be seen to advantage.

Now the subject most interesting to man is man. Some of the higher animals which remind man of himself and are closely associated with him may also be added — horses, dogs, cats, bulls, lions, deer, panthers, and the like. Not long ago it was safe to say (and some critics did say) that the only suitable subject matter for sculpture was man and the higher animals. Plant forms and geometrical forms could be carved on architectural features, on capitals of columns and in friezes. But these were in the nature of architectural decoration and were not pure sculpture. They would not have been justified but for the fact that the material was serving another purpose, too, besides being material for a sculptured form. In the whole history of sculpture up to the twentieth century, the subject matter of sculpture (apart from its uses in the applied arts) was confined to the representation of man and the higher animals. And the reason we now see. These were the only subjects interesting enough to carry the burden of massive material that a sculptural subject must enliven.

But something strange, which earlier critics would have thought unbelievable, has happened in this century. A flourishing school of abstract or nonrepresentative sculpture has come into being. This astonishing development does not mean that the principle that a statue must justify its boulder no longer holds. It simply means that men have discovered such a capacity of interest in the tensions and relations of lines, planes, and volumes that an abstract composition can now equal in intensity of interest a representation of a man or a mountain lion. Not, of course, that great sculpture has not always exploited the plastic values. But until this generation, interest in these values has never been suffi-

cient to permit a sculptor to ignore representation altogether. It is still true that a piece of sculpture on account of its bulk demands more intensity of interest than is necessary in many good pictures. A sculptured abstraction must be particularly rich or intense. Most of them still have some reference to man and the higher animals. Nothing could be more intrinsically nonrepresentative than Brancusi's *Oiseau*, yet he calls the statue *Bird*, and infuses it with the spirit of a traditional sculptural subject. Duchamp-Villon's *Horse* reproduced here (PLATE XIVB) is also essentially nonrepresentative. But it unquestionably gains a good deal of its interest from symbolizing the movements of a rearing horse.

Needless to say nonrepresentative sculpture is not in any sense driving out the representative. It is simply a new source of sculptural interest.

The Sculptural Series from Lowest Relief to the Round

One of the best ways of getting into the nature of sculpture and learning its peculiarities of composition is to follow an imaginary development of the art from scratches on a wall to a free-standing statue in the round. By doing this we can also discover what are the similarities and differences between painting, sculpture in relief, and sculpture in the round.

FIRST STEP: SCRATCHES ON A WALL. Let us start with a blank wall. It may be the wall of a tomb or a cave, or the face of a cliff. It may be an ivory walrus tusk, or the inside of a shell. When a man picks up a sharp tool and scratches lines and shapes on such a surface, he has made the first step in sculpture. One does not quite know whether to call these scratched pictures painting or sculpture. Being only lines on a plane surface, they submit to all the laws of pictorial composition. But being incised lines cut into the third dimension, they are technically sculptural. Such incised pictures on the border line between painting and sculpture can be found highly developed on the walls of some Egyptian tombs, and on ivory tusks carved by Eskimos, and, in fact, the world over. Highly refined, very beautiful works have been made in this technique.

SECOND STEP: MODELING IN FROM THE INCISED LINE. The next step, however, yields unquestionable sculpture. This consists in modeling the form inwards from the incised line. Suppose the form outlined on the wall is a man's arm. The incised outline is cut into the surface to a certain depth — quarter of an inch or half an inch — then the shape of the arm is suggested by modeling in from the outline. The highest bulge of the modeled form will be at the level of the wall. The original forward plane of the wall remains on the surfaces between this modeled form and others. The protruding features of these forms will also be on the forward plane. Since the modeling is shallow, the prominent features of the forms will almost inevitably be close to this forward plane and will be

visually felt at that forward level. Take a face in profile. The nostril, forehead, eyebrow, cheek, ear, hair, and chin will all be in the forward plane. The eye will show as a slight indentation in this plane. The whole breadth of the face and all its prominent features will be felt as in this forward plane. Similarly for the whole figure. This is an extremely important sculptural feature to grasp. For it shows that, in the very nature of the technical process of modeling forward from an incised outline, all the prominent features of the composition lie in the forward plane close to the original plane of the wall surface. It turns out also that the gathering of all these features onto a single plane produces a unity of composition aesthetically most desirable.

There is a great deal of fine Egyptian wall-relief executed in the manner just described. The composition often includes dozens of human figures and quantities of other depicted objects, yet the whole is easily grasped. The unity comes in large part from the fact that all the prominent features are seen in one plane — the forward plane close to the original wall surface.

THIRD STEP: UNCOVERING THE REAR PLANE. Now the third step in our imaginary series comes when the material is cut away between the modeled figures to the depth of the relief. Then we have genuine relief sculpture. All the forms are now modeled forward from a *rear* plane. But it is important for unity of effect that the prominent features of the modeled forms should still be seen and felt as all on the forward plane. In such relief sculpture there are just two planes. The rear plane of the background, and the forward plane upon which all the objects of prominent interest are delineated. The rear plane is empty. It comprises the negative spaces of the composition. It is sculptured empty space. The desire to sink these negative spaces to the rear instead of leaving them as the uncut surfaces of the forward plane is probably due to the pressure of the figure-and-ground principle. For, as we have seen elsewhere, the ground always feels to the eye as if it lay behind the figure. The relief sculptor could hardly be expected to resist very long the demand of this figure-and-ground relationship that the ground between his figures should actually be behind them, and so to sink the negative spaces between his modeled forms back to the rear plane where we all feel they really belong. So it comes about that by far the greatest quantity of relief sculpture has its ground plane in the rear of its modeled figures.

FOURTH STEP: HIGH RELIEF. The next step is to increase the depth between the rear plane and the surface. Depending on the amount of this depth, arises the classification of relief structure into low, medium, and high relief. In very high relief some features such as a head or a hand may come out completely in the round. And here is where relief sculpture runs into its most serious dangers. For when many figures and forms are introduced into a piece of relief

sculpture, and the depth of relief is increased to provide space for them, then comes the danger of confusion, or of that which is just next to confusion, lack of emphasis and of directness of impact.

The sculptural solution of this problem, acquired from much experience, is to add to the planes in relief. Up to this point we have considered only two planes in a piece of relief sculpture — the empty rear plane and the forward plane on which all the features of interest are depicted. Now we encounter the situation in which there are so many features of interest to be depicted that they cannot all be successfully placed in the single forward plane. The solution is to add one or two or three intermediate planes between the forward plane and rear ground plane. Moreover, the ground plane does not need to be empty. Distant forms may be represented on the ground plane in very low relief. The point is that a plane, in this way of composing, acts as a grouping device, unifying all the features gathered into that plane. The series of planes thus becomes an organizing pattern in depth. Four or five planes are well within the attention grasp. They constitute an embracing pattern, ordering the multitude of details into a small number of groups.

Thus in a piece of relief sculpture so organized there will be low relief features visible on the rear or ground plane. Some inches in front of this will come the forward plane in which are gathered all the foreground features. Then at intervals of an inch or so back come, say, two intervening planes in which all the middle-distance features are gathered. No features of any importance are depicted in the spaces between these planes. The most prominent features of the composition are not necessarily on the forward plane. They may be in the second plane back. That is, the interest climax of the series may be not the forward plane but next to the forward plane.

Once this principle is grasped, we realize that the simple two-plane sculpture, consisting of an empty ground plane and an interesting forward plane, actually illustrated the principle too. It was an embracing organizing pattern of two elements, one of which acted as ground to the other. In other words, the organization of relief sculpture into an embracing system of planes is a characteristic aesthetic trait of this sort of sculpture. Rarely, if ever, is a composition in relief sculpture successfully organized without some recognition of the principle of planes in depth.

This fact inevitably suggests a comparison between composition in relief sculpture and in painting. These two arts have so much in common that one is tempted to ignore their differences. But it must now occur to us that we had no occasion to mention planes in depth as one of the organizing patterns of painting. Yet it is, as a matter of fact, sometimes used in landscape painting. Some landscapists compose with a definite view to foreground, middle distance, and background. The unifying effect is strong. There is nothing wrong in a

painter's using the principle. But, strangely enough, it tends to make a picture two-dimensional. Consequently, the principle is not adapted to three-dimensional pictorial composition. The reason is that with such a series of planes in a painting, each plane is parallel to the picture plane and tends to migrate forward onto the picture plane unless strong diagonals are introduced between these planes to force them back (by the cues for three-dimensional mass). That is to say, parallel planes in a picture seem paper-thin unless pushed apart by strong depth cues interposed between the planes. But then we develop a lot of interesting dynamic features *between* the planes, so that the planes then cease to perform the unifying function of gathering all the interesting features onto the planes as was intended. In short, if a series of receding planes is used as an organizing pattern in painting, the artist must resign himself to an essentially two-dimensional composition. The sculptor in relief is not bothered by this limitation because he is modeling in a three-dimensional material which contains plenty of depth cues. The planes can actually be seen cut back into the stone or wood, or modeled forward in the clay.

The forward plane in relief sculpture, however, has a dominant function over the others. For besides acting as a unit in an organizing pattern, it also performs the duties of the picture plane. It represents the surface of the wall or of the block of stone or wood. And just as the surface of a canvas can rarely be ignored with impunity, so with the surface of a wall with relief sculpture. At that surface the picture box begins and its imaginary volume extends back in depth. This plane maintains the psychical distance, separating the imaginary space of the composition from the real space out in front of it. It helps to hold the composition together in its imaginary volume.

In subtractive sculpture, the surface plane of the material is not likely to be ignored by the sculptor who chisels or carves his own composition into the wall or block. But in additive sculpture, in the modeling of clay for bronze plaques and the like, the rear plane may be the one of which the sculptor is the more conscious, since technically he is modeling his composition forward from that plane. But even here, he is likely to give his relief the effect of protruding into space, and not being self-contained, unless he works towards a forward picture plane, and establishes it strongly at the surface of his composition. In a plaque, this plane is often marked artificially by a sculptured molding around the edges, which acts like the surrounding wall of a stone relief, plainly showing the forward surface or picture plane of the composition.

Before leaving relief sculpture in our imaginary series from the scratch to the statue in the round I want to call attention to a statement Rodin once made: "Procession is the soul of bas relief" (quoted from Bruno Adriani, *The Problems of the Sculptor*, Nierendorf Gallery, New York, 1943, p. 78), which points to a mode of composition in relief sculpture rarely to be found in paint-

ing. A great many of the finest works in relief are architectural friezes, the carving of long horizontal strips. This use of relief leads to a unique compositional problem. It is often solved from the representational point of view by the principle of a procession. One inevitably thinks of the Parthenon frieze depicting the Panathenaic procession. But the same idea can be seen on Egyptian, Babylonian and Roman walls. It permits of an indefinite succession of figures and a directional movement. But the idea has a compositional aspect even more interesting. It permits human figures to count as elements in a roughly repetitive serial pattern. A procession can be organized like a border pattern. To emphasize this mode of organization the convention developed of keeping the heads of the figures all at about the same level. The rhythmic movement of these friezes when finely executed is one of the unique experiences sculpture can give. For the rhythm gathers up somehow the representative significance with the weight and size and massiveness of the material in which it is wrought.

FIFTH STEP: RELIEF IN THE ROUND. The next step in our imaginary series begins to depart from the wall. Here the figures that had been modeled in the wall step forward free from all support. They are statues in the round but they do not yet step quite away from the wall. They are composed with the wall still behind them. I am referring to the sculptural groups in the pediments of the façades of Greek temples, and quantities of similar sculptural compositions designed to be seen from one aspect only with a plane ground behind them. Many statues designed for niches would be of this sort. The famous sculptured groups from the pediments of the Parthenon and the temples of Aegina and Olympia were conceived in the spirit of relief sculpture. The spaces seen between the figures — the negative spaces — were not seen as empty air but as the rear plane of the composition, which was literally the wall of the temple within the angles of the roof behind the statues. The boundaries of this area acted as a frame for the composition just like the boundaries of the placque on which relief sculpture is made. And, as we said, even though the figures are in the round, still they are designed to be seen from the front only. In all these respects such sculpture is essentially relief sculpture in which the figures are modeled free from the rear plane, in order to obtain a certain emphasis in the forms which this depth affords. We might call such sculpture relief in the round.

Once the relation of such sculpture to relief sculpture proper is realized, we at once see the importance of maintaining a sense of successive planes in depth for these compositions as for all deep relief sculpture. The rear plane is there as the wall of the building. But our aesthetic demands for unified pattern and emphasis require also that the prominent features of the forms in these sculptural compositions fall into definite planes in depth just as with deep relief sculpture proper. Failure to abide by this principle of planes in depth accounts in part for the dullness of most nineteenth-century pediment sculpture in imita-

tion of the Greek. If you look at the remains of the pediment groups from the Parthenon with this principle of planes in mind, you cannot fail to see how nearly all the salient features of these statues fall into two planes. Similarly with the earlier Aegina and Olympia pediment groups. That is, these sculptures give me the feeling literally of the simple three-plane relief sculpture accompanied with the accident that the figures are carved free all the way around. I wonder if the sculptors of these pediments were not thinking in terms of their aesthetic experience with relief sculpture. And I wonder if their faithfulness to the principles of successful composition in relief is not one of the main reasons for the impact of these statues on those who have learned to appreciate them.

SIXTH STEP: THE FREE-STANDING STATUE AND ITS CIRCLE OF ASPECTS. The last step of our series is that in which the figures leave the walls that have supported them through all the previous stages, and come forth as free-standing statues in the round to be seen on all sides. Consequently, now the appropriate setting for them is on a pedestal, so that the spectator can walk all around them.

Several critical things happen when this last step is taken. One obviously is that a free-standing statue in the round has many aspects of view. A statue in the round should be a beautiful thing all the way around. No matter where you stand to look at it as you circle about its pedestal, it should have something to delight you. Moreover, the different aspects should clearly be related. The composition from the rear should be one that fits with the composition from the front and with those from the side. It should not only fit but should amplify. I do not mean merely that after seeing the face and breast of a human being from the front we should expect the back of the head and the shoulders of the same human being from the rear. I mean that the attitude, mood, and action of the figure should be reinforced in every aspect.

Two views of Praxiteles' *Satyr* (sometimes called *Marble Faun* and possibly a copy) are reproduced (PLATE X) to stress this point. The sculptor chose the attitude of his satyr with a keen dramatic sense. Now, the point to observe here is the manner in which the side view reinforces the front view of this attitude. The significance of the tip of the head to the left in the frontal view is reinforced by the tip forward in the side view. The relaxed arms and legs from the front are reinforced from the side by the same relaxation to the very fingers and toes. And so on. But why not, you say, if the attitude has been fully conceived? Exactly the point, that it should be fully conceived from every aspect and correspondingly executed.

But this is not the end of the matter. Not only should the representative values reinforce one another from aspect to aspect, but also the plastic ones. Line and shape and texture motives that appear in one aspect should reappear in another and the different aspects should in terms of pattern and design integrate and work into one another.

For instance, a prevailing motive of the front view of this work is a long gently curving line — a plastic element that repeats the mood of relaxation depicted in the attitude of the satyr. The line runs down each thigh and calf of the leg, and down the arm, and down the folds of the skin thrown over the satyr's shoulder and elsewhere. That this line is selected with a purpose and is not necessarily the anatomical line of a human leg or arm may be tested by looking at the Despiau (PLATE XIVA). Compare the bent arms of the two statues. The same muscles are indicated, but Despiau breaks up the possible sinuous lines with slight angles and depressions. The silhouetted line of the calf of the right leg in Despiau's statue is angular. That of the satyr is smooth and graceful. And so on. Now look at the side view of the satyr. The same long sinuous lines reappear in this aspect. Another motive in the front view is the angle stressed at the elbow, and under the arm, and in a few other places. This reappears in the side view not only in the left arm but above the right arm, in the angle of foot into leg, and at the right knee. We may also consider the large quiet areas of smooth flesh contrasted with the small busy areas of the leopard skin and of the satyr's hair. This contrast in the same proportions reappears in both aspects.

In fact, as you circle the statue these plastic and representative features of the composition repeat, amplify, and reinforce each other in a cumulative effect which is the character of this statue. Every aspect is a variation on the theme of every other. This trait, one can see, is a trait that applies peculiarly to a statue in the round. Visually a free-standing statue is a collection of many views. There is no one view of it. If there were, it would not be a statue in the round. It would be a relief in the round, and should be set against a wall. Or, if such a single aspect statue had not been conceived to be seen against a rear plane, it would simply be a failure.

It is true, however, that among the aspects of a statue in the round, one of them is generally the principal aspect. If we are taking one photograph of the statue, this is the aspect we choose. This, we are likely to say, is the " front " of the statue. It represents the interest climax of the whole series of aspects. We tend to seek it out and start with it, and also to end with it. When the statue is set up in a garden or in a court or hall, the main aspect is toward the spectator's avenue of approach. A statue that has a main aspect is more likely to convey a feeling of integration than one that has not. Its presence is a sign of restraint. The interest in the other views is held back and saved up for the principal view. The subordinated aspects lead the spectator eventually back to the main and climactic aspect and bring the episode of this experience with this statue to a conclusion there. Thus the main aspect functions like a period to the series of lesser aspects, or like the tonic of a melody — in fact, this last is a very good analogy. And yet, just as there is atonal music, there are fine

statues that do not have a main aspect. But such statues carry simplicity and restraint into every aspect. They are generally of the kind I shall presently distinguish as sculpturesque.

Incidentally, there is a lot of sculpture in which the top view is as important as the side views. So particularly of low-standing animal sculpture. And in small pieces intended to be picked up and handled, the bottom view is not to be ignored.

Now for some examples. Clearly the main aspect of the *Satyr* is that in which he is facing us. The side view reproduced may seem just about as interesting, but it is definitely subordinated to the front view by the fact that part of its interest is a desire of the spectator to move around to the left and see the figure face-on. The view of Despiau's *Seated Boy* (PLATE XIVA) photographed is also obviously the main view. Similarly with the Michelangelo (PLATE XVI). In fact, this group composition comes near being a relief in the round, so dominating is the frontal aspect. On the other hand, Pegot Waring's *Bull* (PLATE XIII) seems about equally interesting on all sides, and also Duchamp-Villon's *Horse* (PLATE XIVB).

THE SEQUENCE OF ASPECTS. There is another point to bring out on this subject. From what has been said, it must occur to a reader that the successive aspects of a statue in the round are something like the successive scenes or, better, the continuum of a play. True, in a play there is only one sequence open, the sequence given in time, whereas in looking at a statue one may start with any aspect and circle the statue either to the right or to the left. Still, the statue does have its sequences of aspects. Would not it follow, then, that just as we expect one scene of a play to lead us into the next, so we should expect each aspect of a statue to lead the spectator round to its neighbors? Indeed, this is an important sculptural principle. Most well-designed statues in the round respect it. In the *Satyr* as in practically all free-standing Greek and Hellenistic sculpture this principle is abundantly exemplified. Take the side view of the *Satyr*. Did not we notice a very strong tendency to step around to the left and get the frontal view? That is the sort of thing I mean. All kinds of cues in the side view pull the spectator round to the left. The pull is so obvious I can leave it to the spectator to find the cues if he is interested. But is there not also a lesser pull to go round to the back? There are three lines that particularly give this pull — that of the oblique of the lower right leg (we want to get around and see what happens to that leg in behind there), the oblique of the draped skin passing under the Satyr's left arm, and the oblique of his hairline running back over his left shoulder. All of these lines parallel and reinforce each other. These I feel as the cues drawing me round to the right.

Similar cues will be found in the frontal view, even while we recognize it as the main and culminating aspect of the statue. For me the tendency is to start circumventing the statue to the right. Partly, this is due to the obliques of the

draped skin and of the right leg both leading back and to the right, but partly
also it is due to the slight twist of the plane of the Satyr's body to the right, and
the tip of the head to the right. The point is that the directions of these lines
and planes is not compensated anywhere, so that nothing blocks the movement.
If we let ourselves follow the stimulus, we find ourselves walking round to the
right. The tendency to go to the left is much weaker. The lines of the drapery
running back over the Satyr's right shoulder have a leftward pull. And if one
happens to notice the line of the bark on the tree trunk close to the pedestal,
again one is drawn to the left to see what the rest of that line will do. But for the
most part the strong vertical of the tree trunk carried on through the Satyr's upper
arm blocks the movements to the left. Yet there is some connection with the
neighboring aspect to the left. Though the spectator is most strongly encouraged
to move round the statue to the right, still a small doorway is open to the left.
In short, the successive aspects of this statue do lead into one another. They do
so with the facility and naturalness of a tradition that has become second nature
to the sculptor of that statue.

By way of contrast, look at the Despiau. Though this is a statue in the round
and the side views are unquestionably well conceived, there is no inducement
for the spectator to move right or left. The straight line from the shoulder to the
ankle blocks movement to the left, and the angle of the arm on the right prac-
tically pushes the spectator back from any movement in that direction. Fine as
the statue is in other respects, there is a certain frustration in not being visually
conducted round the composition from view to view as is done so graciously in
the *Satyr*.

This sort of frustration does not arise in Michelangelo's *La Pieta* (PLATE XVI)
even though the frontal view is so dominating as to convince one that the back
view is hardly part of the composition at all. One is drawn by many lines and
planes to view the group from the angles. Though we should have excused this
composition if it had held us to a frontal view like a relief, yet Michelangelo in-
vites us around the statue.

The Pegot Waring (PLATE XIII) and the Duchamp-Villon (PLATE XIVB) like-
wise have strong transitions from view to view which lead the spectator around
the composition. Though there are undoubtedly many exceptions, most statues
in the round, when not planned solely for the frontal view and a background
plane, maintain deliberately a sort of incompleteness in every aspect which en-
tices the eye to the next aspect for a fulfillment. In this respect sculptural com-
position is clearly very different from pictorial composition, which always seeks
to be self-complete in one aspect only.

PLANES IN FREE-STANDING SCULPTURE. The last stage of our series from the
scratch on the wall to the free-standing statue is not, however, altogether forgetful
of the earlier stages. A statue in the round usually does well to keep us mindful

of the wall from which it stepped forth, the block out of which it emerged. In short, even in the round many, if not most, of the highly satisfying sculptural compositions still maintain the planes which relief sculpture can scarcely do without.

We are now familiar with the principle of disposing the main features of a composition in relief into a small number of planes in depth. The same principle can be applied to sculpture in the round, and for the same reason that it simplifies and unifies a complex composition, and by emphasis adds impact to the visual impression.

The principle can be seen in Michelangelo's *La Pieta* (PLATE XIV). Nearly all the important features are disposed in two planes, the forward plane of Christ's head and a plane, farther back, of the mother's head. Notice that from either side, the same disposition in planes holds true. Take the left view. The kneeling girl is there in the front plane which includes Christ's right hand and left foot. And in the next plane in depth come Joseph's head, Christ's hand, left arm, and right knee, and Mary's hand.

The feeling for planes in Pegot Waring's *Bull* is obvious.

Notice how carefully Despiau has disposed the main features of his statue in essentially two planes.

And now notice that the Praxitelean *Satyr* (PLATE X) apparently gives no attention whatever to planes. This is one reason why some critics speak of such works as decadent. All sense of a wall or of the surfaces of a block of heavy material has vanished. The statue is in marble. The original may have been in bronze. The demand that this weight of material be justified by a subject of human interest is recognized. But from that point on it is as if the sculptor were showing how little the material bothered him. There is no reason to think that Praxiteles did not have this very ideal in mind. It has been a common sculptural ideal, and the justification of some of the world's worst sculpture, for it tends toward unmitigated realism in violation of psychical distance. But this statue has plenty of distance given it by the refinement of its design and pattern and the simplicity of its silhouette. It deserves the admiration the Romans gave it — for they had many copies of it made — and it has often been greatly admired since. But it is worth noticing that such indifference to the material is at the cost of that earnestness and absorption in the material which characterizes the Despiau.

Respect for the principle of planes is one of the means of keeping contact with the sculptural medium, for it reminds us of the surface and the depth of the material. In general, respect for this principle is a good thing, though some of the greatest sculptors organized their compositions by other means. But the principle shows us that even in sculpture in the round, which is the last stage of our imaginary series, the first stage of the scratched plane of a wall is not forgotten.

Pictorial Sculpture

We have now finished following our imaginary series from the scratched wall to the free-standing statue. In so doing we have learned many things about sculpture. For what we have done amounts to a classification of works of sculpture in terms of kinds of relief. And a comparison of these kinds brought out a number of significant qualities for the appreciation of the art. But there are still other things we ought to know about the art for the fullness of its enjoyment. These can be brought out by another classification, one that applies particularly to statues in the round.

Its basis is the sculptor's attitude in conceiving the statue — his aim. Is he thinking of his statue mainly as a visual object, or as a tactile object, or as a physically constructed object? Is he thinking of it mainly as something to look at, or is he thinking of it as something he has modeled and carved out with his hands, or is he thinking of it as something consisting of various parts that have weight and need to be supported in a well-related construction? Let us call these three kinds of sculpture the *pictorial*, the *sculpturesque*, and the *built-up*.

The first kind leans towards the attitude of the painter, the last towards the attitude of the architect. One might then conclude that the middle kind was at the center of the art and hit the actual goal of its technique, that the sculpturesque sculptor was the only real pure sculptor. There is some slight justification for the conclusion, and many contemporary sculptors and critics have leaped to it rather too quickly. But bias aside, there seems to be quite adequate justification for all three attitudes in terms of the requirements of the technique of the art. Sculpture is after all one of the *visual* arts. To ignore its visual appearance would mean the disappearance of the art. A statue is, in fact, *modeled* with the hands. The feeling of the material is always potentially there. And the material does have *weight*, and, if the statue is of any considerable size, the support of the weight by its various parts has to be provided for and may be a source of constructive delight. There is no good reason why anyone should deny himself the full enjoyment of each of these kinds.

In general a statue (and, in fact, the whole output of a sculptor) falls into one or another of these groups. It is predominantly visual, or sculpturesque, or built-up. Nevertheless, a statue does not necessarily fall entirely into one of these groups to the exclusion of the others. Probably the greatest statues are those that partake of the traits of all three groups at once. Such, as we shall see, is Michelangelo's *La Pieta*.

We shall now take up each of these kinds of sculpture in turn. Our desire, it should be remembered, is simply to increase our discriminations, to make us better aware of the many sources of enjoyment in a work of sculpture.

Pictorial sculpture, as we said, is the sort in which the art is conceived primarily in visual terms. A statue is an organization of light and shade (and sometimes hue) out of which emerge lines, shapes, masses, and volumes, all visual. It differs from a picture only in the nature of the stimulus material from which the composition is reflected to the eye. A picture gives visual shapes by means of pigment spread over a plane surface. A statue gives visual shapes by means of modeling a solid block. To be sure, a statue permits of a number of visual aspects. This is an important difference. But, on the visual theory of sculpture, it is still true that a statue is nothing but an organization of visual aspects.

Consequently, this sort of sculpture tends to minimize effects of the solidity of material and of the particular quality of the material. Epstein is a good example of a pictorial sculptor. His portrait of a girl (PLATE XI) shows his technique. Notice at once the dramatic effects of highlight and heavy shadow — the shadows in her hair, under her eyebrows, by her nose and lips, and the modulation of light and shadow over her cheeks. Epstein has modeled her face in light and shade, by means of bronze to be sure, but only as a medium for reflecting light.

By way of extreme contrast look at the Egyptian statue of Hatshepsut. This is also a portrait. Compare the Egyptian head with Epstein's. One cannot fail to see a radical difference of mental attitude in the conception of these two statues. Epstein is composing a pattern of lights and shadows in the representation of a girl, and modeling his bronze only to get the proper shapes of light and shade. The Egyptian sculptor is chiseling a block of granite, and modeling the stone to a human shape. This is a work in stone, not in light and shade. There are no dramatic effects of light and shadow, the facial features are kept close to the surface of the stone, and selected and simplified. Basic three-dimensional mass forms are stressed throughout. Arms, body, and legs keep close to cylindrical forms, the offering jars are spheres, and the head feels spherical. The beard and headdress are close to cubical. Everything indicates the tactile joy of working a three-dimensional material, with practically no thought of light-and-shade effects. The eye is only a means for appreciating the stone.

Just to see that this difference of conception is not due to the difference between stone and bronze, look at Despiau's *Seated Youth* (PLATE XIVA). This statue shows more consciousness of light-and-shade pattern perhaps than the Egyptian figure, but its treatment is still mainly sculpturesque. Despiau evidently had tactile shapes constantly in mind. To preserve this tactile feeling, he models the head of his boy with great simplicity. The sphere of the head is almost unmarred. The features of the boy are like incidents on the surface of that sphere. The eyes are modeled with great simplicity and not deeply set. The ears, also simplified, lie close to the head. The hair is suggested by indentations close to the rounded sphere of the head. The nose and mouth are simple forms. The

modulations of the cheeks are limited and constantly mindful of the total form of the head. The mass of the head is dominant, simple, easily comprehensible to the touch. The features never interfere with that dominant mass feeling.

Now look at the Epstein. There is no search for a simple mass for the head — in fact, no feeling for solid mass at all. A hand moving over the head would find a multitude of confused and jagged shapes. The spectator has no desire to touch it. For Epstein was not conceiving the head in tactile terms. The bronze of the hair is a tumultuous form of many highlights and deep shadows. The ear under the hair is modeled forward and deeply concave. The eye is deeply set in the socket (even though a girl) and shaped in great detail to suggest the smoothness of the upper lid, the softness below the lower lid, the large pupil. It is an intricate, visually sensitive portrait of that feature executed with virtuosity. Similarly with the nose, nostrils, mobile lips, and the modulations of light and shadow over the cheek.

With the same contrast in mind, look at the hands in the two statues. Despiau keeps them in total simple shapes, not separating the fingers, and each finger is a modification of a cylinder. Epstein ignores the search of a simple shape. He is thinking of the visual significance of the positions of the fingers. Especially the forefinger in its relation to the others is full of sensitive meaning as seen by the eye. But the shape of this sculptured hand would mean little to the touch and would probably feel confused.

Altogether, the surface of the Epstein statue, particularly the head, is greatly broken up. In some of his statues the surface is actually pitted to give a surface quality like impasto (heavy pigment) in painting. Does not the hair of the girl in this statue give the impression of broad dashing brush strokes? In short, Epstein seeks to give color quality to his surfaces by his modeling, rather than to model so as to enhance some intrinsic quality of the material.

The difference of attitude involved in these two sorts of sculpture becomes more and more apparent as we look at them. They have different modes of organization, also. Visual sculpture is in principle much more complex than sculpturesque. Being visual, it easily absorbs detail, and then, as in a picture, orders this detail by skeletal patterns.

There are two principal types of skeletal pattern employed in sculpture. These may be called the silhouette and the involuted. The one is suited to outdoor sculpture, the other to indoor. The Greeks developed the first and it is well exemplified in the *Satyr* — which is definitely a piece of visual sculpture. (Notice that you think of the Satyr's human body rather than of a marble mass.) Greek statues ordinarily stood out of doors in a strong light. The lines of the silhouette consequently stood out clear, and the interior lines were blurred to the spectator's eye. The main organizing lines were accordingly silhouette lines. Actually the governing line of most such statues is the line of the total pose of the figure. A

man standing erect on both feet with his arms at his sides makes a vertical straight line of his pose. Early Greek statues were in just that pose. Gradually the rigid vertical line softened and bent and became an S-curve. The S-curve is to sculpture what the triangle as a basic skeletal form is to painting. It is amazing how large a proportion of both Occidental and Oriental sculpture is organized about that curve. It is a beautiful curve in itself. It is a constantly changing line and so has variety, and it reverses direction and so contains its own contrast. Hogarth called it " the line of beauty " and based an aesthetic theory on it. It can be pushed into a vigorous bulge, or extended into a gentle bend.

The development of this curve as an organizing line seems to have reached a sort of culmination in Praxiteles. I have chosen his *Satyr* chiefly because it exhibits the use of the S-curve so well — better than the *Hermes* which, being possibly an original of Praxiteles, is much superior in most respects. The point to notice is that the S-curve runs through the figure from *whatever* aspect you view it. In the *Hermes* the back view loses the curve though the front view is organized beautifully about it. But in the *Satyr* this curve appears wherever the spectator stands, and integrates the total composition of aspects with a most skillful consistency. Moreover, the curve is always essentially a gentle one, carrying through a motive that, we saw earlier, was repeated over and over and was expressive of the relaxation of pose represented. In the front view the curve goes as in Fig. 51 from the tip of the head thence bulging to the left, then bulging to the right guided by the curve of the hip, and so off down the leg to the ground. In the side view the curve is reversed as in Fig. 52, FIG. 51 bulging first to the right from the head bent slightly forward and then to the left guided by the bulge of the bent knee, and so down the rear leg to the ground. It would be hard to place a wire along the line, but the general S-ness of the pose from both points of view is unmistakable. It is the same if you go round to the rear and to the left side. Subordinate lines, such as that of the arm akimbo and of the other leg, of the leopard skin, of the tree trunk, are disposed in definite relation to the main S-curve of the organizing pattern.

FIG. 52 Turning now to the involuted form of skeletal pattern, we find this developed for indoor sculpture where the reduced illumination weakens the silhouette effect and permits interior lines to stand out. The silhouette in such sculpture is generally totally uninteresting. The main organizing lines lie inside the outline. There is some degree of involuted organization in the Despiau (PLATE XIVA). One does not notice the silhouette, but if one does it is of no interest. But the organizing lines are inside — a sort of circle made by the arms and shoulders, and two descending verticals made by the legs as in Fig. 53. This pattern is easily taken in by the attention, and subordinate lines are organized off this main system. But Michelangelo's *La Pieta* (PLATE XVI) exhibits a beautiful involuted structure of linked ovals. The pointed oval FIG. 53

is the main motive of this composition. We may pick it out first, if we wish, from Joseph's hood (Fig. 54). The lower half of the shape is repeated at the opening of his neck (Fig. 55). This motive in many variations appears over and over again. But notice particularly how the main skeletal lines on the interior of the work are made out of this motive. At least these

FIG. 54 are the controlling lines for me, as in Fig. 56. The upper apex of the first link is Joseph's hood, and the lower apex the crook of Mary's arm. Christ's arm overlapping Mary's marks one side of the second link, the upper apex being hidden behind Christ's head at the convergence of the lines of his shoulders, the lower apex at the convergence of Christ's left arm with the kneeling girl's right. The third link has its upper apex at

FIG. 55 Christ's right armpit and its lower apex at the meeting of Christ's foot and the girl's kneeling leg. These together with the silhouette lines of the statue,

which in this instance are significant, constitute the main skeletal structure for this intricate sculptural design. For notice that Michelangelo composed the whole group in a silhouetted shape which is the upper half of the repeated motive, as in Fig. 57. Though this is an indoor statue of the involuted type, still Michelangelo did not

FIG. 56 ignore the tradition of the organizing silhouette.

Let me show another thing. The figure of Christ embedded in the heart of the group, and, so to say, silhouetted against the three subordinate figures, is itself composed on the old classical tradition, in an approximation to the S-curve. This group amalgamates most intricately, but with perfect clar-

FIG. 57 ity, the silhouette tradition with the involuted.

Both of these traditions having to do with organizations of visual lines are obviously traditions of the visual approach to sculpture.

Sculpturesque Sculpture

In sculpturesque sculpture the emphasis is on the character of the physical material — the stone, the wood, the bronze. The sculptor stresses the solidity of the material, the surface quality of it, the tactile feeling of it. The sculpturesque is sculpture you want to touch and run your hands over, for the delight of the texture of the material and the modulations of surface under the hand.

Actually we do not usually touch such statues. We imagine and empathize these tactile and kinesthetic feelings. But the desire to feel the statues is very strong, and it should be so for the full enjoyment of them. And sometimes, especially if the pieces are small, we can really have them in our hands or run our hands over them.

We have already compared the Epstein (PLATE XI) and the Despiau (PLATE XIVA) on this basis. We find very little surface of the Epstein that invites us to

run our hands over it. Particularly the hair and face which are the central features of the statue would be confused and disagreeable to the touch. But the whole surface of the Despiau would be grateful to the touch and understandable. And the modulation of the surfaces looks as if it would fit the cushions of the fingers and cupping of the palm. The statue is composed to the hand as much as to the eye. Particularly is this quality of gratefulness to the hand present in O'Hanlans' *Young Hawk* (PLATE XIII) and in Henry Moore's *Reclining Figure* (PLATE XV).

Some of this tactile quality can be felt in Pegot Waring's *Bull* too. But here another trait of sculpturesque sculpture comes out. That is the granite quality of this statue, since it is of granite — the stress on the physical material. The *Bull* is frankly a block of granite chiseled into the semblance of a bull. Compare it with the Praxitelean *Satyr*. This is the form of a man done in marble, not a marble block shaped into a man. And then look at the Michelangelo (PLATE XVI). This group too partakes of the sculpturesque mode. The stone is not denied at all. This group is a block of stone shaped into passionate human representations.

The emphasis in this phase of the sculpturesque mode is on the feeling of the sculptor's struggle and mastery of the material. It is the feeling of the sculptor handling his tools, carving the wood, chiseling the stone, manipulating the clay. The spectator enters into the sculptor's excitement in working with the material, and is imaginatively brought into close contact with it.[1]

[1] A practice was developed among many sculptors, especially in the eighteenth and nineteenth centuries, of modeling a statue in clay and then turning the model over to an expert marble cutter to reproduce in marble. The sculptor might then put on a few finishing touches with his own chisel, but essentially his work was finished when he turned his clay model over to the marble cutter.

To a sculpturesque sculptor this practice would obviously be unpardonable. The sculptor is making his statue in one material, and palming it off on the public in another material. Moreover, the spirit of clay is just opposite from that of marble. The technique of clay modeling is additive, that of stonecutting subtractive. A sculptor who thinks in clay cannot possibly make his statue come out as if he were thinking in marble. The sense of the material is entirely lost. Only the shapes of the superficial visual appearance are similar in the clay and the marble.

This practice is held responsible for the long period between the age of Donatello and Michelangelo and the beginning of the twentieth century during which no great sculptor seems to have arisen and the general level of the art was mediocre. This may well be a correct judgment. We seem to be in a genuine renaissance of sculptural activity. A vitality seems to have returned to the art that it has lacked for centuries. And the sculpturesque sculptors are the ones mostly leading the modern movement.

However, the modern emphasis on the sculpturesque mode is probably being overdone. It is quite surely disparaging unnecessarily the pictorial mode of sculpture. The admiration that Praxiteles received a century ago, he will probably receive again. Because there was a great deal of mediocre pictorial sculpture done by sculptors who hired marble cutters, one should not conclude that pictorial sculpture is mere marble cutter work. One should not even assume that all statues on which marble cutters have been employed are bad.

It is worth bearing in mind, when this issue grows hot, that practically no sculptor pours

Often, to stress the material, sculpturesque sculpture preserves the traces of the workman's tool. So Pegot Waring leaves the surface of her *Bull* unpolished. Partly this is to give the rough texture quality appropriate to the subject. But also it serves to express the stone. And similarly there are parts of the Michelangelo group that are " unfinished," with the chisel marks showing. A good many of Michelangelo's works have such " unfinished" passages. One suspects he may have been willing to leave them so. They bind the statue into its material, as much as to say, " These are not men and women, but only the forms of them that I have been carving out of this hard stone. Never forget the massiveness of this material and the shaping of it as you become absorbed in the patterns of light and shadow and in the drama of the subject. See, I leave signs of the strokes of the mallet as a reminder."

Yet, contrariwise, much sculpturesque sculpture has a highly polished surface. But then one feels that its polish is for refinement of the surface quality of the material and for the smoothness to the touch. Most Egyptian statues are highly polished and are extremely sculpturesque. If they look to you as if they would be very cool to the touch on a warm day, that is a sculpturesque appeal. But any rather choice material like diorite or obsidian or marble (not to mention ivory and jade) calls for a polished surface from anyone who loves materials. And a sculptor who has found a beautifully grained wood will want to exhibit the beauty of the grain in his statue. So you will find statues such as Henry Moore's *Reclining Figure* (PLATE XV) where the movement of the grain of the wood over the surface is one of the sources of delight, and the surface is finished to emphasize the grain. Notice also in this statue how Moore has utilized the grain of the wood to accentuate the contours of the figure modeled. This sort of treatment, too, is sculpturesque in feeling.

Another point. In emphasizing the material, the sculpturesque sculptor tends to keep the block of the material intact. There is a saying attributed to Michelangelo that a good statue is one that could be rolled down a hill without injury. You can see that that could be done with O'Hanlan's *Young Hawk*, Pegot Waring's *Bull*, and Michelangelo's *La Pieta*, and possibly Despiau's *Seated Youth*. It could not be safely done with the Praxitelean *Satyr*. The point is the sculptor of

his own bronze. The technique of pouring bronze for a statue is a highly specialized one, and the sculptor leaves this to the specialist — and even the modern sculpturesque sculptor raises no issue over this.

The use of an intermediary does not necessarily spoil a work of art. Japanese prints were a co-operative work between a painter and a wood-block carver. In fine printing there is the author, the type designer, the printer, and probably several manual helpers. If the book is specially bound, there is also the designer of the binding and the bookbinder. In music, the composer is rarely the performer, and he is rarely the best performer. In the theater, the number of different artists involved is often very large. So there is nothing intrinsically reprehensible in an artist's using an intermediary, or a helper, or a partner. It is the result alone that decides the matter.

the *Satyr* had only a secondary interest in his material. He was primarily interested in the visual forms.

However, even Praxiteles (if he was the sculptor of the original) kept the forms of his statues fairly compact. This has been a basic aesthetic principle for sculpture in the round. Many unpleasant results in certain ostentatious statues of the past can be ascribed to a neglect of this principle. For in relief sculpture a large opening between figures in a composition simply outlines a shape against the rear background plane. The air or empty space is, so to speak, sculptured in relief as a negative space form. But in the round, air opened up between the forms is simply air and empty and does not ordinarily outline a shape with definiteness. It is a wide area of absolutely zero interest. So a statue, or a group in the round, ordinarily needs to be kept compact with a minimum of meaningless open space inside the composition. You will notice there is no empty space at all within any aspect of Pegot Waring's *Bull*. There is practically none in Michelangelo's *La Pieta* — and this was more of a technical feat for this group than a layman is ever likely to surmise. There is not much in the Despiau. And not much in the Praxitelean *Satyr*. A sensitive visual sculptor is careful of this sculpturesque feature. Empty air is a disrupting force in sculpture.

So, at least, it has been until recently. One of the principal sources of sculptural interest in Henry Moore is his utilization of empty spaces. One cannot exactly say that he is the first sculptor to make expressive use of holes and concavities in sculpture. Michelangelo certainly understood the effect of the concavities under Joseph's hood. Praxiteles and Despiau were probably not unaware that the shapes of the holes under the arms of the *Satyr* and the *Seated Boy* were not disagreeable. But the emphasis Henry Moore puts on holes and concavities as sculptural themes is something new. It is not new to human experience. Caves have always been exciting, and the hollows of shells, and the gnarled shapes of old windblown cedars on exposed ridges. What Henry Moore has done is to accept and incorporate these forms into the sculptural tradition. He is through and through a sculpturesque sculptor in the very breaking of the old sculpturesque rule of the compactness of the statue. For it was respect for the material that inspired the rule, and it was simply this same respect for the material that led to Moore's opening the material out and puncturing it wherever the material seemed to lend itself to such treatment. Actually for all their open treatment his statues can safely be rolled down hills too.

But the important thing to see is how he loves his materials. His *Reclining Figure* (PLATE XV) is obviously not a statue of a woman in wood but a block of wood modeled with certain suggestions from the shapes taken by a reclining woman. It is an emotional treatment of a block of wood on the theme of woman. We have already alluded to his handling of the grain of the wood to follow the shapes of the form. See how the lines work over the back and shoulders, around

the neck, under the armpit, in gradations and climaxes over the surface. Watch the silhouette lines. Notice that the holes and concavities are all sorts of variations of one another. Of course, a concavity is simply a hole that has not gone way through.

Between Moore's *Reclining Figure* and Pegot Waring's *Bull* one can get a good idea of the range of sculpturesque treatment and the variety of its appeal. For the *Bull* stresses the compactness and massiveness of a material but does not particularly suggest gratefulness to touch and choiceness of surface treatment. The latter, Moore's *Reclining Figure* exemplifies superlatively. In fact, I notice that the upper knee is already oily from the touch of many hands.

Incidentally these two statues show what a degree of emotional expressiveness comes out of the very material of sculpture if it is used emotionally — and if the spectator has become susceptible to it. For in these statues the material is very heavily emphasized. Other obvious instances are the monumental Egyptian stone sculpture, and the wood sculpture of the African Negro tribes and of the Indian tribes of the American Northwest.

There is nothing particular to say about organizing patterns in sculpturesque sculpture. The sense of the integrity of the block of material itself is ordinarily the dominant unifying agent in such works. The rectangular block of granite in Pegot Waring's *Bull* is never lost sight of and holds all the forms together. Similarly the cylindrical section of a tree trunk enfolds Moore's *Reclining Figure* in spite of all the carving that has been done upon it. Moreover, such sculpture is generally simple in treatment and does not demand strong organizing patterns.

Built-up Sculpture

Finally, there is built-up sculpture. As an example of this sort of treatment, I am reproducing Duchamp-Villon's *Horse* (PLATE XIVB). Many will see in this composition simply an abstract organization of forms. No more needs to be seen. Yet it adds something if you notice that the forms are suggestive of, and suggested by, a horse rearing back on its haunches. The subject does guide the emotional tension of the piece.

Our special concern with this statue is to point out that it is differently organized from any of the statues we have described so far. It is too much concerned with solid material to be genuinely pictorial, and yet it lacks the simplicity of treatment and obvious love of the material that characterizes the sculpturesque. The secret of the difference is revealed as soon as one notices that the dominant interest in such a work is the building up of three-dimensional masses within a sculptural whole. This accounts for the absence of a pictorial effect, and also for the absence of intense sculpturesque respect for the material. Duchamp-Villon is not interested in the visual pattern, nor in the material in any other sense than

in its possession of the three-dimensional mass characters of size, volume, and weight. He evidently conceives sculpture as essentially a matter of building up a satisfying organization of three-dimensional masses.

There are relatively few statues that are as completely dominated by the built-up treatment as this one is. Notice how the cantilevered cylinder of the horse's body is supported by the shapes under it and pulled down at the left, too, so as to hold up the forms representing the horse's neck and curled up fore-leg on the right end of the cylinder. As you rise from the base, there is a climax of forms about the rump, and then again a major climax about the head. The bare cylinder sets these active areas off as an area of restraint. The organizing pattern that holds the composition together is the building-up principle itself. To me it is a highly satisfying composition and one that has not grown stale after many views of it.

But, as I said, there are not many statues of the purely built-up sort. There are, however, a great many statues that have the appeal of the built-up treatment along with other appeals. The monumental seated statues of the Egyptians (PLATE XII) have this appeal so strongly that it often seems stronger than the sculpturesque appeal. Despiau's *Seated Boy* has it. See how the forms build up from the base. The head rests on the shoulders which are supported by the body and arms, which in turn are supported by the legs and seat. The weight of the boy's right arm on his right leg is particularly unmistakable. That is, all these are felt as heavy forms built up and supporting one another.

There is a built-up character in the *Satyr* also. The body of the Satyr is leaning on the post and supported on the left leg. The sense of flesh and bone, however, so dominates this statue that the physical mass forms are overshadowed by the sense of human vitality. I feel very little of the built-up character in the Epstein, and none in the Pegot Waring because of the single solidness of the block. For the same reason there is not much of it in the Henry Moore. But, for me, it is one of the strong elements of appeal in Michelangelo's *Pieta*. Neglecting the representational effects, and seeing it simply as a pyramid of forms, I find these piling up from the base magnificently like a rock mountain.

So this Michelangelo group appears to have every important source of sculptural appeal. It is pictorial, with both involuted and skeletal organization. It is sculpturesque and features the quality of its material and the simplicity of its block. And it is built up within the block in massive forms. All of these appeals it has together with the representational, the dramatic, and the emotional. Among the illustrations I have used here to stress this or that quality of sculpture, the Michelangelo stands, for me, far above the other statues because of its depth and its richness. It is a sort of epitome of the art. Many statues may be preferred for one good sculptural reason or another. But few can be found as well-balanced at so high an intensity of excellence.

ARCHITECTURE

The Art of Architecture

THE BEST working definition of *architecture* is probably that of *the aesthetic art distinguished by the technique of building for some major human purpose*. The central purpose of architecture is customarily taken to be shelter. But aqueducts and bridges are also often treated as architecture, and it is becoming more and more difficult not to think of ships and airplanes and the like as architectural objects. So, it is best, perhaps, to allow the defining purpose of architecture to be any humanly important one involving building.

By "building" is meant any techinque by which a final shape is attained through putting different pieces of material together — piling bricks, nailing boards, etc. — as distinguished from the characteristic sculptural technique of modeling, by which a shape is hewn out of a block, or formed out of some material like clay. Of course, there is some literal building in some works of sculpture and there exist in India elaborate caves and temples carved out of solid rock. But as a working definition, that given above will distinguish sculpture from architecture well enough. In our illustrations, we shall be thinking only of buildings intended for shelter, such as tombs, temples, palaces, factories, and dwelling houses.

ARCHITECTURE AS AN APPLIED ART. From the foregoing definition, it appears that architecture is an applied art. So far, we have been dealing only with what are known as pure arts, in which most of the works are created solely for the ultimate satisfaction they yield. But since works of architecture serve primarily a utilitarian purpose, these belong to an applied art. There are many applied arts, most of them visual, such as printing, bookbinding, weaving, dressmaking, ceramics, glass blowing, furniture making, metal work. All of these arts are absorbed in making objects which are primarily instruments for some human purpose, and attain aesthetic value only in the service of some instrumental value.

Usually the instrumental character of a work of applied art somewhat dampens its expressive power, and confines it within rather narrow limits of aesthetic satisfaction. A spoon or a bowl could hardly attain the emotional depth of satis-

faction to be found in Michelangelo's *La Pieta*. But in architecture the reverse seems to be true. The purposes many works of architecture serve are of such far-reaching human significance that they actually increase aesthetic satisfaction. For this reason architecture is the only applied art that has also attained the dignity of a major art.

Since architecture is an applied art, it is important that its distinctive character should be emphasized. The treatment of this art will accordingly be different from that of painting and sculpture. The difference arises primarily from the fact that the appreciation of a work of applied art requires a special attitude. It requires that the spectator should fully understand the utility of the object as an instrument and yet maintain an aesthetic distance between his using of the object and his appreciation of its fitness for use. The beauty of the object actually does depend on the efficiency of its utility as a tool. If an object of applied art does not serve as an excellent means to its end, it loses all its beauty. Nevertheless, its aesthetic value lies not in its actual use in attaining its end, but in the appreciation of its capacity to do so.

Sometimes, perhaps usually, the appreciation of this capacity comes out best in actually using the instrument. One may not fully appreciate the beauty of the lines of an axe or a saw or a paddle or a canoe until he actually uses them. But for the aesthetic appreciation of a work of applied art, using it is not enough. In using a tool one often becomes entirely unconscious of it. One must have an awareness of how useful it is, and for the fullest appreciation one must stand off once in a while and contemplate the details of its structure, its shape, its lines and articulation, and all that renders it so good an instrument. We shall, in our present study of architecture, attempt to give as clear an idea as we can of this special sort of appreciation which an applied art calls for, so that the same principles can be transferred to other applied arts. Our study of the appreciation of architecture will then act as a sample for the way objects of any of the other applied arts should be approached for the fullest appreciation.

THE FITNESS OF BUILDINGS TO THEIR TIMES. At this point I must call attention to something in the history of architecture which is worthy of reflection and which will also help us to bring the vast range of subject matter for this art within the bounds of a single chapter. A sequence of kinds of buildings was listed earlier (tombs, temples, palaces, factories, and dwelling houses). This sequence was, in the writing of it, a spontaneous linkage of associations. But the linkage comes to mind because it follows a sequence in history.

The buildings associated with the Egyptians are tombs and temples, with the Babylonians temples and palaces, with the Greeks temples, with the Romans temples and other public buildings and public works of engineering, with the Middle Ages cathedrals, with the opening of the Renaissance palaces and churches. But the buildings primarily associated with the present are skyscrap-

ers, factories, dams, grain elevators, housing projects, and above all private houses. The most imaginative architectural work of the present seems to be largely directed upon houses. If you ask for examples of the works of the great architects of the past, Brunelleschi, Alberti, Bramante, you will be shown churches and palaces, but if you ask for examples by the eminent architects of the present, Frank Lloyd Wright, Le Corbusier, Mies van der Rohe, Gropius, you will be shown a great number of dwelling houses.

This shift from the tomb to the dwelling house tells quite a story. More eloquently than words it says that society has become more and more interested in the happiness of the individual man, and has been building more and more for his personal comfort, and that this movement has reached a culmination in Occidental culture within the last century or so — in fact, within the last two or three decades.

Moreover, it makes very clear one of the most prominent characteristics of the art of architecture — its close association with its times. Of no other major art do we demand as a requirement for the beauty of its works that they fit their times. But this is a requirement of works of architecture precisely because these works serve such deeply significant cultural interests. A Greek temple or a medieval castle built in the present day appears artificial, and is so; and the beauty of that style of building is destroyed, or at least marred, when transplanted out of its time, because there is evidence then of a lack of seriousness in satisfying vital present-day interests. It happens that the most deeply significant cultural interest of the present day, at least in America and Western Europe, is the comfort and happiness of the individual. Hence the architectural emphasis today on the private house, or on housing generally.

Accordingly, in this chapter on architecture I shall stress the private house, and most of my illustrations will be taken from the problems of the private house. There are two advantages in this treatment. First, the house is not only of prime importance in the study of modern architecture, but is also of major concern in our daily lives. We should therefore learn to appreciate it as an object whose beauty cannot be fully realized without reference to the degree to which it satisfies the practical requirements of a human dwelling.

The second advantage is that all of us know quite intimately the purposes to be served by a house, since we have all lived in houses and know what convenient or inconvenient living means. After analyzing the aesthetic bearing of the purposes of a house upon its beauty, we can then see the importance of working out with equal care the purposes of a medieval church or a Greek temple for the fullest appreciation of these works.

THE DOMINANT PURPOSE IN ARCHITECTURE. In any work of applied art, then, the purpose it serves is its dominant aesthetic feature. The demands of the purpose constitute an aesthetic type, what we called in Chapter 5 a type of

utility. The pleasure comes from recognizing the efficiency with which the demands of the type are fulfilled, from recognizing how the object fulfills its function. The more difficult the fulfillment of the type, the greater the delight in recognizing its fulfillment. Accordingly, if the functional demands of a work of applied art are intricate and difficult to fulfill, it is important the spectator should be conscious of this and should have a clear conception of these demands so as to obtain the greatest intensity of satisfaction available to him.

In any work of architecture the demands of its dominant purpose are surprisingly intricate, much more so than the average spectator is aware. The total function or dominant purpose of a building is a whole system of interrelated lesser functions, many of them conflicting and requiring much ingenuity of mutual adjustment. An appreciation of these intricacies and of the builder's imagination in bringing about a solution is a source of intense pleasure for a spectator who has acquired the necessary discrimination.

What, then, is the dominant purpose of a building? It is basically the satisfaction of the *needs* which a building serves. These needs, however, can only appear in the building in the form of the *plan* that distributes them in space. The plan in turn must be realized in some manner of *construction*. To understand the dominant purpose, then, which controls the beauty of a building, we must understand the needs, the plan, and the construction. Beyond these lies also the visual appearance of the building, which is its *pattern and design*, what first stimulates the eye in the perception of the building. Altogether, then, there is the dominant purpose or function of the building on the one hand, consisting of its needs, plan and construction, and, on the other hand, the visual appearance of the building, consisting of its pattern and design.

The sources for the beauty of a building now begin to reveal themselves. A sort of aesthetic canon for the beauty of a building can in fact be framed with an assurance that could not be had in pure arts like painting and sculpture, for these lack a dominant purpose. We can say definitely of a building:

1. Its plan should fulfill its needs.
2. Its construction should embody its plan.
3. Its pattern and design should conform to its construction.

In the sections which follow we shall consider each of these requirements separately. Actually, of course, they are not separable in a building or even in perception or judgment. But as a means of bringing out the distinctive features of aesthetic appreciation in architecture it will be useful to regard them separately.

The Plan of a Building

The plan of a building consists in the distribution of its needs for the space at its disposal. It entails a clear conception of the needs and a careful examination of the place where a building is to be located. Plan thus splits into a discrimination of the needs and of the location. Both of these discriminations involve many considerations. We shall try to give some idea of what these are. For the most part we shall have in mind the dwelling house, but the principles apply to any building. Let us begin with space. The obvious general principle is that a building should be suitable for its place. What more specifically does this mean?

1. SUITABILITY TO PLACE. This principle involves suitability to climate, lot, and surroundings.

The demands of *climate* on a building are usually so taken for granted and, in an established culture, so naturally and inevitably fulfilled that they are likely to pass unnoticed. But imagine a New England farmhouse on the tropical shores of Tahiti, and the principle becomes obvious. Then we see that a New England Colonial house in southern California or Florida also does not exhibit a careful consideration of appropriateness. It seems transplanted, and not as if it belonged in the region. For climate makes possible certain ways of living and eliminates others, and these will show in the plan, and be reflected in the construction and design of the building. Where there is heavy snow, a steep roof is appropriate. Where there is much cold, a compact plan is needed. Where there is little sun, plenty of light should be provided for; where heat and sun are excessive, shade is required. Consideration of all such things makes for the comfort of living and the smooth functioning of a building. And we begin to feel a unique beauty in a building which not only is adequate for its climate but also takes advantage of features of a climate so as to make them serve toward fuller living. Such is the source of the beauty of a Spanish patio and of the large fireplace of an old New England farmhouse. The former is elaborated in the tiled courts of the Alhambra, the latter in the mantel-framed fireplaces of New England mansions. Both make an architectural feature of much beauty and comfort through overcoming an uncomfortable climatic feature.

But a building must not only fit its region, it must also fit its particular *lot* or *site*. Many have spoken of the beauty of the sites of Greek temples. The beauty of the temple at Segesta [1] is due as much to its setting, its placing on the slopes of the Sicilian hills, and the proportion of its size to the height of the hills and its distance above the valley, as to the internal proportions of the building itself. The same could almost be said of the Parthenon on the Acropolis of

[1] A surprisingly well-preserved temple in Sicily supposed to have been built about 420 B.C.

Athens were it not for the exceptional beauty of the building itself. Most of the great architectural monuments owe much to their sites. To some extent a site may be made to fit its building. To a degree this may be said to be the function of landscape architecture. But in large degree a building has to adapt itself first to its site.

Probably the most intimate way for most of us to get an appreciation of what is involved in fitness to site is to consider how any ordinary house can fit its lot. A lot is simply the specific place where a house must go. Architecturally considered, no two lots are just alike. Size and shape and contour of lot obviously make a difference to the house going up on it. Also, one must consider the exposure. Which side is south where the sun comes from? What are the prevailing winds, that determine both coolness and shelter? Where is the best view? Are there ugly views that have to be concealed? How near are the nearest houses? What noises must be prepared against, such as neighboring radios, clatter of dishes, street cars, the whir of constant automobile traffic, or possibly a railroad? On which side or sides of the lot does a road give access? All these things are involved in a lot. Two lots almost exactly alike, but one of which has access from a road on the north, the other on the south or east or west, require totally different plans of houses.

With these and similar considerations in mind, we may now say that the suitability of a house to its lot consists in so placing and planning the house in relation to the lot that there is least waste of land. For both efficiency and comfort of living, the most that is possible should be made of the land. Just how this should be done is a unique problem for each separate lot. When a particularly happy solution is reached, there is much delight in perceiving it.

But ordinarily very little attention is given to this side of architectural beauty, which is one of the reasons for the dullness of so many residential sections. Customarily in suburban districts a house is placed as nearly as possible in the middle of the lot. No placing of the house could ordinarily be more unfortunate. More land is wasted with the house in this location on the lot than in any other. For if the house were set well back, it would give a big front area. If it were set well forward, it would give a big secluded back area. If it were set well to one side, a large area would open out on the other side. The land outside the house then becomes something that can be enjoyed and lived in. But in most American communities the land about a house is a fringe of grass too small to invite anyone to come out and enjoy it. The occupants of the house are driven indoors for comfort and seclusion, and the land outside is wasted.

Place also involves *surroundings*. Though these are hardly to be separated from the character of a site, still they are not quite the same. A building should fit its surroundings. Too often a house is thought of in isolation, as it appears in a photograph or an architect's elevation. Actually a house is always seen in

its surroundings. If the relationship is discordant, the beauty of the building is marred; and if it is harmonious, the beauty is much enhanced. Fitness to surroundings refers particularly to two quite different sorts of demand. In a city or thickly settled region, it means that the appearance or style of a building should harmonize with the buildings on either side. In the country it means that the materials of a building should look as if they were the natural ones to use for such a building in such a place.

Wherever buildings are so close together that you cannot fail to see those on either side of the one you are looking at, clearly the group of visible buildings forms a total composition. There is no way of avoiding it, for there they are permanently juxtaposed. If their styles clash, every building in the group suffers. There is hardly an American town that does not suffer from this sort of inconsiderateness. Especially in the recent eclectic days of building in all the styles of the world, this sort of ugliness has spawned. It is not infrequent in a well-to-do residential section to find a sequence of houses something like this: an English cottage, a white stucco Spanish villa, a bungalow, something suggestive of an Indian adobe dwelling, a chalet, and a " modern " house. Some of the houses may be rather attractive examples of their individual styles. But consider what they do to one another.

To obtain the harmony we are talking about, it is not necessary that all the houses be of the same style, only that each new house should take some thought of its neighbors. But if the neighbors are all ugly, what then? This question can only be answered by asking another: if a lot is by a city dump, or a canning factory, or an oil refinery, what then?

If examples where this harmony does exist are called for, I think of the cathedral squares in almost any Italian city, in Florence, Siena, Pisa, Venice. The beauty of Venice lies very largely in a sort of architectural harmony with, nevertheless, great variety of historical styles. St. Mark's Cathedral and the Doge's Palace side by side, Byzantine and Gothic, could hardly be more different, yet by their mutual proportions, and a sort of common mood, they harmonize and vitalize each other.

The harmony of a building with its rural surroundings also concerns the proportions of a structure to neighboring features, to the slope and height of hills, the height of trees in a forested country, the breadth of a river, the size and bend of a cove by lake or sea. But harmony with country surroundings particularly refers to materials. For a very simple illustration, consider the stone walls that border the farms in New England. Every visitor remarks upon them as one of the great charms of the countryside. They run along the sides of the roads, wind up over the hills, into the woods and out again, across brooks, accenting the contours wherever they go. Yet they would be an absurdity if it was not obvious that the countryside itself is stony, and that the stones for the walls are

simply gathered out of the fields themselves and used along the edges as the easiest disposal of them, and also as very handy material for fencing. Stone walls on the stoneless plains of Illinois would have no such fitness.

When the materials used in a building suggest some similar relation of appropriateness to the materials of the country, the building acquires an added beauty. So, if a stone building in the country can use the rock visible in the neighboring outcrops, that fitness is felt. And as a log cabin fits the woods, a wooden building is likely to seem most appropriate for more elaborate structures in a wooded country. For the same reason sun-baked adobe (mud) bricks are natural for the desert buildings of the Southwest.

While we are speaking of materials, we should recall that there is also an emotional quality of materials which fits them for certain purposes and unfits them for others. We spoke of it in relation to the use of various kinds of stone and wood and metal in sculpture. A tact in feeling the fitness that a certain sort of material or combination of materials has for a specific building is just as important in architecture as in sculpture. Again one source for the exceptional beauty of the Parthenon is the appropriateness of the warm ivory-toned Pentelic marble for the religion and the location of that temple. Take the temple out of the Aegean climate, where its yellowish marble cannot be seen silhouetted constantly against a deep blue sky; or imagine it the temple of some morbid and savage religion, and the appropriateness of the material vanishes. Similarly the gray stone of the Gothic cathedrals of central France seems exactly right for the place and the purpose of those buildings. Coming down to modern times, we feel the same emotional appropriateness of steel for our great suspension bridges, skyscrapers, and factories. The emotional fitness of materials thus also enters as one of the demands in the system of demands that comprise the dominant purpose of architecture.

2. SUITABILITY TO NEEDS. Having obtained a notion of the intricacy of the demands of place on the plan of a building, we can now take up the plan itself, or the distribution of the needs of a building in the place where it is to go.

Just as no two lots or sites are exactly the same, so no two buildings ever embody exactly the same needs. If we consider a dwelling house, two different families planning a house for an identical lot would have different needs even if they had the same income and the same number of children. For each family has its own personalities which exhibit themselves in difference of interest or needs. Equally true is this of public buildings. As similar as were the needs of every Greek community for a columned temple, and of every considerable twelfth-century city in France for a spired cathedral, still the character of each community demanded and created a distinctive building even though of the same style. Conscientious planning is almost inevitably the planning of an individual and unrepeatable thing. If a building exactly fits the needs of one situa-

tion, it will not exactly fit the needs of another. A great work of architecture is as unique an object as a great work of sculpture or painting.

This declaration is not intended to exclude architectural beauty from multiple housing projects or prefabricated dwellings. These are also produced to satisfy a particular situation and may fit the needs of that situation to perfection. But again, to appreciate the possible beauty of a multiple housing project one must understand the particular needs of that situation.

For the moment, however, let us think in terms of the needs we are most familiar with — in terms of a dwelling house to be built specially for a particular location for a particular family.

Suppose we begin by listing the typical needs of an ordinary family. The list would be something like this: living space, dining space, cooking space, laundry, sleeping space, toilet space, closet space, entryway. This is a list of functions, not of rooms. And this distinction brings to light two quite different conceptions of planning. If the planning is conceived in terms of a separate room for each important function, the result is called *closed planning*. But if the functions are disposed without set partitions, the result is *open planning*. There is at present a strong movement towards open planning, at least for part of the functions of a dwelling house. But the problems of planning are more simply revealed in closed planning. Our needs will then resolve themselves into requirements for a certain number of rooms — a living room, a dining room, a kitchen, a laundry, one or more bedrooms, one or more bathrooms, several closets or storerooms, one or more hallways.

Having listed these rooms, we must next consider them in terms of their relative importance. For the rooms with the most important functions should be in the most important places. Different families may disagree on the relative importance of these rooms. But the living room would generally be regarded as the most important room, since that is where the family sits for comfort and receives its friends. Next perhaps comes the dining room, then the kitchen or possibly the master bedroom, then the other bedrooms, and then bathroom, laundry, and halls, and finally closets wherever they can be tucked in.

Now we are almost ready to dispose these rooms in the space of the lot, but not quite. There are two more things we want to know. What sizes are best for these rooms, and are not some rooms closely related to others in function and so require to be close together in space? For a well-planned house is one that is efficient and comfortable. Now, kitchen and dining room are clearly closely related in function, and so are dining room and living room. That practically settles the relative disposition of these rooms. The kitchen should be close to the dining room on one side, the living room on another. Also the entry into the house should for smooth functioning bring one rather directly both into living room and kitchen; one should not have to go through the kitchen to get

into the living room or through the living room to get into the kitchen. There should also be ready access from bedrooms to bathroom and, in fact, the bathroom should be available from all parts of the house without one's having to go through a bedroom, or, if possible, any other room except hallways. Closets should be accessible to the rooms in relation to which they function for storage.

Moreover, besides these allied functions which require rooms to be near together, there are opposed functions which demand that rooms be far apart. One does not ordinarily want the smells of the kitchen blowing into the living room, or any other room, though they are least objectionable in the dining room. That means the kitchen should be as isolated as possible from all rooms, even including the dining room with which it has a closely allied function. This conflict raises one of the enduring problems of house planning. How keep a kitchen both near and clear of a dining room? Also, bedrooms should be quiet and isolated from the waking functions of the house.

I am here treating these rooms in the traditional way. One must recall, however that a tradition may be breaking down and a function changing. Kitchens, for instance, are acquiring the functions of a living room, and there is a tendency to amalgamate living room and dining room, and bedrooms are beginning to be thought of as secondary living rooms where people can retire and read and sew and entertain if somebody else is using the living room.

But, for simplicity, let us stick to the traditional functions. Then it appears that the traditional distribution of rooms upstairs and down and on either side of a central hallway is a surprisingly good solution of the ordinary needs.

The Governor Smith mansion (PLATE XVII), as its exterior plainly shows, is planned in the traditional way. The front door opens into an entryway with stairs winding to an upper hallway. On the left is the living room, on the right a study or office. The dining room is behind the living room and next to the dining room and behind the study is the kitchen. Upstairs are four bedrooms, and, somewhat recently provided, a bathroom with access from the hallway. Roughly this is the plan of the house. The requirements of the various functions are adequately provided for. It is a livable house today though built years ago for a sea captain in the days when Wiscasset was an active port for ships in world-wide trade. The balustraded area on the top of the roof was the " captain's walk " from which he could overlook the harbor. The house reflects the dignity of the owner's occupation in a period when gentlemen assumed dignity. The front doorway is receptive and impressive. The hallway is large enough to support the dignity of the doorway and divert visitors either into the office on the right or into the living room on the left. The downstairs areas looking toward the street are clearly regarded as the most important areas in the house, and they receive the most important functions. Then the dining room and

kitchen are given the secondary areas downstairs. The sleeping quarters are segregated upstairs out of the way of the downstairs functions.

This is a typical example of what is called a closed plan. And, unless special provision of ample doors onto a porch or terrace is made, the walls of the house (as in the Governor Smith mansion) close the house off from the lawn and garden and the rest of the lot. A closed plan gives a general atmosphere of seclusion and protection. It tends to turn attention constantly inward, to the inside of the house and the inside of each room. It tends to lead to a neglect of garden and the possibilities of a more ample living mingling outdoors and indoors and across partitions of function. Moreover, functions often overlap. Often it is pleasant to dine on the porch. Sometimes we want plenty of open space, so that we can have a dancing party, or a small theatrical performance, or a big reception. Then we wish we did not have an immovable partition between living room and dining room and entry way and porch. Perhaps we are genial and generous-minded persons and would like our house to have an expansive and open and out-going atmosphere. If so, we are ready for what is called the open plan.

For us of the European tradition, the open plan in domestic architecture is a novelty. Consequently, it is well to be reminded that the open plan has been traditional for centuries in the Orient, particularly in Japan.

As a concrete illustration of imaginative planning and also to make us better acquainted with some of the characteristic features of open planning, I am selecting a house designed by Fred Langhorst for Dr. Alexander Ker (PLATE XVIII). The lot is in a residential area north of San Francisco, and slopes south with a view over fields and woodland to the bay and the hills. Access is given from a road along the north edge of the lot. The slope is warm and ordinarily protected from chilly winds. It is a lot which invites outdoor living and a plan that makes the most of the southern exposure and the view.

The needs were for a small house suitable for a couple only. One bedroom and bath were adequate, and then space for study, for living room, dining, and cooking, for storage and workshop, and for two cars since the house was some distance from town. The accompanying plan (Fig. 58) shows the solution, with open planning for the main living quarters and the feeling of an open plan throughout, but modified to give privacy for bedroom, bath, and study, and isolation to the kitchen and shop.

Cars drive in from the north into an ample turn-around in front of a car shelter. The long horizontal supports of the shelter roof extend over the covered walk and through to the bank of the hill, making an arbor along the side of the covered walk. The visitor is greeted by a vista down this covered walk and arbor to a green door which is plainly the entrance to the house. Halfway down the walk is a service entrance to the left. All of this is so arranged that visitors and

delivery men are out of sight of the living quarters and the garden, and seclusion is guaranteed to all the inner functions of the house.

The front door opens into the living space, but is so screened as to amount to an entryway separated in function from the part of the living room where

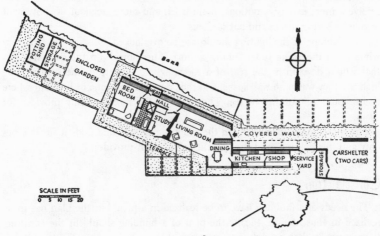

FIG. 58

people tend to sit and gather together. The screen, left of the doorway, also serves to mark off the space that functions as dining room. Nothing but a plate glass partition separates this large living area from the terrace which is covered by an arbor and which also functions as part of the living area. From the terrace you step directly onto a lawn beyond which is the garden and a grassy slope and the view to the bay and the hills. One function opens into another, and all of them open out-of-doors, and no sharp line occurs anywhere. Space flows from function to function. Living goes on easily with a minimum of opening and shutting of doors or turning of corners.

At the same time, the conception of open planning is not carried to extremes in this house. There is complete privacy in the study and bedroom, both doubly isolated from the living quarters by a door and a small hallway. The chimney, moreover, furnishes a heavy partition between these two sets of functions, and keeps out the noise. Fireplaces for both study and living room are provided. The kitchen also is isolated, so that the smells do not get into the rest of the house. Closets extend along the whole north side.

Notice how the living quarters occupy the heart of the house. The bedroom where most privacy is desired is in the most secluded location. The bathroom is easily accessible both to bedroom and living quarters. It can be reached from

the living room without disturbing the study. The bedroom can be used as a private sitting room and has its own exit into a small enclosed garden.

Moreover, the house is so planned along the contours of the lot that there is no waste space in the rear, and every room has the sun and the view. The living quarters get the most favored location simply by the way they are planned to receive a more extensive outlook, more light, and more freedom of movement into neighboring spaces and out of doors.

The planning of the lighting should not be overlooked. Observe the clerestory windows in the living room (PLATE XVIIIB). These break up the dark shadows that would develop in the rear of a room lighted only from the front. Being high up, they waste no wall space, and they do not tempt one to look out where there would be nothing to see. The pitch of the roof naturally provides for them.

The more one studies the plan the more remarkable one finds it in its economy and imagination, and the geniality of living it provides.

Construction

The needs of a building have to be realized in a plan, but the plan has to be realized in construction. Ideally the plan of a building should fit the construction so snugly that no difference between them appears. Actually this ideal is rarely attained even in the finest architecture. We have already seen how complicated the planning of the disposition of the needs is, quite apart from the added limitations and requirements of construction. When the latter are added (naturally, they are never out of an architect's mind while he is planning) the complications are still further increased. The requirements of construction may demand more space for a room than the function of the room needs, or again it may squeeze a function into too small a room. For instance, there is an ideal size and shape for a kitchen for each individual family. But the space for the kitchen in relation to the rest of the house and to the structural (and probably the financial) limitations may make a compromise inevitable. The kitchen becomes both too small and too big, develops perhaps a bottleneck by the dining room door, and requires too many steps from the stove to the sink. Yet any attempt to remedy these deficiencies develops worse deficiencies for other functions by requiring changes in the location of partitions and structural supports, which will squeeze or wastefully spread out other functions.

The neat fitting of construction to plan is a source of great aesthetic delight. The result can be felt sometimes without a detailed discrimination of the reasons for it. Just from the look of the two houses illustrated (PLATES XVII and XVIII), one can sense the nicer adjustment of plan to construction in the Ker house than in the Smith house. In the Smith mansion, space is rather loosely

handled within the four walls. The walls control the planning of the rooms within, which appear to be of about the same size whether their functions call for equality of size or not. Allowance is probably made to have plenty of space for every function — which, to be sure, gives the mansion an air of prodigality — but there must be a good deal of unnecessary space in most of the rooms. In looking at the Ker house one has the feeling of the functions all fitting together in their structural niches as neatly as tools in a compactly made carpenter's chest. And then applying one's discrimination, one can follow the functions of the house as they meet their structural embodiments and have a cumulative delight in recognizing how function is continually fulfilled in the structure and structure reflected in function in so tight an organic relationship that the two are hardly distinguishable.

This sort of relationship is an implicit ideal in the whole history of architecture. In fact, the history of architecture can be conceived as the cultural pursuit of modes of construction flexible enough to embody the needs of the time. Construction thus becomes the pivotal feature in architectural appreciation. It lies between the needs, which can only be fulfilled through it, and the purely visual effects in design and pattern which can only be developed over it. The more one studies architecture, the more one becomes fascinated with the problems of construction. This becomes more and more the center of one's appreciation of the art. Here is where the architectural imagination is most deeply at work.

There is, consequently, no more enlightening way of becoming acquainted with the important aesthetic features of architecture than by following the history of architectural construction. This we shall proceed to do very briefly in the present section. No method can so quickly bring to light most of the major aesthetic issues in architecture.

As it happens, the two houses illustrated here represent, in being placed beside one another, one of these major aesthetic issues. Both are wooden frame houses, and so superficially of the same construction, but they come out of totally different streams of architectural conception. We should be able to appreciate both types, I believe, and to be discriminating in our appreciation. These two houses are modest symbols of differing concepts of construction. The whole history of architecture lies behind them, and both of them can become much more significant in the light of that history.

Broadly speaking, there are two principal methods of building — wall construction and post-and-lintel (that is, upright and crosspiece) construction. The one naturally leads to closed planning, the other to open planning. On the whole, the Occidental tradition has until very recently been based on the conception of wall construction, the Oriental Chinese and Japanese on post-and-lintel. Stone and brick lend themselves to wall construction, wood to post-and-

lintel. The Occidental tradition has been mainly concerned with construction in stone and brick, the Oriental with wood. There are, of course, many exceptions. But these trends of architectural thinking are fairly obvious and account for the disturbance of traditional lines of thought by modern movements in Occidental architecture.

Let us follow the Occidental developments. Suppose we begin, as usual, with the Egyptians. We find them building masonry structures, with walls and pillars. The central functions of these buildings, the sanctuary of the temple, or the chamber containing the deceased for the tomb, are sheltered by walls. The pillars are performing secondary functions. What, then, does a wall do, and what is a wall?

In its simplest form, a wall is stones piled on top of one another so as to separate sections of space, usually so as to make an enclosure. In the next stage the stones are shaped to fit closely at the joints, and then mortar is used to make the joint solid. Skilled wall building is masonry, and a well-built wall is a delight in itself not only from the skill it exhibits but from its color and texture and the pattern of the stones and the varied expanse of it. Just a simple wall, to enclose a garden, for instance, has more structure than one might think. If it is meant to last, it will have a foundation, often in the form of a tier of stone or brick broader than the tiers of the wall proper, and it will have a " coping," a tier of stone laid flat over the top to protect the wall from seepage of water and deterioration. The coping for greatest protection often extends beyond the wall, with a sloping top to carry off the water, and a " drip " cut underneath the edge to throw off the drops. Such a wall is already quite a piece of architectural construction. The main elements of a wall-construction building are already there — roof and cornice, wall surface, and foundation.

A wall-construction building is four such walls joined at the corners, with a sheltering roof thrown over the enclosure. Apertures are punctured in the walls for doors to give access, and windows to give light and air. The corners of a wall-construction building are particularly important for its strength and are often reinforced with extra thickness of masonry, or at least apertures are not made very near a corner, never in a corner. A window bitten out of the corner of a wall-construction building gives a very uncomfortable feeling as if the building would collapse at the corner — as indeed it would in simple masonry. A corner aperture is only successful where a building does not even distantly suggest masonry construction.

The characteristic of masonry building, then, as contrasted with mere walls about an enclosure, is the roof. And the history of wall-construction architecture practically resolves itself into the story of how to solve the roof problem.

The simplest solution is the one suggested by the typical wood construction of post-and-lintel. There is some evidence that the earliest Greek temples were

of wood, and that stone was later substituted for wood. But even if wood construction were not present to suggest crossbeams, the natural thing would be to throw wooden beams across from wall to wall, and build a wooden roof over them. Then for the wooden beams stone would soon be substituted. Horizontal beams of wood or stone, however, cannot span a very wide space without support. So if a wide space had to be spanned, pillars had to be introduced within the area to be covered over. This is the structural origin of the columned temples of Egypt and Greece.

The Egyptians, as someone has said, were " timid builders." They were afraid to give their stone lintels a very long span. So they placed their columns close together and made them very thick. This practice gave their architecture a feeling of enormous solidity and weight. The Greeks developed a much lighter stone construction, and a Greek temple can almost be dated by the relative slimness of the columns in relation to the space between.

The Greek temple was a very simple problem on which the architectural talent of many generations of devoted artists was concentrated, gradually perfecting the proportions and the lines of every member of the building to the culmination in the Parthenon. The Greek temple was a walled chamber for the protection of a statue of a deity, with sometimes a smaller chamber for the temple treasures. Ritual was carried on outside the temple. In front of the chamber of the god was a portico supported on columns. In the more elaborate temples like the Parthenon a colonnade continued all around the building. Much thought was put upon the proportions of the column and all its parts (its base, shaft, capital), and their relation to the treatment of the lintel which the columns supported (known as the entablature) and to the cornice of the roof and the triangular pediment above that. The system of these relations became known as an " order." The Greek " orders " (Doric, Ionic, Corinthian) have had a tremendous influence on the details of architectural design almost continuously in one part of the world or another ever since. For the proportions of an " order " control the proportions of a whole building that uses it structurally. The " order " amounts to the theme which is repeated and developed all over the building. A careful study of the Doric order as it is developed in the Parthenon is a revelation of a certain sort of architectural refinement that is unlikely ever to be excelled. It represents a culmination of the use of the horizontal stone beam as a means of spanning an opening in masonry construction.

The next development came with the Romans, whose needs required huge public buildings that could take care of great crowds without the interruption of a forest of columns such as obstructed the courts of Egyptian buildings. The solution was the round arch, which amounts to turning the masonry walls inwards till they meet over the space they are intended to cover. If two walls are thus bent over the result is the " barrel vault." The Romans developed round arch

construction to a high stage of engineering excellence, and the remains of their
market places, bathing clubs, arenas, bridges and aqueducts and triumphal arches
are still visible wherever the Roman Empire extended its hold. The massive
dignity of these structures still stands. The culmination of the round arch is the
dome, where, to continue our image, all four walls are bent in till they meet in
the center, and the corners smoothed out. One great domed building still re-
mains in Rome almost untouched by time, the Pantheon. It is not, strictly
speaking, a masonry building for it is made of concrete, not of stone — as, in
fact, many Roman structures were. It was built as the temple for all the gods of
the Roman Empire. The huge domed space, filled with a softly diffused light
that spreads in all directions from an opening in the center of the dome, ex-
presses just that mixed mood of bigness, power, and patience which one imag-
ines was intended for the religious feeling of the place. The Pantheon exhibits
one of the most impressive instances of the emotional effect of volume in all
architecture. The effect was demanded as one of the main purposes of the build-
ing and (at least as regards its interior) the need was exactly met by its con-
struction.

But probably the greatest of all domed buildings is St. Sophia in Istamboul,
built much later in the age of Constantine, which is for round arch construction
what the Parthenon is for wall and horizontal beam construction in masonry.

Then after an interval came the demand for the great cathedrals within which
throngs of worshipers could witness a religious ritual. The round arch Roman
construction would have done. But it was wasteful of material. For any arch
produces an outward thrust when it bends inwards. To take up this thrust the
masonry wall that supports a simple round arch has to be thickened enormously.
The construction problem was how to build vaults over wide spaces without
having to make such heavy walls to buttress the arches. The solution was found
in pointed-arch construction, which developed into what became known as the
Gothic style.

To understand the comparative lightness of pointed-arch construction, imag-
ine four stone piers erected at the four corners of a rectangular space which is to
be covered with a vault. From the top of each of these piers build a narrow
pointed arch to the neighboring pier, so that over each side of the rectangle
there is an arched rib. Similarly build pointed-arch ribs from pier to pier across
the diagonals of the rectangle. Then fill in between the ribs with light material.
The result is a relatively light vault carried by the ribs which are supported by
piers. The thick wall needed for the round arch totally disappears, and a very
open type of construction develops. The space between the piers, being no longer
needed for structural support, can be filled with glass, whence the colored win-
dows which are among the glories of Gothic architecture.

A Gothic cathedral consists structurally of a succession of vaulted rectangles or

"bays." At the front of the cathedral are two towers flanking a light wall, which is penetrated below by a sculptured doorway and above by the large " rose window." Behind the wall comes a succession of " bays " which make up the " nave." This is crossed at right angles by another succession of " bays " known as the " transept." Beyond the transept and in line with the nave comes a third succession of " bays " known as the " choir." In principle this is the whole plan of a Gothic cathedral. The congregation gathers in nave and transept. The altar where the religious ceremony is carried on is in the choir. The plan is directly exhibited in the construction. The two fit each other perfectly.

In fact, one of the details of the plan calls for aisles on either side of the nave. These too are afforded by a need of the construction. For there is a thrust of the pointed arches upon the piers. This is taken up by a half-arch (known as the " flying buttress ") thrown off from the foot of the ribs just above each pier and anchored in another pier outside the nave. Between the buttressing piers outside the nave and the piers that support the vaulting develops a space which just provides for the side aisles.

The great cathedrals of Notre Dame in Paris, Chartres, Amiens, Rheims represent another high point of architectural achievement based, like the Parthenon and St. Sophia, on the mastery of a type of construction.

Then followed the reaction of the Renaissance against the Gothic and all things medieval, and a return to the Roman and Greek conception of building with solid masonry walls supporting horizontal crossbeams, round arches, or domes. The Renaissance styles are characterized by much greater freedom and variety of decoration than the Greek or Roman, and usually a more liberal perforation of the walls with windows and doors.

In the nineteenth century, Renaissance curiosity about the ways of other cultures led to the adoption of many other styles of architecture besides the Greek and Roman. There was even a Gothic revival. This " eclectic " period of architecture, which someone has called " the battle of the styles," is the one in which we are still living.

But we are also living in an age where a most exciting and significant change is going on in architecture. It may be paralleling an even more significant change in social organization and cultural ideals. We seem to be in a transitional period in which the Renaissance is coming to an end and another age beginning. The new architecture that is emerging has acquired no better name than " modern." It is, however, definitely a new architecture and not another Renaissance revival, for it is based on an entirely new conception of building construction.

Throughout this whole long development of Occidental architecture up to the present moment, the basic conception of building has been that of the masonry wall and its adjunct the masonry pillar or pier. This mode of construction invited a conception of closed planning which became traditional and was relaxed only

in the plan of the Gothic cathedral, which was open simply because the masonry wall shrank to a succession of piers. But in the last few decades steel construction, reinforced concrete, and a variety of other materials have emerged, producing a revolution in architectural conception.

If we study the possibilities of steel as a building material, most of the revolutionary ideas of " modern " architecture come to light. Steel can be used effectively in two quite different ways — in sheets or in beams. Steel ships and Quonset huts give us samples of the possibilities of construction with sheets of metal. One of the startling characteristics of this mode of construction is that an opening can be made almost anywhere in a riveted or welded steel box without affecting the strength of the box at all — for instance, the opening can come at the corner. A window, then, can be made in the corner of a sheet metal building and be structurally sound — contrary to the essential structural feeling of a masonry building which demands a strong and solid corner. Hence one of the features of " modern " architecture is the corner window (which looks terrible in any house that suggests traditional wall construction). Le Corbusier and his followers are particularly associated with this boxlike, shiplike conception of architecture. In pattern and design, it stresses volume and three-dimensional mass. Its composition is mainly an organization of masses analogous to a cubistic painting. To a traditionalist Le Corbusier's houses do not look like houses at all and seem very mechanical and forbidding. But Le Corbusier, in revolt against tradition, demands that we look at a house as an instrument for efficient living built of the most efficient modern materials. The severity of his style has been modified by his successors; nevertheless his influence is steadily growing, and shows in many of the wartime and slum clearance solutions of large, inexpensive housing projects. In fact, it shows wherever boxlike, voluminous forms are worked into modern architectural compositions.

The second way in which steel is used has been even more far-reaching in its results. This is the upright-and-crossbeam construction which forms the skeleton of skyscrapers and of nearly all big steel buildings. The significance of this construction for architectural planning and designing seems to have been first observed by the American Louis Henri Sullivan, who influenced the conceptions of Frank Lloyd Wright, who in turn is without much question the most influential and possibly also the most original and imaginative of all the pioneer architects in the modern movement. The Europeans realized his importance before the Americans did, and his influence made its full impact on America only after Americans became aware of the results of his influence in Europe.

Very briefly, the architectural revolution that came out of steel was the revelation that post-and-crossbeam construction was much more congenial to open than to closed planning. A steel construction building of the skyscraper type does not structurally rely upon a wall in any way at all. Structurally a skyscraper has

no wall. The walls of a skyscraper are simply a curtain hung from the steel frame to protect the inmates from the weather. Consequently the whole front of a steel building of this sort can be made of glass, if you like. This is the fact that dawned on Sullivan. Its also follows that the inner partitions within the building are equally just screens to separate one office from another, and can be put almost anywhere because they have no structural function. In short, the inside of such a building opens up completely for as much open planning as one likes.

Moreover, it then also dawned on a number of architects that a wooden frame building is much more like a steel frame building than it is like a masonry wall building, and that open planning is the type most congenial to wood. In fact, surprisingly enough, the Japanese had handled wood construction in their houses and temples for generations on this principle. Architects began to give a lot of attention to Oriental methods of building and planning. The Occidental architect gradually became aware of the fact that the traditional wooden building was based on the conception of a stone building turned into wood. The model Occidental building was the church or palace of masonry wall construction. When a man wanted to build a less expensive wooden building, he simply converted the stone plan into wood, and built wooden walls instead of stone walls. It never apparently occurred to an Occidental till steel came in that a wooden house does not structurally need any walls and that a type of plan congenial to stone masonry construction might not be quite so congenial to wood construction.

The realization of this fact is what is revolutionizing modern architecture. For stone construction is no longer very efficient for large buildings. Steel and reinforced concrete are so much more flexible, and can span so easily so much wider spaces. And now wood, being shown the way by steel construction, is following its natural bent toward open planning and is abandoning the feeling of structural walls. The basic traditional conception of architecture that a building is a structure of walls supporting a roof is rapidly disappearing and being replaced by the idea that a building is a roof supported on upright posts which may be far inside the area of the building, since wood and steel beams can be cantilevered or projected way in advance of the posts, and that walls are needless.

This is the most revolutionary change in architectural style in the whole history of Occidental architecture. The contrast between the Governor Smith mansion and the Ker house tells the whole story — all the more clearly because they are both dwelling houses of wood construction. The Smith mansion could be translated into stone with hardly a tremor. The roof is definitely supported on four *walls*, and the partitions inside the house are just as clearly *walls*. In contrast, the Ker house has practically no walls at all. A large part of the side of the house is glass, and the lightness of the " walls," where it is boarded in, is unmistakably expressed.

It would, however, be erroneous, I believe, to say that houses planned and designed like the Smith mansion are out of date today, and even more erroneous to say that they are not beautiful. But it can be said that the nature of wood construction is much more congenial to the structural treatment and the relatively open planning of the Ker house. A greater perfection of beauty awaits wood construction buildings of the latter than of the former type, for in the latter type plan and construction can completely merge.

In summary, a reflective glance back over the development of architectural styles in Occidental history indicates that the problem of fitting construction to the needs of a society, as these issue in desirable plans, has been the driving force in architectural changes. From the Egyptians to the Greeks we trace the perfecting of wall-and-crossbeam construction. The Romans perfected round arch construction. The medieval builders carried forward the same aim to span a wide space economically, and developed the pointed arch to perfection. With industrial needs and scientific advancement, the modern age developed steel and reinforced concrete construction which, so far as we can see, has capacities to meet any future social requirements for the spanning of space. In other words, whatever the plan in terms of desired social needs, we apparently now possess the methods of building to satisfy those needs. We have been tracing the history of fitting capacities of construction to social needs. At each juncture where a new structural invention came in, we find a radical change of architectural style. But never has so radical a change of style occurred in Occidental culture as the one which we are going through. At the same time, never have methods of construction been so adequate to human planning.

Architectural Design and Pattern

The difference between closed and open planning, which is at root a reflection of the difference between wall and post-and-lintel construction, becomes further reflected in a difference between "traditional" and "modern" designing. This statement demands a great deal of qualification, for there is much overlapping, and, with selected comparisons, it can be shown that there is nothing new in "modern" architectural design. Nevertheless, the statement is essentially true.

Under design and pattern we are now to consider the features that contribute to making a building an object of visual delight over and above its fulfillment of its dominant purpose. For only now do we come out from under the demands of the overarching dominant purpose requiring that a building be suitable to its place and needs through effective planning and construction. Only now have we become free to ask how a building can be also an object of continuous interest and of sensuous and emotional delight.

There are some who in revolt against the frosted-cake decoration of a good

deal of the architecture of the last two centuries assert that utility is all that is needed. Fulfill the type of utility for which a building is conceived, and if that is honestly done the building will attain the greatest perfection of design of which it is capable. These are the extreme functionalists. But the history of the art is against them. Think of Chartres stripped to the barest utility of vaulted space and altar for the service of a Roman Catholic Mass. Moreover, what need of those soaring proportions? Pull the height down to the most economical for the spanning of that space. Even the functionalists shrink from the logical consequences of their dictum, and admit compromises with visual charm.

The line of their retreat is worth following, for it illuminates the relation of design and pattern to utility in architecture. It consists of a series of steps from the conception of pure utility at one extreme to that of pure abstract pattern at the other. Very briefly these are the steps:

1. *Bare utility.* Architecture conceived as engineering with no thought of the eye but only to serviceableness, economy, and strength.

2. *Well-proportioned utility.* The engineer acquires an eye for visual pattern. As between two proportions equally utilitarian, he chooses the one more pleasing to the eye. He thinks of repetition and variety, and of the movement of line, and possible effects of contrast and gradation and climax.

3. *Organic design and pattern growing out of structural forms,* such as the elaboration of the capitals and cornices and the frames of doors and windows, and the selection and decorative treatment of materials consistent with utility but also in excess of necessity and done out of spontaneous delight in creating something pleasing to the eye. Such organic design may be highly reserved as in some early Romanesque churches, or profuse and generous as in the later Gothic cathedrals.

4. *Design and pattern not inconsistent with structure* but not obviously growing out of it. The feeling now is that the structure is a frame for the support of the design and pattern, almost as if it were an easel for the support of surfaces on which the artist regards himself as free to compose within the limitations of the structure. That is, the structure is conceived as a means and the design and pattern as the aesthetic end. Restrictions imposed by the structure are carefully respected, however. Design and pattern do not deliberately contradict structure, though they may often conceal it. Much early Italian Renaissance architecture is of this sort. It has sometimes been dubbed " painter's architecture," and, in fact, some of the renowned architects of the time, notably Michelangelo, were primarily painters and sculptors.

5. *Design and pattern without respect of structure* and even in contradiction to structure. Such are the Gothic and Greco-Roman surface designs of steel skyscrapers.

Now, very few functionalists when faced with these successive possibilities will

stop at step 1. Most of them will go at least through step 3 and some of them will even enter the precincts of step 4 when they realize what a quantity of delightful Florentine and Venetian architecture they would have to reject if they did not concede so far. It is, therefore, only step 5 that all functionalists reject.

But irrational and unjustifiable as step 5 usually is, there are some buildings that fall within this group which only a single-minded functionalist would deny were nevertheless very beautiful. The Colosseum in Rome is one of these. It is a round-arch-construction building with a surface decoration of post-and-lintel type derived from the porches of Greek temples. The Roman architects were caught in the same dilemma with their round-arch structures as the American architects with their early steel structures. The bare lines of the round arch seemed too stark for an opulent public building. No organic decoration had yet developed for this new type of construction. So, the Romans borrowed from the best design in their tradition, from the colonnades of their temples, and laid these colonnades in the form of pilasters as a surface design over their round arches. The abstract effect was highly pleasing on account of the contrast of the straight verticals and horizontals with the curves of the arches. In spite of the structural contradiction, the practice was accepted and became an architectural convention not only for Rome but for the years to come. In view of this classic example, some of us will perhaps be bold enough today to plead for a beauty in some of our early skyscrapers — in the Tribune Building of Chicago, for instance, and in the (dare I say it!) Woolworth Building of New York.

However, the issue over functionalism has brought out a general principle of architectural design which is only violated at great risk — namely, that *the design and pattern of a building should reflect its planning and construction.* The principle implies that design and pattern are distinguishable from construction, so that stage 1, the ignoring of design, is aesthetically as risky as stage 5, the ignoring of structure. It suggests that stage 3 is the most satisfying, provided (as does not always occur) the plan and construction allow for a fullness of design completely satisfying to the senses. The principle admits stage 4, design and pattern not inconsistent with structure.

It is only now and again that conditions converge to produce buildings like the Parthenon, St. Sophia, Amiens, and Chartres, and the Buddhist temples at Nara — buildings which represent culminations of organic design (stage 3). There must be a profound social demand for the structure, a rich tradition, a building technique just suited to serve the social demand, and a maturity of designing suited to the building technique. All of these conditions must culminate at the same moment. Only then can design and pattern organic to the construction be realized with the same significance and fullness as the cultural tradition it shelters and embodies. One or another of these conditions is likely to be missing, so that though fine buildings are fairly common in all ages, a great

building is a rare thing and properly counted among the wonders of the world. Our age is not yet quite ready for such a building. We have the building techniques above anything ever known before as a result of our control of steel and reinforced concrete and a multitude of new materials. We probably have an adequately significant tradition in our pride of industry and democratic government and public education. But we lack sufficient social demand for buildings of great beauty. We demand speed and efficiency too much, and perfection, taking the time and thought it requires, too little. And we lack maturity of design adapted to our new techniques of building. That is why Rockefeller Center and Boulder Dam and the San Francisco Bay Bridge for all their clean beauty still lack the architectural depth of Chartres or St. Sophia. Nevertheless, these very structures suggest that we may be on the threshold of another great architectural era.

But to return to simpler things. The relations of design to structure apply just as truly to a domestic dwelling as to a cathedral. And since we are building houses today with two different conceptions of construction — closed wall construction and open post-and-lintel construction — both architecturally legitimate, it follows, on the principle that design and pattern should reflect construction, that there should be two conceptions of designing and patterning corresponding to the two conceptions of planning and construction — namely, the closed and the open. The two conceptions are so different in treatment that they have to be considered separately.

1. CLOSED DESIGN AND PATTERN. The most prominent features of a building conceived for a closed plan are the walls and the divisions of the walls. Even in the simplest building there are the horizontal divisions of foundation, wall surface, and roof. If there are wings or abutting towers, there will be vertical divisions also between the central structure and the adjoining structures. These horizontal and vertical divisions constitute the basic organizing pattern of such a building, which is clearly an embracing (not a skeletal) pattern. Within these big divisions are often lesser divisions. For instance, the wall may be subdivided into a number of stories indicated by rows of windows, and often by differences of texture and treatment of the wall. If it is a stone building, such as a Florentine palace, the masonry of the lower stories is heavier, and rougher in texture than in the higher ones. The window openings may be deeper. These are indications of the structural requirements of a high wall, heavy at the foot and lighter above; but these requirements are reflected in the subdivisions of the wall in its organizing pattern. Incidentally, they produce a gradational effect with climaxes of lightness or weight as the eye passes up or down the surface of the wall. The roof may also be subdivided, as in a hip roof. If there is a high foundation, this also may be horizontally subdivided. A tall building of several stories may have two or more in what counts as the foundation or basement level, and two or

more in the roof. This sort of designing can be seen in many of our public buildings.

On the other hand, each story may be treated as a separate major horizontal division. Giotto's Tower in Florence is one such well-known structure designed in five horizontal bands graded with increasing lightness of treatment to a climactic band at the top marked with large shallow openings. Such divisions can hardly exceed five without danger of running over the attention span.

Vertical divisions are ordinarily in uneven numbers for symmetry's sake. And the main entrance is ordinarily in the central member. The central member may be larger or smaller than those on either side. Most of our state capitols in the United States have smaller wings on each side of a large domed central member. The national capitol in Washington has a vertical division of five units, with the heaviest accent on the center, and with subordinate vertical divisions in each of the five main units. The typical Gothic cathedral, however, has a smaller central member flanked by two towers. I am speaking now of façades, but the other three sides are also patterned with horizontal and vertical divisions which enfold subdivisions. Unbalanced patterns frequently occur, especially in smaller buildings that do not call for the dignity lent by symmetry.

Within this embracing organizing pattern of horizontal and vertical divisions, the more detailed designing of the wall surfaces is worked out. The obvious elements for development are the proportions of the walls and of the doors and windows which penetrate them. A wall design grows out of these elements. Sometimes the whole design consists in the selection of the proper dimensions for these elements and the placing of them on the wall surface. At other times these elements are the sources of luxuriant elaborations of decorative development. Either way, the proportions of doors and windows are of pivotal importance in designing wall surfaces.

The principle of theme-and-variation operates extensively in this sort of designing. The openings are all likely to be rectangular, or all arched overhead, or all pointed. Or if rectangular and arched openings are combined, the rectangle chosen is the one that develops below the arch, and so is a variation developing out of the arched window. Windows may differ greatly in size and remain harmonious, if they all contain panes of the same size. The pane becomes a unit of variation. In fact, any elements will seem related if you have the sense that they are multiples of a single unit. The Greeks are said to have made all the proportions of their temples on the basis of such a unit (for instance, half the diameter of a column) which was known as a " module."

There is an illustration of the module in the Ker house (PLATE XVIII). The distance between the rafters of the roof is two feet. This is the module for a number of proportions in the house. The bedroom windows are two modules

(or four feet), the living room windows are four modules. The distance between the horizontals on the terrace is four modules. The dimensions of the rooms are also related to the module. So panes of glass or any shape that can enter as a multiple into other shapes may act as a sort of module relating shapes and causing them to be felt as variations of one another. On similar grounds, the pitch of a roof will feel right if it is parallel to the diagonal of some prominent rectangle on the wall surface. For that means that the roof shape is tied in, and related to a wall shape — is a development, a traceable variation of it. The pitch of the roof in the Governor Smith mansion (PLATE XVIII), for instance, is parallel to the diagonal of the rectangle formed by one story of the façade — that is, the diagonal of half the long dominating rectangle of the façade. In the great Gothic cathedrals and the refined Italian Renaissance wall designs there is scarcely a shape that is not related as a repetition, variation, or development of every other shape. The principle of theme and variation spreads all over the building and relates every feature producing an over-all feeling of rightness and harmony.

If elaborateness of design is sought, the elaboration begins to grow and spread from structural features, from around the doors and windows, from the cornice, from the capitals and bases of columns, thence to the spaces developing between these (cf. PLATE XVII, Smith Mansion). The decoration may finally, as in some Baroque architecture, cover almost the whole wall surface with intricate and restless detail. However, even in the most ornate Baroque there is usually some restraint. Some surfaces are relatively quiet in contrast to others, and there are gradations and climaxes of interest, often with a grand climax above and about the main entrance. The Gothic does this too. Much of the finest sculpture in the world — medieval, Roman, Greek, Assyrian, Buddhist — is from the architectural aspect superlatively developed wall decoration. The sculptured pediments of the Parthenon were the decorative climax of a temple façade. The beautiful elongated stone figures of Chartres were designed to contribute to the climactic attraction of the cathedral entrance.

What is done on the exterior should reflect and be reflected by the interior. If a great entrance is featured on the exterior, we should expect to enter a great hall behind. The entrance of Chartres is monumental and leads us to expect the monumental nave we find behind it. When, consequently, a monumental entrance opens into a small dark corridor, as it does in one ostentatious university building I know, our sensibilities are shocked and with a few other such shocks the whole building becomes a specimen of supreme ugliness. The disposition of windows leads to expectations of the kinds and sizes of rooms inside. Likewise when we are inside we expect the outside to reflect in its design the inside plan.

Interior decoration in a closed plan building is on a smaller scale the same

sort of thing as exterior design. Each room has its four walls, its lighting, and its exits. There are the furnishings to consider, and the treatment of the walls should fit (or at least not contradict) the designs of the furniture and the uses of the room. Being separate rooms they do not need to be treated alike. However, to treat each room as if it had no relation to its neighbor and perhaps belonged to a different "period" is, to say the least, taking great architectural risks of designing *contrary* to function (stage 5). It is likely to make one's house look and feel like the "period" wings of an art museum — this room in Sheraton, that in Chippendale, the next in Empire, and another in "modern." It may work out. If a person is really interested in styles of furnishings, loves to collect them as a lover of old books collects first editions even though they are often very hard to read, then he should have his period rooms. But there is not much excuse otherwise.

Interior decoration is part of the architectural problem. The total effect of a house depends on its interior as well as on its exterior. Also, part of the interior beauty of a house depends on its furnishings. And the principles involved in the relation of design and pattern to function in interior decoration are exactly the same as those which apply to architecture in general. Modern open planning has brought this point to light in an emphatic way, because in this sort of planning there is no sharp line between interior and exterior, nor between architectural features and furniture, since much of the "furniture" — seats, tables, chests, stoves, refrigerators, etc. — is built into the house. Looking back from open to closed planning, we now plainly see that interior decoration has always affected the beauty of even a closed plan house. This rediscovery is nothing against closed planning, but it reveals why so many houses of the last ten decades have been unsatisfactory. They have unnecessarily closed the inside from the outside, and one room from another, and the room from its furnishing — and the beauty of the architecture has inevitably disintegrated.

2. OPEN DESIGN AND PATTERN. A glance at the two views of the Ker house will show how differently the designing of an open plan house is conceived. Here is a composition of planes of different shapes and textures, set at different angles to one another, in an integrated system of spatial forms. It resembles modern abstract painting. The angles of the planes develop tensions between, as if the planes went toward or away from one another. Volumes are felt as visual units, not as voids left between walls.

First notice the angular tension in the plan of the house, which is not suppressed but emphasized as a feature of the design. The triangular terrace shooting at an angle from the plane of the living quarters and as an extension of the plane of the kitchen stresses that tension. The shape of the terrace is re-emphasized by the strong horizontals of the trellis and by the uprights carrying

along the plane of the kitchen. Cutting the interrupted plane of the trellis is a long continuous horizontal plane below the tip of the roof. Its acts as a gutter and a shade, but in the design it is the longest single plane visible and acts as a sort of spine that pulls all the other planes together. Remove it in thought, and see how much weaker the composition looks. The glass of the living quarters makes a descending vertical plane interrupted by the chimney. The mass of the chimney pushes through all the other planes and seems to anchor the composition to the earth.

Go inside the living room and the same interrelationships and tensions of planes develop. The slant of the ceiling is stressed, and the angle of the partition between the dining alcove and the living room. The volumes of the living room and the dining alcove overlap and interpenetrate. The planes of the terrace are also involved in the living room. The floor plane goes right through. The vertical posts of the plate glass windows are picked up by the outside verticals of the terrace. The rhythms of the horizontals of the trellis are seen and felt repeated in the dark stripes of the rafters, and the angle of the plane of the roof to the plane of the trellis is thus stressed. The ceiling, so to speak, slips right out into the plane of the trellis. Note the importance for the design of the heavy horizontal crossbeam above the windows. Notice also, how in every instance design grows right out of function.

Lastly, consider the textures of these planes — the smooth floor, the white ceiling, the boarded partition, the glass, the cement terrace, the rough stone of the chimney. For its massiveness and heavy texture, the chimney is a most important element of contrast in this design.

Altogether, the whole conception of architectural designing is totally different in open planning from what it is in closed planning. There is relatively much less thought of theme and variation, or of repetitive patterns, and the embracing organizing patterns of vertical and horizontal division no longer appear. In place of these are interpenetrating planes and volumes, space tensions, and contrasts of texture, shape, and line movement. There is great interest in materials. Choiceness of material and variety of texture, and the shapes of areas tend to be substituted for decoration in the traditional sense. Some few modern architects will not even have pictures hung on their carefully shaped vertical planes. They tell us painting is a bygone art and has no function in modern living! But most of the younger architects are not quite so fanatic, and are willing to indulge their clients' whims and traditions. You notice there is a picture in the Ker living room! Quite surely in time some sort of decoration suitable to open designing will develop, and the designs will become more relaxed, and then this architectural period will have attained maturity.

Summary

The fundamental principles in the understanding and appreciation of architecture, then, are these: As an applied art it is subject to a dominant purpose. Only when this purpose is recognized as fulfilled with distinction is a building entirely satisfying. In fulfillment of this purpose a building must be suitable to time, place, and needs, and by suitability to needs is meant that it will be satisfying in plan and construction. The plan should fit the needs. The construction should fit the plan. Lastly, the design and pattern should fit the construction, and thus reflect the plan and the needs and the time out of which the needs arise, all in relation to the particular place where the building is located. If this result is approximated, whether the building be a cottage or a cathedral, it will be something very beautiful and satisfying.

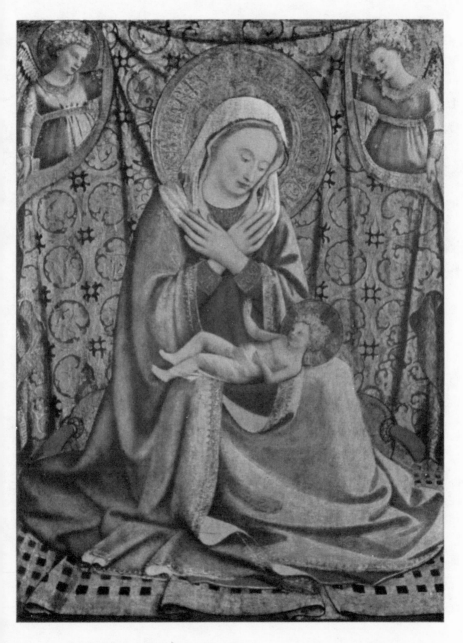

PLATE I Fra Angelico, *Madonna of Humility*

PLATE II Auguste Renoir, *Madame Charpentier and Her Children*

PLATE III Central Asiatic
Baluchistan rug
(nineteenth century)

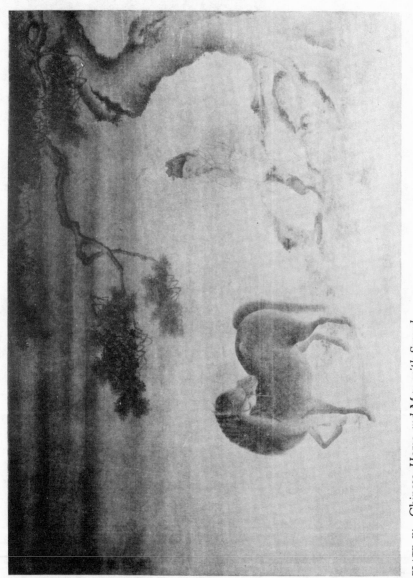

PLATE IV *Chinese, Horse and Man with Sword*

PLATE V Tintoretto, *Christ at the Sea of Galilee*

PLATE VI Velasquez, *Pope Innocent* X

PLATE VII Honoré Daumier, *Au Théâtre*

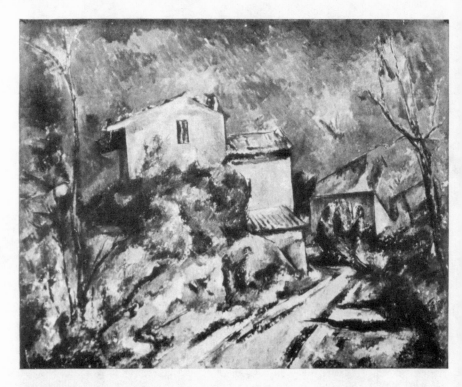

PLATE VIII
A. Paul Cézanne,
Maison Maria

B. Photograph of subject
of *Maison Maria*

PLATE IX

A. Georges Seurat, *The Artist's Mother*

B. Pablo Picasso,
Death of a Monster

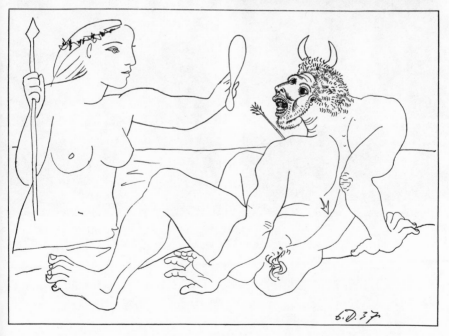

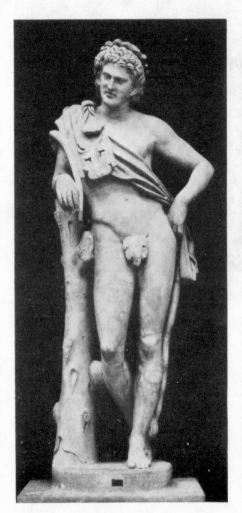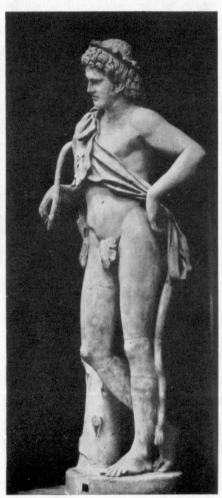

PLATE X Praxiteles, *Satyr* (A. front, and B. side view)

PLATE XI Jacob Epstein, *Portrait of Oriol Ross* (bronze 25″ high)

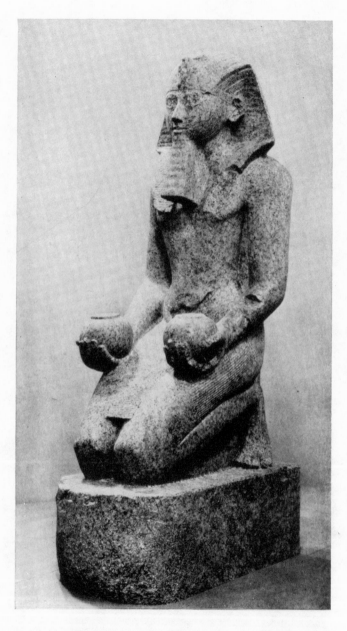

PLATE XII Egyptian (1490–1480 B.C.) *Statue of Hatshepsut*
(red granite)

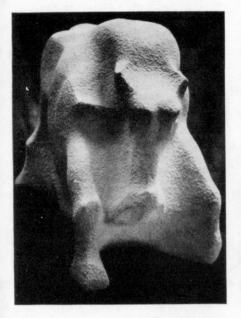

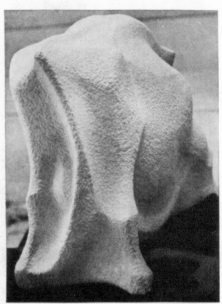

PLATE XIII
Pegot Waring, *Bull*
(A. front view)
(B. rear view)

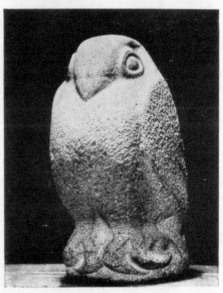

C. Richard O'Hanlon, *Young Hawk*

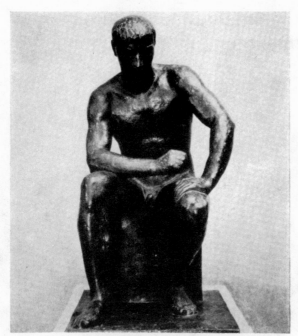

PLATE XIV

A. Charles Despiau, *Seated Youth*

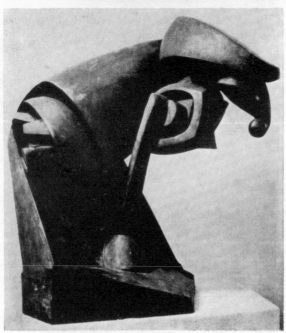

B. Duchamp-Villon, *The Horse* (bronze 30″ high)

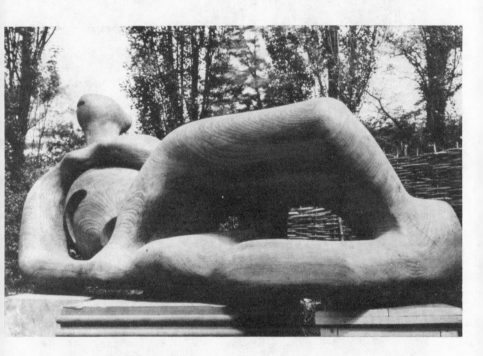

PLATE XV Henry Moore, *Reclining Figure*

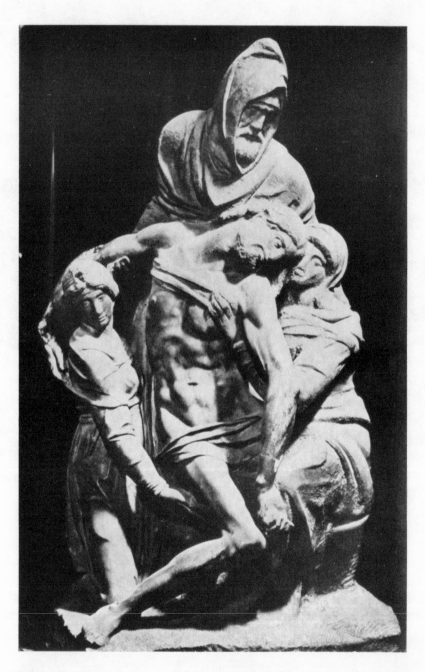

PLATE XVI Michelangelo, *La Pieta*

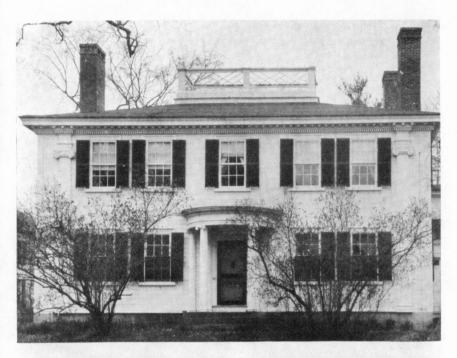

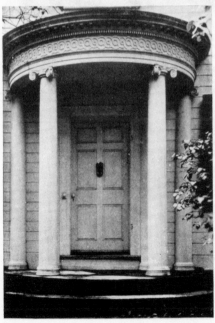

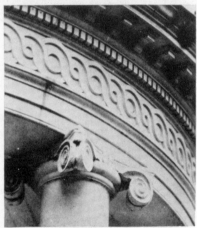

PLATE XVII

The Governor Smith Mansion

Wiscasset, Maine (1792)

(left) porch (above) detail of porch

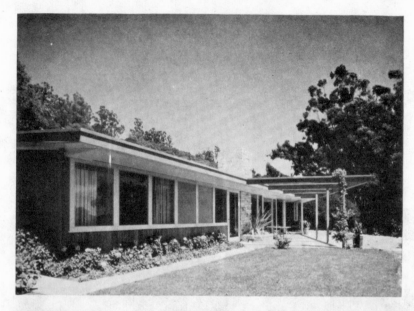

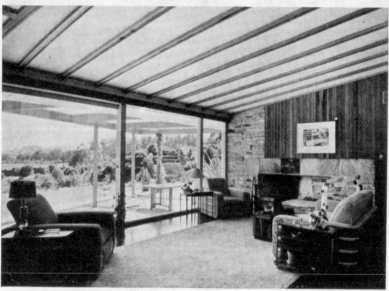

PLATE XVIII Alexander Ker House (1948) Fred Langhorst, architect

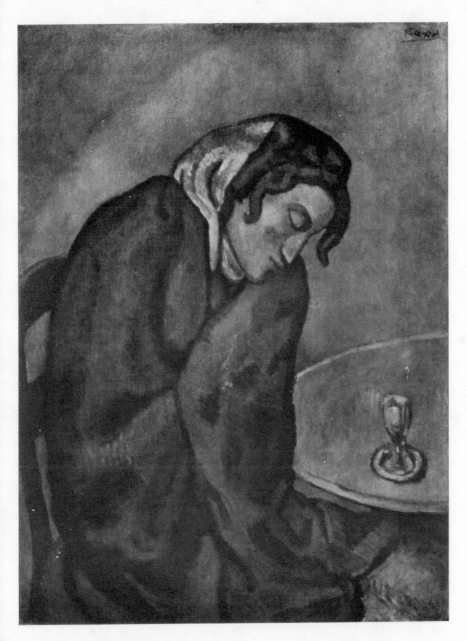

PLATE XIX Pablo Picasso, *Absinthe Drinker*

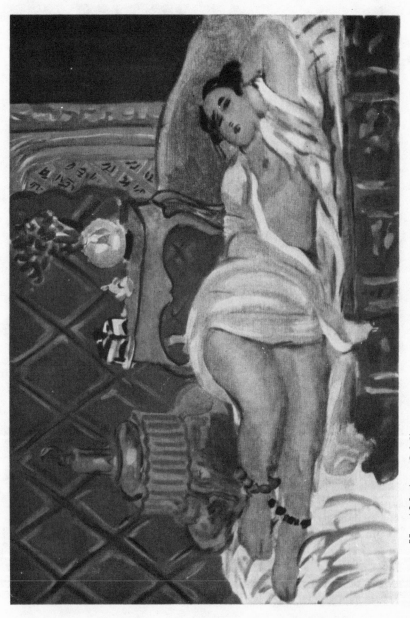

PLATE XX Henri Matisse, *Oddalisque rouge*

INDEX